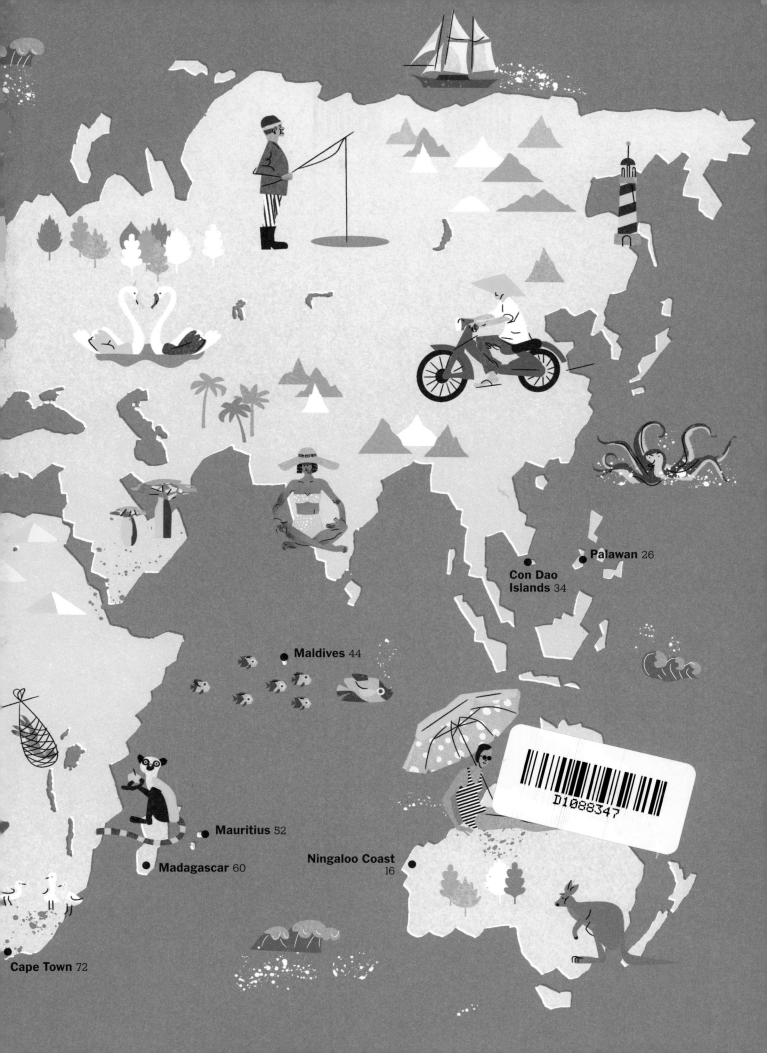

D1088347

The New York Times

EXPLORER

Beaches, Islands & Coasts

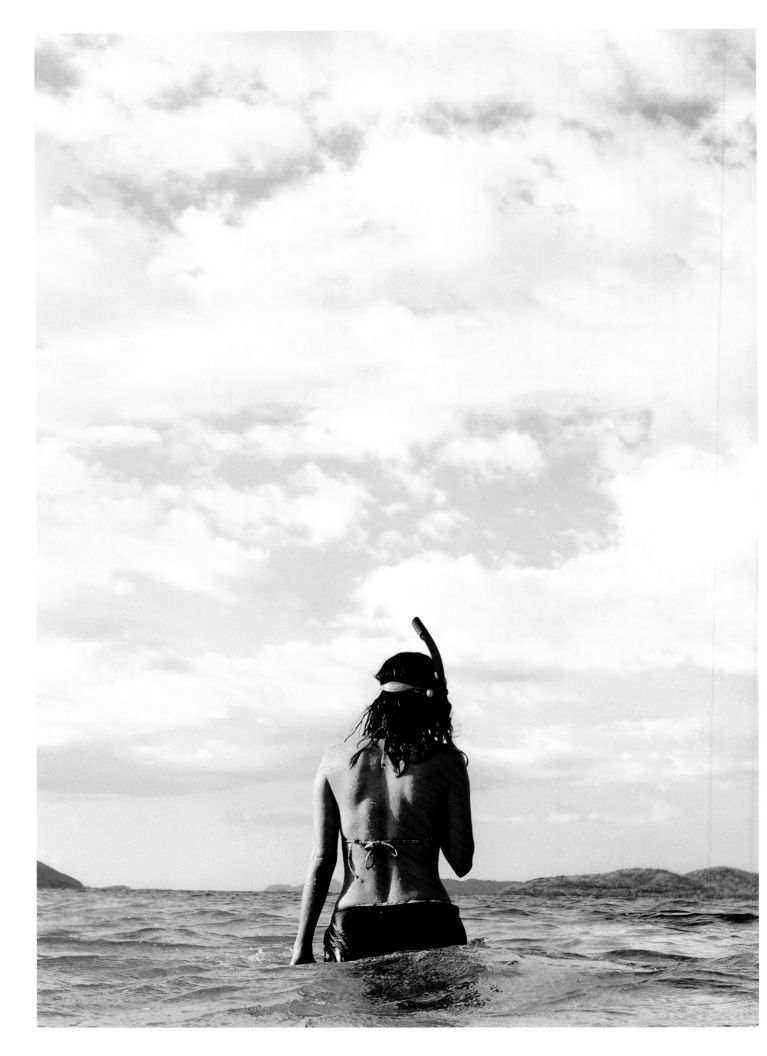

The New York Times

EXPLORER

Beaches, Islands & Coasts

**Edited by
Barbara Ireland**

TASCHEN

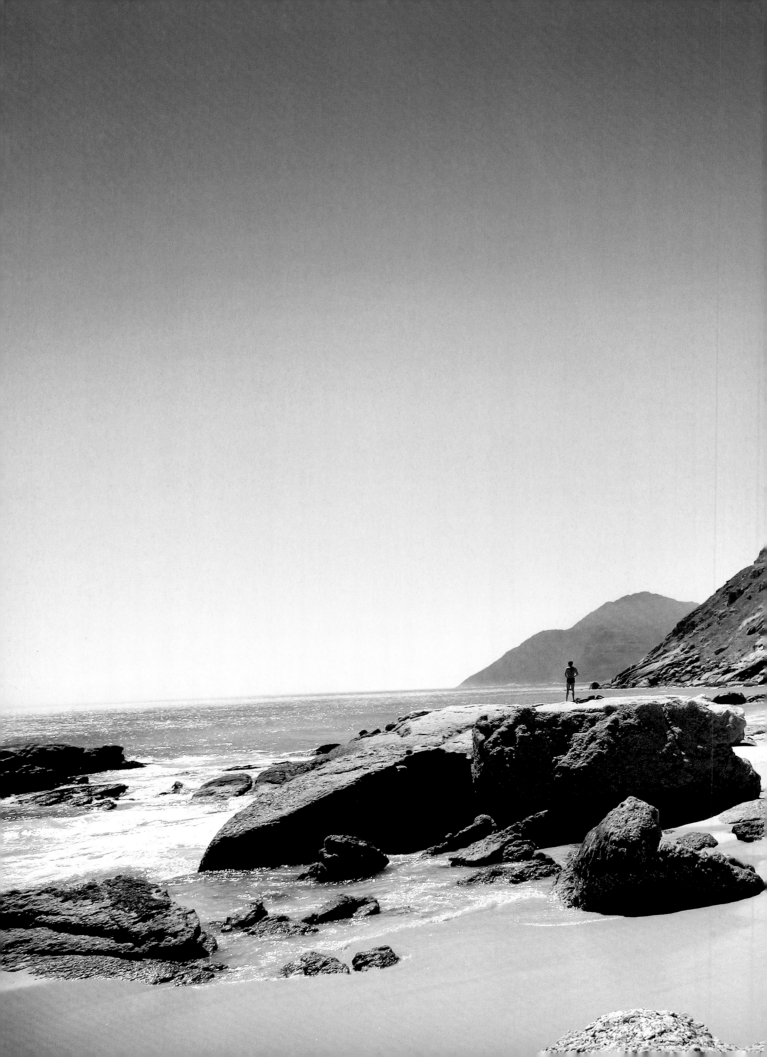

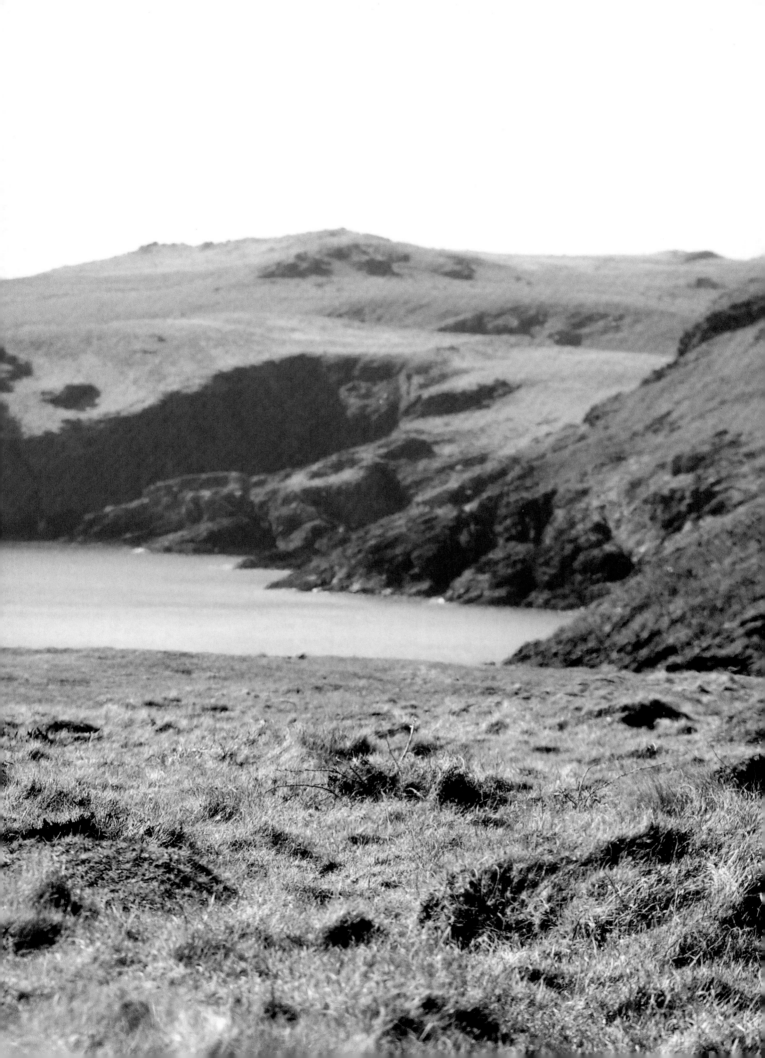

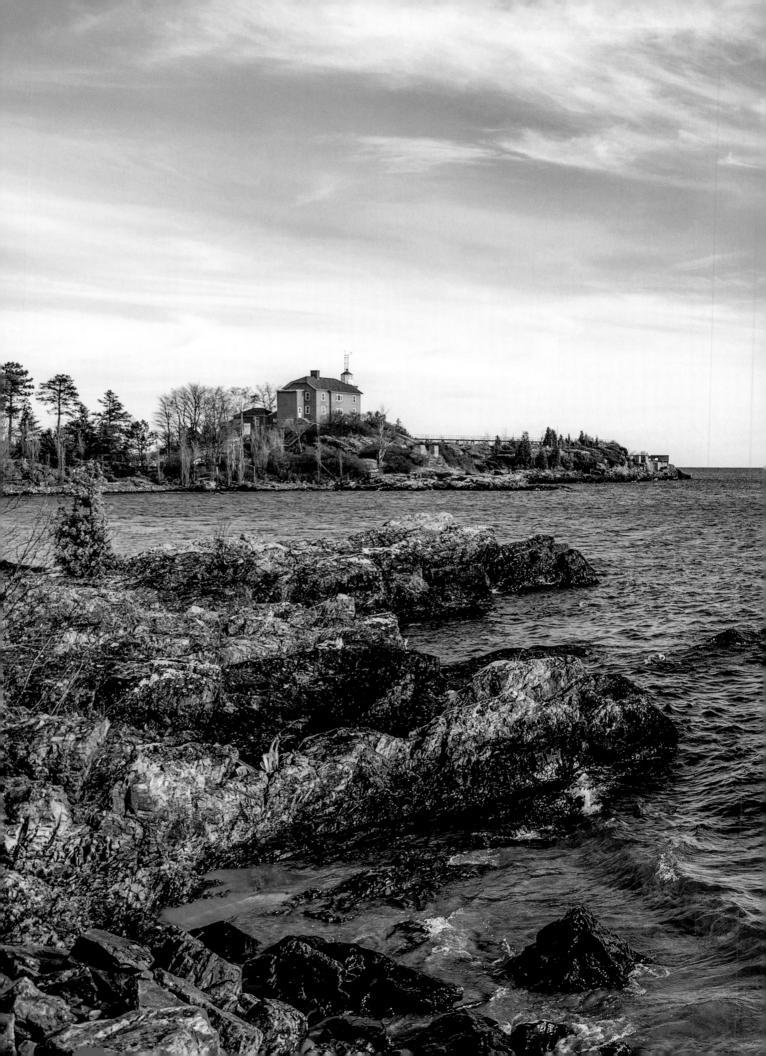

Every traveler is an explorer. When that explorer is also a talented writer with an itch to share the story, readers can ride, hike, fly, glide, float, race, or meander along, partaking in the excitement of discovery in new or unexpected places. And when a gifted photographer also makes the trip, bringing back images that capture the beauty and the unique spirit of far-flung locales, the experience only gets richer.

Distinguished travel journalism first found a home in The New York Times *generations ago. This book, part of the* Explorer *series published by* The Times *and TASCHEN, collects 25 articles by today's crop of fine travel writers, all focusing on the fascination of places where land and water meet. Together with the stunning photos that accompany them, they roam the planet from the Maldives to Newfoundland and from an Australian reef to the Florida Keys.*

On these pages, red-hot lava hisses down into the sea on the Big Island of Hawaii. Waves crash against coastal cliffs in Wales on a drizzly day capped by a rainbow. Lemurs decorate riversides in the unique island ecosystem of Madagascar. Our literary explorers charge through it all with sharp eyes, wonder, and a sense of humor, ready to take the world on its own terms and learn from it.

You are invited to page through this book with whatever purpose suits your life. Harvest ideas for trips of your own; although this is not a guidebook, some basic guidance is included. Relish the writing and the photography. Or just flip the pages, marvel at the variety of experiences out there to be had, and dream. Every traveler is an explorer, and every explorer is a dreamer first.

— Barbara Ireland, Editor

Palawan, Philippines (page 2); Noordhoek Beach, South Africa (pages 4-5); Lago d'Orta, Italy (pages 6-7); Pembrokeshire, Wales (pages 8-9); Michigan Upper Peninsula (previous); Île Ste. Marie, Madagascar (opposite); Bathsheba, Barbados (following).

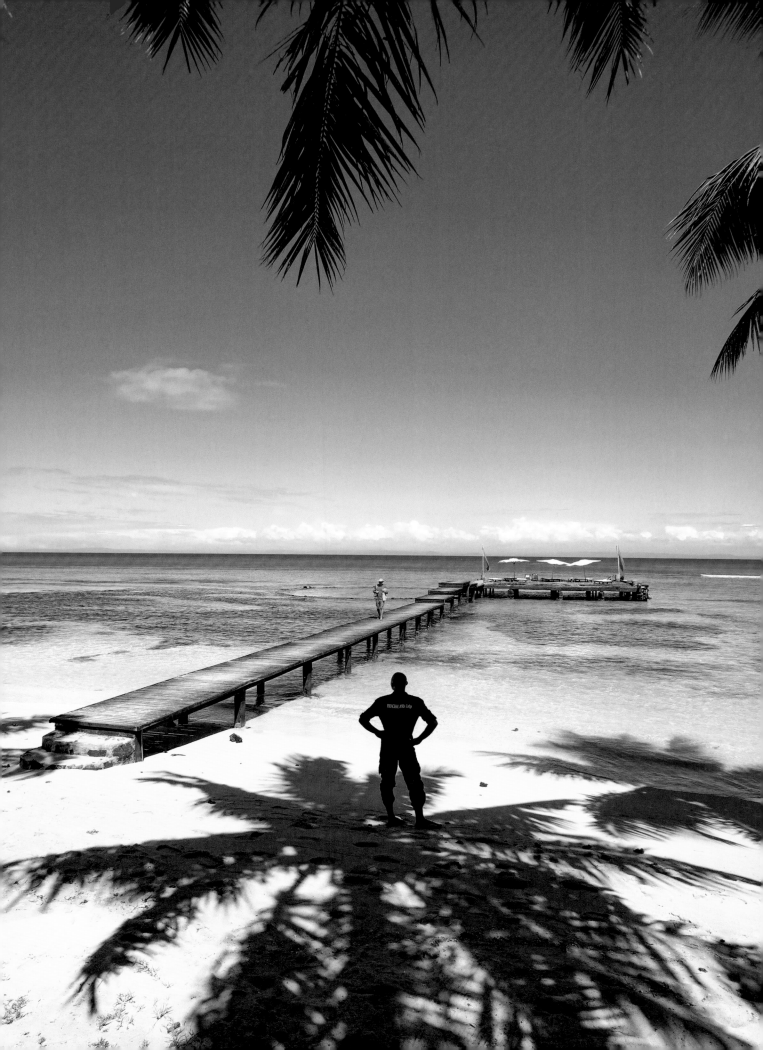

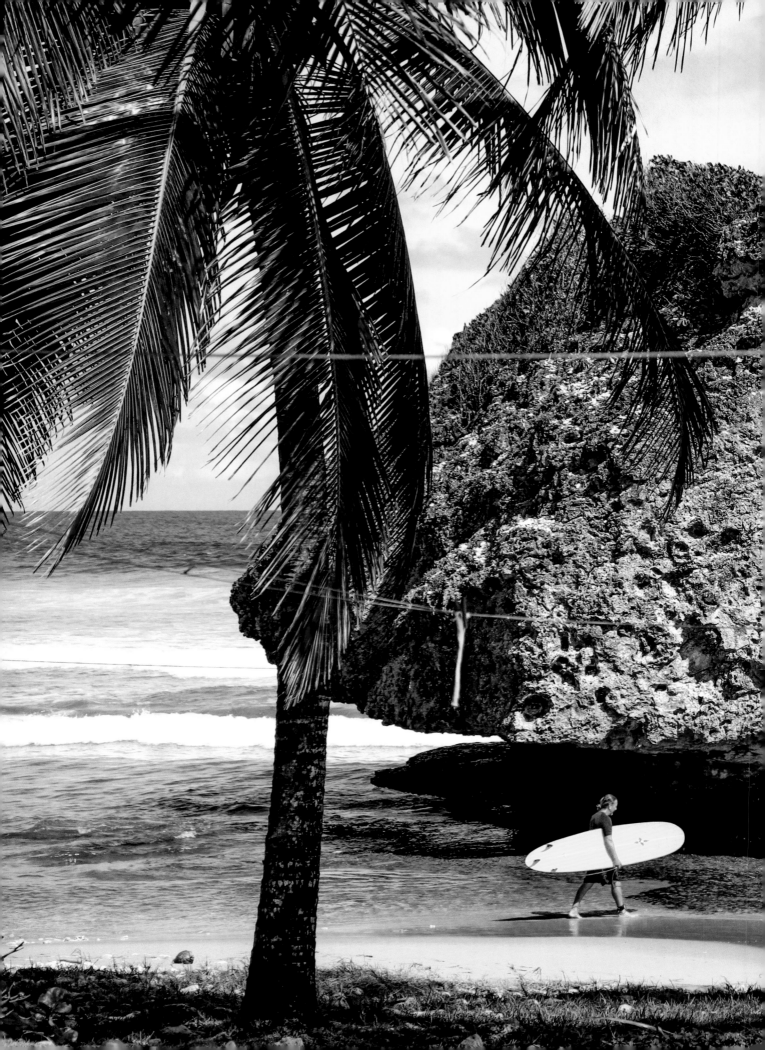

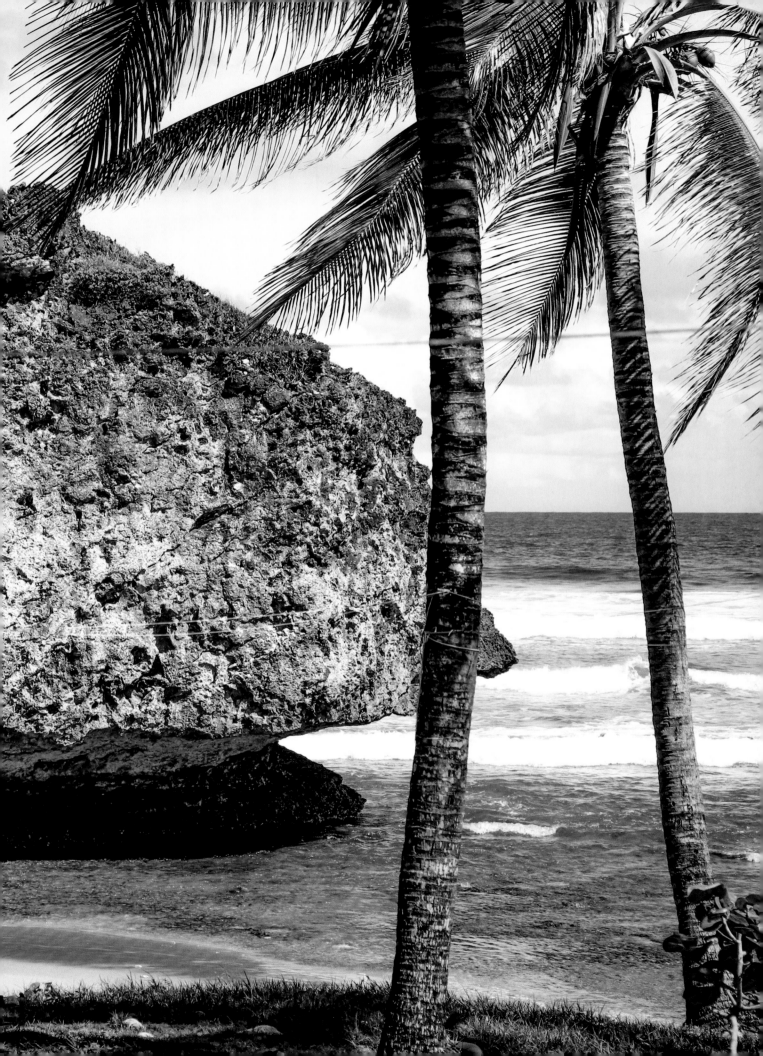

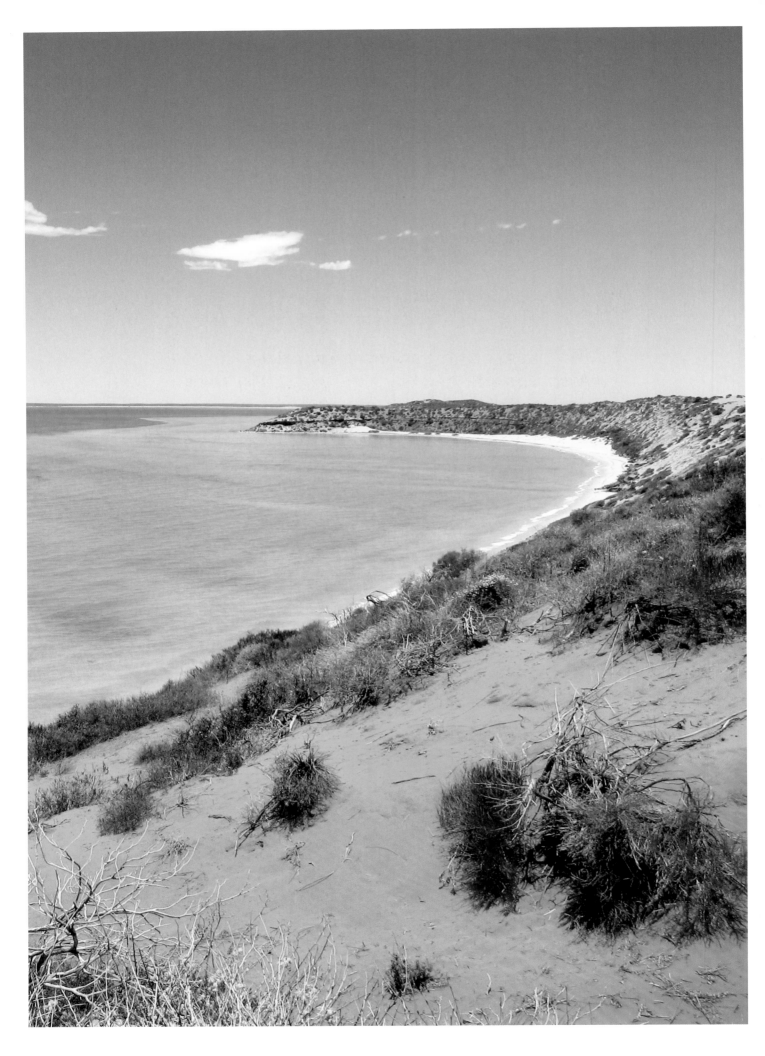

THE LONG WAY TO NINGALOO

It's easy to reach the great reef off Australia's west coast by plane, but hardier types make the 700-mile drive from Perth.

TEXT AND PHOTOGRAPHS BY ALEX HUTCHINSON
ADDITIONAL PHOTOGRAPHY BY ANDA KING

Previous Red dunes, white beach, and clear water at the tip of the Peron Peninsula.

Left Letting air out of a vehicle's tires to improve traction in the soft sand of Francois Peron National Park.

Opposite Shell Beach, in a cove off Shark Bay, is literally made of shells — millions of crushed ones.

At the end of a thin peninsula jutting into the ocean's void, a stunning tableau stretched out near the westernmost point in Australia. On either side, the coastline fell away in tricolor stripes: azure sky, red dune cliffs, blindingly white beach. The water was perfectly transparent, and from a cliff-edge platform we peered down into another world, a child's primer of aquatic life in the Indian Ocean. A pod of dolphins frolicked; huge manta rays cruised below the surface like undulating black shadows; dugongs and sea turtles drifted. Right below us, a cowtail stingray skimmed along. And everywhere you looked, patrolling the shoreline and lurking behind rocks were sharks, sharks, and more sharks.

I was halfway through an 11-day road trip up Australia's unsung west coast, with my wife, Lauren, and her parents. We'd flown to Perth, the only major city on that side of the continent, and rented a car. Our goal: Ningaloo Reef — the "other" great reef, a 160-mile-long stretch that hugs the coast starting about 700 miles north of Perth.

The reef that Ningaloo is "other" to is, of course, the one on Australia's east coast, the Great Barrier Reef. It is the world's largest living structure, although troubled in places now by the death of coral from warming ocean water. Because it has long been a major tourist destination, long stretches of the shore facing it are overdeveloped. The Great Barrier Reef's best spots are also a couple

of hours by boat from shore. Ningaloo promised the opposite: an empty coast and a reef within wading distance of hotels' beaches.

We had forgone the easy flight from Perth to the airstrip in Exmouth, near the heart of the Ningaloo, in favor of driving 700 miles up the coast, an alternative that had all the makings of an epic and quintessentially Aussie road trip. Within hours of leaving Perth, we were barreling along a straight, smooth highway, red desert to our right and coastline to our left, tweaking the steering wheel only to avoid the occasional flattened kangaroo.

We soon realized that this stretch of coast was much emptier than we'd expected; between the isolated dots on the map where we'd booked accommodations, there was almost nothing. In a series of near-empty national parks, we hiked along coastal cliffs and marveled at peculiar rock formations and deep river canyons cutting through the parched desert.

Then, three days into the trip, we reached the edges of Shark Bay, named in 1699 by the British privateer William Dampier. "Of the sharks we caught a great many," he noted in his journal, "which our men eat very savourily."

Our first stop in Shark Bay, now a Unesco World Heritage Site, was Shell Beach, where the high-wattage white "sand" is actually a 30-foot-thick layer of crushed

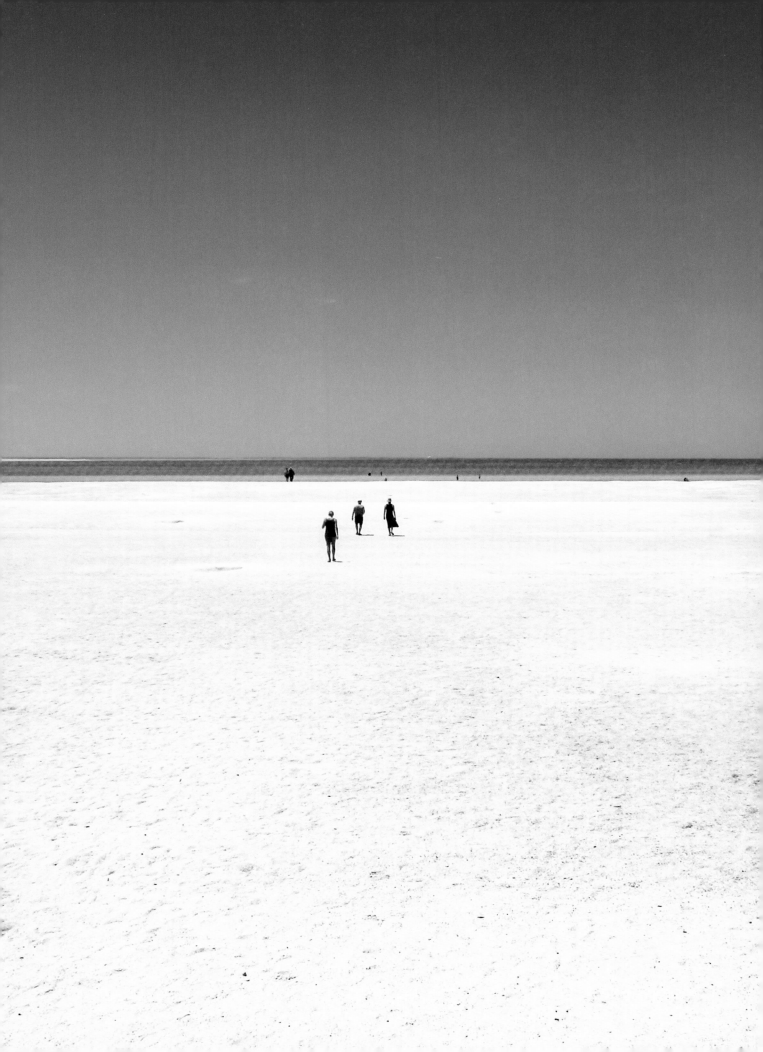

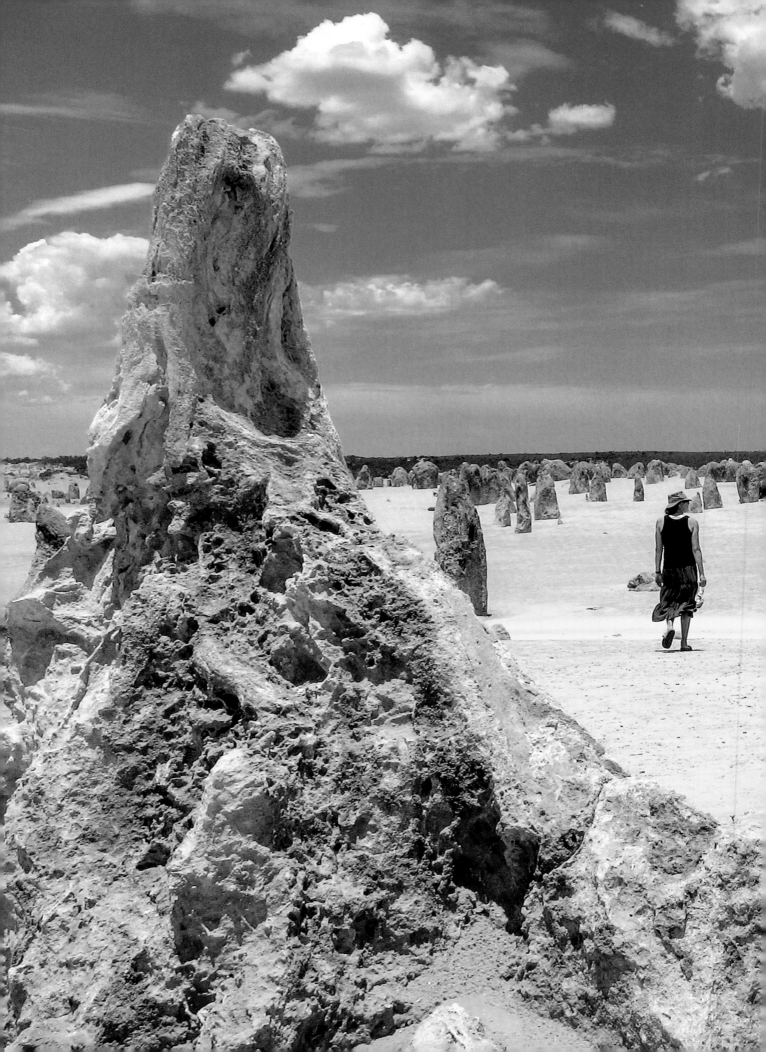

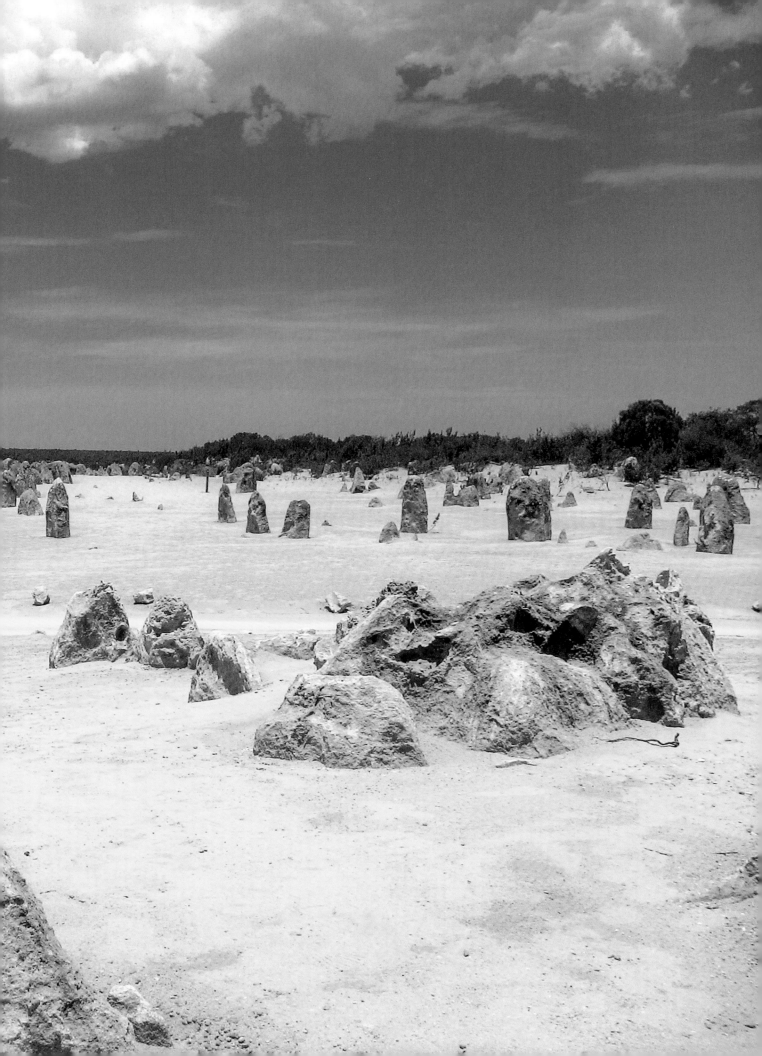

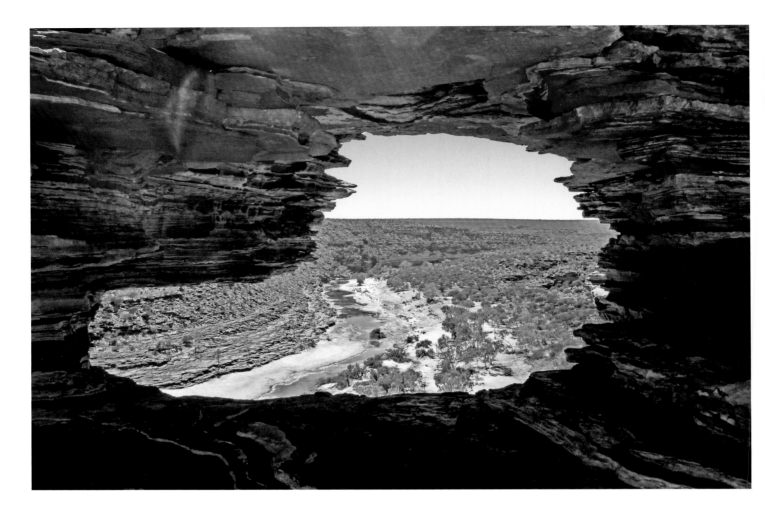

Previous The Pinnacles Desert in Nambung National Park, one of the surprising distractions from ocean views along the Western Australia coast.

Above Nature's Window in Kalbarri National Park, a vista point over the Murchison River gorge.

Opposite More of the astonishing landscape near Ningaloo: stromatolites, rocklike constructions of microbial life forms.

Following The view at the tip of the Peron Peninsula.

cockleshells. In the hyper-salty shallows, what looked like lumpy rocks turned out to be stromatolites, aggregations of bacterial organisms that are one of the oldest life forms on earth. The ones here were estimated to be "only" a few thousand years old.

Whale sharks, at up to 60 feet long the world's largest fish species, migrate along this stretch of coast between March and July. But Shark Bay's most reliable year-round tourist attraction is its friendly wild dolphins. On the beach at Monkey Mia, a ranger gave a talk while a dozen of them frolicked impatiently behind her. They swam up one at a time to take fish from a volunteer.

Later that morning, we took a catamaran tour of the bay, tacking back and forth amid manatee-like dugongs, brightly colored sea snakes, a loggerhead turtle, and a tiger shark. At one point, we looked down through the netting between the two hulls and saw dolphins speeding along with us, leaping and playing on the breaking edge of our wake.

Monkey Mia, by far the most popular tourist spot in Shark Bay, is on the Peron Peninsula, which shelters the inner waters of the bay. The upper half of the peninsula is protected as Francois Peron National Park. It was there that we walked through red sand to the end of the cliff, looked down at the ocean, teeming with sharks and rays and dolphins, and were overwhelmed.

The last leg of our northward push took us to Coral Bay, a minuscule outpost at the south end of the Ningaloo Reef with a hotel and a few campgrounds. En route, we screeched to a halt just long enough to gather a couple

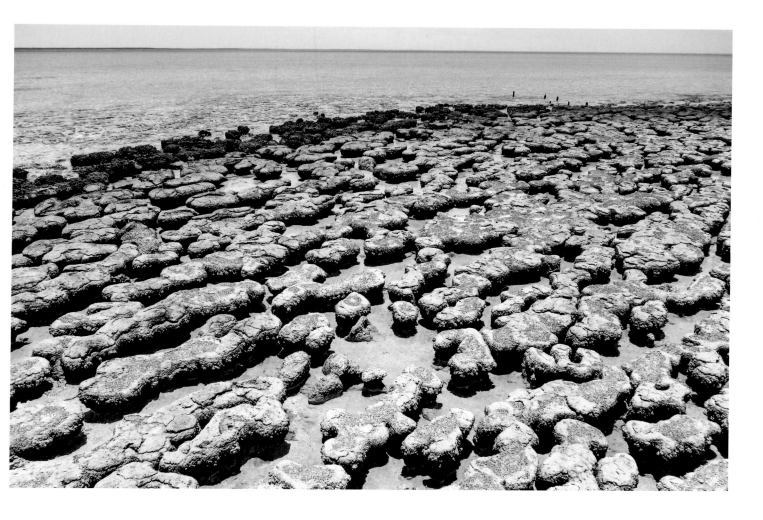

Explorer's Notebook: Kangaroos can weigh nearly 200 pounds and are clueless in traffic. Thousands lope onto roads and are hit every year. Some drivers bolt metal "roo bars" to their vehicles to deflect not only marsupials but also slow-moving eagles dining on kangaroo carcasses from earlier collisions. Sans roo bars, the best defense is to get off the road before nightfall.

dozen windfall mangoes lying along the side of the road. Their sweetness was so irresistible that we stopped in the same place three days later on the way back.

One choice here was a turbocharged Zodiac boat tour that whisks snorkelers to three prime spots. Lauren and I, looking for a more peaceful option, joined a kayak tour.

We paddled out through gentle surf for 25 minutes to reach a mooring point, then donned our snorkels and slipped into the bath-warm water. For the next hour or so, we followed our guide through a maze of staghorn and blue-tipped coral, swimming alongside a Technicolor array of tropical fish, rays, and sea turtles. We kept a nervous eye on the black-tip reef shark that circled us — totally harmless, we knew, but somehow still scary.

The next morning, we walked a few hundred yards up the beach, around a narrow point, and waded into the water on our own. I was still trying to avoid stepping on the rays that were burying themselves in the sand along the shoreline when we spotted a green sea turtle.

Farther into the water, we entered the coral jungle. As schools of tiny blue fish flitted around my head, and giant square-headed mahi-mahi drifted past without a glance in my direction, I soon had the sense that I was invisible. When I lifted my head, I saw empty water and unbroken coast, with no signs of civilization except, in the distance, the beach at the end of the dead-end road across from my hotel, where my book awaited alongside a bowl of fresh mangoes and a refrigerator full of cold beer.

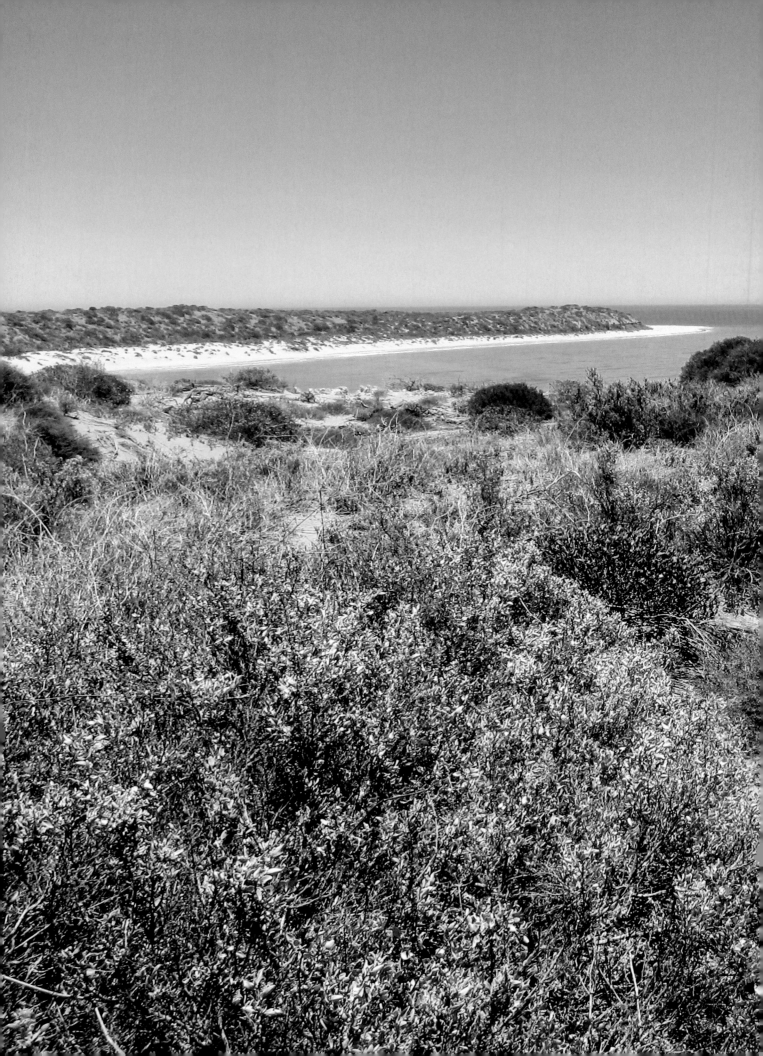

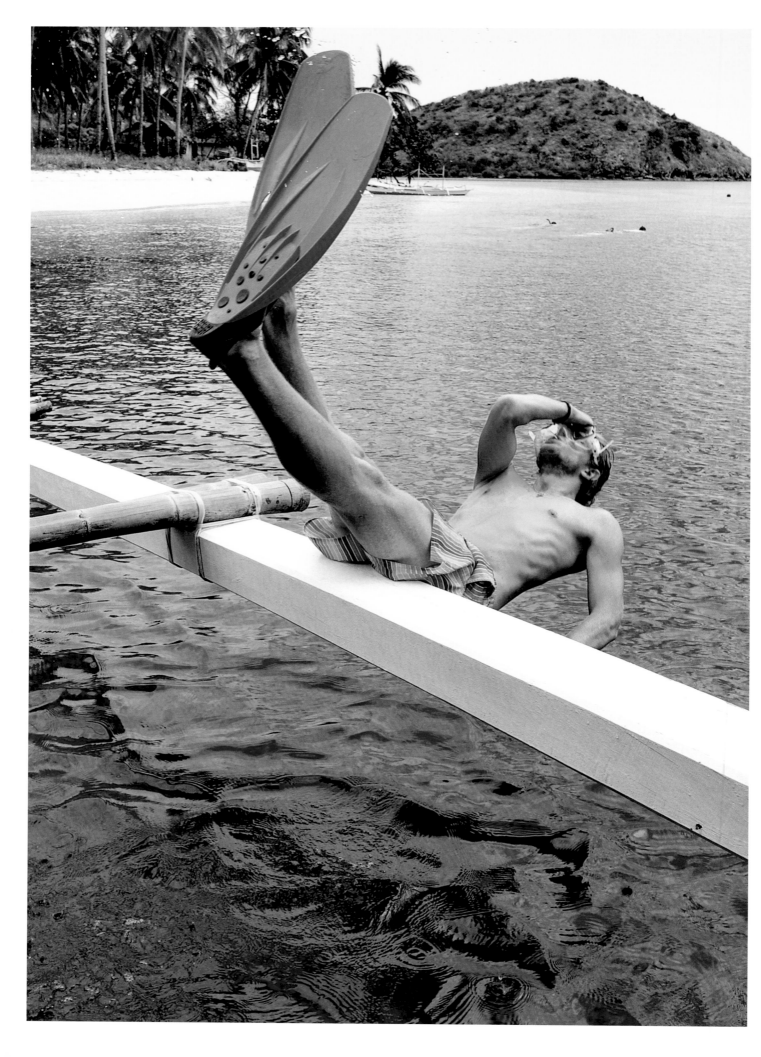

BEYOND THE HORIZON IN THE PHILIPPINES

*On an aimless trip in the middle
of nowhere, with azure sea on every side,
relaxation is never in short supply.*

TEXT BY DAN LEVIN
PHOTOGRAPHS BY JES AZNAR

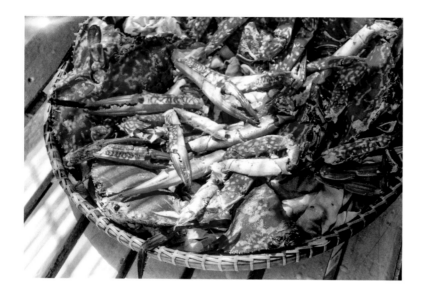

Previous Exiting the *Buhay* for a splash into the clear waters of northern Palawan.

Left Fresh crabs for lunch aboard the *Buhay*.

Opposite Beach volleyball during a stop on a quiet island.

We were floating gingerly over a forest of antler-shaped coral when I heard a Swede who was snorkeling with me shout. I popped my head above water and caught only a fragment of his declaration in the slosh of waves: "Monster in a hole!"

Pulling the mask from my eyes, I suddenly felt extremely exposed. We were snorkeling in the waters off Palawan Island in the Philippines, and the 82-foot blue-and-white boat that was our home for this five-day trip was too far away to provide a quick escape.

So I readjusted my snorkel, inhaled, and pumped down toward the reef. Some of the 19 adventurers on our sailing expedition were already there, peering into an orange coral bigger than an armchair. That meant the creature was not lethal. But it did look hungry. Half hidden in a crevice loomed a long, speckled predator, jaws agape. I kept my distance and made a mental note to teach my Scandinavian friend a new name: moray eel. But first, I needed to breathe.

Fortunately, relaxation was never in short supply on this trip aboard the *Buhay*, a bangka (the distinctive boat of the Philippines, resembling a large outrigger canoe with a roof on top) fitted out for basking tourists. We were in the middle of nowhere, paradise-style: a sea of high-definition azure stretching to the horizon, dotted only by distant uninhabited islands. After a few days of

sailing, life had become a lazy routine: eat, snorkel, chill out. Repeat.

Most tourists who land in the Philippines for some R-and-R head straight to well-known resorts like the island of Boracay, a tropical convenience store fully stocked with jet skis, pools, and hangovers. But I wanted a real getaway, not one that involved getting hammered on scorpion bowls. So I booked online with the bespoke sailing outfit Tao Philippines, which not only explored some of the most remote islands in Southeast Asia, but also offered me a total digital holiday: no email, no social media, no phone.

Tao was founded by Eddie Brock, a lanky Filipino, and his British buddy Jack Foottit, who met waiting tables in Scotland and then lit out for the islands of Palawan. Over the years, they discovered an authentic lonely planet of untrammeled islets and fishing villages and, so they could keep the adventure going, began taking those in the know along for the ride. They now have several bangkas.

The point of the trip, Brock said the night before we set out, was simple: "There is no plan." During our voyage from El Nido, in the north of Palawan island, to Coron, nearly 100 miles to the northeast, each day's course would be set by the winds and currents. Along the way we would land on islands so isolated that tourists rarely see them.

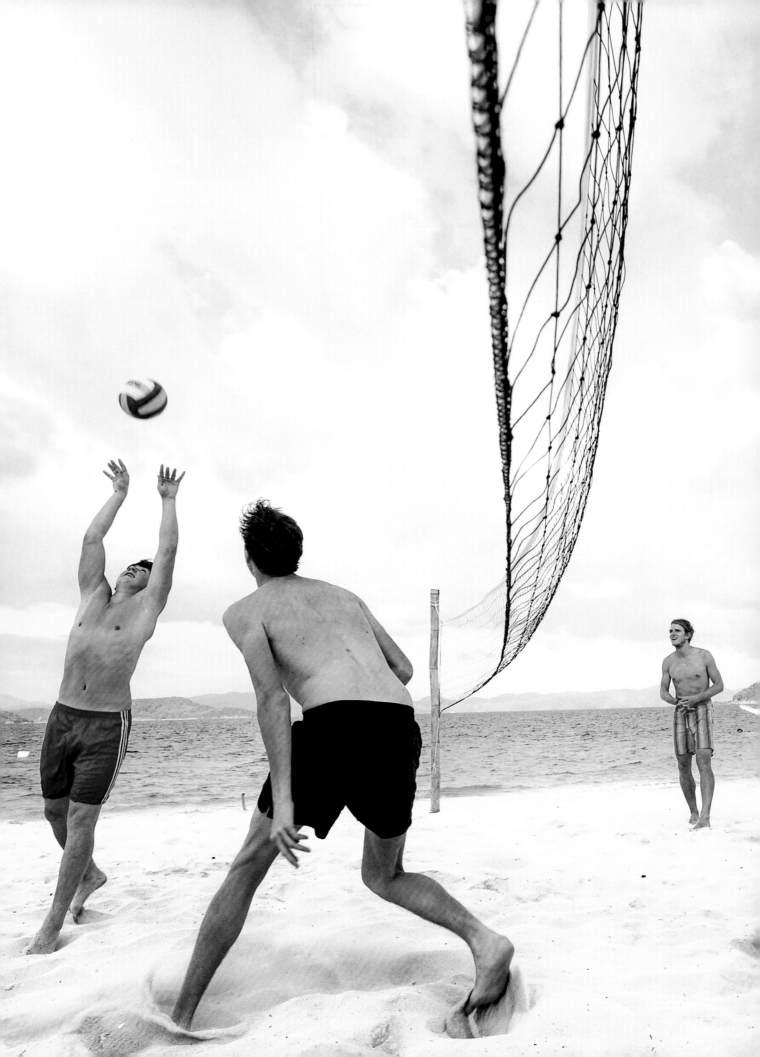

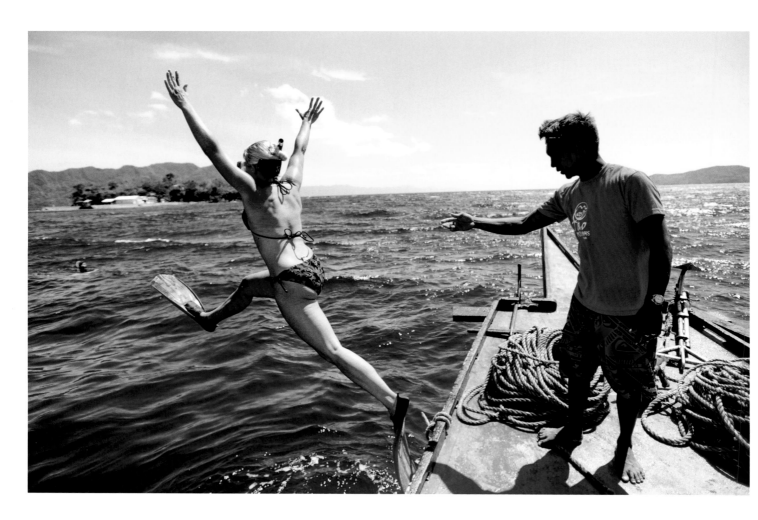

Above In flippers and bikini, a dive off the port bow.

Opposite Coffee service, with the *Buhay* in the background. The boat's locavore coffee came from a village near its base.

Following Snorkeling off a remote island, one of many dotting the warm, clear sea off northern Palawan.

That first morning aboard the *Buhay*, we ditched our flip-flops and tested our sea legs. The vessel was a typical bangka reimagined, with double open-air decks and two guitars. In the galley, our chef, Annie, was ready to whip up Filipino island gems like tuna adobo and coconut crab curry. My shipmates were mostly European, including two Belgian men trailed by comely Filipina companions. Each night we would sleep on a different island, sometimes sharing huts.

That afternoon we landed at Tao's base camp on the island of Cadlao. Fishermen once lived in the area but sold their land to Brock and Foottit a few years ago. Today, some of them work for Tao as sailors and cooks. Tao supports each village it works with throughout the islands, building schools and paying for teachers, an investment

that has won local loyalties. Our crew members were from this rural landscape, and they had taught our hosts how to shinny up a coconut tree and navigate by the stars.

Clambering aboard the *Buhay* the next morning, we felt like a tribe of our own. The sun was high and the air smelled of salt and sunscreen. Over the slap of wave on hull I could hear the strumming of guitar strings and laughter. We were lying belly-up on the prow when Nina Peck, a strawberry-blond Liverpudlian, asked what, at that moment, sounded like life's most important question: "Is it beer o'clock yet?" (It wasn't, so we resumed watching the clouds.)

When the *Buhay* stopped, Johan, our Filipino expedition leader, announced that just beneath the waves, a World

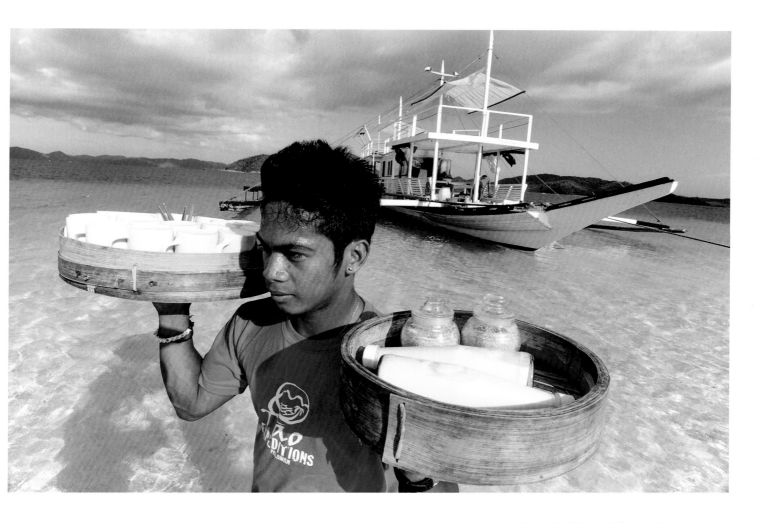

Explorer's Notebook: From a boat at night in the Philippines you may glimpse the lights of bangkas guarding submerged oysters. Rising sea temperatures and overfishing have left many local fishermen without a secure livelihood. Pearl farms provide some employment.

War II-era shipwreck sat waiting to be explored. We raced to snag snorkels, leapt overboard, and found a vessel upholstered in coral. Clown fish darted toward our masks from anemones that clung to the rusted hull. It was a submerged playground, complete with portholes big enough to swim through.

Suddenly Nina grabbed my arm and pointed toward the sea floor. There, a cuttlefish was frozen in panic, rapidly flashing green, motley, and fluorescent beige like a chameleon on speed.

Tao supports a small rural economy that spans the Philippine archipelago. Our morning coffee came from Brock's village up north, while dinners were strictly locavore. When we stopped on one island, a large boar was roasting on a spit. We feasted and then relaxed by the beach until late, mangling the words to Tracy Chapman's "Fast Car" and Red Hot Chili Peppers songs.

Another evening, on another beach, the lyrics were provided. After sunset and prawns, we assembled in a hut around the reason for the village's generator: a karaoke machine. English was not the mother tongue of all of my shipmates, but they made up for any mistakes with their fluency in American-Brit pop. We sang Oasis's "Wonderwall" and danced the Macarena.

Taking a breather, I crept barefoot off to the beach, empty save for the ghost crabs that hovered by their burrows, watching me with googly eyes. The tide was a sigh, the sky aglow with constellations, and I was, thrillingly, the only witness.

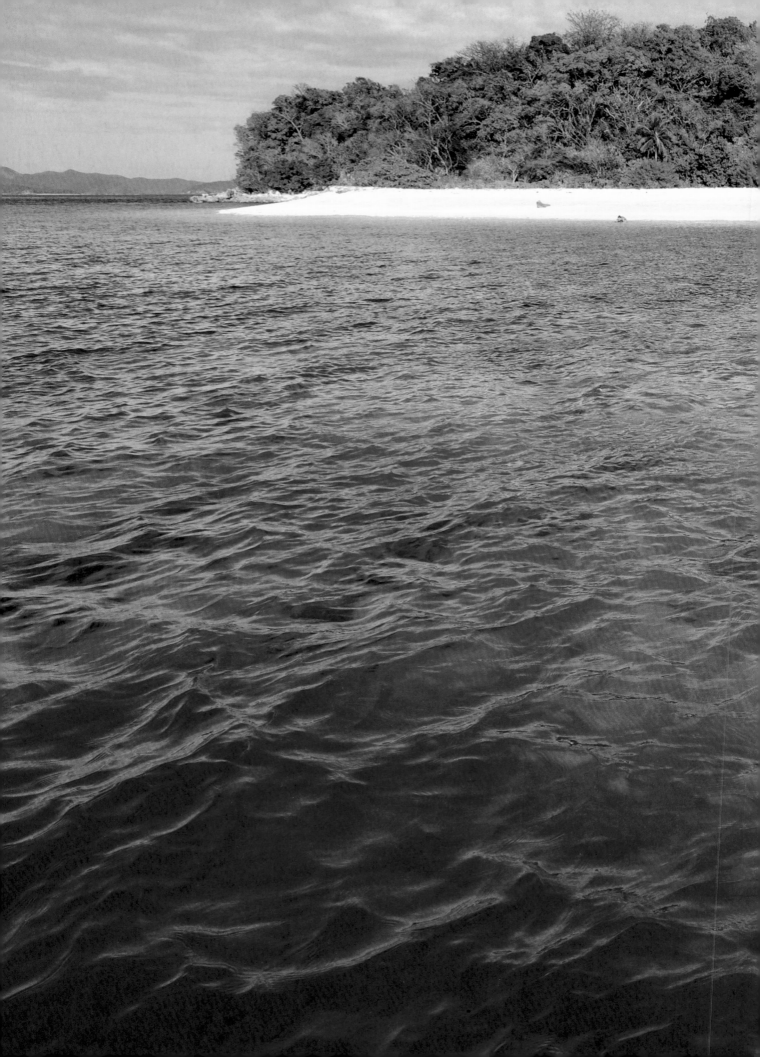

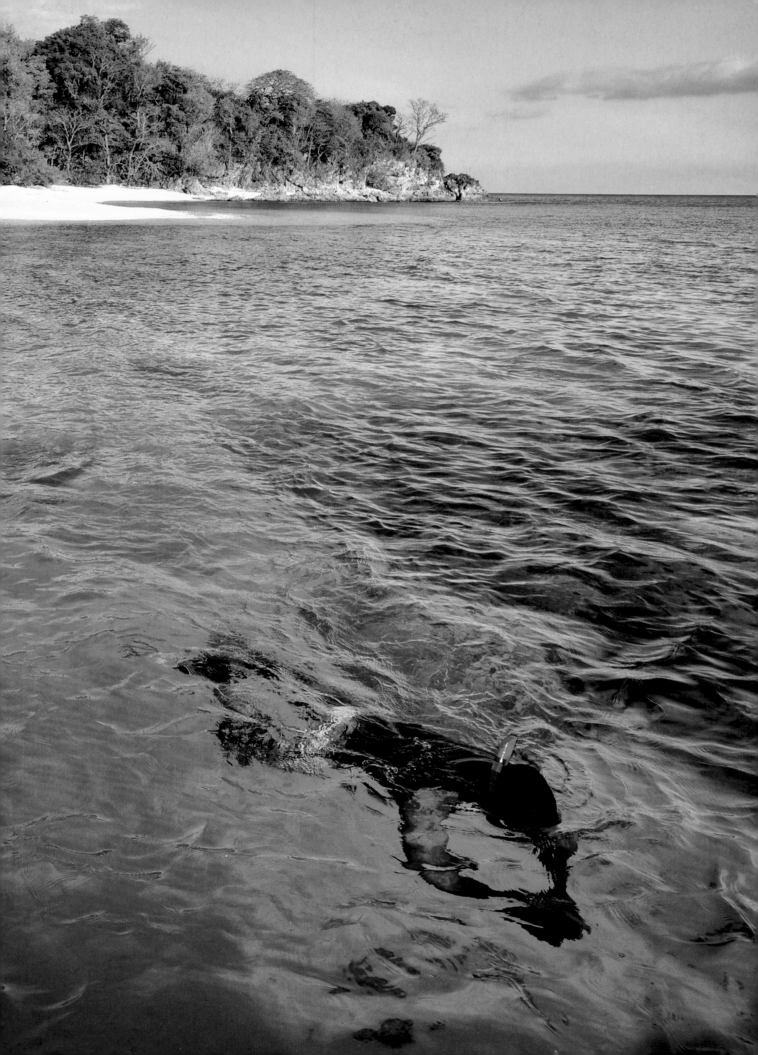

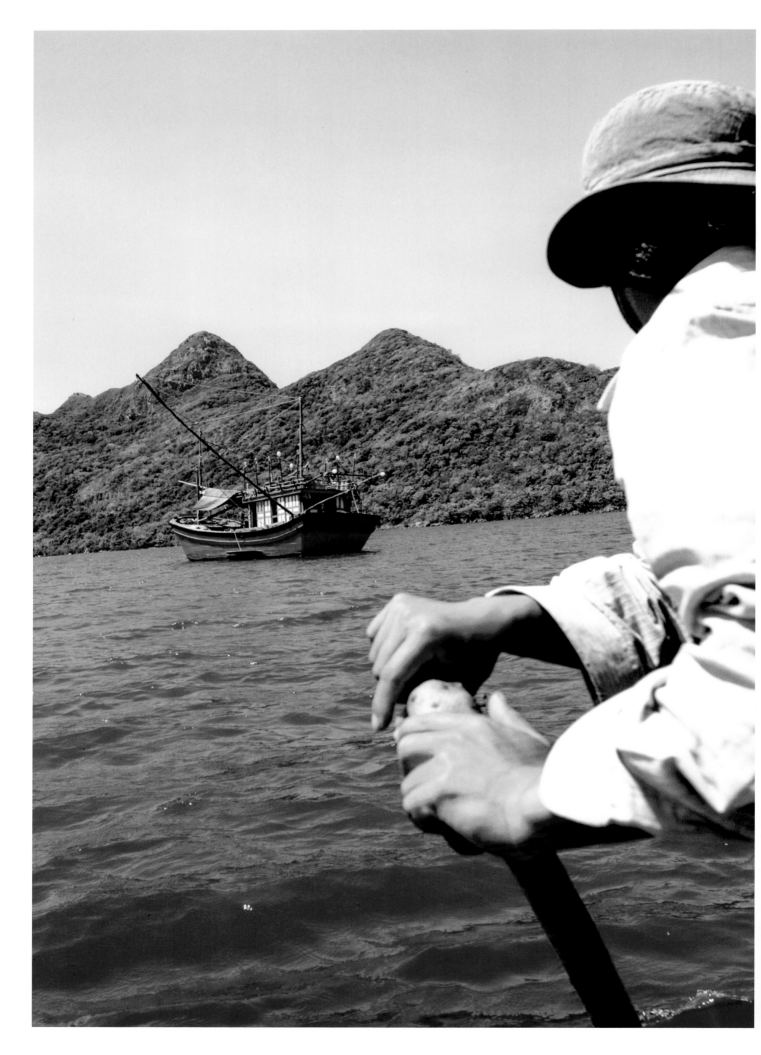

OUT AT SEA, AN UNSPOILED VIETNAM

Its isolation once made the Con Dao archipelago a prison. Now it gives vacationers a breathtaking escape.

TEXT BY NAOMI LINDT
PHOTOGRAPHS BY KEVIN GERMAN

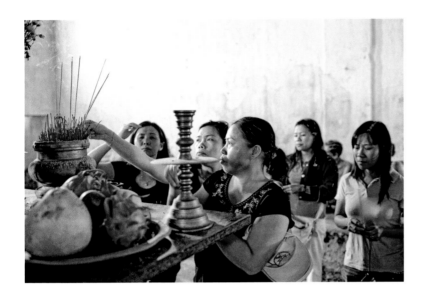

Previous A fisherman rows his small boat near Tre Lon, one of the 16 mountainous islands and islets that make up the Con Dao archipelago.

Left Burning incense in memory of those who died at a notorious colonial-era prison on Con Son Island.

Opposite Biking in a national forest. Of the archipelago's total area, 83 percent is protected by the Con Dao National Park, including a 50-square-mile marine reserve.

As the sun's last rays streaked the sky bubble-gum pink and tangerine, the residents of Con Dao Island were calling it a day, and the mile-and-a-half-long beachfront promenade that serves as this small Vietnamese island's social hub was filling up as the heat of the day finally relented.

Teenage boys pulled up on Honda scooters, kicking off their shoes and rolling up their jeans to play soccer on the white sand; young mothers led small charges by the hand into the gently lapping aquamarine water; an elderly woman, her teeth lacquered black in the style of her ancestors, watched a group of children fly colorful animal-shaped kites on a pier that was built in 1873.

If not for the Communist slogans being piped out of the town's loudspeakers, it would have been hard to believe this was Vietnam. Where were the motorbikes, the honking horns, the shiny high-rises, and the constant activity that has come to characterize this rapidly developing country?

Until recently, the isolated 16-island archipelago of Con Dao (its largest island, Con Son, is commonly called Con Dao Island), 110 miles off the mainland's southeastern coast, was a place most Vietnamese wanted to forget. For 113 years, this island was home to one of the country's harshest prison systems, established by French colonists in 1862 and later ruled by South Vietnamese and American forces until Saigon fell to the North Vietnamese in 1975, at which point the prisons were closed.

These days, officials on government-sponsored group tours make pilgrimages to the crumbling stone prisons, which have been turned into museums that depict the suffering endured by their comrades. Some Vietnamese visitors are former Viet Cong who were once imprisoned there themselves and are now invited to enjoy the beauty of the island — a starkly different experience from their earlier ones there.

Outside the prisons, other buildings constructed by the French have been converted into cafes and private homes in the main town, where the business sector consists of little more than a daily market, a few seafood restaurants, and some souvenir shops selling items like shells, carved wooden canes, and Ho Chi Minh paraphernalia. Quiet streets are lined with flame-trees and bougainvillea. The few signs are likely to deliver messages such as "With the Party comes peace, comfort, and happiness."

Despite, or perhaps because of, its ugly history, Con Dao is one of Southeast Asia's most untouched and breathtaking getaways. Its past, coupled with its remoteness, have spared it from the million-plus hordes that descend on coastal boomtowns like Nha Trang and Danang every year. Limited numbers of high-end tourists have arrived, however, since the opening of Six Senses Con Dao, part of a chain of small, exclusive resorts. Based in Bangkok, Six Senses is known for introducing

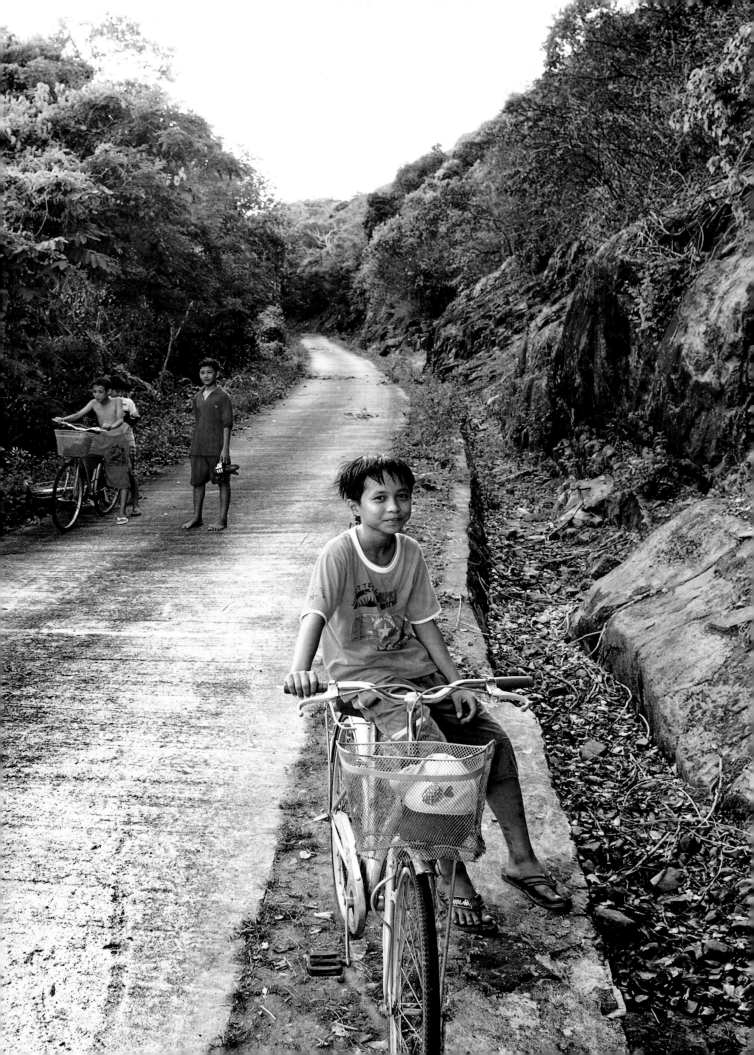

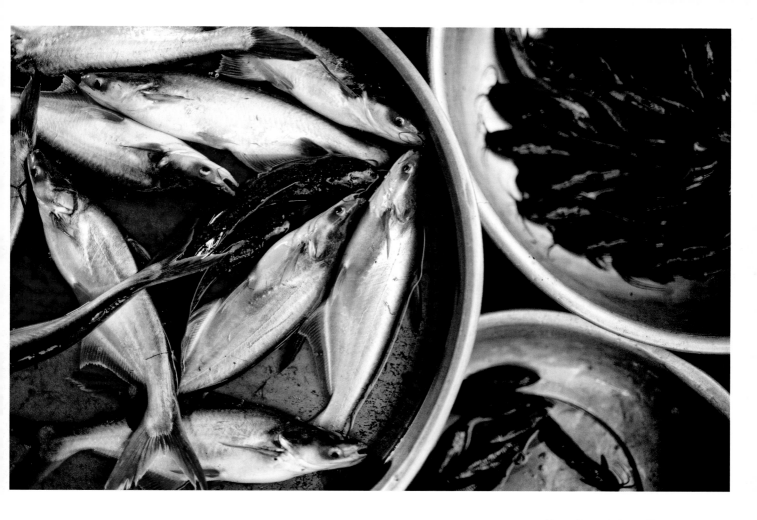

Opposite and above Clams and fish from local waters at a market on Con Son Island, known commonly as Con Dao Island.

Below Calamari meets the fire at the Orchid Restaurant on Con Son Island.

Above Phu Binh Camp, part of the Con Dao prison system, where many political prisoners were tortured.

Opposite Floral memorials to prisoners who died on Con Son.

Following The prettiest beach on Con Son Island, the boulder-peppered Bai Nhat, fully emerges only at low tide.

eco-luxury to Southeast Asia's most unspoiled up-and-coming locales.

The Con Dao archipelago's beaches remain mostly empty and immaculate. The azure waters are brimming with Vietnam's best coral reefs, and the forests bustle with macaque monkeys and black squirrels, one of several species indigenous to Con Dao.

Efforts to preserve Con Dao's natural beauty are unrivaled in the rest of Vietnam. Of the archipelago's total area, 83 percent is protected by the Con Dao National Park, including over 50 square miles that make up the country's first marine reserve.

With help from organizations like the World Wildlife Fund and the United Nations Development Program, the park won approval for a $16.5 million development

plan through 2020, which will finance natural resource protection, research, and eco-tourism.

Though the population increased as tourism took off, Con Dao's slow, friendly rhythms and spectacular beauty are still there to be found.

On one visit, aside from a film crew shooting a season of *Koh-Lanta*, the French adaptation of *Survivor*, I saw relatively few foreign tourists. One of them was Fred Burke, a managing partner of Baker & McKenzie, an international law firm with offices in Ho Chi Minh City and Hanoi.

"This feels like some sort of secret Tahiti," he said, referring to the lush, rolling hills and sharp cliffs that abut the sea. "Most of the popular seaside destinations in Vietnam are being degraded with trash on the beach, inadequate waste-water treatment, noisy motorbikes, and

Explorer's Notebook: The prison ruins at Con Dao include vestiges of the "tiger cages" where political prisoners were kept in tiny, claustrophobic spaces. The discovery of their existence by American civilians during the Vietnam War helped to feed opposition to the war, and they became a symbol of cruelty and repression.

jet skis. It's a complete surprise to find an amazingly beautiful place like Con Dao with almost nobody here."

Though English is not widely spoken and most places cater to Vietnamese tour groups, independent travelers can still partake of the islands' treasures. The Con Dao National Park arranges guided treks through dense tropical jungle and to remote beaches like Dam Tre Bay, a deep, sheltered cove that is home to golden fields of swaying seaweed and giant clams with electric blue lips. There are also snorkeling trips to Bay Canh islet, where fine sand lures endangered hawksbill and green sea turtles during the May to September nesting season.

But cruising the winding cliffside roads on a rented scooter might be the most memorable way to experience Con Dao, where often the only traffic is the occasional black-haired goat or wild pig. Hidden down a sandy track marked "Mieu Cau," about eight miles northeast of town, is Dam Trau Beach, a crescent-shaped expanse of golden sand and sapphire water fringed by feathery casuarinas, the peace disrupted only by the arrival of flights from Ho Chi Minh City.

Head west to encounter rolling dunes and Con Dao's main port, Ben Dam, where spearmint-green, sun-beaten fishing boats bob in the turquoise water. The island's prettiest beach, the boulder-peppered Bai Nhat, emerges only with the low tide. If you're lucky, that will happen in late afternoon when the sun drops behind the 1,000-foot-high Love Peak, so called because it looks like two heads nestled together.

Chances are you'll have the beach to yourself.

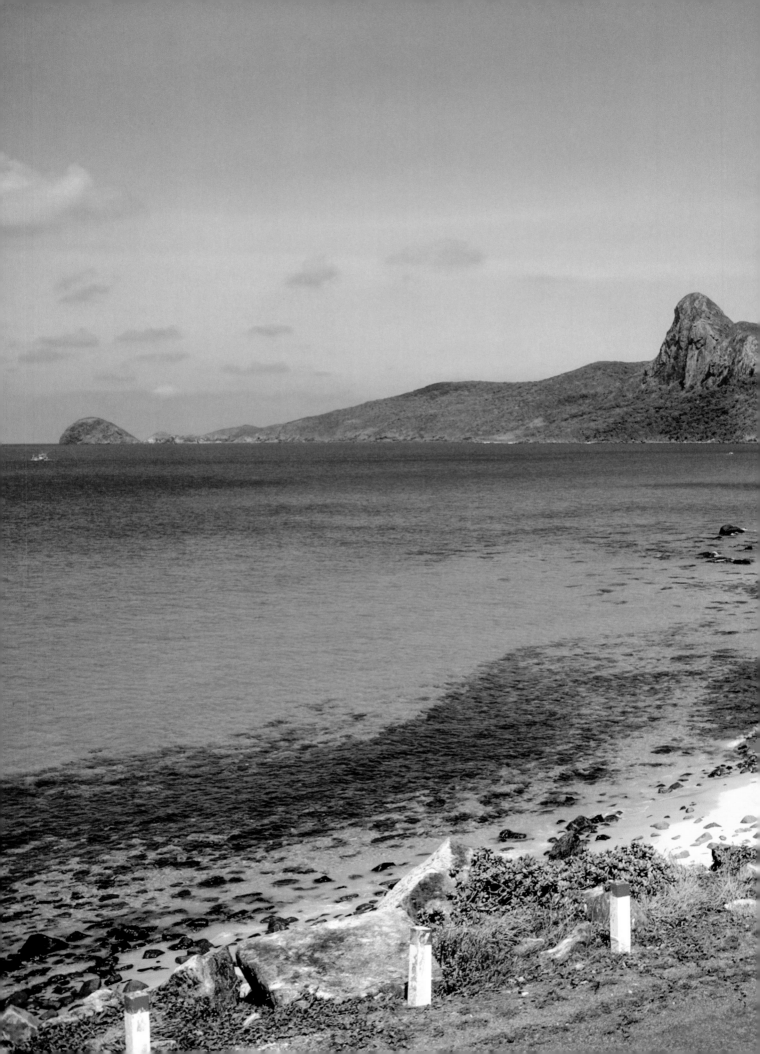

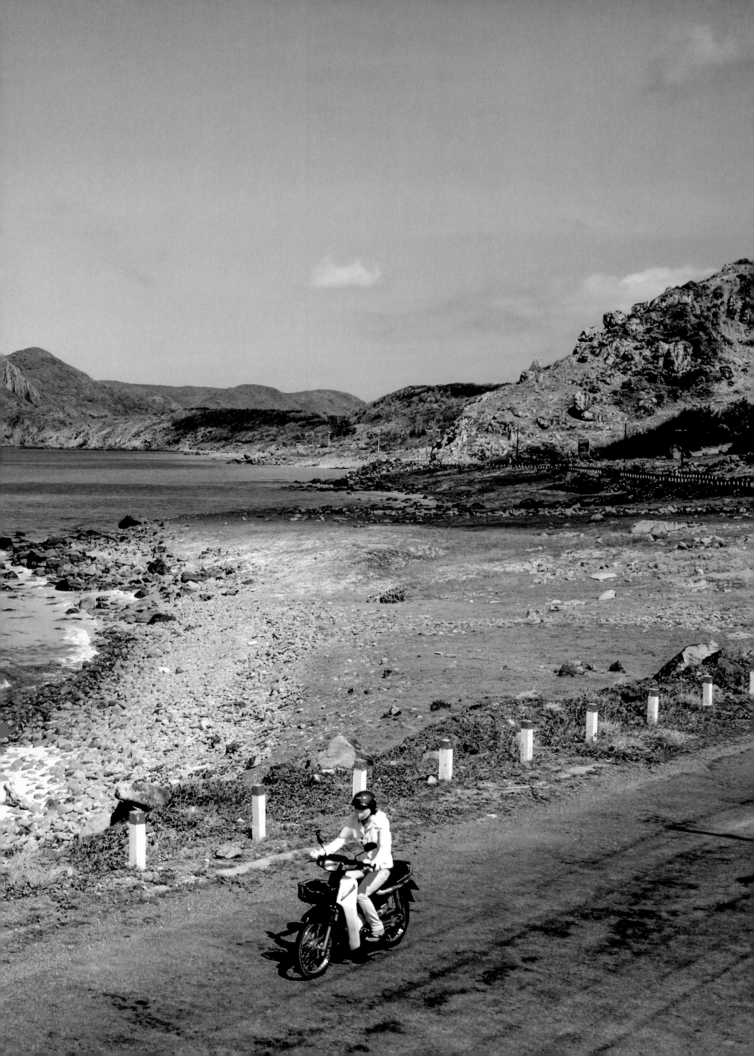

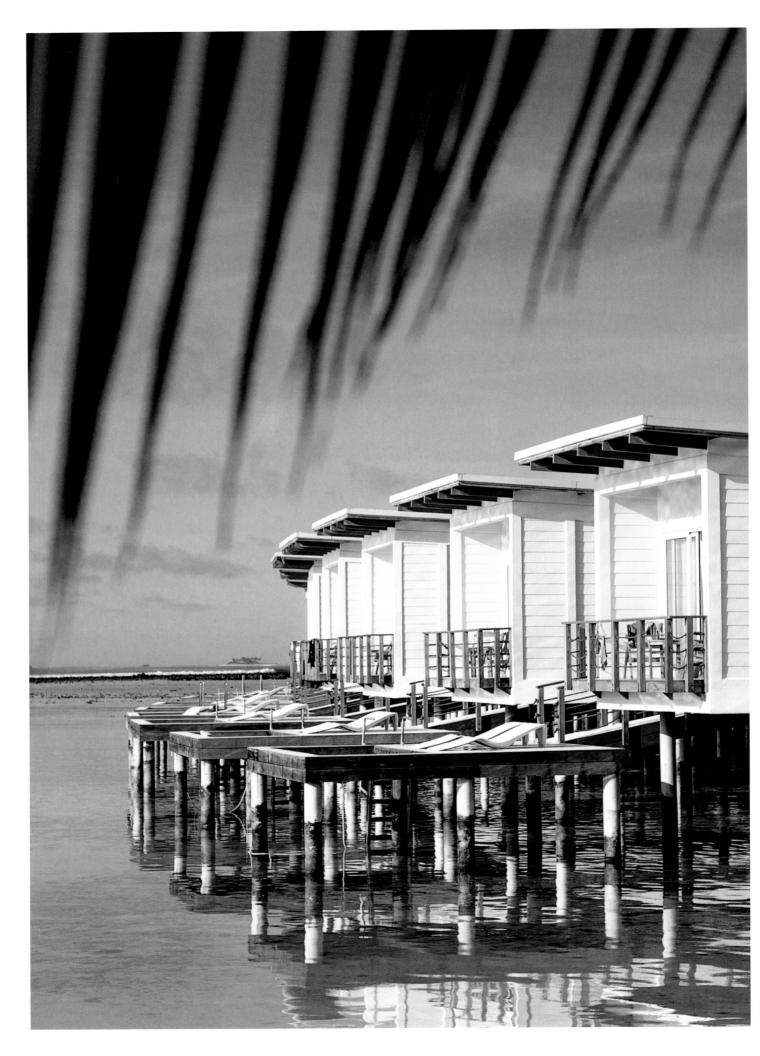

THE TWO WORLDS OF THE MALDIVES

*Politics on this equatorial archipelago
can be repressive, but for tourists it is a paradise
of white sand and rose petals.*

TEXT BY ALAN FEUER
PHOTOGRAPHS BY JES AZNAR

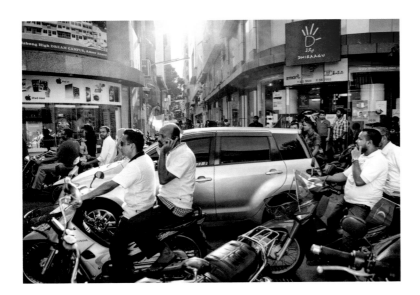

Previous An over-the-water villa hotel in Kandooma Fushi, Maldives.

Left and opposite While most tourists stay secluded at plush resorts, the everyday life of the local population goes on close by. Vehicles ply the narrow streets of Malé, and boats take local passengers from island to island.

The Maldives, a natural necklace of more than 1,000 coral islands off the western coast of India in the Laccadive Sea, is mostly known as a glamorous vacation destination, the sort of spot where supermodels and their soon-to-be ex-boyfriends go for beach-and-bungalow retreats. Its reputation is both hedonistic and decidedly high-end. The Duke and Duchess of Cambridge have gone on holiday there, taking a seaplane to a five-star resort on the remote atoll of Noonu. The two-bedroom villa where they stayed — thatched roof, sun deck — stands on stilts above the water with a 40-foot infinity pool and unhindered ocean views.

But the Maldives, unlike Bermuda or St. Barts, is more complex than many getaways for European tourists. After the establishment of an Islamic government, Maldivian citizens, who are mainly Sunni Muslims, were barred from practicing religions other than Islam; Shariah law was adopted; and pork and alcohol were widely banned except, of course, at the resort hotels that cater to foreign travelers. Dissent has been discouraged, sometimes harshly.

The majority of Maldives tourists arrive at the airport and are shepherded by uniformed employees of the Hyatt or the Sheraton to nearby jetties where speedboats whisk them off to resort islands. Perhaps it's in the nature of an escapist beach vacation to escape: to ignore the local culture and, in essence, face the sea with your back to the land. There's no doubt that over the course of six

days, spent at three resorts, my girlfriend, Cheyne, and I escaped into extravagant indulgences, whether that meant massages in an underwater spa or a swim with stingrays in a coral reef. But the atmosphere of decadence, while certainly engrossing, was not hermetically sealed. It was possible to let real life — or real life for Maldivians — occasionally intrude on the reverie.

We spent one day resting in Malé, the capital, where motorbikes swarm and local boys play at a beach while black-clad women walk in the sand. The next day we were on a speedboat to the elegant Per Aquum resort on Huvafen Fushi island, a private sandbar in the North Malé Atoll. After handing us our life jackets, an attendant proudly told us that in Dhivehi, the Maldives' native language, Huvafen Fushi meant Dream Island.

As befit the island's name, we were greeted at Huvafen Fushi's dock by a beaming team of staff members and offers of sweet, gingery drinks. We were briefed on the available entertainments: restaurants, snorkeling reef, glass-walled gym overlooking the sea. Though it was only noon, the heat was already at perspiration levels, but that was quickly remedied by the polo-shirted man who appeared beside us holding out a tray with more damp towels. As we cooled ourselves and moved toward the golf cart that would take us on a tour, freshly cut rose petals were strewn beneath our feet.

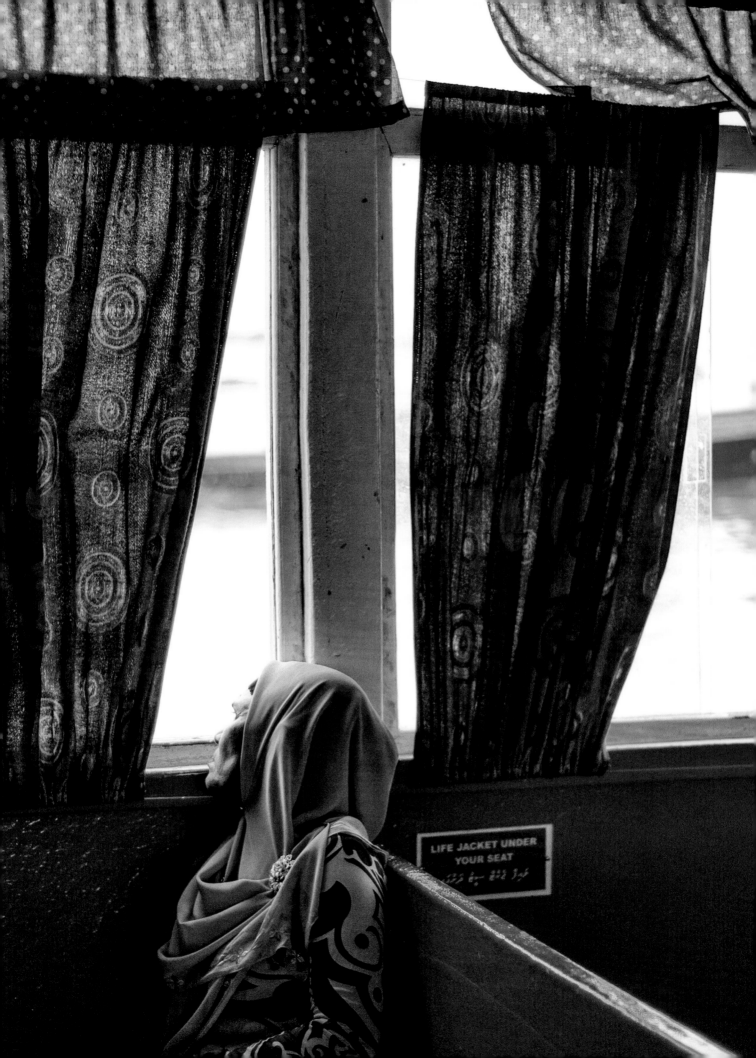

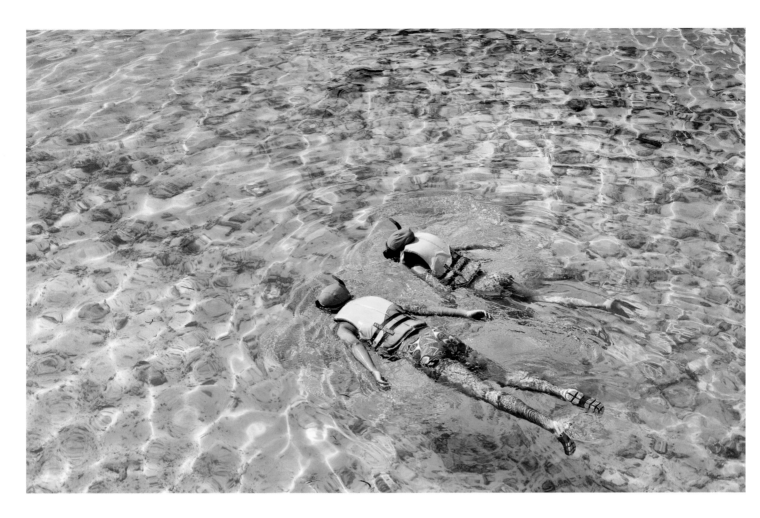

Above Snorkelers in
clear turquoise water at
Kandooma Fushi.

Opposite Laying out a picnic
on South Malé Atoll.

Following Strolling a beach in
the Maldives.

Hufaven Fushi is a lush green refuge from the world where dirt roads cut through mangrove breaks and weathered boardwalks wander over shallows, connecting a village of native huts on stilts, each designed in faux primitive style. The resort, which prides itself on privacy, has only 44 rooms.

"What we offer is escape, a dream of luxury and remoteness," Marc Gussing, the manager, told us over dinner. "We're only four hours from Singapore and Dubai, but we give the impression of being far away."

I asked Gussing if it was difficult to operate a luxury resort in a country where Islamic law is exactingly enforced. Huvafen Fushi claims, for instance, to have the largest wine cellar in the Indian Ocean, a climate-controlled chamber boasting bottles of Romanée-Conti that sell for

nearly $30,000. Were there, I inquired, ever any troubles with the government? "If I can fill a 6,000-bottle wine cellar on a sandbar, you can't really say that the government is not accommodating," he told me with a smile.

The tourist business in the Maldives includes more than 100 resorts, 30 or so of which define themselves as deluxe and offer amenities like lime-and-ginger salt scrubs and private starlight dinners on the beach. Four or five additional resorts are going up each year. The clientele is mainly European — British and Italian — though the number of Chinese visitors is on the rise. The Maldivian economy, formerly based on fishing, would probably not exist without the tourist trade, which, according to official statistics for 2013, provided the government with almost half of its revenues.

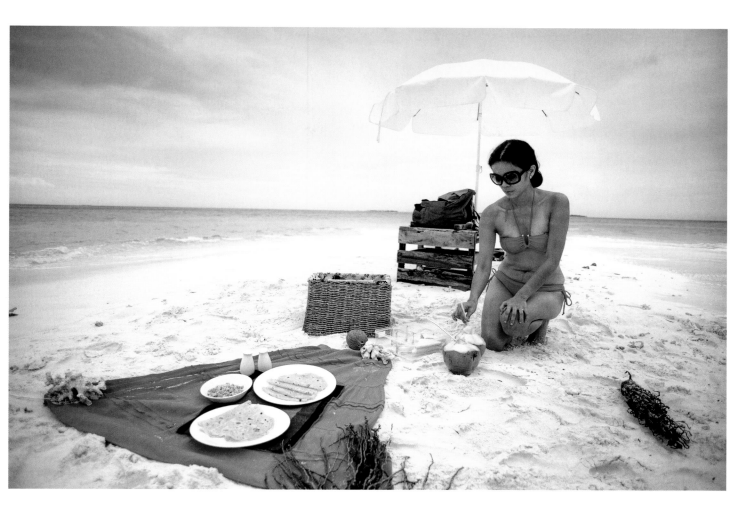

Explorer's Notebook: The Maldives is dangerously vulnerable to the rising sea levels and aberrant weather that are a result of global warming. Because the average elevation on its more than 1,000 islands is about five feet and there are no hills, it is likely that the sea will eventually overtake the entire nation.

We found more luxury at the Naladhu resort on the South Malé Atoll, and then at the Holiday Inn on Kandooma Fushi island.

We swam on our own along empty beaches; there were carefree walks alone beneath the palm fronds. Still, by the end of the visit, I felt I needed to explore what the Maldives had to offer beyond the pampered bubble of resorts, and so one afternoon I arranged a trip to the undeveloped island of Guraidhoo.

Guraidhoo, with its unpaved streets and leashless dogs, is home to about 2,000 ordinary Maldivians — most of whom, it seemed, were on the beach in hammocks on the day that I arrived.

My guide, Imran Janeen, was pleased to show me Guraidhoo's hospital and its dilapidated shipbuilding yard where 20 shirtless men were toiling on huge wooden yachts. He told me that there were three mosques on the island, which is only 40 acres. There were also seven guesthouses, eight or nine restaurants (depending on the season), and 50 souvenir shops.

After I was led into what seemed like a dozen of these shops, Imran and I stopped into a small restaurant. It was early afternoon. Crickets were chirping, a salty breeze was blowing through the windows from the street. A waiter came by to take our order and, with a furtive glance at the bar, offered me a drink. I followed his eyes across the room and there, among the bottles of tea and orange soda, was a row of Kingfisher beers.

I didn't get one, and Imran, who could not partake, seemed pleased.

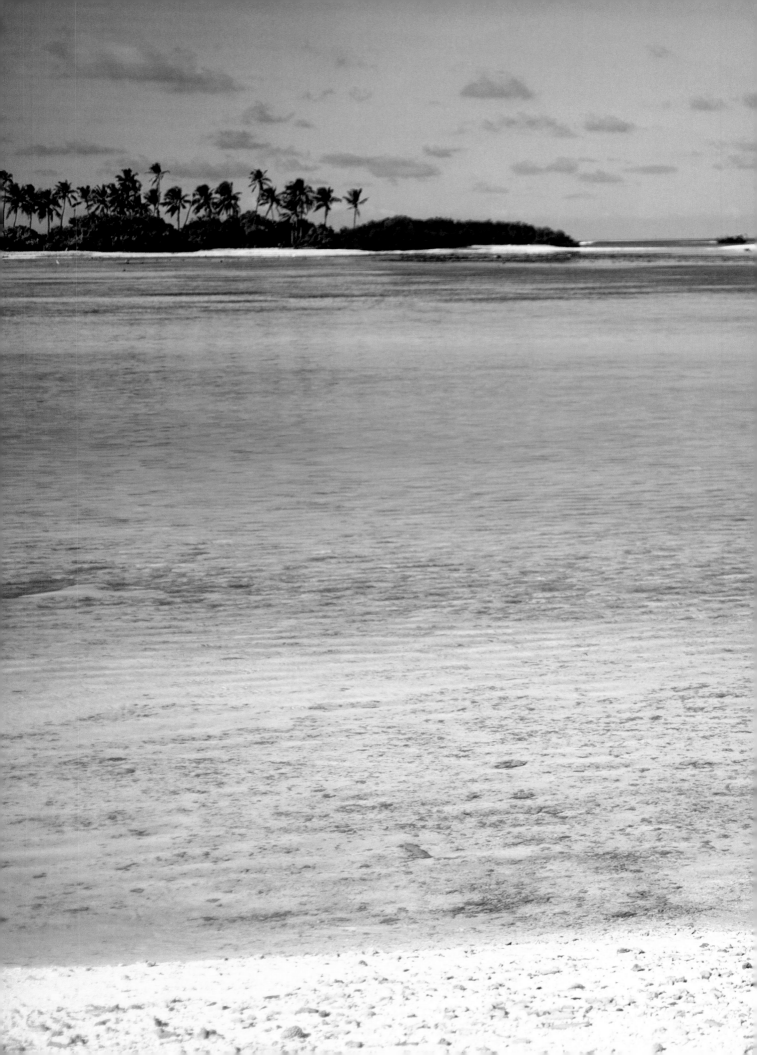

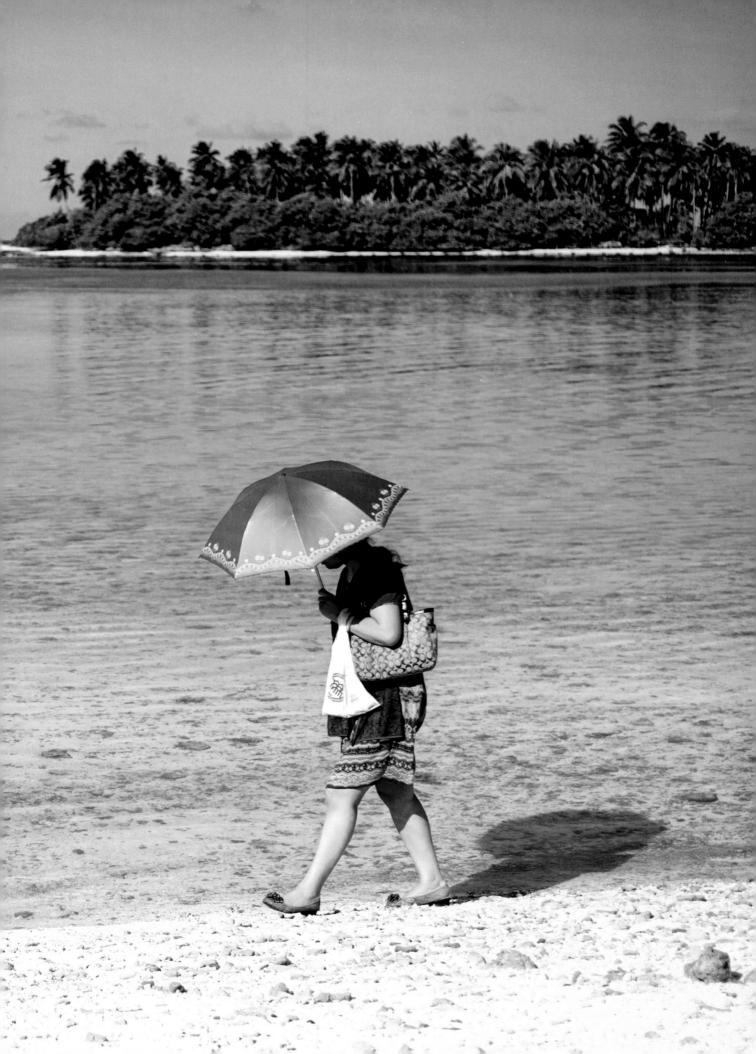

PEARL IN
THE INDIAN OCEAN

*Long a favorite of the global elite,
Mauritius also beckons travelers who
aren't part of the jet set.*

TEXT BY SETH SHERWOOD
PHOTOGRAPHS BY BÉNÉDICTE KURZEN

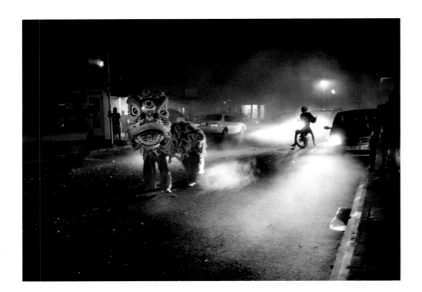

Previous A view in motion from the road to the Bois Chéri tea plantation.

Left A dragon in a belated Chinese New Year celebration in Grand Baie. Mauritius's three main ethnicities, among many, are Creole, Indian, and Chinese.

Opposite Shoppers move through aisles between colorful displays at the covered market in Port Louis.

Somewhere near the Tropic of Capricorn, a gust of warm wind blew down on the old French colonial town of Mahébourg, rushing across strange jagged brown hills and lightly rustling green fields of sugarcane. It carried the smell of damp vegetation — a result of a typical morning sun shower — as it rippled offshore and gently undulated the translucent curaçao waters of the Indian Ocean around our slow-chugging motorboat.

My scuba instructor, an affable 25-year-old Mauritian named Hans Nobin, cut the engine. Nearby, glass-bottom boats were dispensing groups of sun-bronzed European travelers in snorkeling gear. Like us, they were here to explore the stunning coral reefs that ring the island. Along the shoreline, families in bright swimsuits lay splayed on the white powdery sands of Blue Bay beach.

Safely anchored, we fell backward into the sea. The shimmering quicksilver surface of the water splashed and receded above us, and we descended into an unearthly silence. Hans guided me over expanses of jagged white branching coral and waving ropelike anemones. Then he produced a chunk of French baguette, and small fish in bright hues appeared from every direction to nip from it. All around us, black and white dominoes, thin yellow pavillons, and red-silver maldacques formed a polychromatic shifting cloud. Sunlight filtered through the clear aquamarine water.

Mauritius, long called the Pearl of the Indian Ocean, has for decades been one of the planet's most elite island getaways. Prince William of Britain, Princess Stephanie of Monaco, J. K. Rowling, and Robert De Niro have all been spotted there, vacationing at its ultraluxurious resorts. In recent years, stylish but much more affordable hotels, along with an increase in flights, have also opened Mauritius to travelers who don't have to dodge the paparazzi.

I began my explorations in Grand Baie, a lively oceanside strip of hotels, scuba centers, souvenir shops, and restaurants on the island's northern tip. There I boarded a tour company's minivan and, after winding down serpentine roads past vast sugarcane fields and fuzzy green hills, switched to a motorboat for the ride to a small, gemlike sister island, Île aux Cerfs.

Île aux Cerfs is dominated by Le Touessrok, a famous five-star resort. But, fortunately for less well-heeled travelers, all of the coast in Mauritius is public land. On a soft white-sand beach, I laid out my towel under a thatched umbrella marked "Reserved for Touessrok guests only." Within minutes, a white-clad hotel employee came over to ask me if I was staying at Le Touessrok. I shook my head and awaited his disapproval, but he just nodded politely. My towel and I remained in place.

Soon, crowds of other interlopers from other tour companies arrived. Clothes came off, wide-brimmed hats

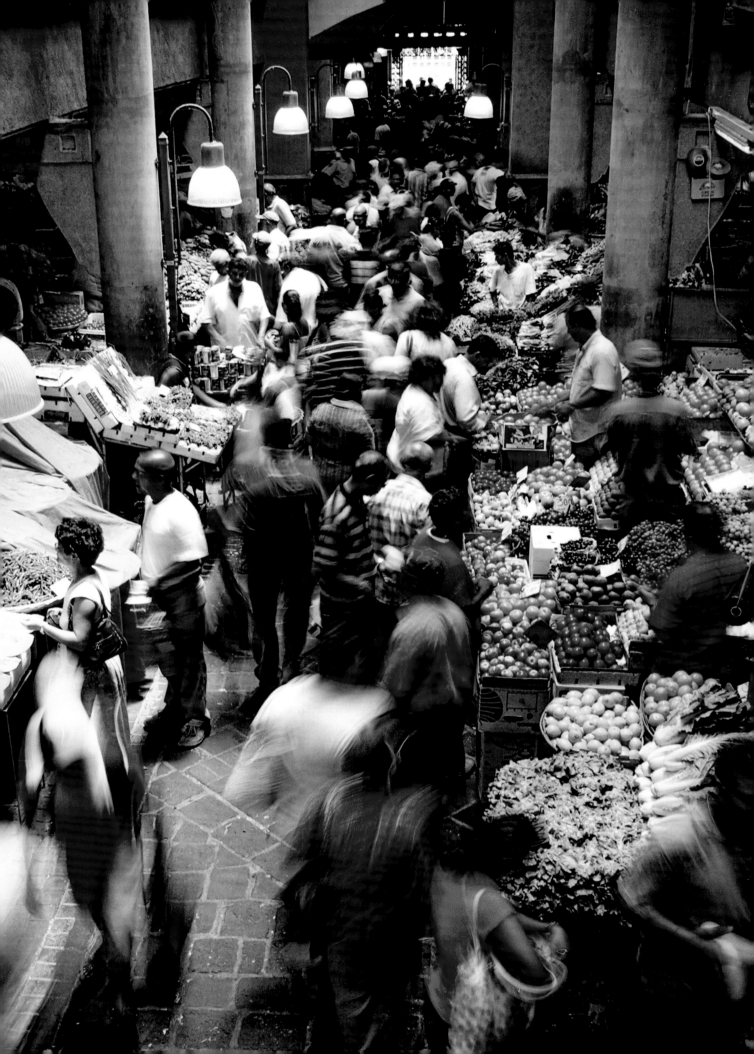

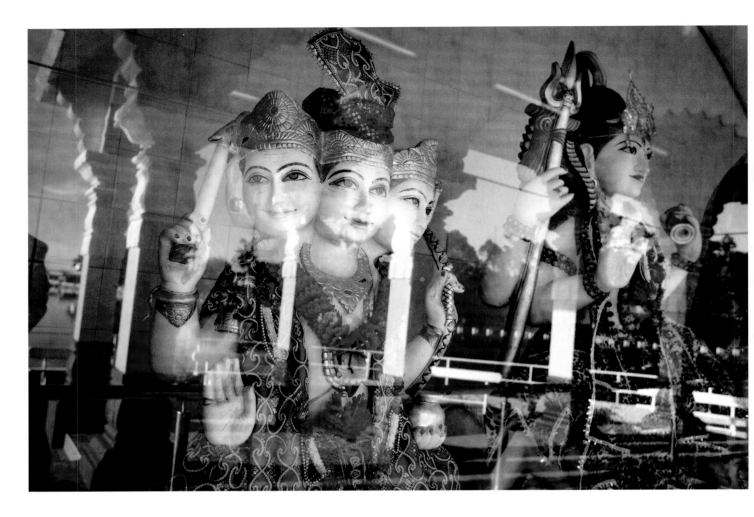

Above A scene at Grand Bassin, the main Hindu temple site in Mauritius.

Following A diver's-eye view of an underwater seascape near Mahébourg.

Opposite Bois Chéri, a tea plantation dating back to the 19th century.

went on, and the scent of coconut oil mixed with the smell of the island's fragrant conifer trees and the buzz of conversation in French, Italian, German, and Dutch. Some of the day-trippers hit Le Touessrok's outdoor bar, mingling with the real guests over kiwi caipirinhas. Some infiltrated the nearby crafts market or hired glass-bottom boats. My group took a scenic motorboat excursion to a waterfall, followed by a stop at another tiny island for lunch.

Another day took me to another city, Mahébourg, where I took the magical scuba dive near Blue Bay Beach.

And on yet another, I stepped off a wheezing bus in Port Louis, the capital. In his travelogue *Following the Equator,* Mark Twain described Port Louis as "a little city but with the largest variety of nationalities and complexions we have encountered yet." It was immediately clear

to me that the ethnic stew he had seen in 1896 still endured. Within the city — a mix of clapboard neighborhoods, colonial mansions, large French-style squares, and a few skyscrapers — trucks painted with Hindu deities honked and sputtered while sari-clad women of Indian origin and African-blooded Creole families shouted greetings and replies to one another in Creole, the local lingua franca. I passed through Chinatown and came upon the creamy white Jummah Mosque, which dates back to the 1850s. At the city's celebrated covered market, stalls offered Bollywood DVDs, hand drums, shark jaws, sea shells, dried fish, pashmina scarves, and incense.

Another cheap public bus took me south to the coastal town of Flic en Flac, where the beach was packed with weekending Mauritian families. They lay sprawled on

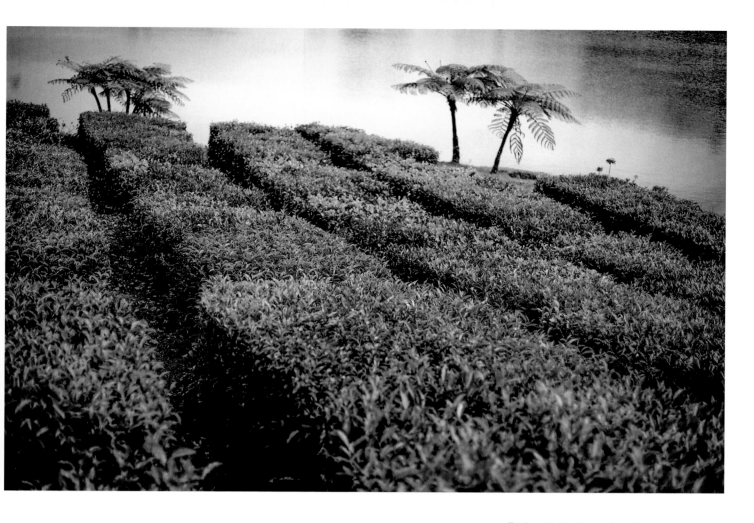

Explorer's Notebook: An officially English-speaking former Dutch, French, and British colony, Mauritius is Africa's farthest-flung nation, more than 1,200 miles off the African mainland.

blankets and under tents, dueling at cards and dominoes. Some took part in whole-family jam sessions, with brothers, sisters, uncles, and aunts taking up instruments.

Lusciously sandy, generously wide, and lapped by turquoise waters, the beach at Flic en Flac extends freely for miles before being invaded by the mammoth hotels where the deep-pocketed foreigners hole up. Beyond them hides Tamarin Bay, celebrated for its dolphins and its surf break. Farther down the coast, a soaring jagged promontory called Le Morne Brabant juts dramatically into the sea. Long ago, it was a common refuge for slaves who escaped from the colonial sugar plantations.

I took one day to explore the island's interior, traveling with a taxi driver who doubled as a guide. We rolled through fields of flaming red flowers and expansive groves of trees bowed under the weight of bunches of purple litchi fruit. At Bois Chéri, a tea plantation dating back to the 19th century, laborers dotted the green fields and a small on-site museum was filled with strange 19th-century tea-making contraptions.

Farther into the island's center, a towering longhaired man appeared in the distance, copper-colored and at least 100 feet tall. It was Shiva, the Hindu god, and behind his statue lay a large placid lake surrounded with temples. We had arrived at Grand Bassin, the holiest site in Mauritius.

Within the temple, bells rang and pungent incense filled the air as Hindu faithful lined up to have their foreheads anointed with red paint. Outside, the sun had begun to dim over the lakes, forests, and fields. The coastal resorts could not have felt farther away.

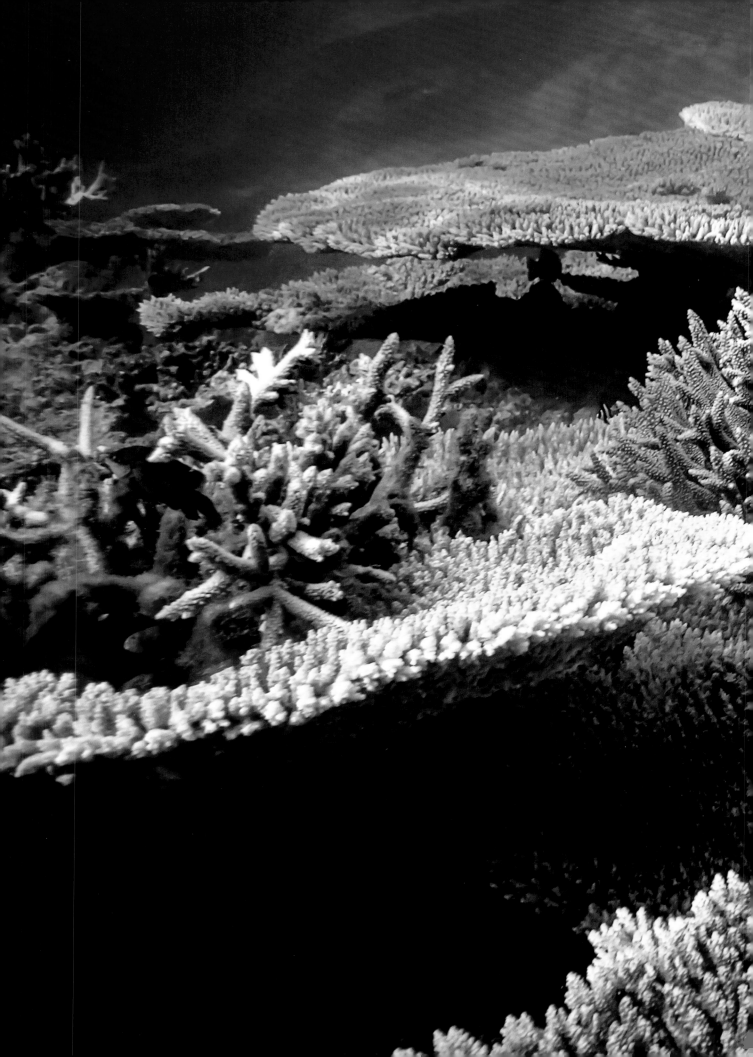

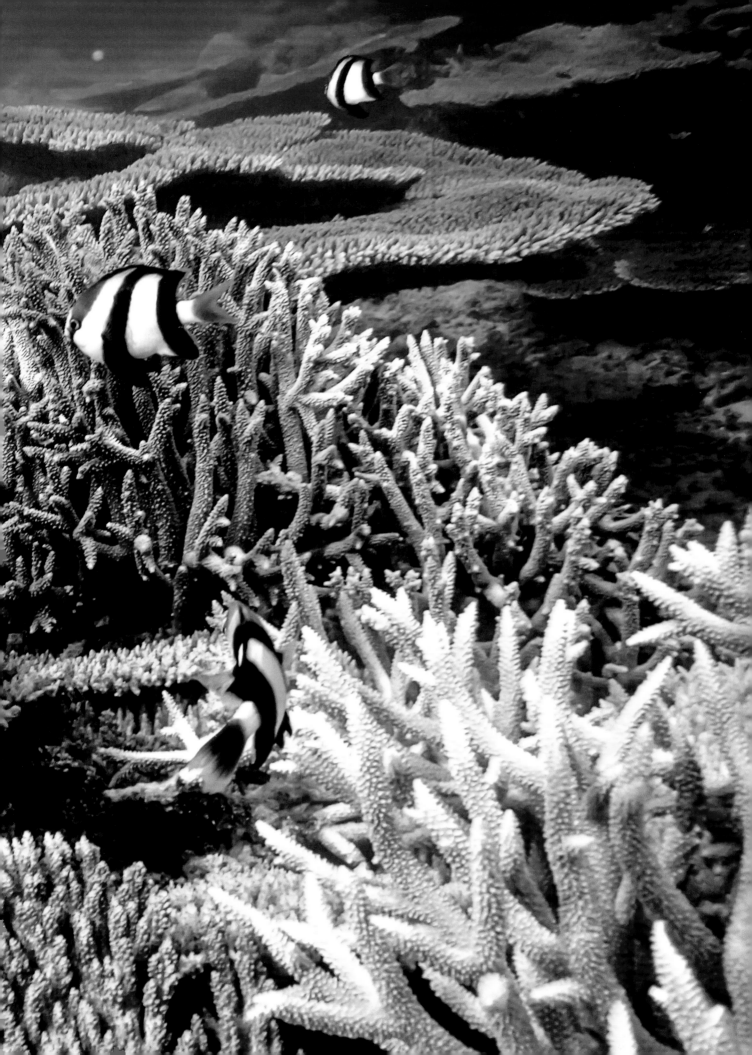

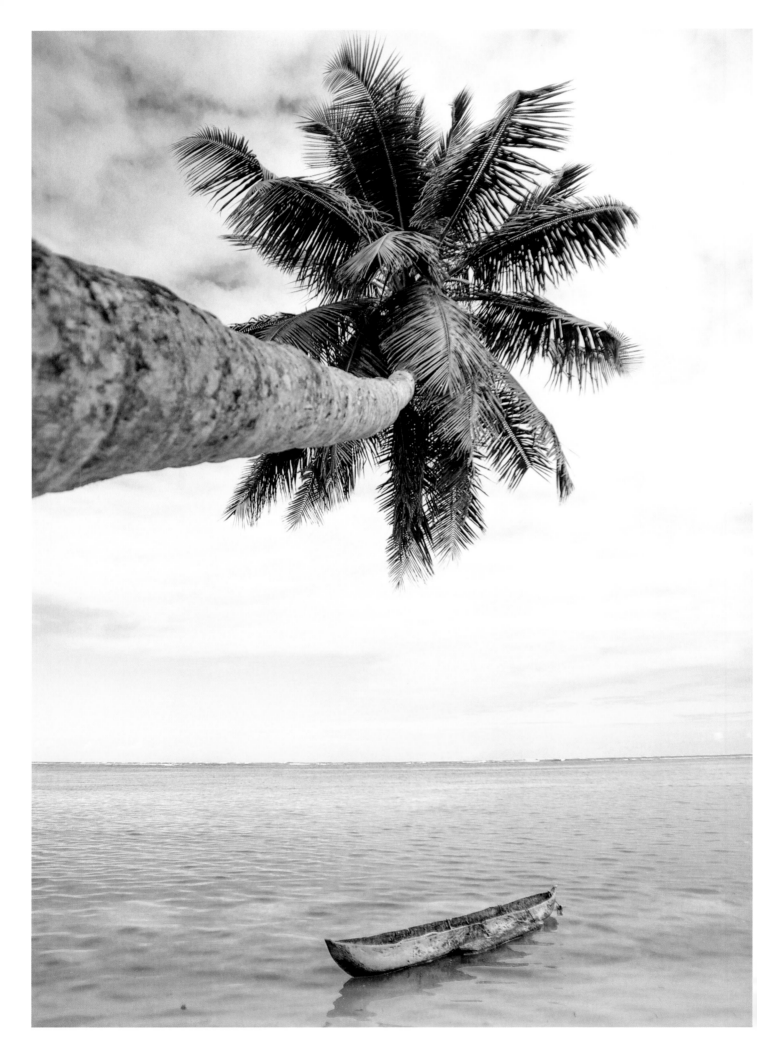

ONLY IN MADAGASCAR

*Lemurs are just the beginning of
the zoological and botanical spectacle in a country
with its own unique ecosystem.*

TEXT BY JEFFREY GETTLEMAN
PHOTOGRAPHS BY ROBIN HAMMOND

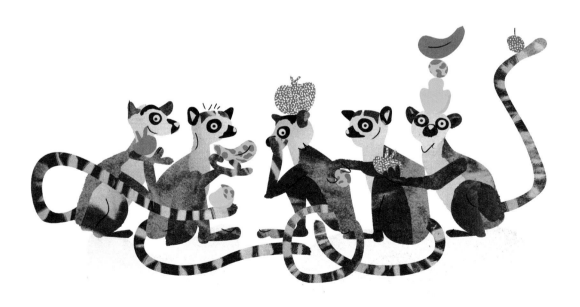

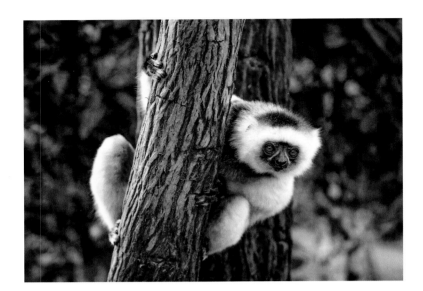

Previous Pirates have left the island of Ste. Marie, but the spectacular beaches remain.

Left and opposite Lemurs, the rock stars of Madagascar's singular fauna, in Andasibe-Mantadia National Park.

It was probably the weirdest sound I'd ever heard. There we were, our first morning in Madagascar, breakfasting on the veranda of a jungle lodge near Andasibe-Mantadia National Park, munching on Paris-grade baguettes, when all of a sudden a ghostly cry erupted from the thick green hills. It sounded a little like the mating call of a whale. Or someone pinching a balloon and slowly letting the air out. Or a squeaky metal wheel with no grease. I had never heard anything quite like it before: a long, haunting, melodic wail, carried through the trees.

"My God," my wife, Courtenay, said to me, "that is otherworldly."

Our toddler son stabbed his pudgy finger toward the mountains and blurted: "Waz zat?"

The next thing I knew I was in the middle of a tropical rain forest dripping with vines and literally crawling with snakes, stumbling behind Monique, our indefatigable guide, in search of the animal responsible for the noise — the elusive Indri indri lemur.

Like so many other mammals, insects, trees, plants, and reptiles (I'm talking fire-engine-red tomato frogs and geckos shaped like leaves), the Indri indri is unique to Madagascar. This 1,000-mile-long petri dish of an island, cut off from the African mainland 160 million years ago, is a naturalist's dreamland, home of some of the rarest and most unusual flora and fauna in the world.

"Look, look!" Monique suddenly said. A whole family of Diademed sifakas (an endangered species of lemurs) was frolicking in the trees, snacking on leaves with their little leathery, humanlike hands, and seemingly unfazed by the tourists below.

Madagascar was unpopulated until 2,000 years ago, when anthropologists believe that some brave souls from Southeast Asia canoed or sailed thousands of miles across open ocean and settled here. You can see the Asian touches today: the rice paddies, the wide-brim hats, the steaming bowls of noodles for sale on the streets. The closest living relative of the island language, Malagasay, is found in Borneo.

Add to that an enduring legacy from French colonialism, with delectable French patisseries, French-run boutique hotels, and French spoken widely. But while the French may have left behind great cuisine, they did not prepare the country well for independence, leaving Madagascar distressingly poor and politically volatile. In a country with enormous export potential — rich with sapphires, rubies, timber, oil, and its signature product, vanilla — we saw poverty nearly everywhere.

We had come to the national park from the capital, Antananarivo, a city of two million where we wound through small, curvy Candyland streets, past 40-year-old Citroën taxis with roll-back roofs, and by houses dipped

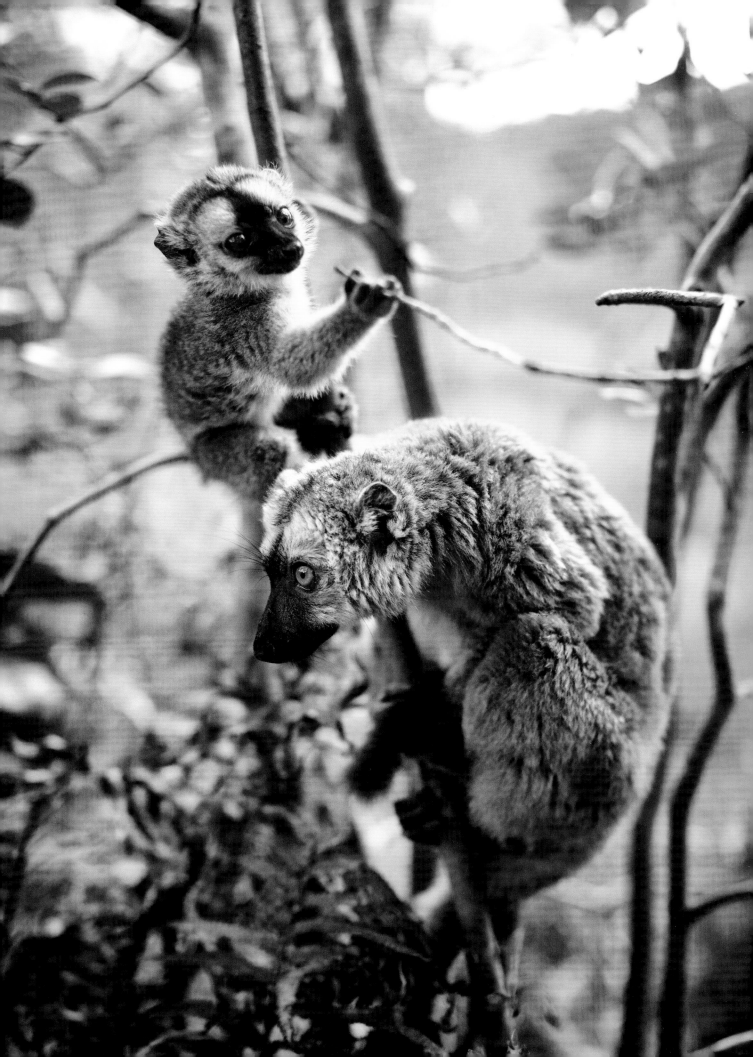

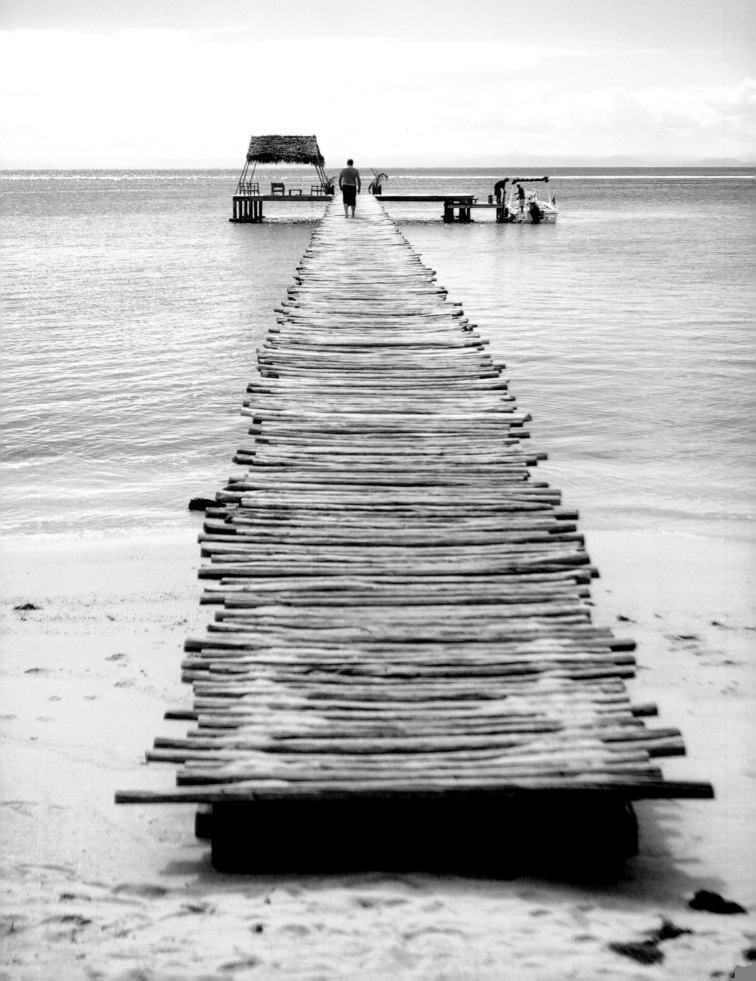

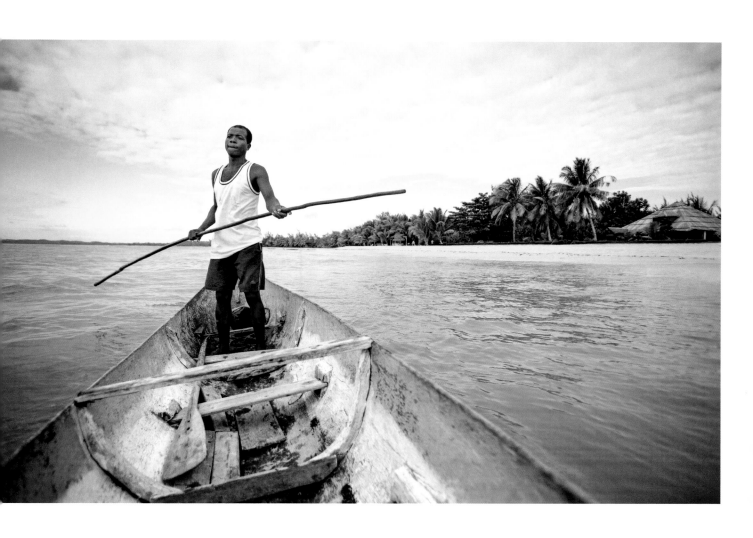

Previous Madagascar wildlife on a smaller scale.

Opposite and above The beguiling island of Ste. Marie features one postcard-perfect strip of sand after another.

Above Vakona Forest Lodge, an eco-lodge with expansive grounds.

Following Madagascar's tropical rain forest.

Opposite A look up into the canopy in lemur-friendly territory at Andasibe-Mantadia National Park.

in every color — purple, blue, maroon, orange, yellow, black. They like color here. After we left the city behind and the road eased into lush farmland, I even saw a pink tractor. Around dusk we pulled into the national park, which is home to several species of lemurs, including the Indri indri, whose name simply means "look up" or "look at that" in Malagasy. Apparently, the first European who saw a lemur was with a local guide who spotted one in a tree and said "Indri! Indri!"

Lemurs are adorable monkey-like animals that live only in Madagascar and tend to dwell deep in the forest. The Indri indri resembles something that has been assembled from spare parts in the animal kingdom's chop shop: raccoon snout, baboon legs, koala ears, a long tail like a fuzzy muffler, black and white fur like a skunk.

Lemur-watching doesn't pack a huge adrenaline punch, but it does offer an intimate, delicate view of nature. The lemurs are an excuse and a pretext to tramp through a pristine rain forest where the air is cool, the sun warm, and the rivers Evian-clear. Entering those forests and quietly padding through, I had the feeling I was stepping inside nature. Madagascar is ideal for trekking. The snakes aren't poisonous, and there are no big predators.

The cities, too, feel safe, including Antananarivo. Though there is street crime, you don't see bars covering every single window or helmeted security guards swinging batons as you do in so many big African cities.

And there are also beaches, really good ones. We spent time on the beguiling island of Ste. Marie, off Madagascar's coast. It used to be a pirate hangout and

Explorer's Notebook: Lemurs are the most obvious evidence of Madagascar's one-of-a-kind ecosystem, but there is more: fire-engine-red tomato frogs, geckos shaped like leaves, hissing cockroaches, giant jumping rats, moths as big as dinner plates. Then there are the flora, including odd, wavy plants growing out of the desert that look as if they belong underwater.

still draws treasure seekers. We met some American divers who were convinced they were about to excavate Captain Kidd's infamous pirate ship from the bottom of the Windex-blue seas. Empty, white-sand beaches were everywhere, and in the morning, we watched pirogues slide by in the shallows. Little boys went door-to-door selling the catch. The whole 40-mile-long island can be covered by bike — a smooth paved road threads through the palms.

We also made a stop at the Berenty Private Reserve at Madagascar's southern tip. The place is not luxurious, and it's hard to get to (about two hours by plane from the capital and then a spine-crunching, three-hour drive), but its access to lemurs — and especially the amusing dancing lemurs — is unrivaled.

We woke up there to see dozens of the lemurs playing right outside our bungalow, gobbling down green berries, springing through the trees, awkwardly sashaying along on their hind legs while waving their little stubby arms like the abominable snowman.

During breakfast we watched a group of eight sunning themselves by our table. At what seemed to be some hidden signal, they all sat up, and — en masse — made their advance. Then it was lemur madness. One jumped into my lap and snatched the hunk of baguette I was just about to butter. One of his comrades grabbed the breakfast cake. Another glanced right, glanced left, and then shot for the sugar bowl. I swear I caught a look of unbridled ecstasy on his furry little face as he dug his Lilliputian hands into the sugar and shoveled it into his mouth.

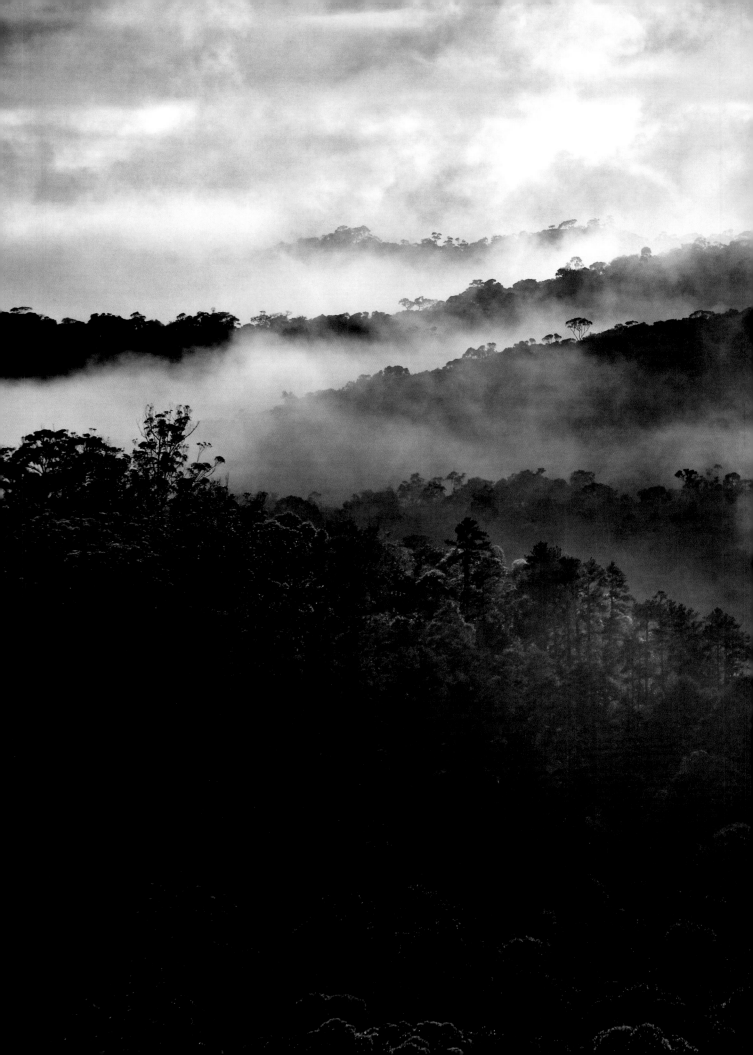

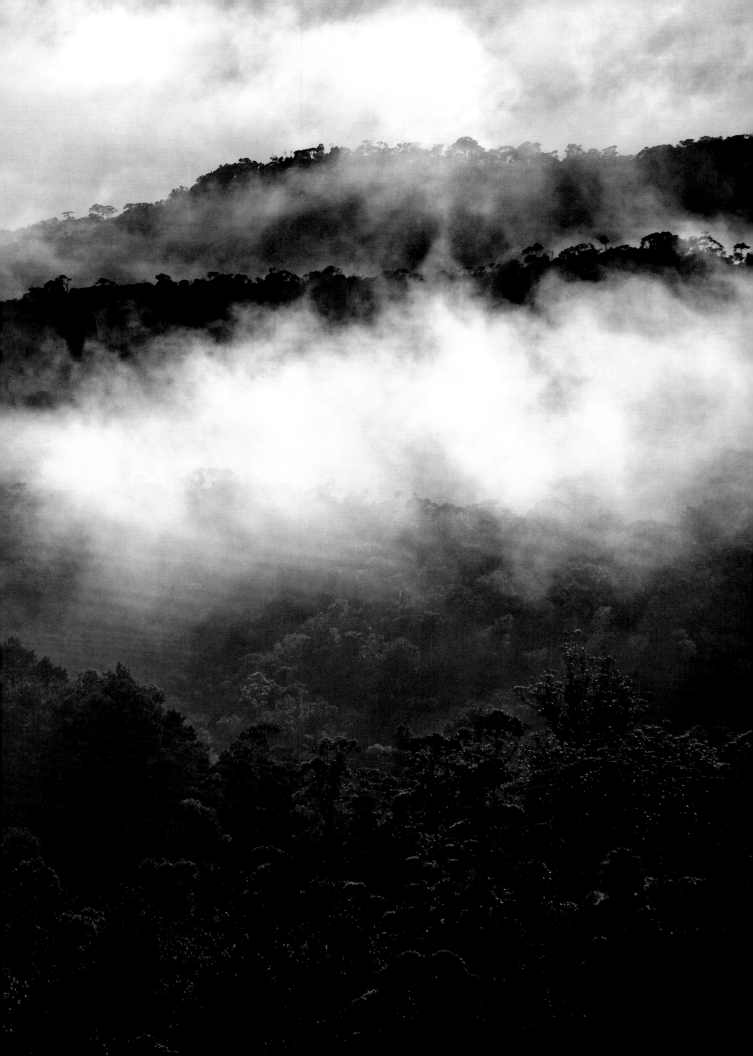

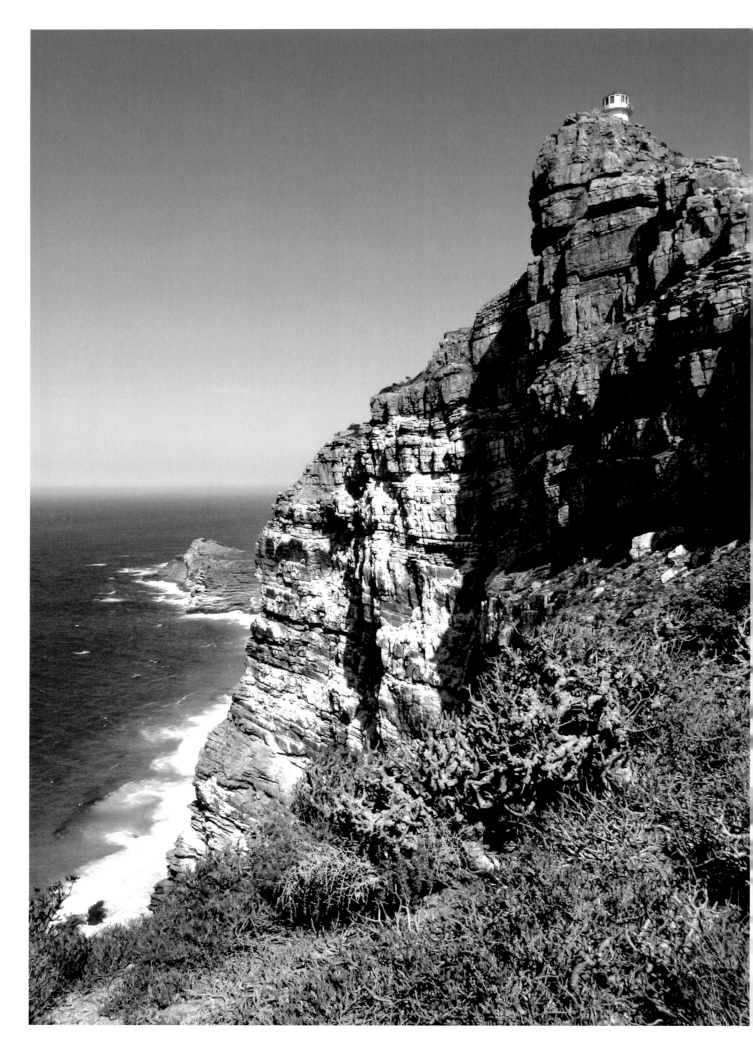

CAPE TOWN, TAMED AND WILD

*Penguins on the beach, baboons in the cupboards,
and cabernet on the vine all play their parts
at South Africa's cape of contrasts.*

TEXT BY JOSHUA HAMMER
PHOTOGRAPHS BY BÉNÉDICTE KURZEN

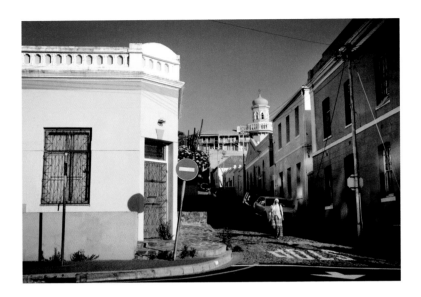

Previous The lighthouse atop
Cape Point at the Cape of
Good Hope.

Left Bo-Kaap, a neighborhood
of Cape Town that was once
called the Malay Quarter.

Opposite The pier at Kalk Bay.

Following Fishermen taking
advantage of the rocks and surf
at Kalk Bay.

The inhabited world seems to peter out at Noordhoek
Beach, a five-mile strip of white sand on the Atlantic coast
of the Cape Peninsula 15 miles southwest of Cape Town. At
4 o'clock in the afternoon, with a pale sun shining weakly
through an overcast sky, a friend and I followed a trail
on horseback through dunes and wetlands. A long-billed
Hadeda ibis and a pair of Egyptian geese waded nearby.

The horses broke into a trot, then a canter, as we hit a
beach speckled with gnarled driftwood and great, squiggly
strands of kelp. In the distance, a near-perpendicular
cliff face soared high above the sea, its striated green
flank cut by the fabled Chapman's Peak Drive, one of the
world's most heart-stopping stretches of asphalt. The air
was thick with seagulls, cormorants, and black oyster-
catchers.There's wildness to Cape Town — the big skies,
the rugged canyons, the jagged outcroppings of sand-
stone and granite that rise over the icy South Atlantic at
the tip of Africa. Penguins waddle across white-sand
beaches, elands roam the dunes, hungry baboons swoop
down from their shrinking forest habitat to raid the food
cupboards of unsuspecting suburbanites.

Cape Town can overwhelm a visitor with its grand-scale
landscapes and its feeling of remoteness. It's an agora-
phobic's nightmare and a naturalist's dream. But there's
a tamer side, and the contrast can be exhilarating. The
Dutch colonists who settled in the Constantia Valley

350 years ago built their tidy town and covered the fertile,
sun-drenched basin with vineyards.

On a trip to rediscover Cape Town, where I had lived a
few years before, I arrived in mid-November, at the start
of the Southern Hemisphere's summer. I splurged for the
first two nights, staying in one of the elegantly furnished
suites at the Constantia, on the cape's historic wine route.

Early on my first afternoon, I set out on the Ou Kaapse
Weg (Old Cape Road in Afrikaans), a two-lane ribbon that
winds steeply through the arid Steenbergs, a treeless
range of hills blanketed with fynbos — hard-leafed heath-
like vegetation that evolved in isolation in this windswept
corner of the world. Soon the road dipped toward the
beachside community of Noordhoek.

I was meeting a friend, Peter Bouckaert, a South Africa-
based Human Rights Watch investigator, at the Foodbarn,
a prime example of the local culinary revolution. The
prix-fixe menu that day consisted of a crispy prawn and
avocado salad, grilled salmon on a bed of crushed Nicola
potato, and an iced café au lait. The value of the rand,
the local currency, fluctuates; this was a time when the
exchange rate for my U.S. dollars was particularly favor-
able, and the total cost of this superb lunch for two, with
a local sauvignon blanc, was less than $50.

After two nights of self-indulgence at the Constantia, I
moved a couple of miles north to a bed-and-breakfast in

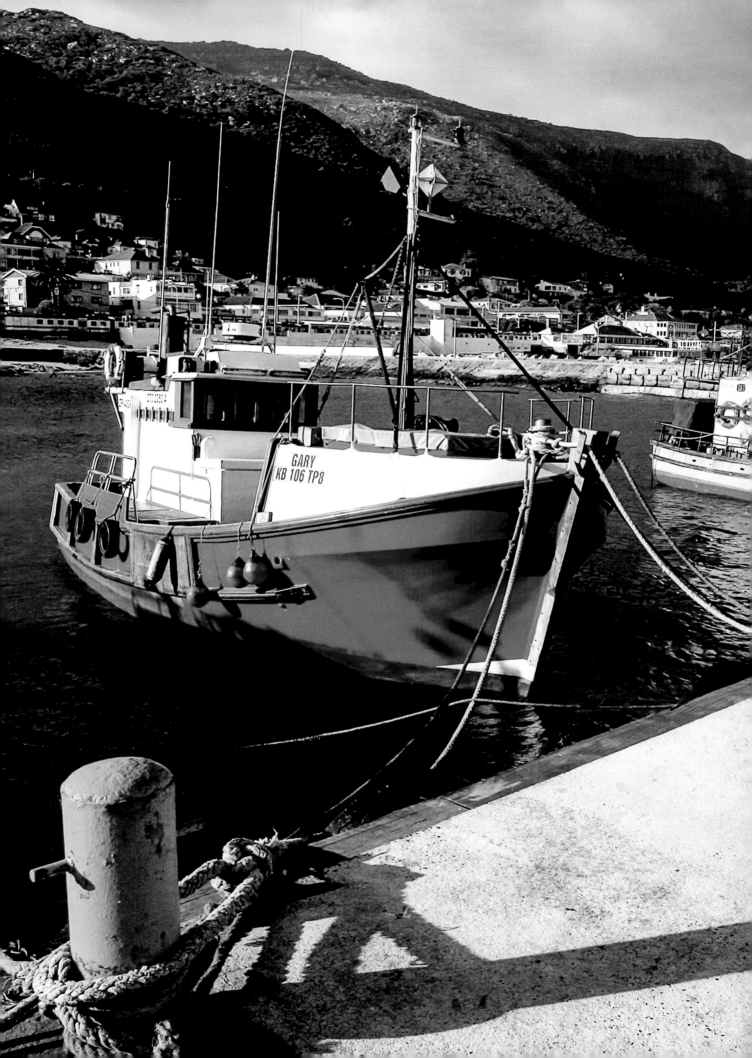

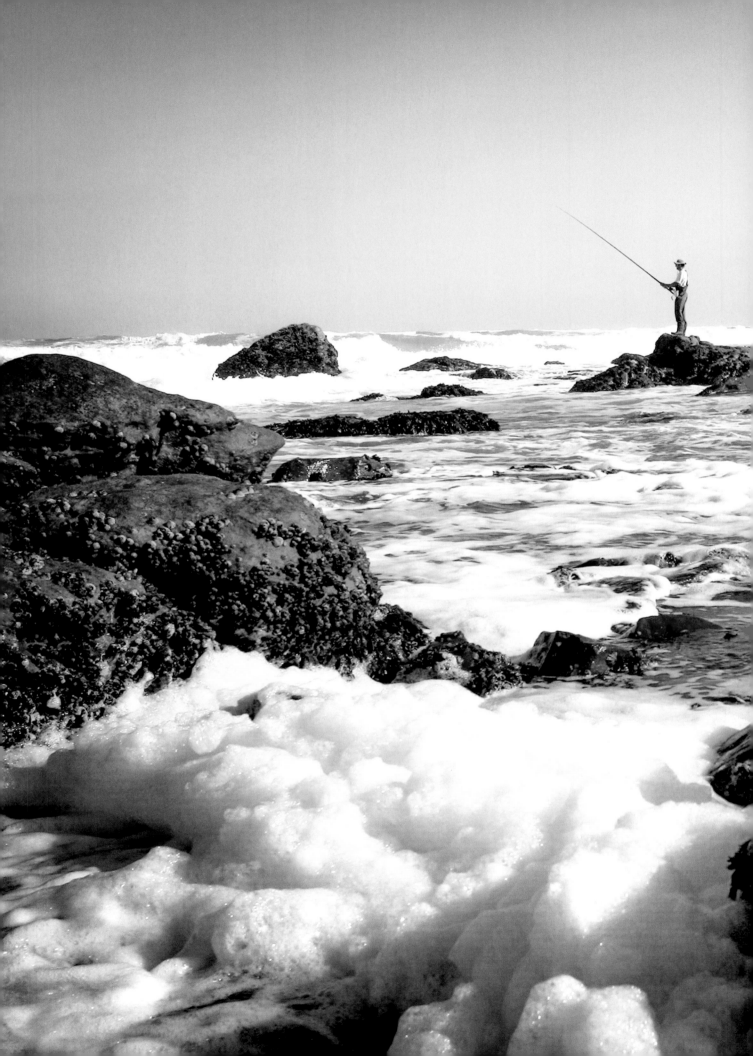

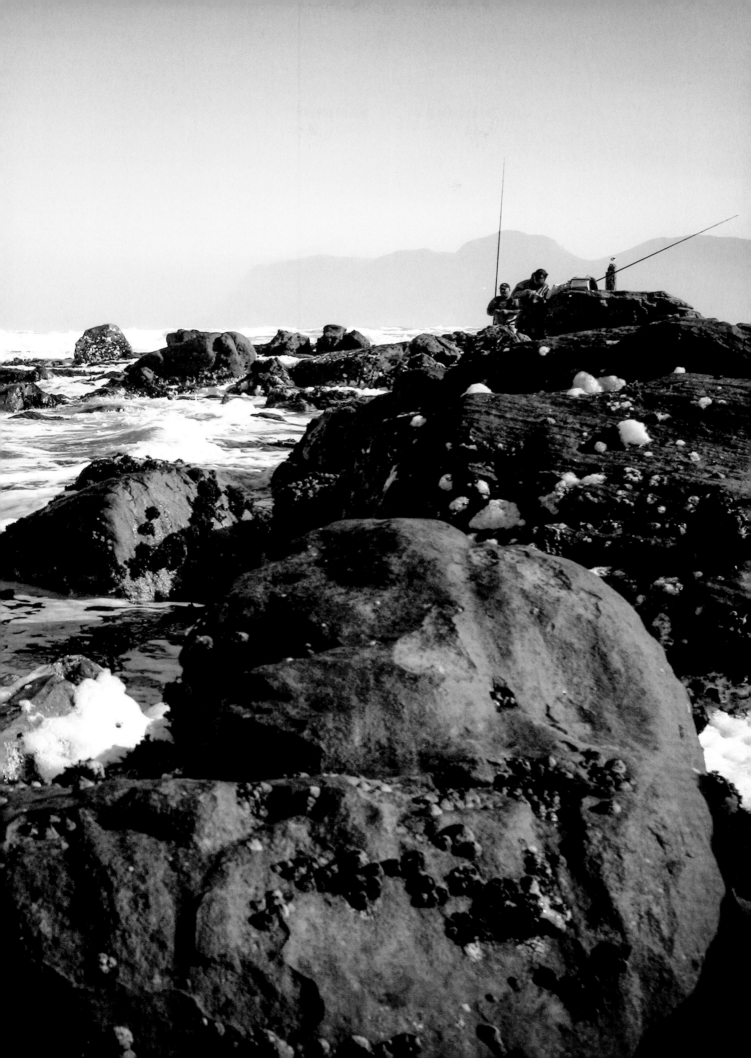

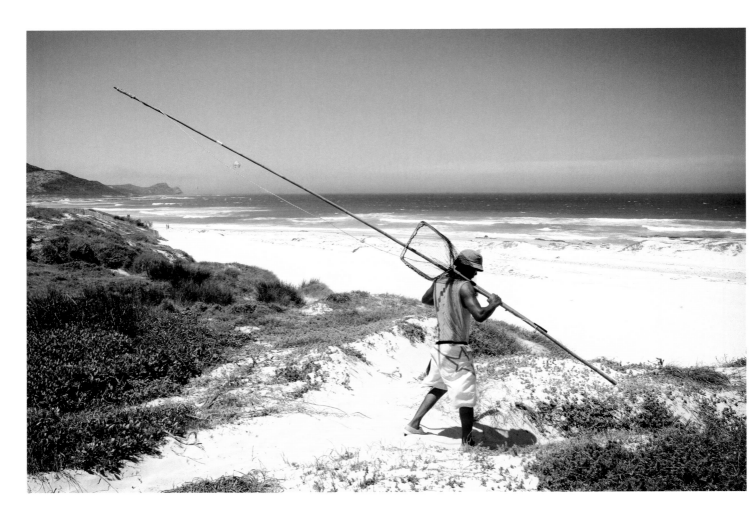

Above A crayfish hunter
heading for the water at
Platboom Beach.

Following Platboom Beach at
the Cape of Good Hope.

Opposite A quiet pool is walled
off from tumultuous surf at
Kalk Bay.

the exclusive southern suburb of Bishopscourt. Here, both the climate and the landscape change dramatically. The heavily forested eastern face of Table Mountain attracts more rainfall than any other part of the Cape Peninsula, and the suburbs along the monolith's lower flanks are bursting with bougainvillea, frangipani, eucalyptus, and date palms. My room looked toward Kirstenbosch, the national botanical gardens. Kirstenbosch exemplifies Cape Town's juxtapositions. Its Table Mountain backdrop, with a tangle of forest clinging to the rough sandstone face, exudes the raw power of nature, while its meticulously landscaped grounds reflect the hand of man.

I followed its gravel and cobblestone paths past manicured lawns; gardens of protea, ericas, restios, and other plants unique to the Cape Peninsula; and lush groves

of trees gathered from across southern Africa, including yellowwoods, common cabbages, wild almonds, wild cottons, and quinines. Had I chosen to, I could have walked farther. Kirstenbosch's paths merge with hiking trails that climb steeply to the top of Table Mountain.

For dinner, I drove to Bizerca, one of many high-end restaurants that are animating once-desolate corners of the city. The place was packed, and the energy was palpable.

A friend and I ordered a bottle of the local chenin blanc and started the meal by sharing a delicate beet-root, goat cheese, and beet-root sorbet salad followed by king prawns and pork bellies on sweet potato purée. My main course was free-range chicken and spiced garbanzo beans, and dessert was a raspberry sorbet.

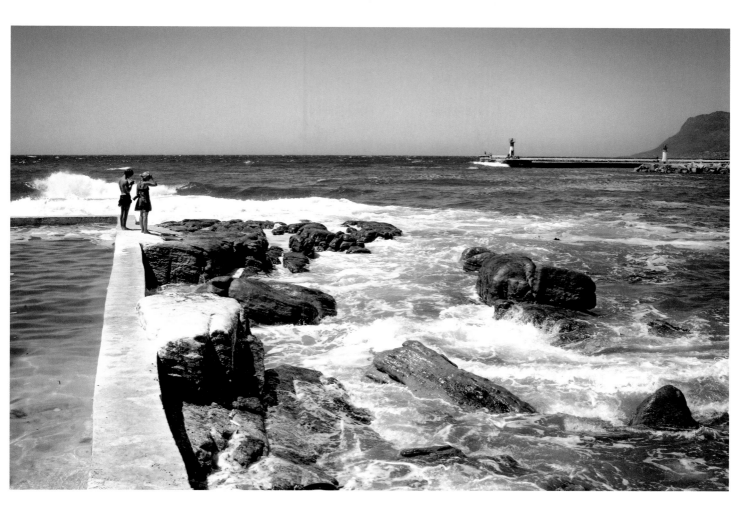

Explorer's Notebook: To get the lay of the land, take a cable car to the top of Table Mountain, the city's 3,051-foot icon. From there, views of the city, Table Bay, and the spectacular landscape beyond the mountain's south flank are not only awe-inspiring but a good orientation to the area.

I spent the next several days rediscovering familiar pleasures — a climb up Lion's Head peak before sunset, the chili prawns at a favorite Mozambican restaurant — and discovering new ones. I hiked along deserted trails through meadows and pine forests at Silvermine, a part of Table Mountain National Park, watching as a dense mist rolled in from False Bay. I drank Castle beers and watched South African cricket with a friend at his local pub.

On my last full day, I drove with Peter Bouckaert to the Cape of Good Hope for a day of lobster diving at the bottom of the world.

The surf crashed against a curving, rocky beach. A pair of blesboks, or antelopes, plodded across the dunes, gazing at us with doleful eyes. Three ostriches nibbled at tufts of beach grass.

I squeezed into my hooded wet suit, dived, and combed through a tangle of seaweed where the crustaceans usually lurk, but I could see nothing through the swirling sediments stirred up by recent storms. There would be no lobster supper that night. But we were here, and we clung to the rocks, battered by the waves, and watched a pair of surfers ride a breaker a hundred yards off shore.

The African sun dipped low, glinting off the Atlantic with blinding intensity. I lay back on the beach and basked in the warmth of the fading day as a pair of cormorants dived and weaved. Then we hoisted our duffel bags, empty-handed but content, and began the long hike back to our car.

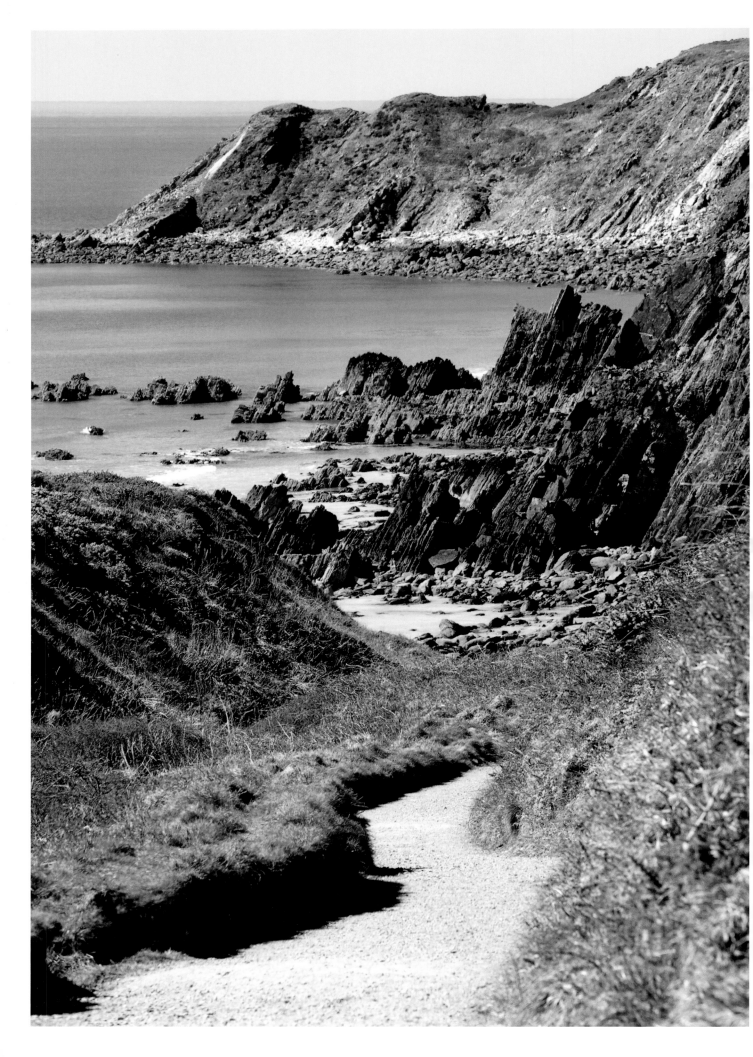

A WALK
WHERE WALES MEETS
THE SEA

*A linked footpath of 870 miles
of trails follows the entire Welsh coastline,
harbor to harbor and cliff to cliff.*

TEXT BY DOMINIQUE BROWNING
PHOTOGRAPHS BY HAZEL THOMPSON

Previous The coastal path at Marloes Sands on the Marloes Peninsula of Wales.

Left Allenbrook, a manor house turned bed-and-breakfast in the village of Dale.

Opposite Horses and riders on the beach near Broad Haven.

My idea of heaven is a long walk. Aimless hours pass, thoughts drift. I was never ambitious about how many miles I covered — until I read a biography of Johann Sebastian Bach. He loved to walk, too, and thought nothing of walking to a town hundreds of miles away to try a new organ, or to look for a new job. I wanted to walk from one town to another, too.

And that is why I went to walk in Wales. Most of us carry around in our hearts places we must visit. My list began with Wales — verdant, mystical, rimmed with cliffs, dotted with castle ruins. When I learned that Wales had become the first country in the world with a formal footpath along its entire coastline — 870 miles of trails — I could no longer resist. Particularly alluring was the Pembrokeshire Coast Path, in southern Wales, with those cliffs tumbling down to heaving seas. A friend, Frances Palmer, agreed to join me.

At our starting point, Milford Haven, we asked Jayne Hancock, the owner of our bed-and-breakfast, about the paths. Were they nice? "Oh yes," she said. "Not like sidewalks, like you have in New York. Think of the little trails animals make when they walk through grass. They're like that." Then she added, "You know, you must take whatever comes your way."

The next morning, we hurried into a September drizzle to reach the steppingstones across the estuary of the River Gann near the village of Dale, about four miles away, before the tide came in. The cliffs were low, the path was gentle. All around us lay flower-speckled meadows, fragrant herbs, thick tussocks of grass of an emerald shade I had rarely encountered. Everywhere, I saw plants I tended, slavishly, in my own garden, like a purple and crimson fuchsia, but here they were extravagantly large, pendulous shrubs. Blackberry canes groaned under the weight of their fruit.

The drizzle thickened, but nothing could dampen our enthusiasm for the dazzling beauty of the coast — and the dizzying freedom of a long walk. We hit our stride, gulping in the wet, fresh air. Whitecaps were rippling across the bay by the time we got to Dale, where we took a 5.5-mile loop around the peninsula and then settled in at our new B&B.

As I fell asleep that night, it struck me: For the first time in my life, I had walked from one town to another. I was suffused with a splendid, ennobling feeling, a sense of fortitude and power.

We woke to the sound of rain beating against the windowpane. At breakfast, two sailors eating at the next table predicted we were in for a doozy. "It will be wet today," one promised. "But it doesn't matter, does it? Not if you have the proper kit."

Their kit was splendid. Every inch of their bodies was waterproofed; even their backpacks were swathed in

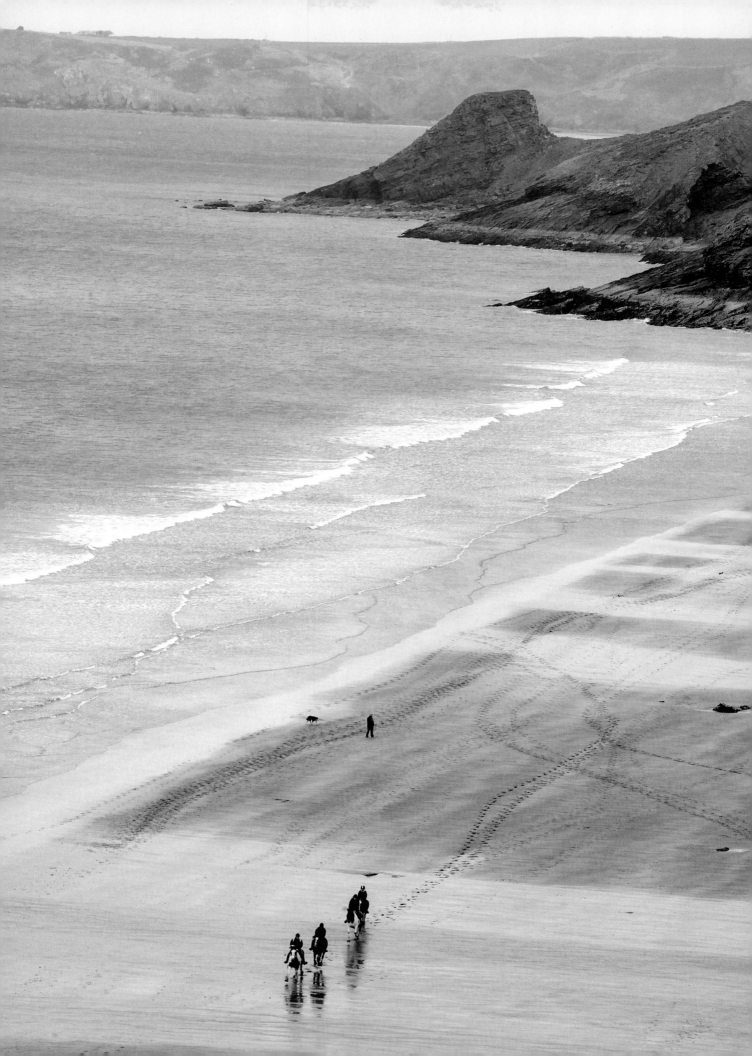

Above A warning sign at
the Marloes Peninsula makes
its message of danger
perfectly clear.

Opposite White gannets
sheltering in the cliffside on
St. David's Peninsula.

Following The cathedral in
St. David's.

plastic contraptions that looked like air-conditioner covers.
They eyed our kit, which ran more to cotton jackets and
baggy pants.

We headed out on the 14-mile walk to Broad Haven. We
made slow progress; the long grass edging those narrow
animal trails hid some real ankle turners. When the wind
and rain picked up, we dumped our packs out to look for
extra rain gear, and found little. The scenery was more
rugged; dramatic rock formations studded the coast, carved
out over eons of beating waves. Signs showed people
and rubble falling through the air. The message was clear
even when it wasn't spelled out: Cliffs can kill.

The sweeping, throat-catching grandeur of the coastline
awed us, but it was tiny miracles that stopped us in our
tracks. Slugs crawled with small majesty through the long
grass. Spangled blossoms sprouted from tumbling stacked
walls. And always, we were accompanied by the pounding
sea, heaving over rocks, crashing through eddies.

We met fellow walkers and learned something about
how they had organized their expeditions. Some rented
cars, drove to a starting point, walked a few days, and
returned by bus. Others recommended favorite outfitters.
Everyone had taken walks in various parts of Britain;
several recommended spectacularly rugged Cornwall.
Britain is crisscrossed with trails that connect villages,
and every day, no matter what the weather, people young
and old are out walking.

The next morning, it was pouring when we started out
for the village of Solva, 11 miles away. My jacket became
a sponge; my boots were small tubs. We stopped at a bar

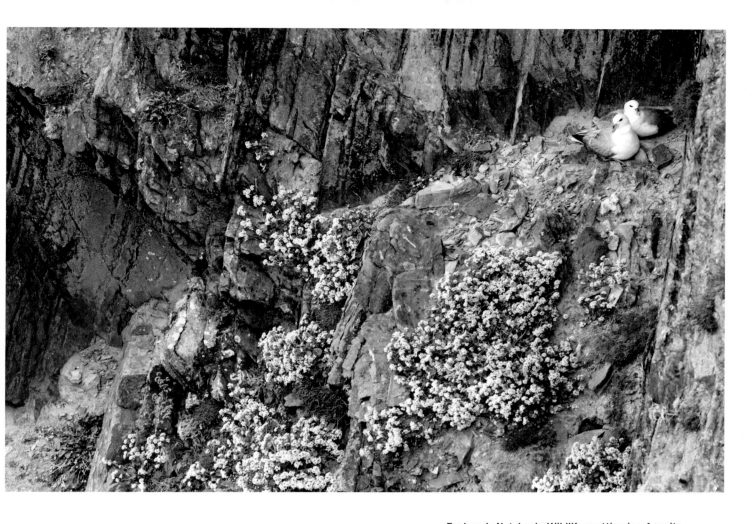

Explorer's Notebook: Wildlife spotting is a favorite pastime on the Wales coastal path. Seals and their pups loll on the rocks, dolphins surf against the tumultuous channel current, and sea birds soar over the waves. The cliffs of Pembrokeshire, important breeding grounds for many kinds of birds, are an ornithologist's dream.

just off the trail and sat by a weak gas fire, water pooling at our feet, and watched a television weather report. We had chosen to hike during Wales's worst September storm in 30 years.

And that was how we came to appreciate the efficiency of the Puffin Shuttle, a bus that runs along the coast, carrying visitors from village to village. It was dismaying to cover in minutes what it would have taken hours to walk. It was also delightful.

In Solva, I bought dry clothes and we wandered through what was easily the prettiest village we had seen. Lower Solva sits at the harbor behind a gorge formed at the end of the Ice Age, when glacial melt gushed down the mountains. Much of the craggy Pembrokeshire coast was created this way.

The rain let up the next morning. A rainbow arced across the sky. We headed for St. Justinian, where we would turn inland for what is said to be the smallest city in Britain, St. David's, and a magnificent cathedral. Far below we saw the remains of houses, brick kilns, and slate slag heaps. Crumbling, flinty stacked walls had become exquisite rock gardens. We passed steep slopes of bracken and heather, long white beaches, forested tunnels of scrub oak, and rocky knolls.

We felt exhilarated and strong with accomplishment. The sparkling sun made the journey — by the end of five days, we'd walked 64 miles — much easier. So did knowing that if you put one foot in front of the other, eventually you get somewhere. You learn to take what comes. Even if it is only the Puffin.

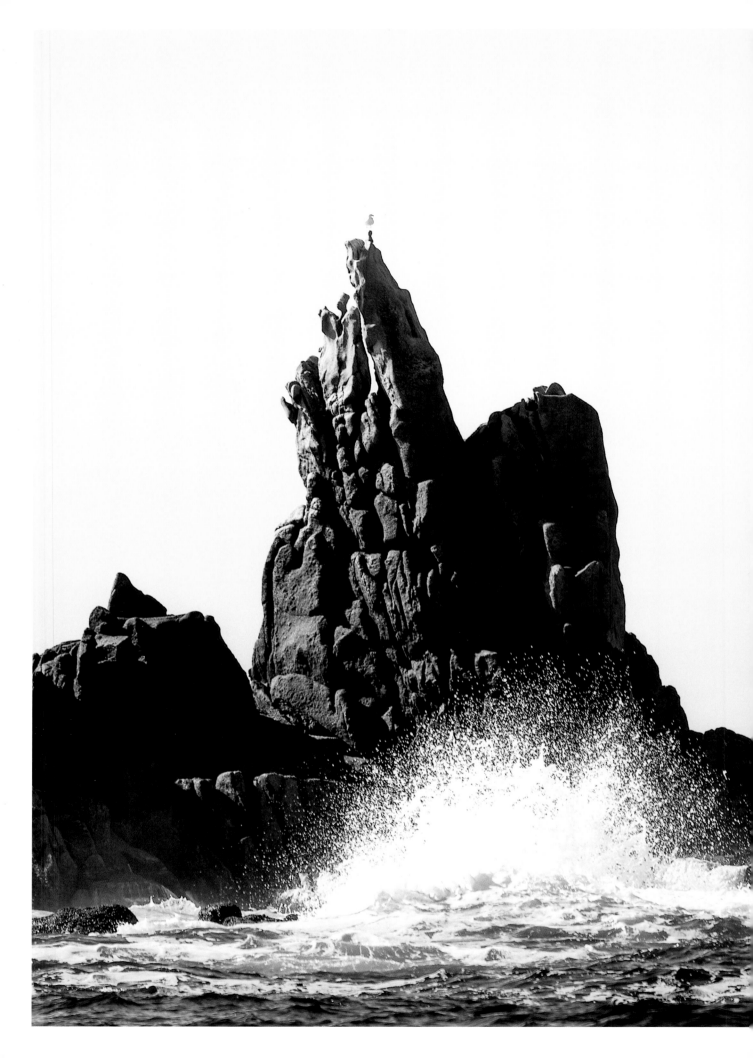

BACK IN TIME ON
THE ISLES OF SCILLY

*Bronze Age hunters, Roman adventurers,
and shipwrecked mariners all left relics on the windy
archipelago at England's westernmost point.*

TEXT BY VALERIE GLADSTONE
PHOTOGRAPHS BY ANDREW TESTA

Previous Rock outcrops known as the Haycocks in the Isles of Scilly, an archipelago off Cornwall.

Left A bed-and-breakfast on St. Mary's, the largest of the Scilly Islands.

Opposite Rocks near the uninhabited island of Samson.

Following Teams at work in a race of the long rowboats called gigs. The inhabited islands of the Scillies compete regularly in gig races.

Through the mist I could make out the empty beaches and crystal-clear water surrounding St. Mary's, the largest of the Isles of Scilly. The view from the airplane window hinted at what draws the visitors who flock to the Scillies for its beaches and unspoiled beauty. They windsurf, sail, watch teams race in the long rowboats called gigs, hike or bike, and peer through birders' scopes at puffins and grebes.

Yet hidden below all of that is what especially sets these islands apart from other British seaside destinations, and what I had especially come to see: a unique record of the past. They hold one of the densest concentrations of archaeological sites in Britain — hundreds of documented monuments ranging from remnants of the Bronze Age and Roman, early medieval, and Tudor periods up to defense structures from the last 500 years. In addition, perilous rocks lie hidden in the surrounding waters, and more than 700 shipwrecks have left a remarkable trove of under-the-sea archaeological finds, many yet to be recorded.

Together these relics provide what amounts to a tour through the islands' history, from the seminomadic hunter-gatherers who settled there as far back as 4000 B.C., when Scilly (SIL-ee) was still one big landmass, to the current-day residents, who number about 2,200. Taking the broader view, the artifacts are a window into the history of England itself.

There's a quick orientation to some of the Scilly past at the Isles of Scilly Museum on St. Mary's, but to see more, get out on your own to a few of the most important sites. Exploring them is a meditative pursuit, a contrast to more lively seaside attractions.

To travel far back in time, there's no need even to leave St. Mary's. A couple of miles from the ferry terminal in Hugh Town, the Scillies' principal town, is the Halangy Down settlement, the most extensive Iron Age and Roman remains on the islands. A tour guide there led me through hunks of stones, remnants of oval houses that were once protected by conical thatched roofs, and into courtyards that dot the steep, grassy slopes that run down to the sea, constructed from 1200 B.C. to A.D. 300. On a distant hill were large mounds from a prehistoric field system similar to modern agricultural terraces, a sign of the farming that has endured for centuries here in spite of the strong winds and salt spray.

Before the courtyards are Bronze Age entrance graves that were created about 4,000 years ago by the Scillies' early inhabitants, who may have come from what is now Cornwall. These communal and family burial spaces have massive granite slabs for roofs and are now carpeted with velvety green grass. The Bant's Carn entrance grave, on the hill above the Halangy Down settlement, is the most famous. Covered with moss, its

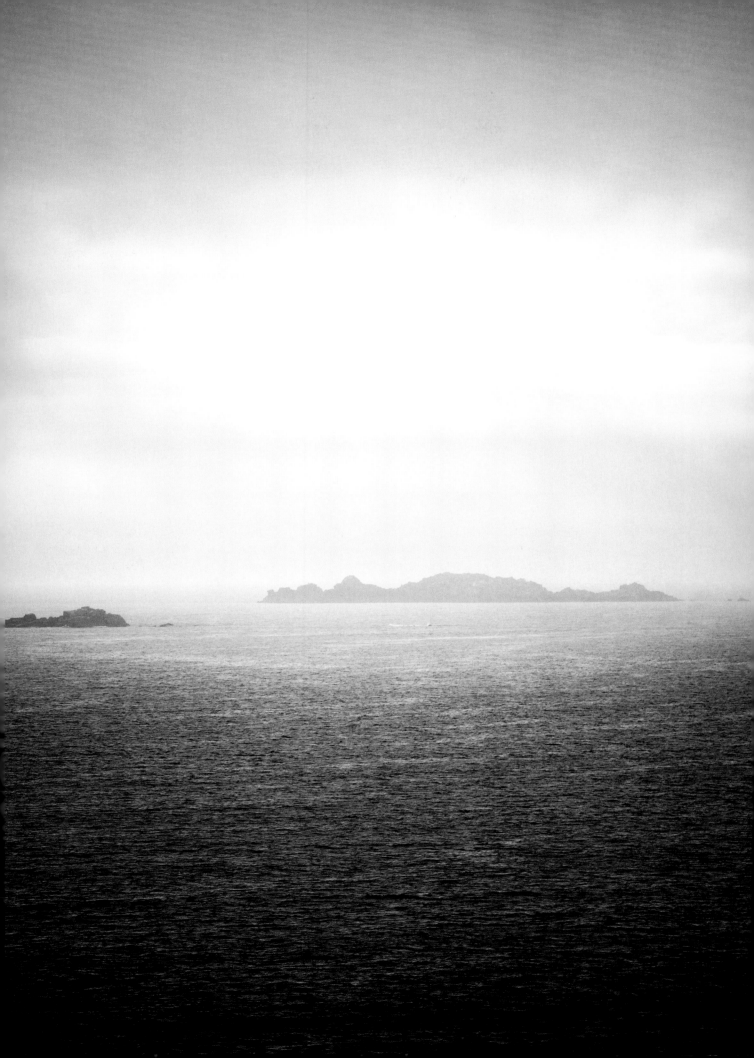

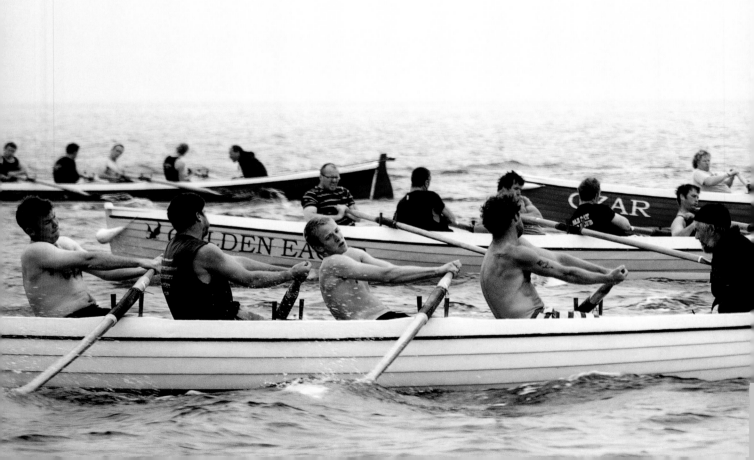

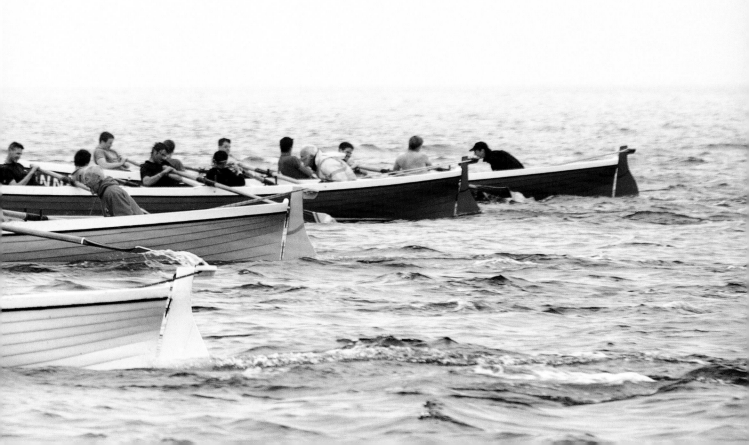

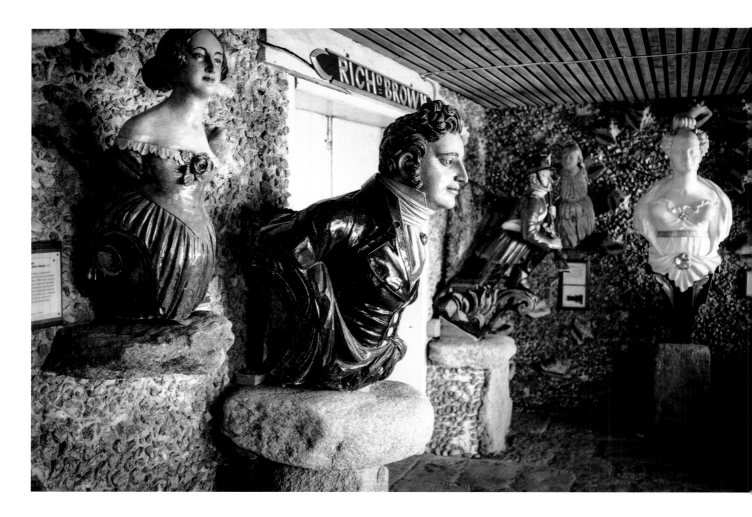

Above Figureheads recovered from some of the 700 recorded shipwrecks off the Scillies. Here, they peer out from walls at Tresco Abbey Garden.

Opposite Horses on St. Mary's.

Following A small crowd waits for a boat at a jetty on the island of Bryher. In the distance are St. Mary's and St. Agnes.

granite walls bleached by the sun and worn by wind and rain, it now resembles a cavelike hideout that children might build.

Back in town, perched on a rocky peninsula near the ferry dock, is Star Castle, a fortress in the shape of an eight-pointed star. The word "castle" conjures up images of huge structures with turrets and moats. Star Castle, now a hotel, is much smaller and feels more accessible, but still presents a commanding face to the sea. It was built in 1593 by decree from Queen Elizabeth I as a defense against both pirates and the Spanish. The islanders moved close to the castle for safety, leaving their settlement on the opposite shore. When the pier was built in 1601, access to traders provided more reason to live in the vicinity. Hugh Town grew up just beyond the castle.

The Star Castle became a hotel in 1933, and later, during World War II, accommodated hundreds of soldiers.

About a 25-minute boat trip away, on the island of Tresco, is the magnificent Tresco Abbey Garden. The garden was created in the early 19th century by Augustus Smith, a wealthy man who realized that the Scillies' mild climate, a result of their location near the Gulf Stream, would allow an exotic garden to thrive. All he needed were Monterey pines and cypress from California to serve as buffers from storms before importing flora from the Mediterranean, New Zealand, Australia, South Africa, Mexico, Chile, the Canary Islands, and California. The gardens, and the island itself, are still under his family's control, and retain his vision. Walking there, I found flower beds brightening every corner, along with manicured

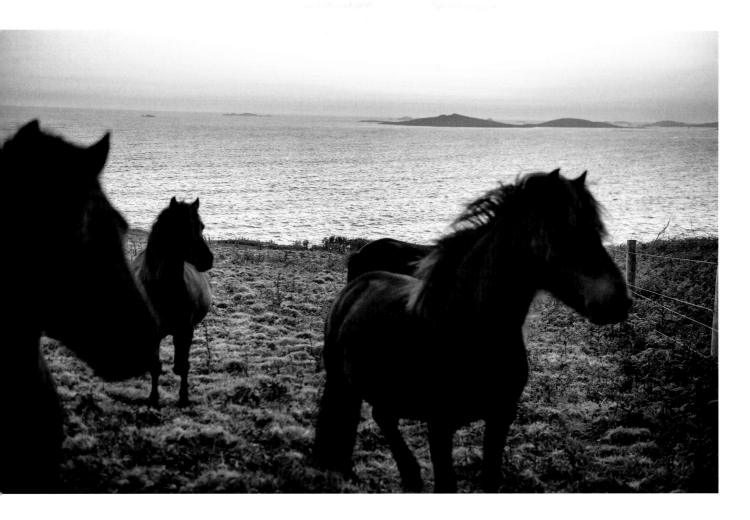

Explorer's Notebook: After four Royal Navy ships sank off the Scillies in 1707, with 2,000 lives lost, the British parliament offered a cash prize to anyone who could find an accurate way to measure longitude. The story of the humble John Harrison, who eventually won the prize, was told in the book Longitude, by Dava Sobel, and in a made-for-television film.

paths, handsome sculptures, a collection of ships' figureheads, and glorious, towering trees.

The Old Abbey itself, now reduced to crumbling walls, was home to Benedictine monks from the 11th to the 15th century. Another artifact in the garden, a Roman altar from the second or third century A.D., was moved from St. Mary's, where it was found.

Tresco's main historical sites are on Castle Down, the steep, windswept, heather-covered northern tip of the island. Reachable only by foot, the area includes ruins of King Charles's Castle; Cromwell's Castle, named after Oliver Cromwell; and ruins of prehistoric graves, agricultural systems, and houses.

Built between 1550 and 1554 in response to a threat from the French, King Charles's Castle originally consisted of two floors and included a ground-floor gun platform with five gun ports. Now all that is visible are portions of the walls and a graceful archway. From there is a view down to New Grimsby Harbor, the 50-foot tower of Cromwell's Castle, and the nearby island of Bryher.

Situated on a rocky promontory, Cromwell's Castle, actually an artillery tower, replaced King Charles's Castle in 1651 as the protector of the harbor. I climbed the interior spiral staircase for another, more intimate look over the water. At the top, I felt as if I had set sail.

I had, of course. Through the history of the Isles of Scilly.

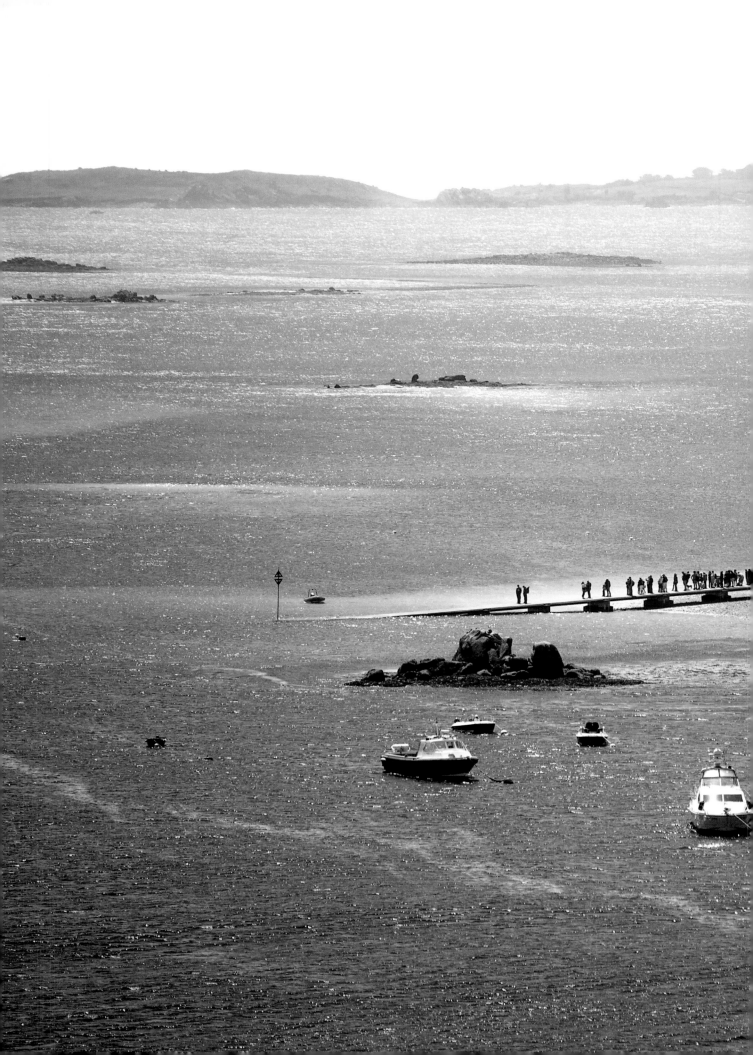

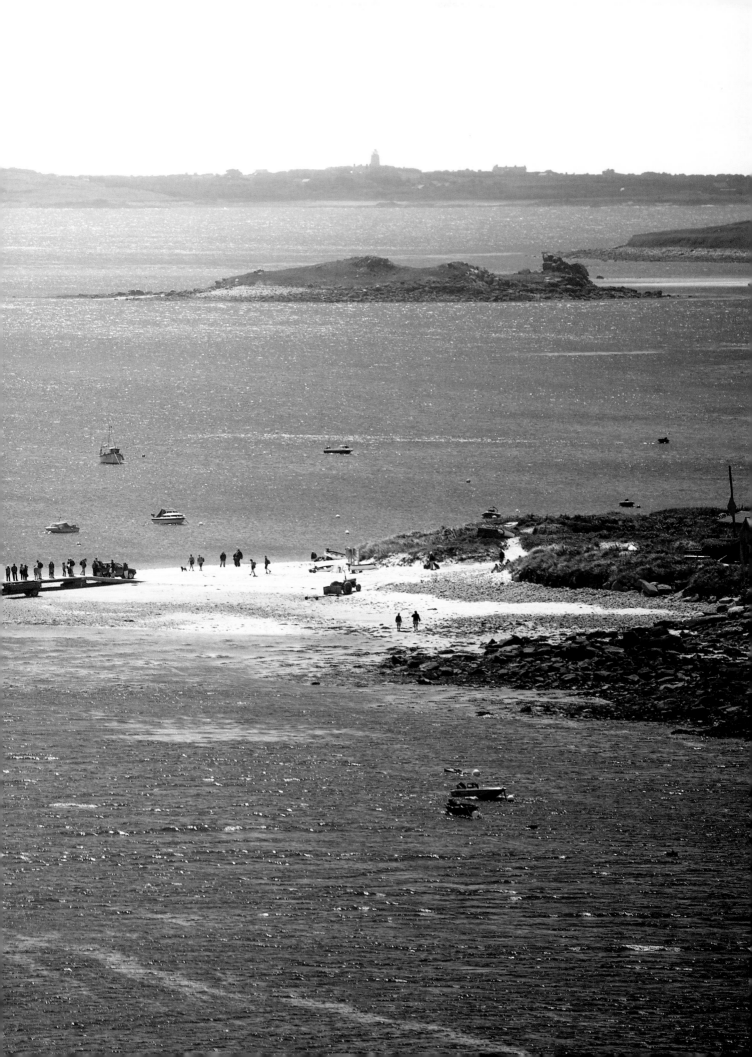

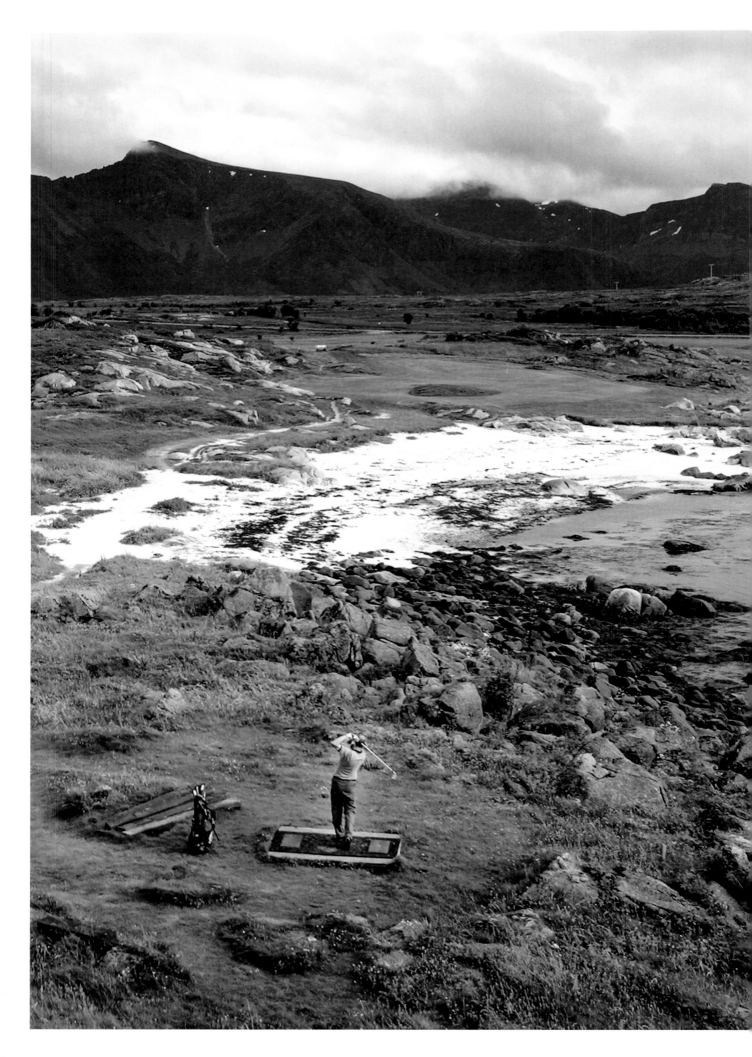

LAND OF
THE MIDNIGHT
TEE TIME

*In Lofoten, Norway, a golfer can play
nine holes in the 24-hour daylight of summer
above the Arctic Circle.*

TEXT BY JEFF Z. KLEIN
PHOTOGRAPHS BY JOHN McCONNICO

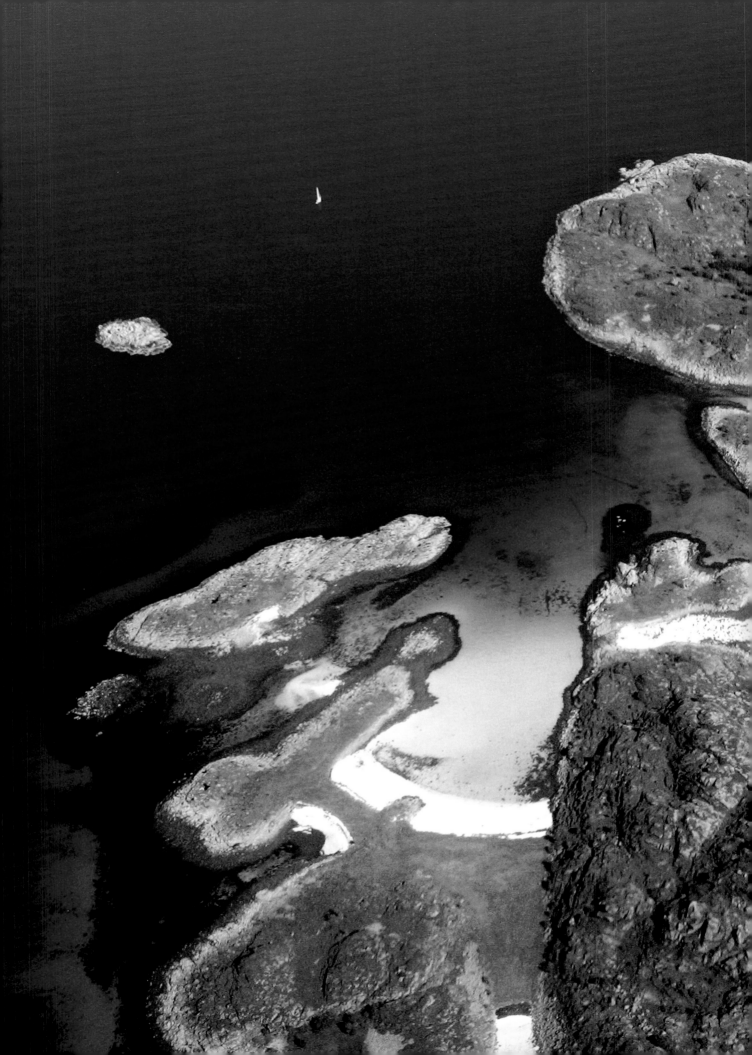

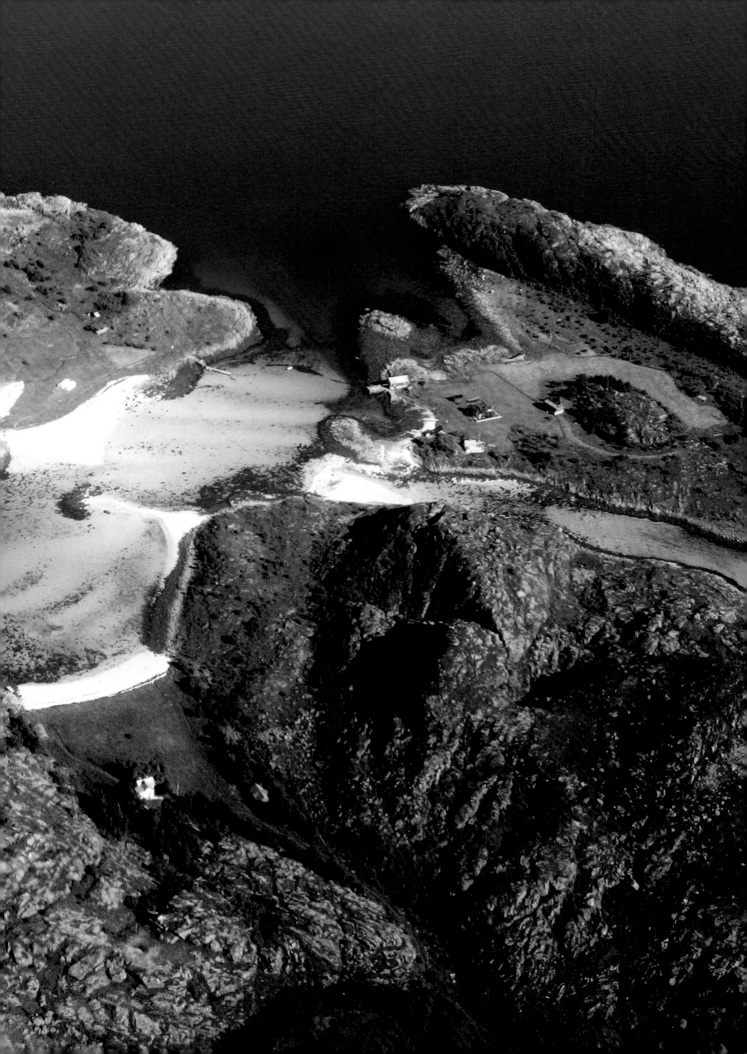

Page 100 One o'clock on a summer morning at the second hole of Lofoten Links in the Lofoten Islands, Norway.

Previous Small islands near the Lofoten Links.

Left The flag at the second hole.

Opposite Teeing off at the seventh hole at 2 A.M. "This is the best time," a teenage local golfer said. "Midnight or later."

It was going to be a tough chip shot: 50 yards onto a tiny green with the ocean right behind, the sun hanging just above the horizon and casting a bright gold glow on the water. One o'clock in the morning, and the sun was in my eyes.

I should have been asleep. But I was at Lofoten Links in Norway, the fourth or fifth northernmost golf course in the world, in the heart of summer. I'd just traveled for 26 hours straight, and I was 95 miles above the Arctic Circle, at 68 degrees north latitude, and exhausted. But the midnight sun was out, the temperature was a soothing 60 degrees, and an inviting golf course was at my disposal, so why sleep?

"This time of year, you get spectacular bursts of energy," Frode J. Hov, the course's founder, told me. "At 2 A.M. you suddenly decide you want to paint the walls."

It may have been one in the morning, but I was not the only golfer on the course. Two local teenagers were searching for a ball in the heather on No. 3. "I play every day," one said. "This is the best time — midnight or later." On No. 5, an Australian named Ian trotted over to introduce himself. "I work here at the shop," he said, "and after I close at 12:30 or so, I come out and play nine holes."

But 90 minutes later, I was the only soul on the course. The mountains were standing out clearly in the Arctic three-quarters light, the Norwegian Sea was lapping

against the rocks, sparrows and gulls were chirping and calling as if it were dawn, and just off a white sand beach less than half a mile away, a small red house stood alone in a deep green field of turf.

Lofoten Links stands on Frode Hov's family land. The idea to open a course here first occurred to a family friend and was embraced by Frode's father and by Frode himself. Many found the idea quixotic — there were few golfers then in Scandinavia, and the game was almost entirely unknown in the north. But the project went ahead, resulting in a nine-hole course incorporating all the natural features of the rocky headland and only rudimentarily manicured. The architect, a Sweden-based Englishman named Jeremy Turner, placed tees on promontories, fairways on narrow isthmuses, and postage-stamp greens bare centimeters from sandy beaches. He left thick stands of gorse and clover everywhere. It's the kind of golf course the Scots might have made hundreds of years ago. And golfers have found it.

The next morning, the wind was up out of the south. Huge clouds poured over the tops of the mountains. I played with Chris and Yvonne, a Dutch couple. Chris sliced his shot into the ocean. I hit mine onto the beach. Yvonne lost balls in the gorse, in a brook, in a lawn of enormous daffodils, in the rocks, on a waterside strand of old mollusk shells. "I am hitting the ball in silly places," she said.

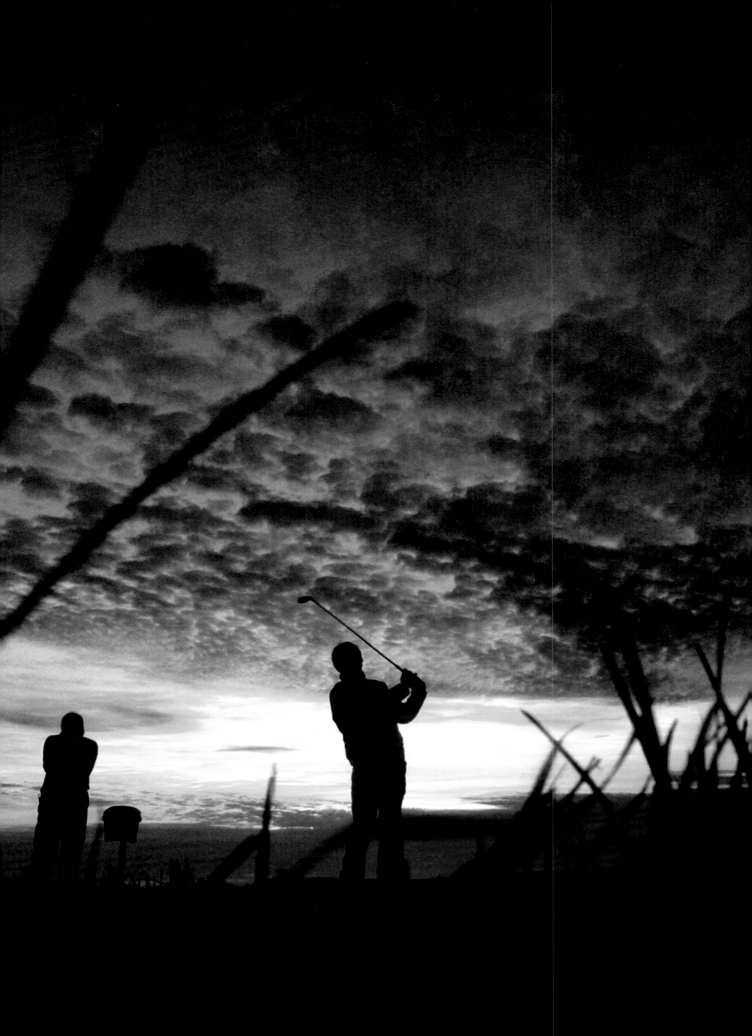

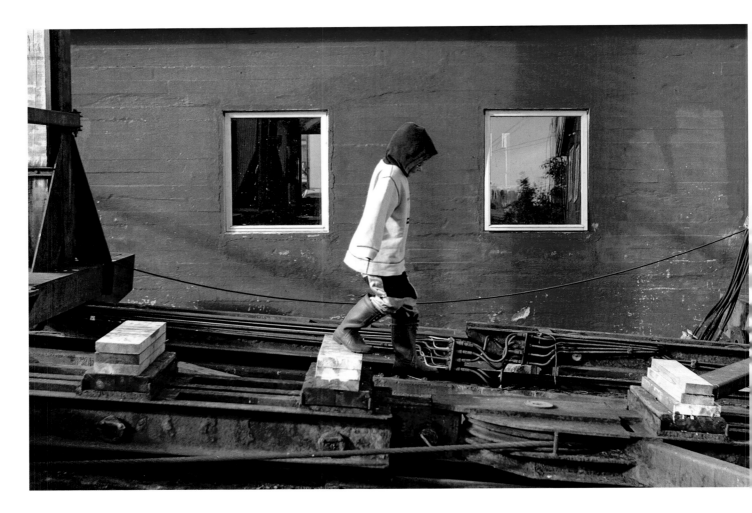

Above and opposite In Henningsvaer, a harbor town near the Lofoten Links, a boy walks down a boat launch and kayakers find an easy passage in quiet waters.

Following The harbor of Henningsvaer in the picturesque Lofoten Islands.

In the afternoon, I played with Frode. On No. 2, he pointed to some rocks and shrub-covered peat marked off by four little white out-of-bounds stakes. "That's a Viking grave," he said casually. "There are a couple more over on No. 8."

What did he think the Vikings would feel about people playing golf where Viking bones rest?

"They'd probably think it's fun," he said. "They were Vikings."

The 100-mile-long Lofoten archipelago is bathed in the mild waters of the North Atlantic Current, making this latitude warmer than it is in North America. In Canada, there are approximations of golf courses on the tundra well above the Arctic Circle, at Ulukhaktok (also known as Holman) in the Northwest Territories, or set up temporarily

on the pack ice in Nunavut, but without the Gulf Stream to warm things up, the golf played in these places is not the golf played in the Scandinavian north.

The Lofoten Islands are first glimpsed as a massive sheet of mountains rising 3,000 feet out of the sea — the so-called Lofoten Wall — but as boats approach, the mountains part into innumerable fjords, bays, and coves. In the main town, Svolvaer, a perfect harbor is set against towering mountains.

In August, when most of Europe is on vacation, Lofoten's narrow roads fill with camping Germans, Swedes, and Norwegians who fish, scuba dive, hike, climb, or just relax. Beaches, coves, cute but sturdy fishing boats, and tidy farm houses appear and disappear in bright light or foggy mists, and islands are linked by spectacular bridges that soar

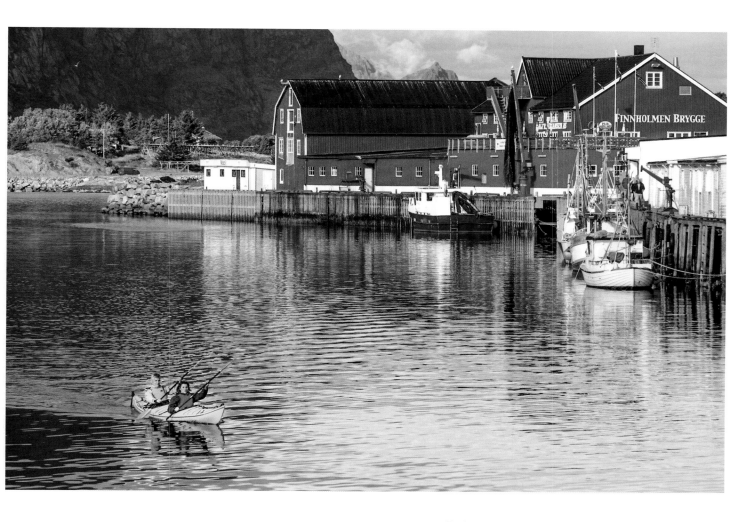

Explorer's Notebook: A few other golf courses are as far north as Lofoten's. In Norway, there are Tromso (69 degrees north latitude), Narvik (68 degrees), Harstad (68 degrees), and North Cape (71 degrees). In Sweden, northernmost is Bjorkliden (68 degrees). In Finland, at Rovaniemi, you actually hit over the Arctic Circle itself on the sixth hole.

over surging tidal straits. Along the way, beautiful fishing villages hug the fjords, and in the middle of the islands, in the town of Borg, site of the largest Viking manor house ever unearthed, a museum recreates the old Norse world.

A fog rolled in from the sea. Frode and I were tromping down the second fairway, through a patch of little white flowers that in July produce the northern delicacy of Arctic cloudberries. "People have gotten into fights over picking cloudberries on other people's land," he said. "You go over to your neighbor's land to pick his berries in the fog so he can't see you. Then you sneak back to your land. And you run into him sneaking back from picking your cloudberries."

Later the clouds were high, leaving everything gray but perfect for golf. At 1 A.M., the light was like late afternoon, and we were out again. But the next day was rainy, and

for a while the clubhouse filled with golfers from Sweden and Norway. We ate and drank and told stories. "I had a good shot on 5," one local man said, "and it was six inches short." Well done, I said. "No, no," he said. "It was six inches short, and it rolled into the water."

On my last night, a group of us headed out for one more midnight round. The tide was high, and sometimes we had to roll up our cuffs as the ocean ran across the little isthmuses that connect the fairways to the greens. I sliced a tee shot into the ocean and muttered darkly.

But it was easy to regain perspective. The sea was swelling against the shore. The mountaintops were shrouded in mist. Gulls drifted above the deep green fairway. And the golfers stood together, laughing at a joke someone had told in the wee-hours light of Lofoten.

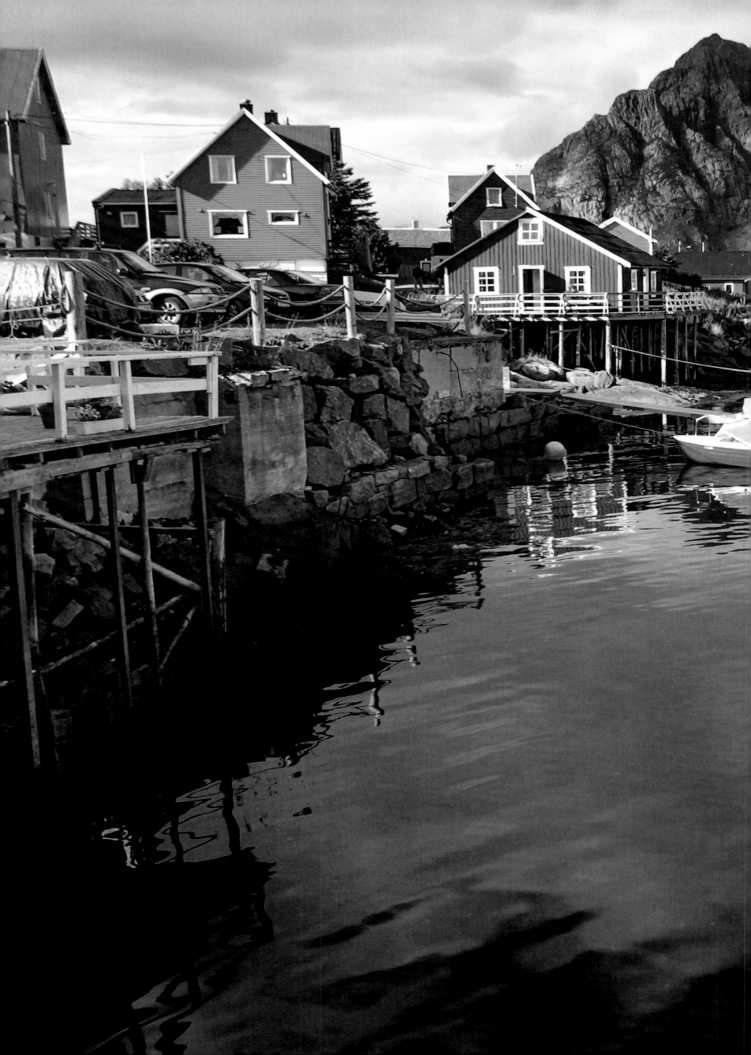

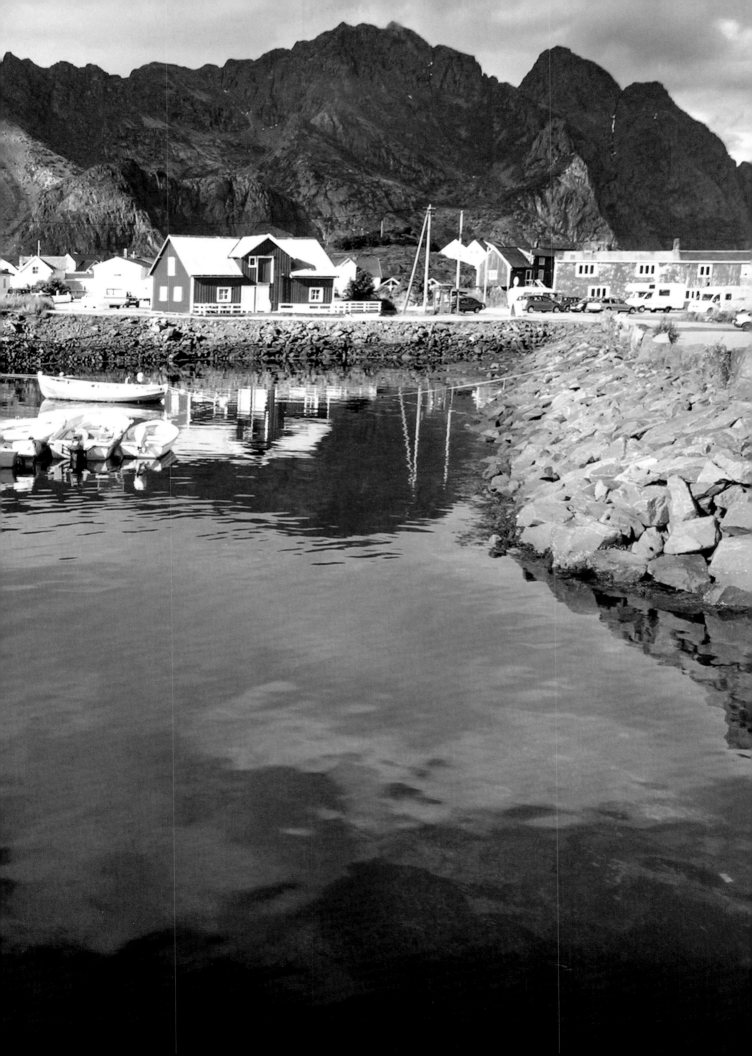

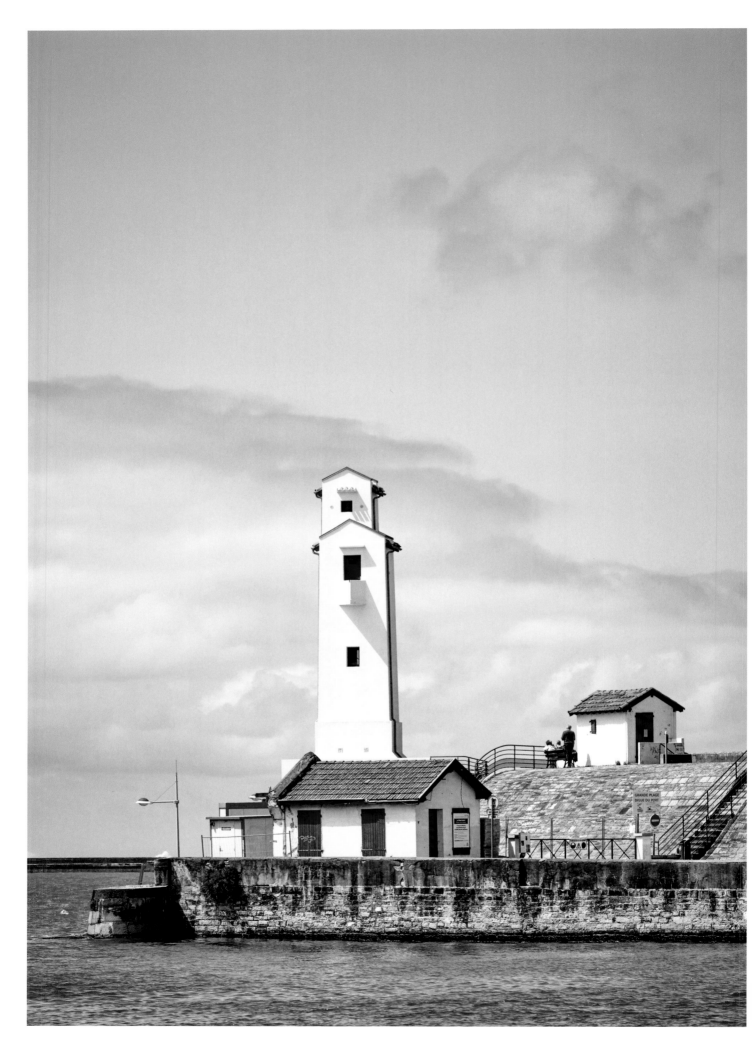

THE FRENCH SIDE OF BASQUE COUNTRY

From the Spanish border north to glamorous Biarritz,
a pocket of France still knows how to speak
Euskara and play pelote.

TEXT BY CHRISTIAN L. WRIGHT
PHOTOGRAPHS BY ANDY HASLAM

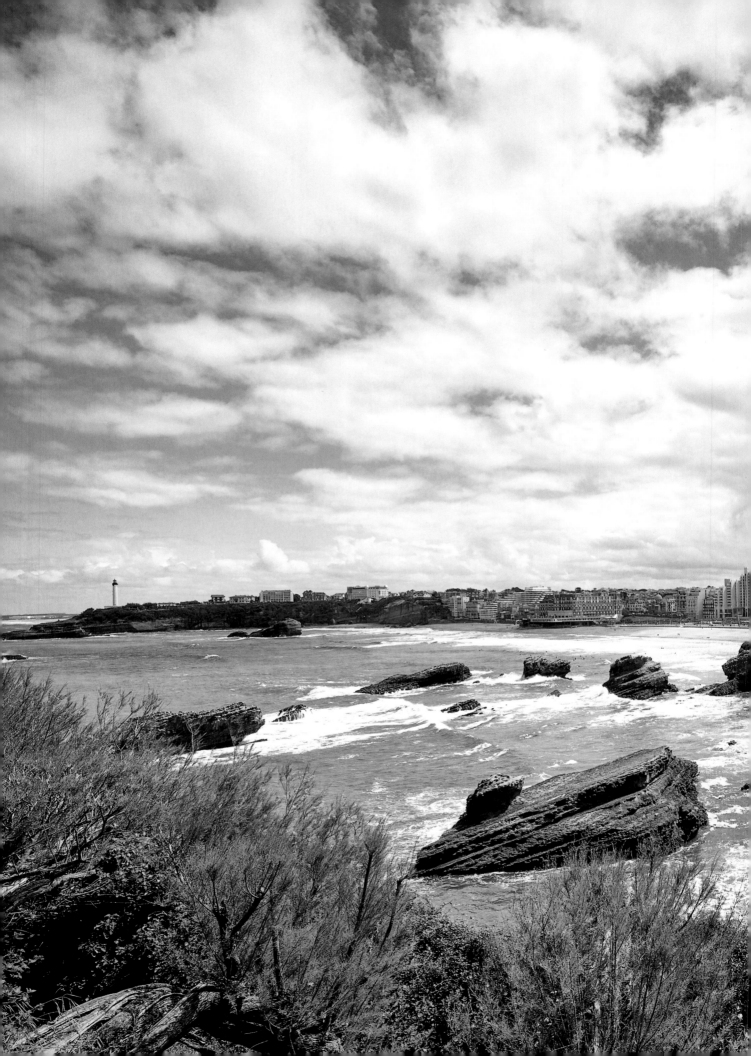

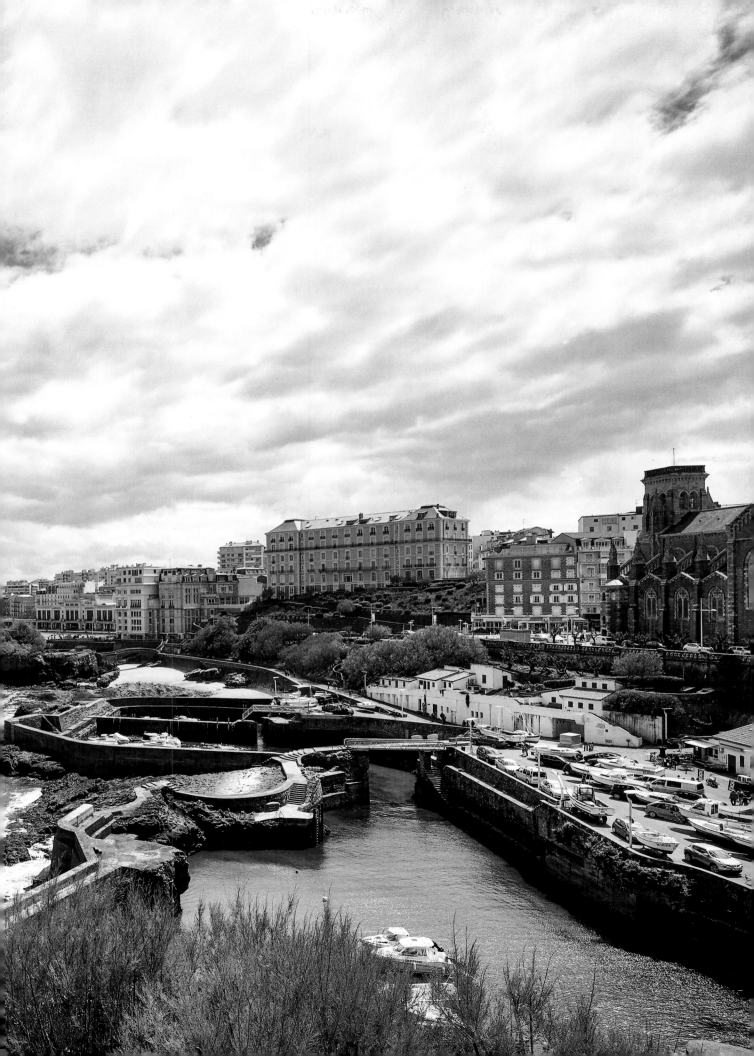

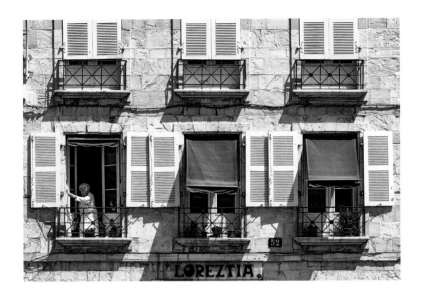

Page 110 A lighthouse at the mouth of the harbor of St.-Jean-de-Luz.

Previous Port des Pêcheurs, Biarritz.

Left and opposite Shutters in Bayonne and a filigreed railing on St. Jean Baptiste Church in St.-Jean-de-Luz. While most Basques live in Spain, three of the seven provinces that make up Basque Country are in France.

On a warm Sunday late in October, it felt as if summer had returned to the Basque Country. Swimmers joined the surfers along the coast. A strong sun turned the Atlantic Ocean from green to blue. In the fishing village of Ciboure, townspeople poured out of L'Église St.-Vincent, a 16th-century church with an octagonal tower. "Bonne journée," called the priest to his congregation as they headed off into the narrow streets.

Most people think of Spain when they think of the Basques, an ancient people whose history in their part of Europe goes back for thousands of years. But this was France. Three of the seven provinces that make up Basque country are French, and while it would be inaccurate to say that Basque France is undiscovered, it is over-shadowed by more celebrated parts of the country, like Provence. In a world in love with France, the Basque part of the country is the little sister who did not get invited to the dance.

Basque France is a tiny land of just 300,000 people, compared to two million in Basque Spain, but with its own defining characteristics and traditions: a history that dates back to pre-Roman times, a distinct architectural style, deep-seated pride, and old men in berets at their local bars. In recent years, a younger generation has opened design shops, remade the food scene, and spruced up classic red-and-white farmhouses.

If you're Basque, you're Basque through and through, but despite the solidarity, there is also a natural cultural divide. While there is an unmistakable joie de vivre in Spain, on this side of the border there is an elegant reserve.

When my friend Gabriella Ranelli and I drove from Spain across the French border into the province of Labourd, the landscape changed. Green hills gave way to the craggy foothills of the Pyrenees. From modest Ciboure, where the composer Ravel was born in 1875, we went on to nearby St.-Jean-de-Luz, the town where Louis XIV married Marie-Therese of Spain in 1660.

We parked the car and hurried through sloping, narrow streets to boutique-strewn Rue Gambetta. The tea towels and espadrilles of St.-Jean-de-Luz are the standard by which all others should be measured. We stopped for lunch at Le Suisse, a little bar, cafe, and terrace with the Paris chef Yves Camdeborde in charge of a menu that plays on the regional cuisine. We had a glistening arugula salad accompanying polenta with shrimp and pork, a light, salty surf and turf.

About 12 miles up the coast, the slate rooftops of Biarritz's grand villas appeared. Up until 1650, Biarritz was a significant whaling port on the Bay of Biscay. It became a storied summer playground for European royalty after Empress Eugénie persuaded her husband, Napoleon III,

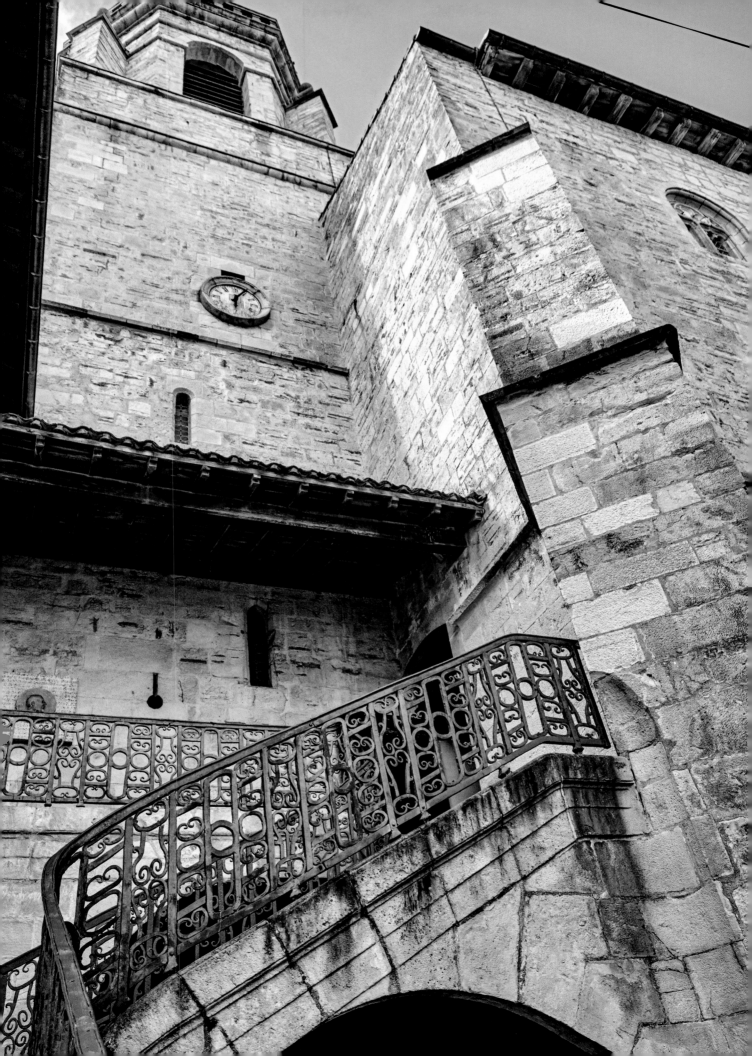

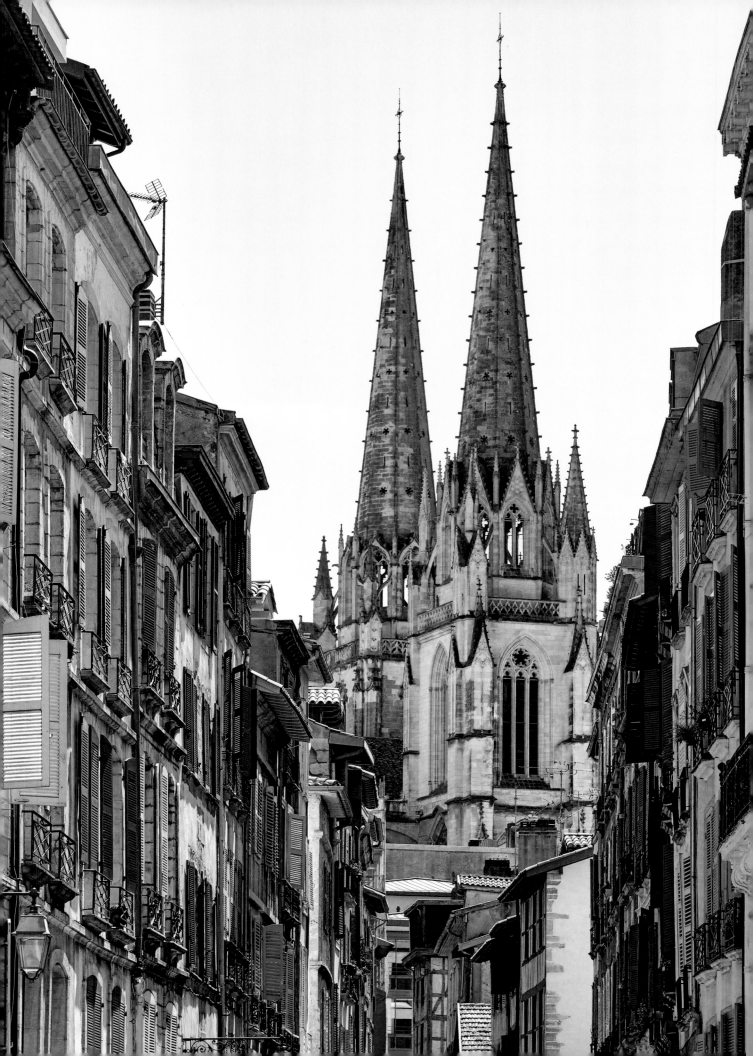

Opposite The spires of
Ste.-Marie, a Gothic cathedral
in Bayonne.

Right A bridge in St.-Jean-Pied-
de-Port. The city's name means
"St. John at the Foot of the Pass."

Below Colorful Bayonne, a
fortified city and the capital of
French Basque Country.

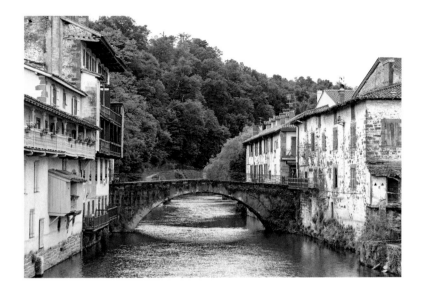

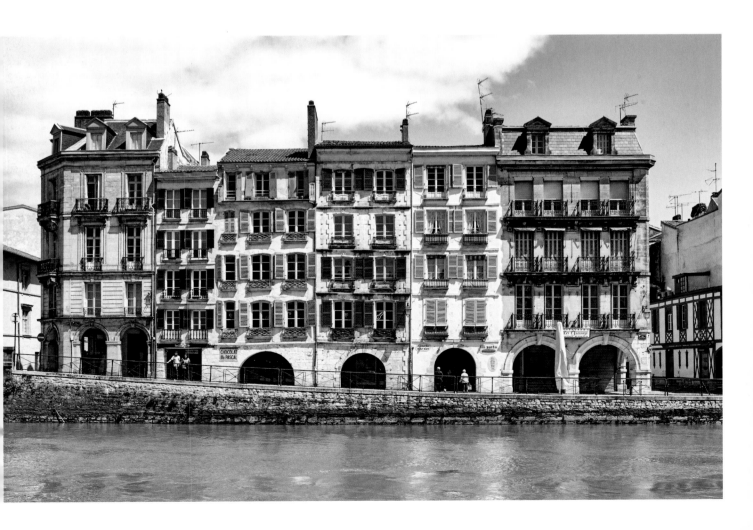

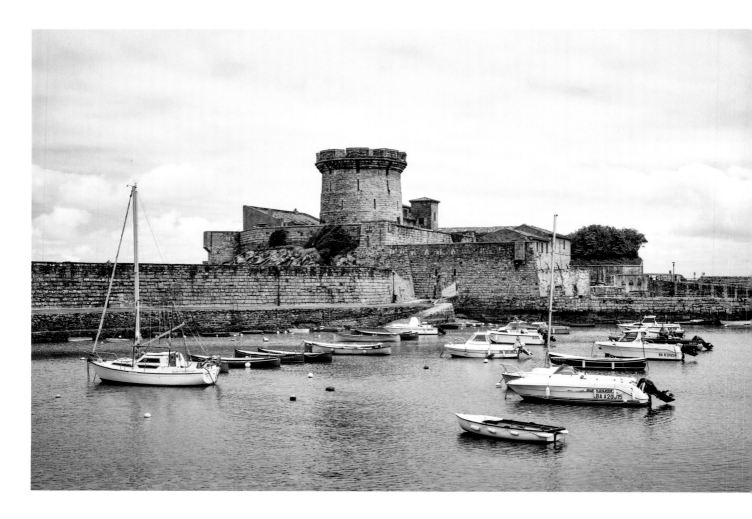

Above and opposite Socoa Fort and the harbor at Ciboure, a modest town a few miles from the Spanish border.

Following Villas at Biarritz. The city's distinguishing architecture runs from Romanesque at the 12th-century church of St.-Martin to Art Nouveau at the train station. In the 19th century, Biarritz was a getaway for the rich and the royal.

to build a palace there in 1854. Today its waves make it the surfing capital of Europe.

Biarritz is distinguished by its architecture: the Romanesque 12th-century church of St. Martin, an Art Nouveau train station now used as a theater, turreted villas high above the sea. There's a different allure at the other end of town, near the market: residential and grittier. We set up at Hôtel de Silhouette, a converted stone house from the early 1600s, and explored cool new shops at the Port Vieux, a tiny cove that's lit up at night.

The weather had turned to bluster and rain by the time we got to Bayonne, the capital of the French Basque Country, a fortified city where the River Nive meets the Adour. At moments along the quais, it seems like a mini Paris or a Basque-flavored Amsterdam. Four- and

five-story houses, some only two windows wide, have faded brick chimneys and shutters in light blue, red, hunter green. Their foundations slant, their sills sag, and they are squashed together, dormer windows at the top and little storefronts at street level. A florist here. A beauty parlor there. In the Petit Bayonne section, surviving fortifications — upgraded by Vauban, the military engineer who advised Louis XIV — form a park.

Inside the Basque and History of Bayonne Museum, I found the story of the bayonet, which was first made here. Used for close combat, it was originally designed to fit into (instead of onto) the muzzle of a musket.

Outside the market, Gabriella gestured excitedly. "The bishop of Bayonne!" she said. "He's having lunch." And there he was, sitting among his people, one guy using a

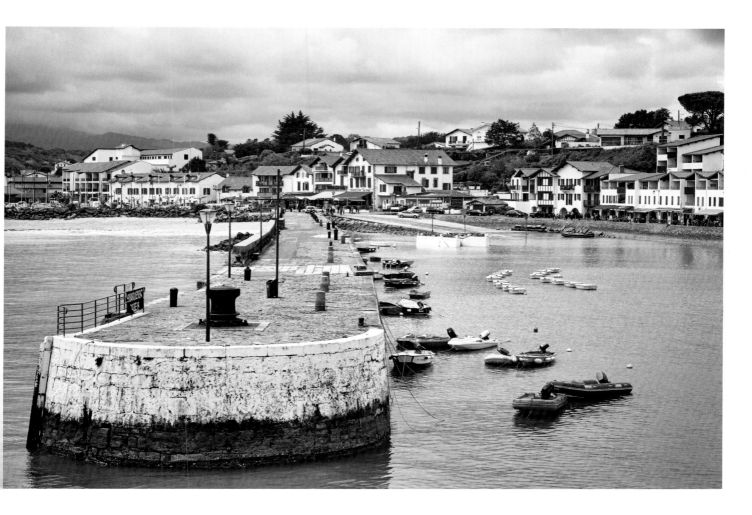

Explorer's Notebook: Every Basque village seems to have a fronton, the backboard used in the Basque game of pelote, called pelota in Spain and said to be the fastest game in the world. South American jai alai is a variation of it. Biarritz is a good place to catch a pelote match.

selfie-stick to get a photo. Gabriella explained his traditional importance; hundreds of years ago, whenever a whale was caught the bishop of Bayonne received the prized tongue.

When we headed southeast out of Bayonne, the Pyrenees suddenly came into view and the countryside opened up. Agrarian customs are alive and well in inland villages, and Euskara is more commonly spoken than it is along the cosmopolitan coast. In one charming village, Espelette, houses were festooned with red peppers. Traditionally, the piments d'Espelette dangle on strings to dry before being ground into the spice that's used widely in Basque recipes.

It was pitch dark and quiet when we pulled up to the Hôtel des Pyrénées, a classic auberge in St.-Jean-Pied-de-Port. We had the glass-enclosed dining room of the Michelin-starred Arrambide restaurant to ourselves.

In the morning the town was bustling. It was market day, and in a covered building in the Place des Remparts, old women in calf-length skirts shopped for vegetables, confits, honey, and the region's famous ewe's milk cheese. The narrow streets of the densely packed village are lined with stone houses whose carved lintels above wooden doors give their dates — say, 1649. Some are shops now, selling black wool berets or heavy woolen cardigans. Some are hostels for pilgrims walking the route to Santiago de Compostela.

At the citadel high above the town, ivy crawled up gray walls and the grounds were wild with hydrangeas. I could see the tiled roofs of the village spread out below and the heavily wooded peaks all around. Spain was only five miles away, but Basque France was a world apart.

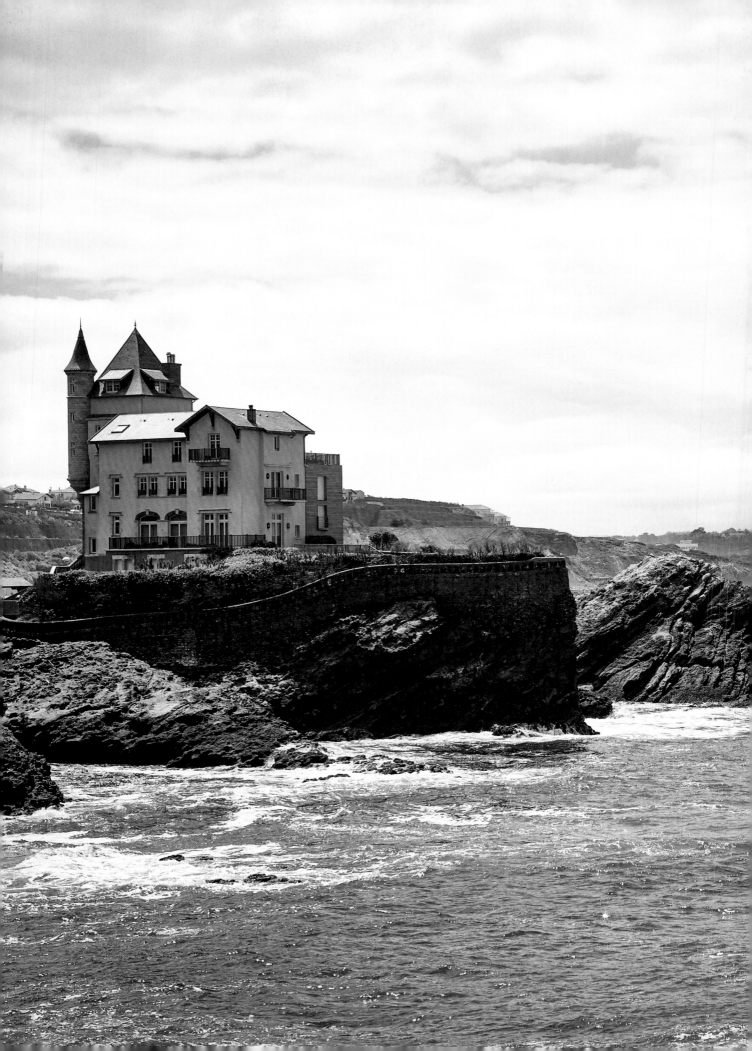

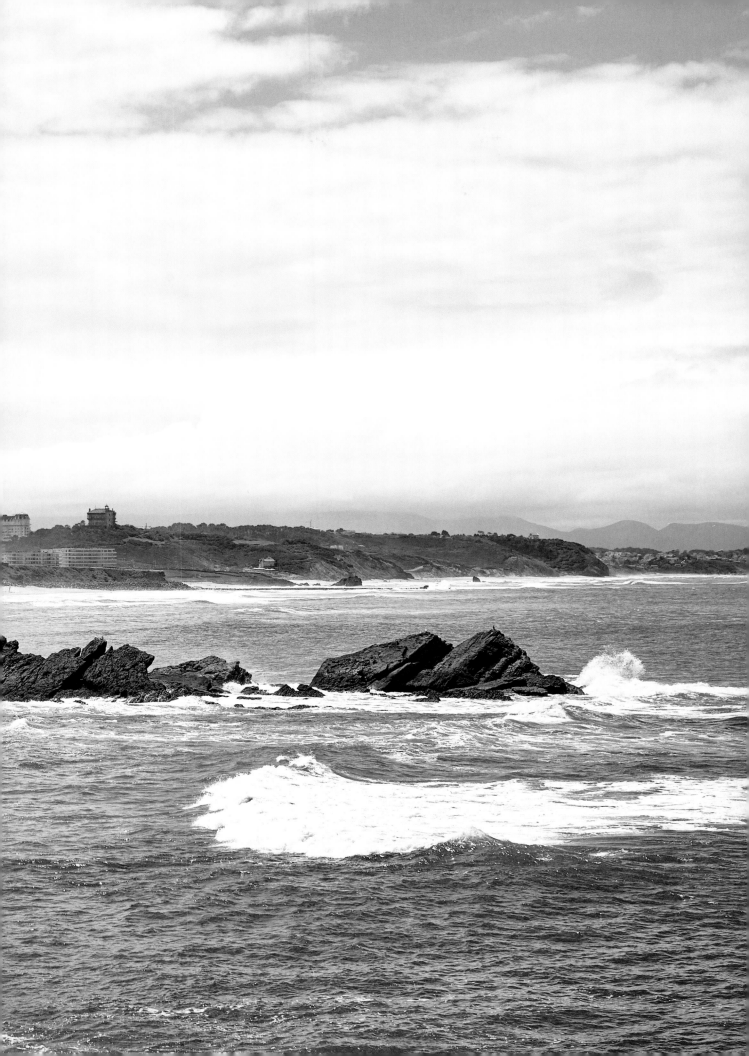

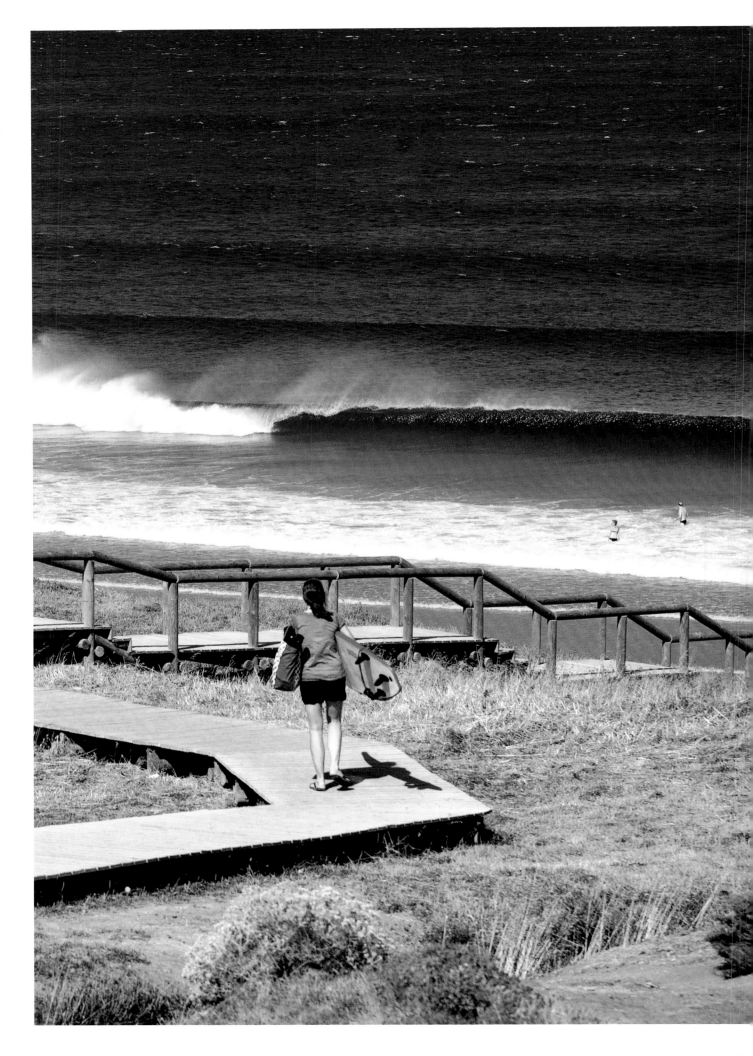

AN UNSPOILED ALGARVE

*Avoid the summer crowds in southern Portugal,
and concentrate on the beauty of the sea
and a flavor of tradition.*

TEXT BY SETH SHERWOOD
PHOTOGRAPHS BY JOÃO PEDRO MARNOTO

Previous Praia do Amado in western Algarve.

Left Red and green peppers top a plate of anchovies at one of the Algarve's spots for seafood.

Opposite On a bridge that splits the town of Tavira in two, a musician provides entertainment for passersby.

It's no secret that come summer, the alluring coastline of southern Portugal — better known as the Algarve — practically sags under the crush of holidaymakers who throng its vacation villages, resort hotels, marinas, golf courses, souvenir emporiums, seaside cafes, and seasonal discos. "In July and August, you can't find a single space to put your towel," one hotel manager told me.

Blame the Algarve's good looks. Stretching from the Spanish border nearly 100 miles along the Atlantic coast to the very southwestern tip of the European continent, the seaside is blessed with windswept dunes, powdery sands, ocher cliffs, and natural grottoes. The seafood can be sublime and the prices extremely modest when compared with those on the Amalfi Coast of Italy or the French Riviera.

Amid the sunscreen-smeared hullabaloo, the question arises: Is there an alternative, less trodden Algarve, where a bit of serenity has been preserved, along with a flavor of the past?

Carried by the region's efficient EVA bus network, I found just such an Algarve to the west: rocky coasts and sun-baked hills, fishing villages and citadel towns, unmarked surfer beaches and mom-and-pop seafood joints. This unspoiled Algarve, it turned out, is available to anyone with bus fare.

I began in Tavira, a coastal town near the Spanish border with vestiges of ancient Phoenician and Roman settlements lurking under its streets. Whitewashed buildings with wrought-iron balconies filled narrow lanes, along with numerous Renaissance and Baroque churches — testaments to the town's wealth generated long ago from the fishing and salt trades.

On a stone bridge spanning the Gilão River, a three-piece band of guitar, accordion, and tambourine played spirited folk songs. More music spilled out from the tile-lined interior of the Renaissance-era Church of Misericordia, where a bearded hipster schoolteacher was strumming a guitar while leading boys and girls, dressed in pink smocks, in a soaring hymn. Above, atop a hillside, the ruins of a medieval castle and the clock tower of an 18th-century church lorded over a sea of orange-tile roofs. A few German and French voices drifted from sidewalk cafes, but hardly enough to drown out the locals' mellifluous Portuguese greetings of "Bom dia!" and "Tudo bem?"

Resurrected historic edifices were scattered all over. The town's former covered market — a lovely wrought-iron structure from the 1880s — bustled with boutiques and restaurants. Some new white walls and oddly angled metal surfaces elevated a former jail into a modern town library.

My impressions were reinforced when I met Tim Robinson, a stocky, blond Englishman who had lived in the Algarve since 2008. "For people who are interested in the historic nature of the Algarve, this is probably the crown

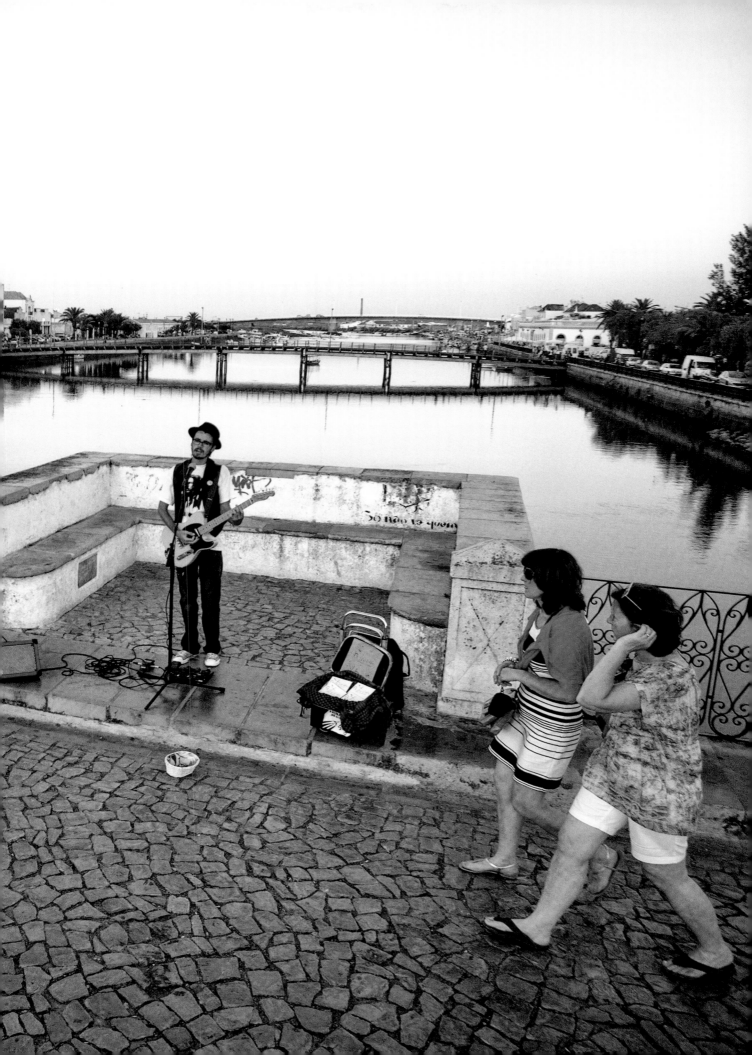

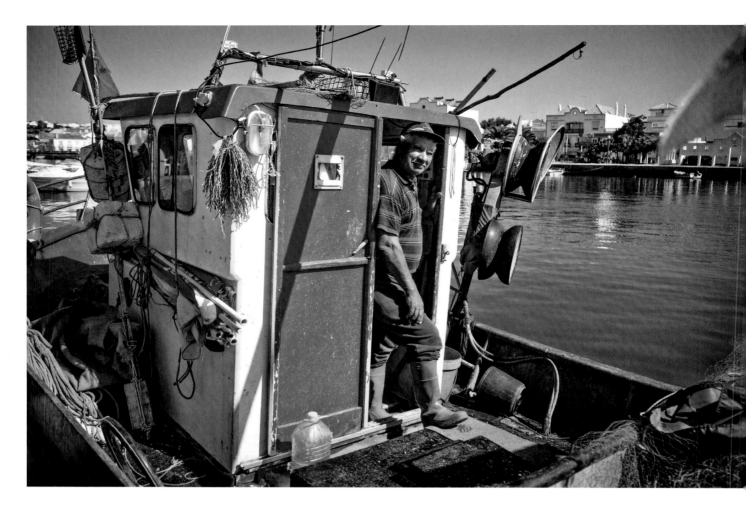

Above and opposite A fisherman and a shellfisherman in Tavira, a town that once derived considerable wealth from the fishing and salt trades. In the town itself, whitewashed two-story buildings with wrought-iron balconies line narrow lanes, along with numerous Renaissance and Baroque churches.

Following Relaxing in Pedralva, a rural town transformed from a near-ruin to a restored eco-tourism village.

jewel of historic cities," he said, adding, "You don't get groups of guys coming here to celebrate a friend's wedding."

Traveling on, I encountered mainstream Algarve in Praia da Rocha, a sprawling beach resort. But instead of stopping, I took a local bus into the countryside, where I found lemon trees, orange groves, and a hilltop fortress. Its red-stone battlements hovered over Silves, a village that spilled down the hillside toward a river.

I met Maria Gonçalves, the chief municipal archaeologist, in the castle's lushly planted grounds. A few couples roamed the ramparts, peering through the crenelations, as she filled me in on the local history.

The original settlers and rulers were Arabs from Yemen, arriving in the 11th century, at the time of the Moorish occupation of Andalusia in neighboring Spain. Silves

became a regional capital and a cultural hub. The Moors are long gone, but you can barely hurl a fez in Silves without hitting some homage to their historic role. Ceramic tiles with swirly Arabesque patterns form the facades of many of the two-story buildings, and shops on Rua Elias Garcia display Moroccan hammered brass lanterns. Within a 16th-century house called Estudio Destra, one of many artists' studios sprinkled around town, shelves showed off ceramic plates, jars, and tiles whose geometric patterns and stylized animals were influenced by Moorish motifs.

My final push to the western edge of the Algarve, Europe's far southwestern corner, landed me briefly in the port town of Lagos, where hawkers held out fliers for typical tourist excursions like snorkeling adventures and

126

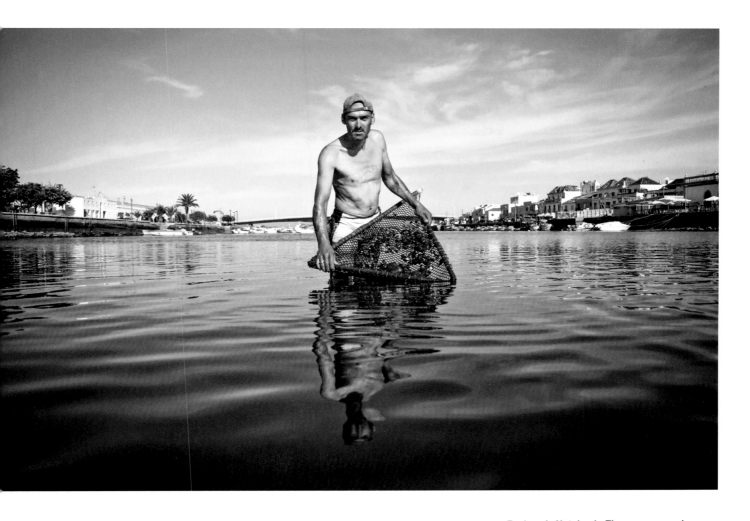

Explorer's Notebook: There are around 3,000 Arabic words in Portuguese, according to Maria Gonçalves, the chief municipal archaeologist of Silves. They include the names of numerous Algarve towns: Aljezur, Albufeira, Alvor, Alfambras.

sightseeing cruises. I made my way to the stone-paved streets and restored white stone houses of Pedralva.

Pedralva's existence is an Algarve miracle. Several years ago its population had dwindled to nine residents, and many of the 19th-century houses were abandoned wrecks. Then Antonio Ferreira, a former Lisbon advertising strategist, effectively saved the town by transforming it into one of the most original new getaways in the Algarve.

In 2010, he and some partners opened Aldeia da Pedralva, an eco-tourism village replete with cobbled lanes, whitewashed houses, a grocery store, and a traditional Algarve restaurant. Outside the reception area where we met, in a quiet valley of pine and cork trees, no nightclub pounded, no driving range beckoned. Occasionally a rooster crowed. "We are the other Algarve," Ferreira said.

Keen to see the coast — the true end of the world, or at least the continent — I hitched a ride with a villager to Praia do Amado, a few miles away at the end of an unmarked road. Despite gray clouds, a steady procession of barefoot young men and women in identical head-to-toe black outfits marched across a crescent of soft sand bookended by jagged cliffs, determined expressions on their faces. They were surfers, looking like some monastic order striding into the tide to worship the wave.

That night, I retired to my cottage in Pedralva, with its timber ceiling and wood furnishings in funky colors. No television, cellphone signal, or Internet link distracted me from the silence and the stars. The only sounds were those of owls and crickets in the surrounding valley: the voices of the unspoiled Algarve.

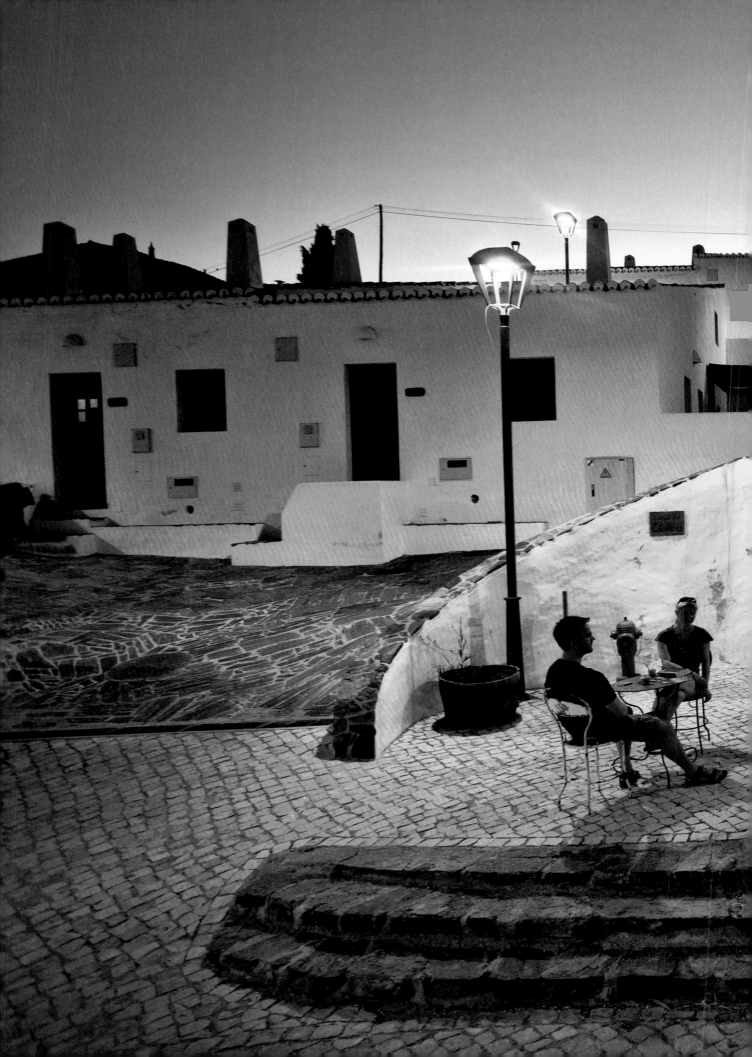

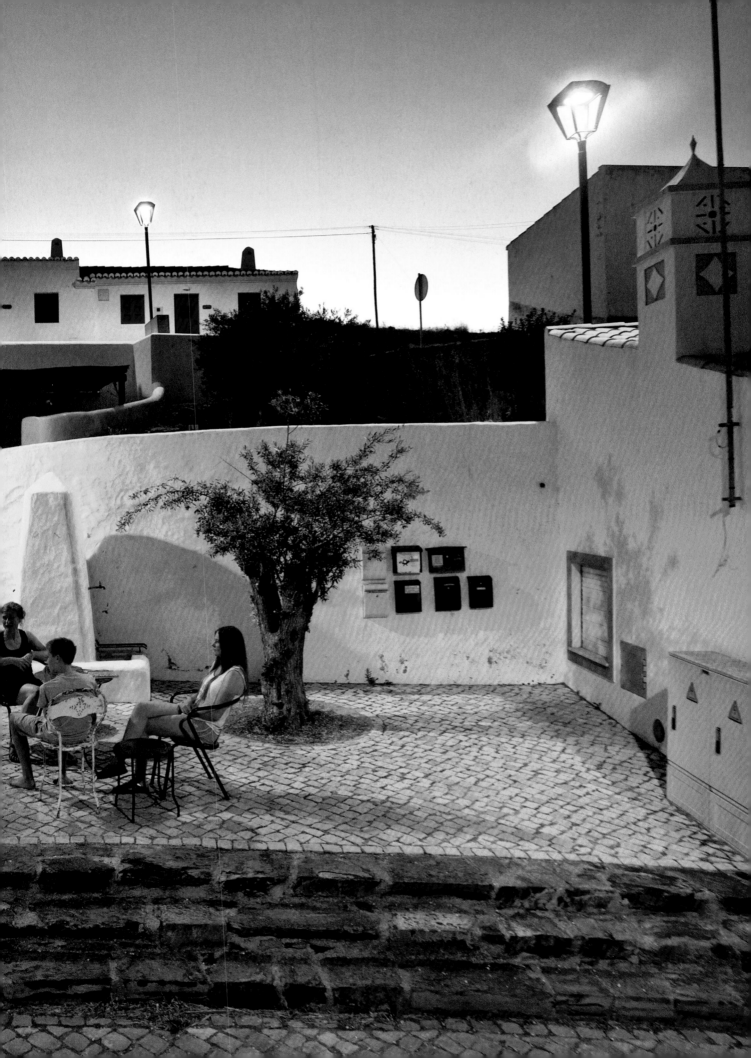

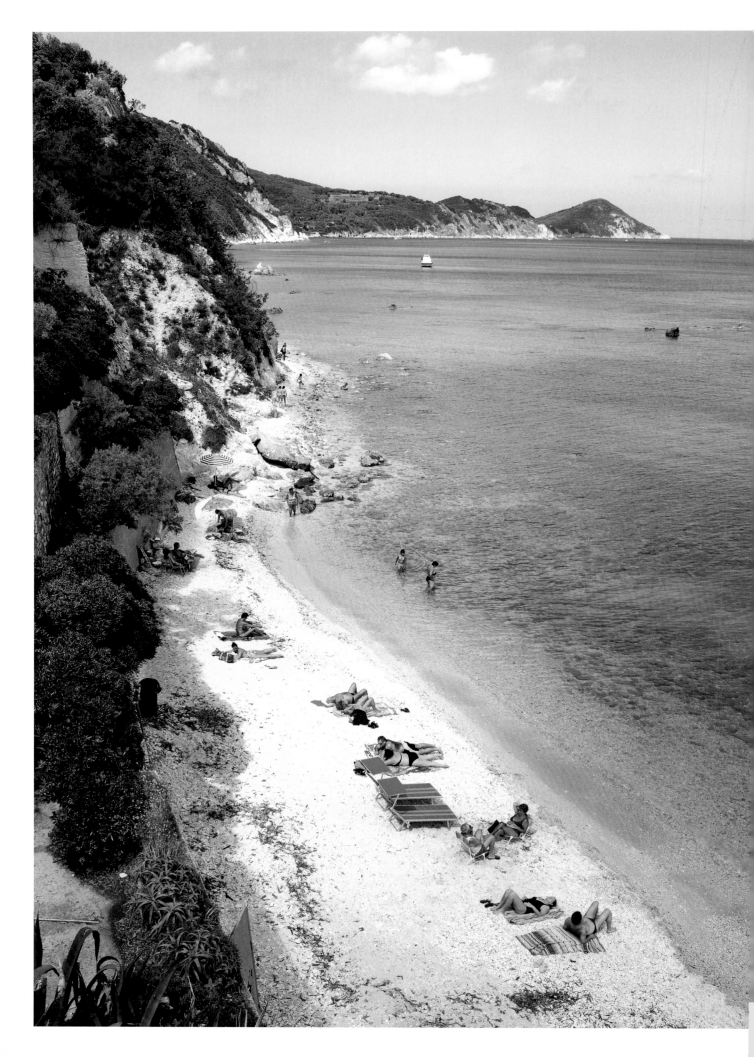

SEASIDE IN THE TUSCAN SUN

*Away from the haunts of the jet set
and not far from Pisa, there's an Italian coastline
that's inviting and accessible.*

TEXT BY FRANK BRUNI
PHOTOGRAPHS BY DAVE YODER

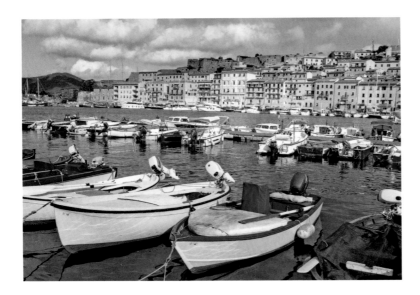

Previous A small cove beach near Portoferraio on the island of Elba, a few miles off the coast of Tuscany. Elba is the largest island of the Tuscan Archipelago.

Left Boats at Portoferraio. To modern eyes, Napoleon's exile on Elba hardly seems like punishment.

Opposite The coast near Porto Santo Stefano.

Following A hotel's private rock beach near Porto Azzurro on Elba.

Outside of Italy, it's easy to forget Tuscany even has a coast. Most foreigners who visit there head straight for the hills and the art-stuffed inland cities: Florence, Siena, Lucca. But if you've ever lived in Italy, as I was once lucky enough to do, you've probably been to the Tuscan coast time and again, because it's accessible, it can be relatively uncrowded, and it's not as potent a magnet for jet-set interlopers as such postcard-perfect haunts as Taormina, down in Sicily.

Not that it's exactly undiscovered. Napoleon was briefly exiled to Elba, the largest of seven islands in the Tuscan Archipelago, many of them a fairly easy boat ride from the mainland. But don't envision an Italian Alcatraz. Elba is a happy surprise, and that phrase applies to much of the Tuscan coast. Name your pleasure. This coast can probably handle it.

Beautiful topography? Monte Argentario is a scenic, sea-skirted hump, once an island, now more of a peninsula, connected by several sandy isthmuses to the shore. It belongs to the southernmost stretch of the Tuscan coastline, known as La Maremma, which is where a Roman might go on a summer weekend when travel time is limited and the inns and hotels elsewhere are all booked. But it is also the location of L'Andana, an exclusive resort near the ocean that has a Michelin-starred restaurant.

As for Monte Argentario, swells in the know have always flocked there, perhaps making a nest at Il Pellicano (the Pelican), a storied resort above Porto Ercole, one of the Argentario's two main towns. The other is Porto Santo Stefano. Apart from those sandy isthmuses, the Argentario doesn't have much in the way of beaches. Residents claim a fair share of its best real estate, and some of its loveliest nooks are most accessible by boat. But the slope-hugging road around it can be thrilling to drive, with breathtaking views to the south, north, east, and west. The sun glints off the water, then sets below it. Best to abandon the car and find a seat in a waterfront cafe before that happens.

You want splendid dinners? They're about as easy to find on the Tuscan coast as anywhere else in Italy, and if your passion is fish, you're in particular luck. Not just in Porto Santo Stefano but every place I visited, restaurant menus brimmed with it. Wine? The restaurants surprised and delighted me with their lists, or rather the prices. The Italian restaurateur's habit of not marking up wine nearly as much as an American restaurateur would mean that I could buy Italian wines for much less than I can at home in the United States, where the price also includes the cost of importing them. So my friend Jeremy and I drank arneis, vermentino, pinot bianco, Lugana.

Farther north, near the slightly inland city of Lucca, is Viareggio, a messier affair: scruffy in spots, tacky in

Above Viareggio is scruffy in spots, tacky in others, none too restful. But it has acre upon acre of sand on a straight shore-line of deep, flat beaches.

Following Porto Santo Stefano, one of the two main towns of the Argentario.

Opposite A jump over a board-walk near Viareggio.

others, none too restful. But it has a majestic stretch of the Apuan Alps behind it, and it has sand, acre upon acre of sand, on a straight shoreline of deep, flat beaches. They're beaches as ruthlessly efficient human rotisseries, set up for cooking people instead of chickens, with long, parallel lines of blue or red or green lounge chairs stretching nearly as far as the eye can see.

You want something totally different, a crescent-shaped hideaway on a contained inlet of still, clear, turquoise water? Your basic island fantasy? Take the ferry to Elba. It's just an hour's ride from the Tuscan city of Piombino, yet it feels more remote than that. And while it doesn't have the cachet of Capri, it's gorgeous, with an interior of green mountains and a perimeter of coves, cliffs, and comma-shaped beaches hugged by imposing ridges of

land. Much of it is still wild, though there are excellent roads: You can zip between the charming, relatively sleepy main towns, Portoferraio and Porto Azzurro, in about a half-hour. The vistas suggest that for Napoleon, banish-ment and Club Med were basically the same thing.

Come to think of it, though, Forte dei Marmi, one of the last significant Tuscan beach towns before you hit the Ligurian coast to the north, would probably better suit an emperor — thwarted, undersize, or otherwise.

It's a beach town that's equal parts high-ticket shopping and high-octane tanning, late-night clubbing and early-morning walks. It serves to some extent as a sort of Hamptons for the city of Milan and to some extent as a sponge for post-millennial Russian money. If you saw Russian oligarchs huddled over cappuccinos in one

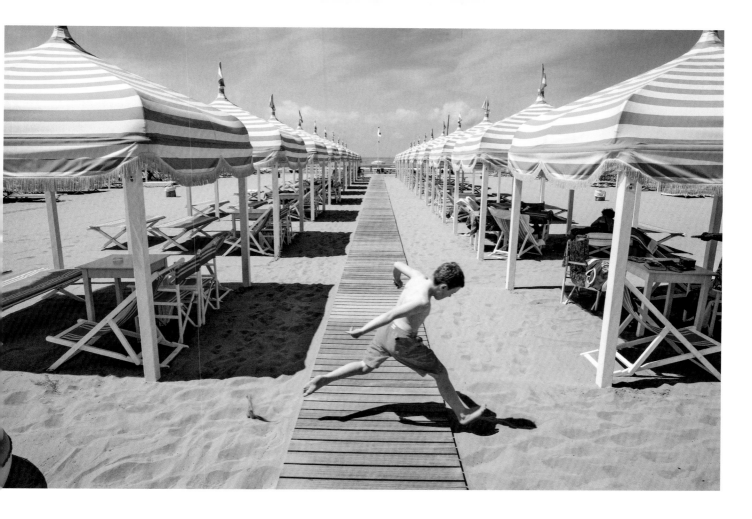

Explorer's Notebook: Coastal Tuscany's parks are one of Italy's treasures for their undeveloped beaches, sandy trails for hiking and biking, and wildlife. Maremma Regional Park in Alberese has 25,000 acres of trails and miles of beach. Orti Bottagone World Wildlife Fund nature reserve, below Populonia, has a series of secluded coves great for hiking.

of the cafes outlining its handsome central square, you wouldn't blink.

Forte dei Marmi's beaches, in their breadth and furnishings, recall Viareggio's, only they're a haute couture analogue to the other city's ready-to-wear. Bisecting them is a long pier that juts far out over the water and teems during the day with fishermen, joggers, and strollers who head to the end of it for the stunning view back toward the town, with its palms and pines and red-roofed bungalows, and to the Alps on the far side of them. Here you're surrounded by water — not as clear as Elba's, but a strong, deep blue nonetheless — and can see miles up and down the coast.

We stayed in a brash new hotel that appeared obsessed with marble. The floor of the lobby was marble. So were

the floor of the breakfast room, the floors of the long hallways, and even the floors of the elevators. If marble could be sufficiently softened, the hotel would probably have used it for bedding.

The obsession can't be wholly ascribed to ostentation, however. It also reflects history and geography. The English translation of Forte dei Marmi is "fort made of marble," and quarries in a section of the Apuan Alps that hover scenically above Forte dei Marmi do produce marble. It's not just any marble, either. It's Carrara, the most famous marble in the world, the stone used by Michelangelo.

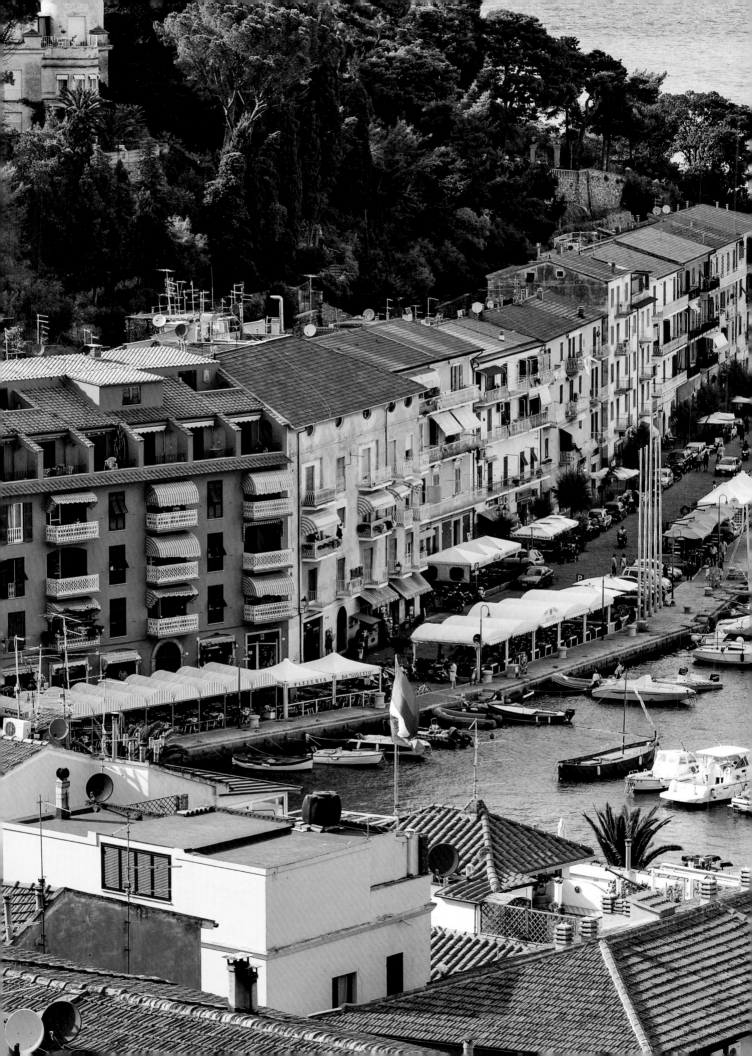

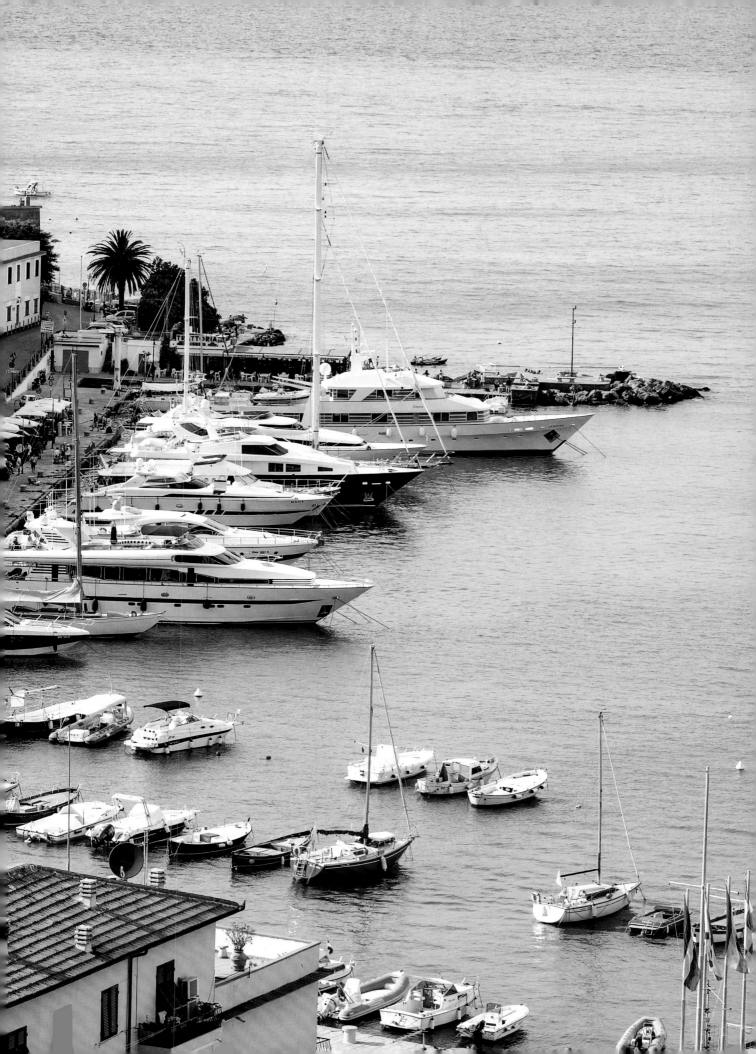

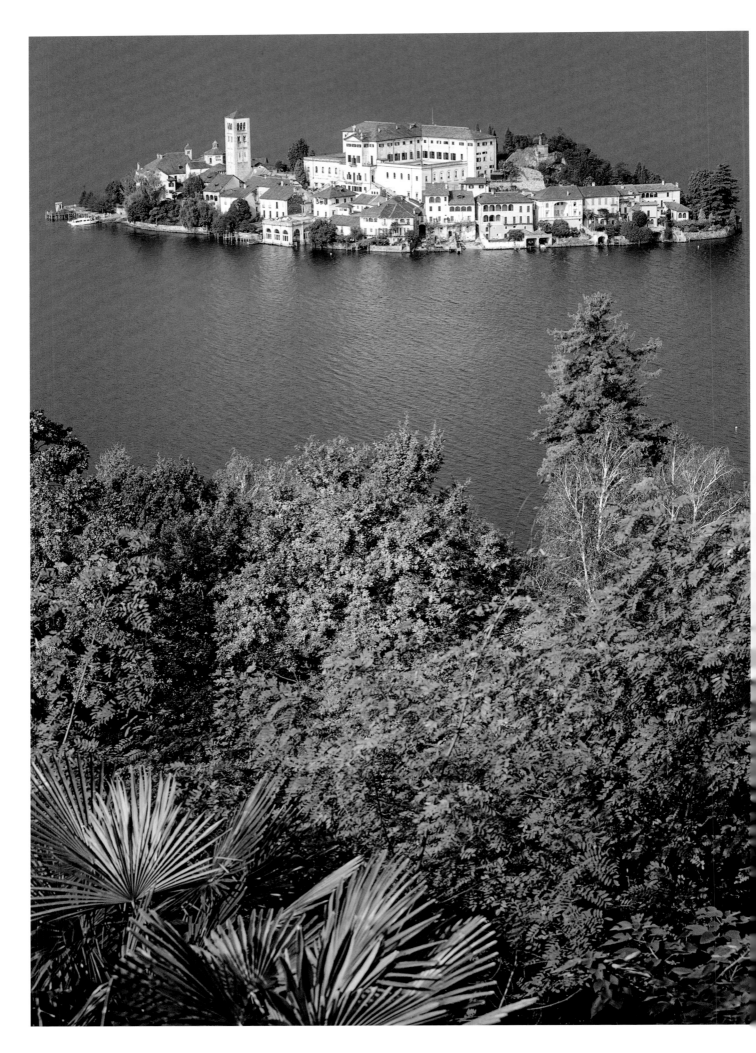

LITTLE SISTER OF THE ITALIAN LAKES

*How to get to the tiny monastery island
in unspoiled Lago d'Orta?
You could take the ferry — or just swim.*

TEXT BY BONNIE TSUI
PHOTOGRAPHS BY SAMUELE PELLECCHIA

Previous Isola San Giulio, the monastery island in Lago d'Orta. This view is from Sacro Monte di San Francesco, a "sacred mountain" above the town of Orta San Giulio.

Left Lining up to take the boat to San Giulio.

Opposite A view from the Hotel San Rocco. A former convent, the hotel directly faces the lake.

Like a siren, the beautiful little island called to us. And so we swam, like crazed Olympic sprinters, from a cobblestone Italian town square to a serene island monastery in the middle of glittering Lago d'Orta.

It started as a bet among three wine-happy men, one of whom was my husband. But I don't blame them, really. The bewitching beauty of Orta, a secluded jewel of a lake just a mile wide and to the west of Maggiore, tucked in the Italian Lakes District, is well chronicled. Friedrich Nietzsche, Honoré de Balzac, and Robert Browning all wrote about how sublimely gorgeous the lake and its surroundings were. (Balzac called Orta's island "a spot coyly hidden and left to nature, a wild garden.") Was it any wonder we, too, were drawn in?

Crowds flock to flashy Lago di Como and Lago Maggiore, but Lago d'Orta is the secret little sister. It's popular as a weekend destination from Milan, but little known outside Italy. And even many Italians don't know about its quiet, forested shores, peppered with sleepy medieval towns, or about that distinctive monastery on the tiny island a quarter-mile from Piazza Motta, the main square on the water in the town of Orta San Giulio.

The island, Isola San Giulio, is home to a 12th-century basilica, 19th-century seminary-turned-monastery, and houses. Both the island and Orta San Giulio are largely pedestrian-only, which makes for romantic, leisurely daily life in umbrella-filled piazzas lined with cafes, markets, and little family-owned restaurants. The friendly, small-town vibe is a huge part of the charm.

There are sumptuous palazzi and old buildings, but Orta San Giulio's most architecturally significant piece of history is the Sacro Monte di San Francesco, one of nine "sacred mountains" in northern Italy that are collectively designated a World Heritage Site. At 1,200 feet above sea level and perched on a hilltop, Orta San Giulio's sacred mount is a complex that includes a series of 20 beautiful chapels built over two centuries and dedicated to the life of St. Francis of Assisi.

A walk here is a lovely, meditative experience, with exceptional views over the town and lake. The frescoed chapels spiral out on tranquil, wooded grounds and encompass a range of architectural styles from the late Renaissance to the ornate rococo of the 18th century.

Orta has a surprisingly avant-garde side, too. Serious home-design aficionados make the pilgrimage to the northern end of the lake to a temple to modern international design: the factory of Alessi, maker of high-end housewares.

What stands out is that the pleasures of Orta San Giulio and its lake are as easygoing as ever. On a visit in a sunny July, my husband, Matt, and I swam, strolled, and napped. We spent hours sipping wine at Al Boeuc, an enoteca

Opposite Dishes at Agriturismo Il Cucchiaio di Legno, a good place to sample the regional foods.

Above and below The lobby ceiling and a guest room at the Villa Crespi in Orta San Giulio. Now a hotel, the villa is an elegant Moorish-style structure built in the 19th century by an Italian trader. It also houses a restaurant with two Michelin stars.

Above On the northern end of the lake is a temple to modern international design: the Alessi factory.

Opposite An old gramophone in one of the guest rooms at the Villa Crespi.

Following The 12th-century basilica on Isola San Giulio. The island's newer buildings include a 19th-century seminary that is now a monastery. Both Isola San Giulio and the town of Orta San Giulio are largely pedestrian-only, providing a romantic, leisurely experience for visitors.

housed in a 500-year-old wine cave, and frequented Agri-Gelateria, a shop serving creamy gelato made with organic milk from its own dairy farm. We lounged at the Orta Beach Club, where most patrons were heavily oiled and impressively sun-bronzed. At our most ambitious, we typically managed to swim a few lazy laps from one buoy to another before climbing onto shaded lounge chairs with books for the remainder of each afternoon.

In keeping with this theme, we'd been content to gaze out at Isola San Giulio from our apartment window, three floors above Piazza Motta and with a direct sight line to the island. For such a fantastically clear, calm lake in the heat of summer, Orta was remarkably free of boats (we probably saw one water-skier a day, at most). A handful of ferries plied the waters between the town, the island,

and the tiny villages on the lake's opposite shore. But this being Italy, things didn't get started until about 8:30 each morning — including the ferries.

But, as it will in a place like this, the conversation — fueled by wine and friends — took a turn for the imaginative. One evening, Matt made a bet that he could run downstairs, swim to and from the island, and end up back on the couch, all in under 21 minutes. A longtime swimmer, I was appointed his companion and scout. A couple of mornings later, we went for it.

Signora Irene, as she insisted that we call her, the shopkeeper at Orta Market, told us to be careful. "È pericoloso!" she cried as we dashed past. "Attenzione per le barche!" (You have to appreciate the neighborly concern — that's pure Orta.)

Explorer's Notebook: Omegna, a busy town at the north end of Lago d'Orta, is the headquarters of Alessi, a renowned manufacturer of artfully designed housewares. Visitors can drive or take a boat from Orta San Giulio and visit the factory outlet store in Crusinallo on the city's northern outskirts.

And so we swam, with me paying particular *attenzione* to those boats and popping my head up every once in a while to make sure we wouldn't be run over by an errant ferry. But the water was glassy and cool, a perfect mirror to the bluebird-sky above, and it turned out there wasn't a boat to be spotted, save for one slow-moving launch that gave us a wide berth.

After a while, I relaxed and began to enjoy the fish-eye view. After all, how often does one get such a unique perspective on such an utterly enchanting spot? As we neared the island, we could spy tantalizing evidence of everyday life in the homes that, from land, seemed so cloistered: toys on a garden patio, an inflatable water trampoline floating near one of the private docks. As a small boat putt-putted away from one of

those docks, the man driving it swiveled his head to greet us.

"Buon giorno!" he called, and he and his young daughter waved heartily. I returned the greeting with a grin, before Matt and I turned and powered our way back to the line of bobbing boats by the town jetty. We emerged from the water to find an elderly paparazza in red pants clicking away with her camera. As I toweled off, Matt sprinted upstairs to our apartment and was back on the couch — less than 18 minutes after he had left it. Later, Signora Irene greeted us with claps and a hearty "Bravissimo!"

Not only did the dreamy vision of Orta move us to jump in and do the unexpected — swim to the monastery and back as fast as we could! — but we were cheered on by the locals.

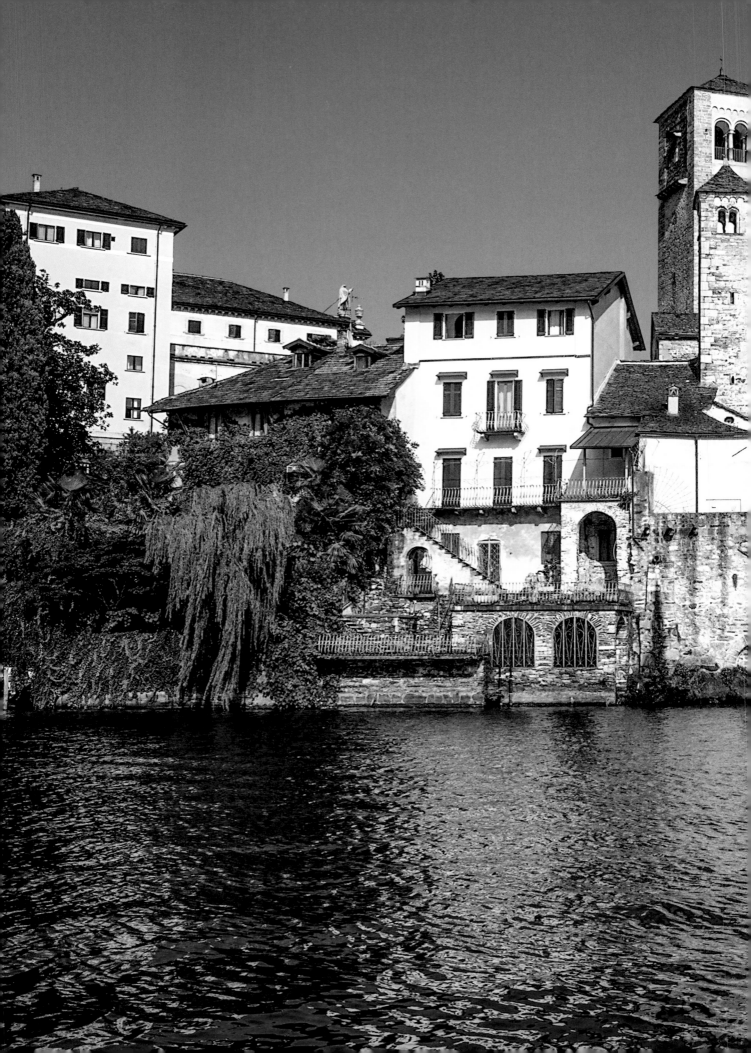

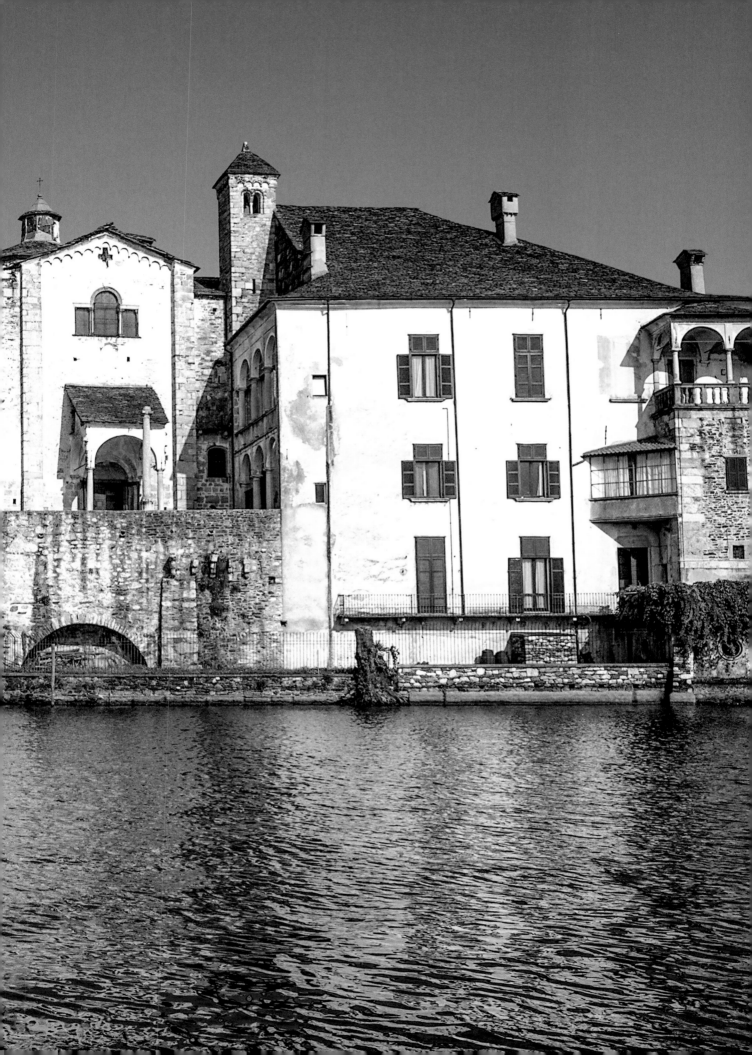

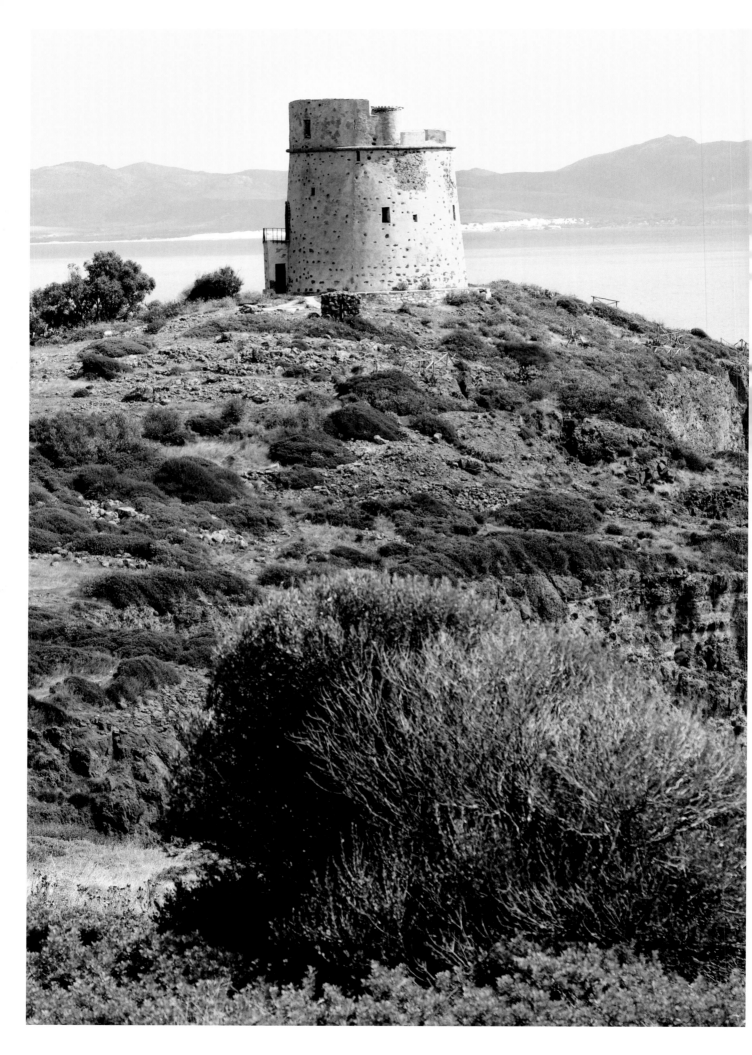

OFF SARDINIA, AN ISLAND WITH WILDER SHORES

*Just a causeway away from a tourist island
known for its commercial glitter,
tiny Sant'Antioco offers an unspoiled contrast.*

TEXT BY JOSHUA HAMMER
PHOTOGRAPHS BY CHRIS WARDE-JONES

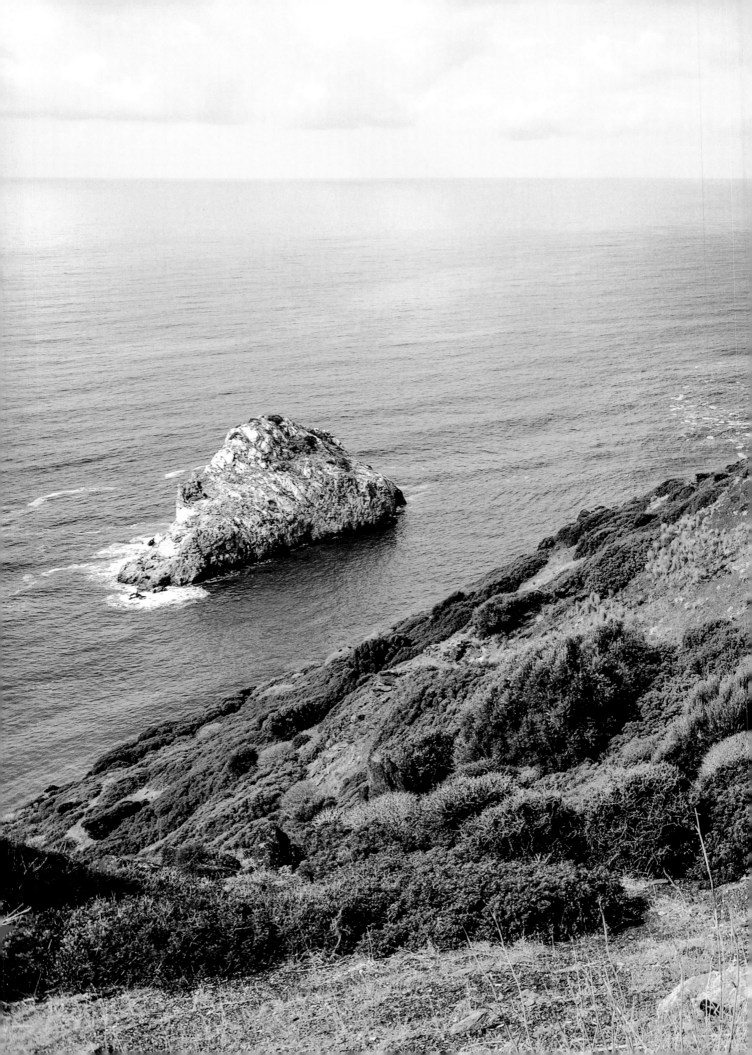

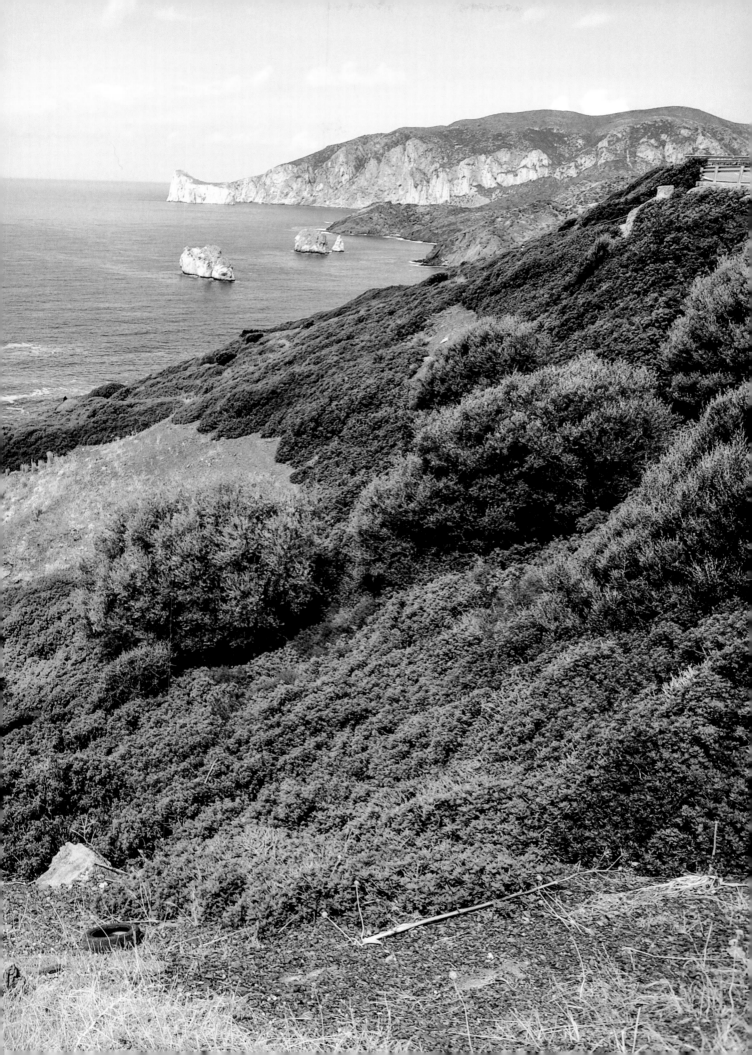

Page 150 A tower near Coaquaddus beach on Sant'Antioco.

Previous Sea and shore along the coast road leading to the ancient fishing port of Calasetta.

Left The Basilica of Sant'Antioco. Its catacombs were a Phoenician burial ground in the sixth century B.C.

Opposite Boats moored in the port of Sant'Antioco. The main island of Sardinia is an easy hop away: a short boat ride or a car trip over a mile-long causeway.

It was half an hour after sunset in Sant'Antioco, and we were lost. I had driven out of the ancient fishing port of Calasetta minutes earlier, following a strip of asphalt that dipped and rose through empty grassland and Mediterranean scrub. Quickly, the paved road leading south along the sea petered out, and my two sons and I found ourselves on a dirt path barely wide enough for our car.

The rocky Mediterranean coast, our only orientation point, disappeared; a dilapidated farmhouse was the only sign of human habitation. I plunged farther down the path, scraping the sides of the rented car against a jungle of thorn bushes, spinning my tires over sand, and searching for a way to turn around. "It's going to be dark in about 10 minutes," my 8-year-old reminded me. "Do you have any idea where you are?"

"Max," I said, trying to conceal my nervousness, "don't worry. We're not lost."

In fact, it's hard to lose one's way for long on Sant'Antioco, a speck of an island connected to Sardinia's southwestern corner by a milelong causeway. Before darkness descended I managed to backtrack and rejoin the road to our rented farmhouse. But the episode was a reminder of what had brought me to Sant'Antioco in the first place: its isolation, simplicity, and wildness.

These days Sardinia may be best known as a celebrity playground; Silvio Berlusconi, the former Italian prime minister, solidified that reputation by cavorting with a bevy of very young women at a palatial Sardinian villa. Sant'Antioco is the antithesis of all that: a tranquil backwater with two quaint ports, a smattering of ruins dating to pre-Roman times, sweeping Mediterranean savannah, the region's most unspoiled beaches, and little else. As my family and I crossed the causeway to get there, the relative bustle of the main Sardinian island — with its four-lane expressways, traffic roundabouts, and roadside restaurants and megastores — gave way almost immediately to a peaceful landscape with thickets of myrtle, wild olive trees, scrubs called strawberry trees, and heather.

Sant'Antioco may be lacking in glamour, but it is rich with history. The island has been populated since prehistoric times and in the eighth century B.C. began to play a key role on Mediterranean trade routes developed by the Phoenicians. The Romans occupied the island in 238 B.C. and constructed temples, viaducts, and an artificial isthmus linking the port town of Sant'Antioco — then called Sulci — to Sardinia. Sant'Antioco reached its apogee in the early Christian era, when it became an episcopal see and a pilgrimage site for devotees of St. Antiochus, a Mauritanian-born Christian martyr who was condemned by the Romans to work the lead mines on this island that now bears his name, and who was executed in A.D. 127.

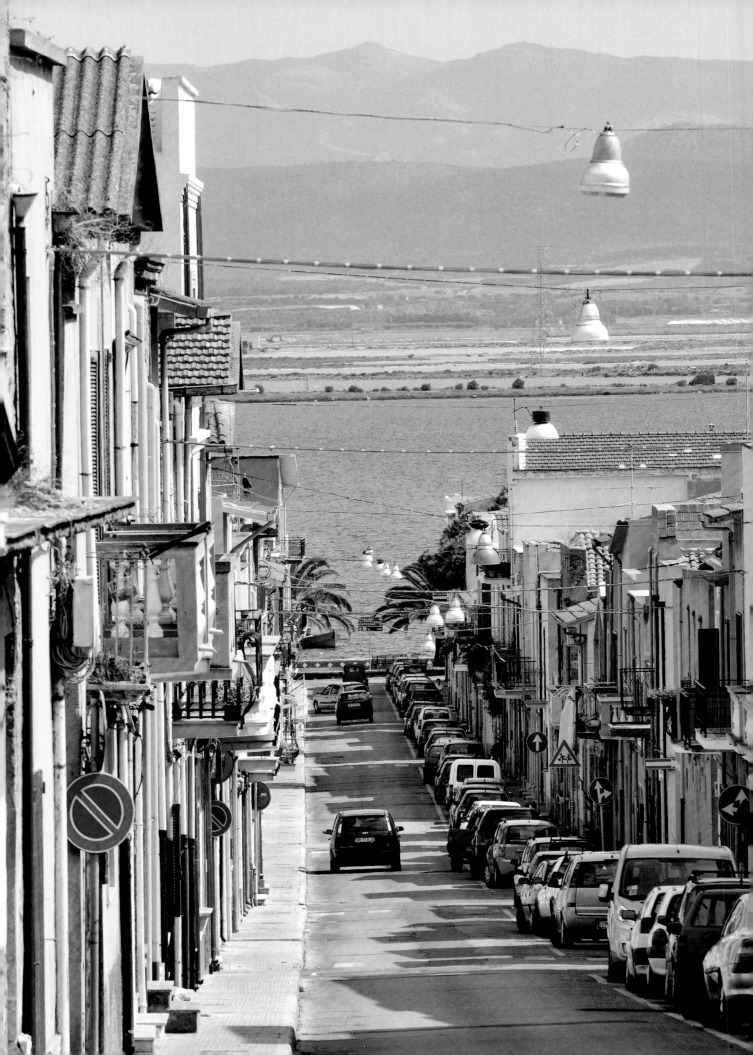

Opposite Pastel-shaded houses on the road down to the port in the main town, also called Sant'Antioco. It has about 5,000 people.

Above A long driveway, lined by cypress and fig trees, leads to the Casa Angelo guesthouse.

Above An archaeological site, part of the abundant evidence of the island's long, varied history. It has been occupied by prehistoric people, Phoenicians, Romans, the French, African pirates, and today's Italians.

Opposite Coaquaddus Beach is a good spot for surf when the sirocco winds are blowing.

Following A moody view from the port of Sant'Antioco.

Later the island was occupied by the French, and then North African pirates landed on the coast in 1815 and massacred most of the inhabitants. Sant'Antioco slipped into obscurity and is now enjoying a modest revival, based almost entirely on tourism.

Our rented home, the Casa Angelo, on the southeast coast, owned by a local couple, stood at the top of a long gravel driveway lined by cypress and fig trees. The nearest supermarket and Internet connection lay eight miles away. Our landlady, Maria, a birdlike woman with a warm and effusive manner, and her husband, Angelo, bald and taciturn, spoke only Italian and the local Sardinian dialect. Maria showed up occasionally, flitting around the house, thrusting piles of towels and bedsheets in my hands, and patting the boys' heads maternally with cries of "bimbi."

Half a mile down the road lay Coaquaddus, the best beach on Sant'Antioco, and our favorite, a curving strip of sand buffeted regularly by the sirocco wind, which stirred the normally placid Mediterranean into a body-surfable froth. African immigrants wandered up and down the beach, selling sunglasses and parasols in Senegalese or Malian-inflected Italian; an elderly Sardinian positioned himself by the boardwalk path leading down to the beach every afternoon at 3 o'clock, selling cut-up coconut bathed in lemon. His cries of "cocco, cocco" rose above the cheers and grunts of boys and young men engaged in impromptu soccer matches in the sand.

On other days we headed for the west coast beach of Cala della Signora, unmarked on the Sant'Antioco tourist map. Hiking down a steep path through a ravine, we arrived at a massive slab of gray rock bordering a horseshoe bay

Explorer's Notebook: Saint Antiochus persisted as a Christian evangelist even when condemned to mining lead on Plumbaria, an island named for plumbum, the Latin word for lead. According to the story, Antiochus converted his jailer. Angry authorities had him put to death, but eventually the island and its city, Sulci, were both renamed Sant'Antioco in his honor.

with tidal pools and underwater volcanic formations studded with sea urchins. One afternoon an Italian man in a Speedo — the first Italian we encountered in five days who spoke some English — warned us to stay away from our customary diving pool. He pointed to the nearly transparent water, where we could see dozens of ethereal pink jellyfish, their silky tentacles waving below their bulbous pink heads. He fished one out with his snorkel, and laid it on a slab of rock. "Very lovely, la medusa," he said in English. "But she will hurt you very, very much."

The charming town of Sant'Antioco, the island's major settlement, has about 5,000 people, with a seafront promenade and warrens of pastel-shaded houses hugging cobblestone streets that slope upward toward the basilica. This stone church at the top of the village dates back to the fifth century. One morning we and about a dozen

Italian tourists followed an Italian-only-speaking guide down a dark corridor below the church to the catacombs, which originated as a Phoenician necropolis in the sixth century B.C. She led us down into a network of low-ceilinged stone chambers and passageways decorated with fragmentary murals from the dawn of Christianity. One room contained the excavated skeletons of several ancient pilgrims.

Back into the sunlight, we walked downhill to the Corso Vittorio Emanuele, Sant'Antioco's main shopping street, and stopped for gelato at one of a dozen outdoor cafes and trattorias nestled beneath plane and chestnut trees.

Then it was back on the quiet roads and through the empty rolling hills to our farmhouse and our choice of a beach for the day.

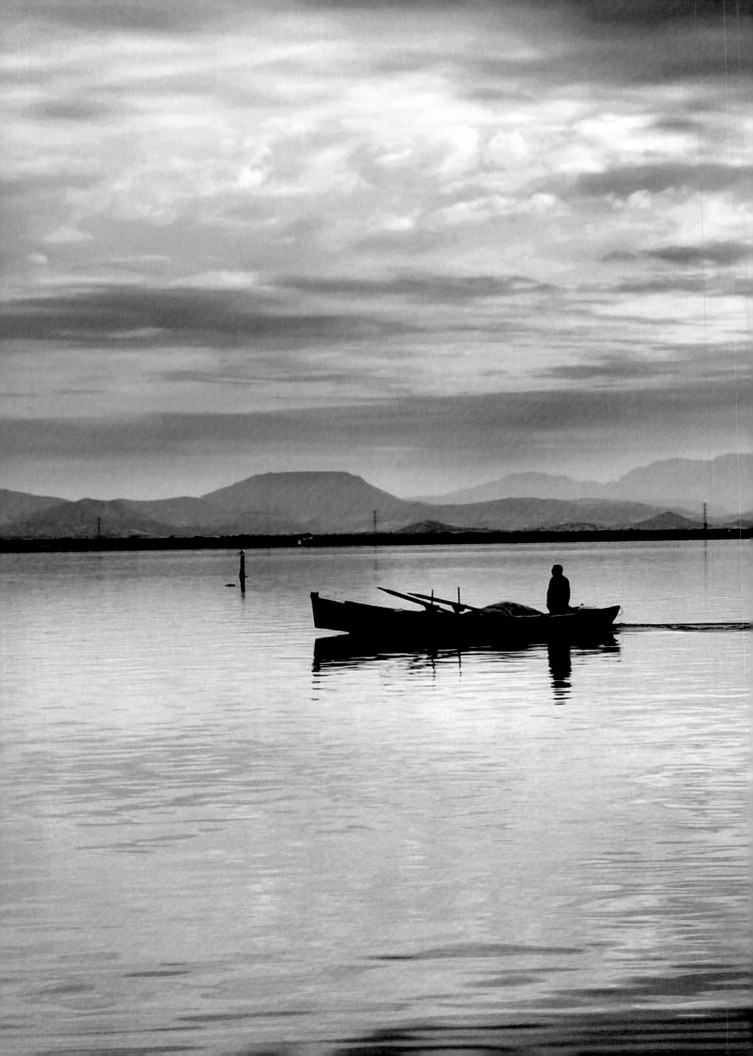

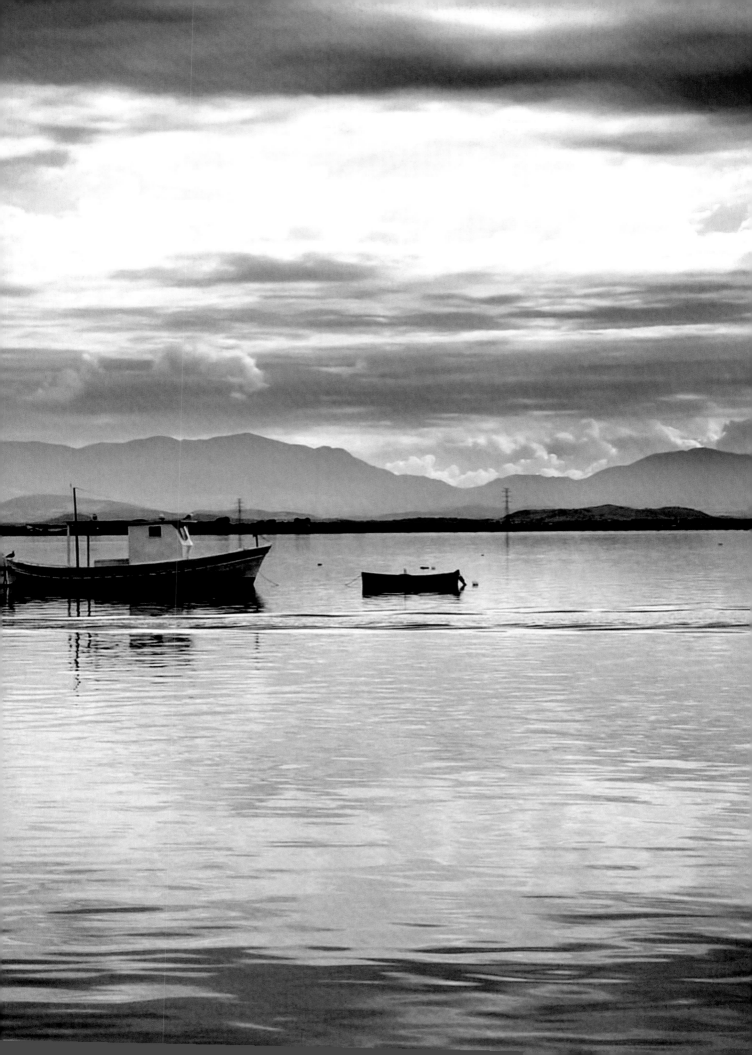

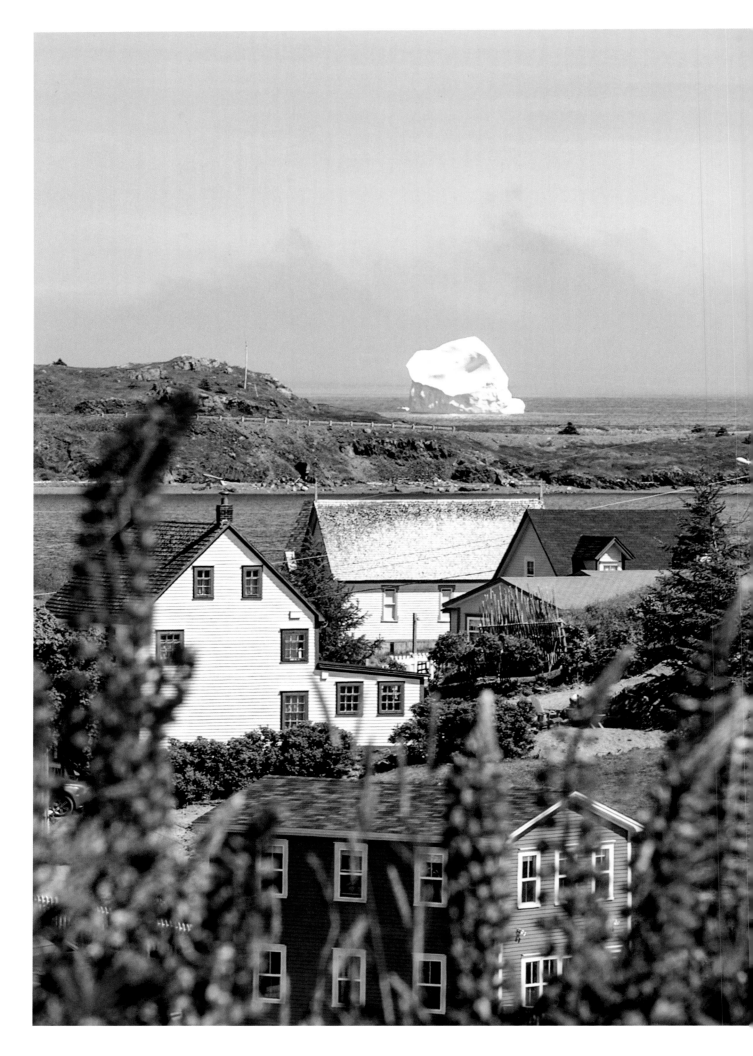

NEWFOUNDLAND'S GHOST COAST

*A spectacle of icebergs, whales,
and puffins plays out against cliffs and abandoned
fishing towns on the Bonavista Peninsula.*

TEXT BY ELAINE GLUSAC
PHOTOGRAPHS BY ANTHONY LANZILOTE

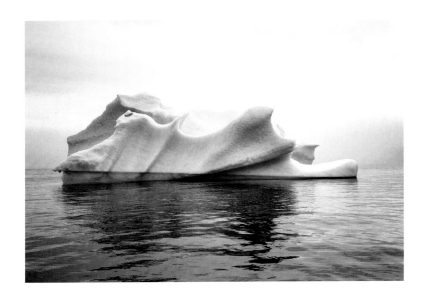

Previous The town of Trinity on the Bonavista Peninsula, with an iceberg in view just beyond.

Left An iceberg in close-up, seen from a tour boat. Tours also go to ghost towns abandoned when the population was consolidated on the peninsula. Tourism now provides some jobs to replace those lost in the late-20th-century collapse of the cod fishery.

Opposite An opening in the rocks of the peninsula's craggy shores.

Bruce Miller slowed the *Rugged Beauty*, his 27-foot tour boat, and entered the tiny harbor at Ireland's Eye, an uninhabited, rock-rimmed island eight miles off the much larger island of Newfoundland. Scattered piles of weathered boards came into view, dotting steep grassy banks like forgotten kindling. Miller held up a black-and-white 8-by-10 photo, showing his passengers the same view circa 1940. Back then, the timber stacks were clearly houses, boats rested at anchor, and on the farthest hill stood a white church. Now, in the church's place, a steeple lay on its side in the tall grass. Worshipers last attended a service here in 1965.

Miller was giving his passengers a ghost-town tour of abandoned fishing villages off the craggy, stunningly scenic Bonavista Peninsula, three hours north of St. John's, the capital of Newfoundland and Labrador. Seventy miles long, the peninsula is a thinly inhabited wilderness of towering sea cliffs, surf-strafed beaches, and mossy forests. If you've seen the 2001 movie *The Shipping News*, based on the novel of the same title by Annie Proulx, you have seen the Bonavista Peninsula, and you probably remember it. In the film, the landscape of this part of Newfoundland was as much a star as Kevin Spacey, Julianne Moore, or Judi Dench, and the camera lingered over it lovingly.

When the cod fishery, Newfoundland's economic mainstay for nearly 500 years, collapsed in the last decades of the 20th century from overfishing, an estimated 30,000 Newfoundlanders lost their jobs. The once prosperous towns of the Bonavista Peninsula shrank and declined. Even earlier, when cod were still being pulled out of the sea here in record numbers, offshore villages like Ireland's Eye were abandoned as their inhabitants were forcibly resettled on the mainland in the name of governmental efficiency.

Now local entrepreneurs like Miller are building a new tourism economy for the Bonavista Peninsula, capitalizing on the lonely beauty that makes a compelling backdrop to its history of frontier survival, collapse, and 21st-century renewal. For tourists, the process has hit a sweet spot, with just enough going on — good food, distinctive accommodations, and interesting tours — to keep a traveler engaged, but not enough to spoil the view.

"Suddenly there's an understanding that people like art on the walls and a decent cup of coffee," said John Fisher, an Ontario émigré who came to those conclusions in 1997 when he opened Fishers' Loft, a four-room B&B in tiny Port Rexton. Today the inn's 33 rooms are spread among six buildings — brightly painted, wood-shingled saltbox cottages and sea captain's homes that are distinctive architectural styles of Newfoundland.

Tineke Gow, an innkeeper who has owned property on the peninsula since 1975, pioneered the diffused hotel

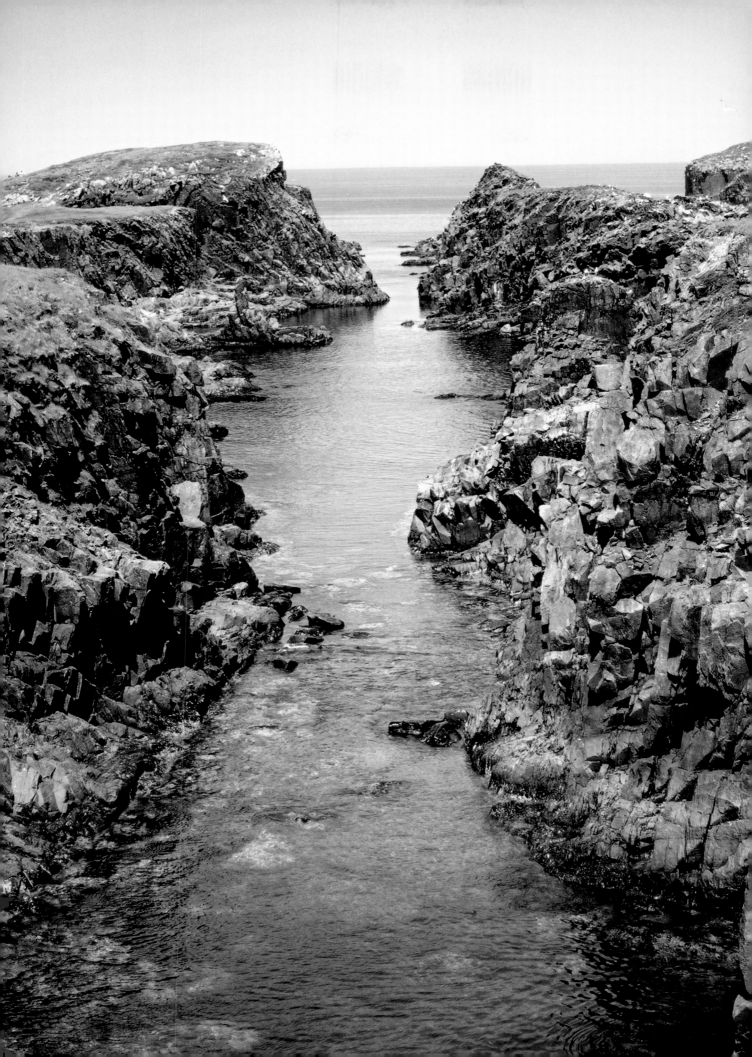

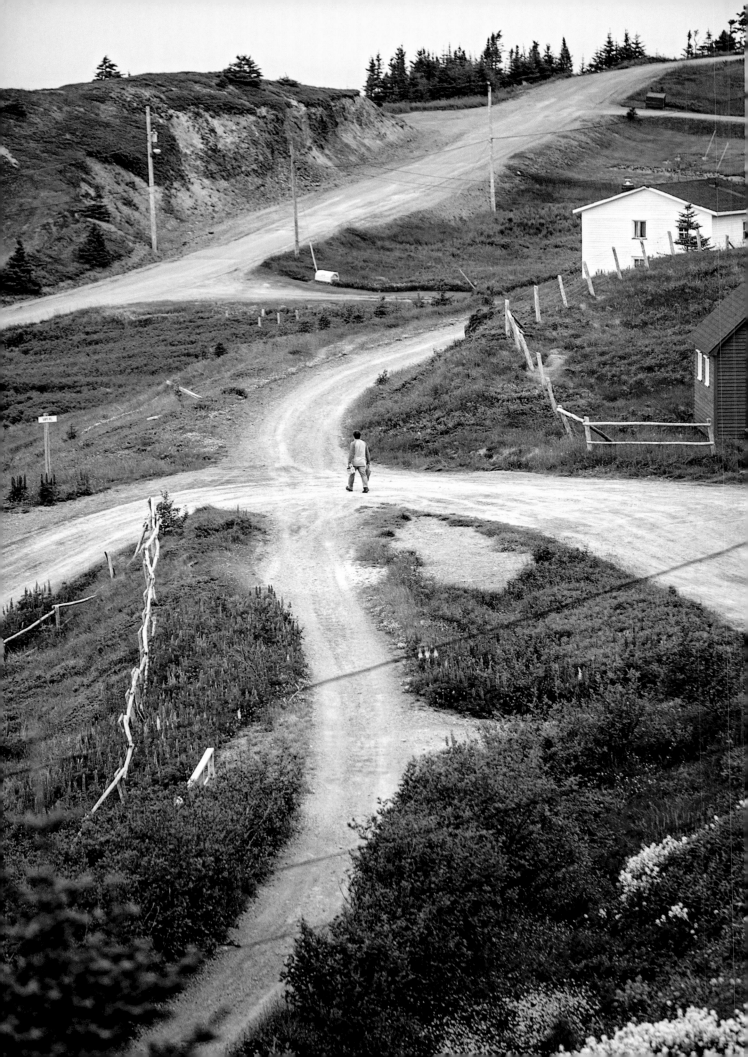

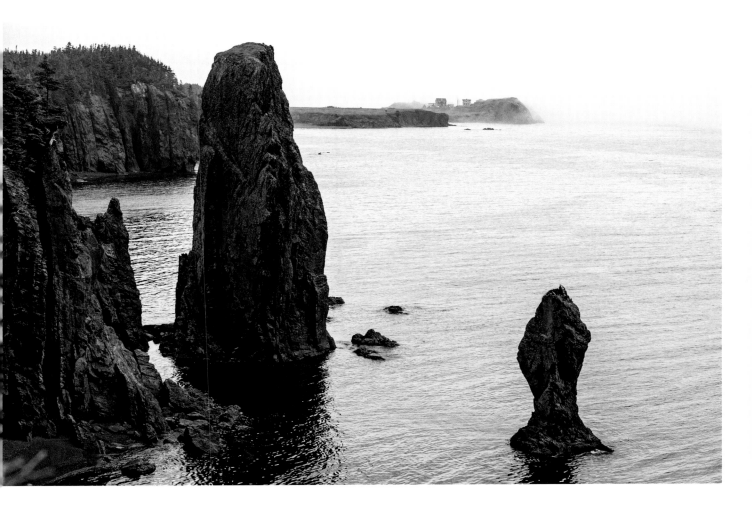

Opposite A crossroad in Port Rexton. Just outside town is the Skerwink Trail, a 3.3-mile footpath on a sandstone headland at the entrance of Trinity Harbor.

Above and below Sea stacks near Trinity, as seen from the Skerwink Trail, and steps on the trail. The path is a snapshot of untamed Bonavista, with pine forests, salt-sprayed rocks and cliffs, and ocean views.

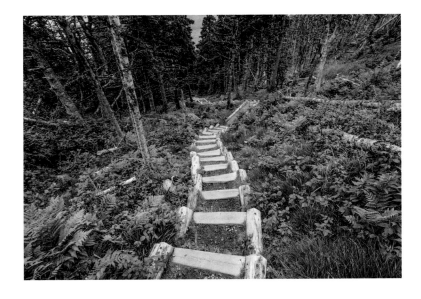

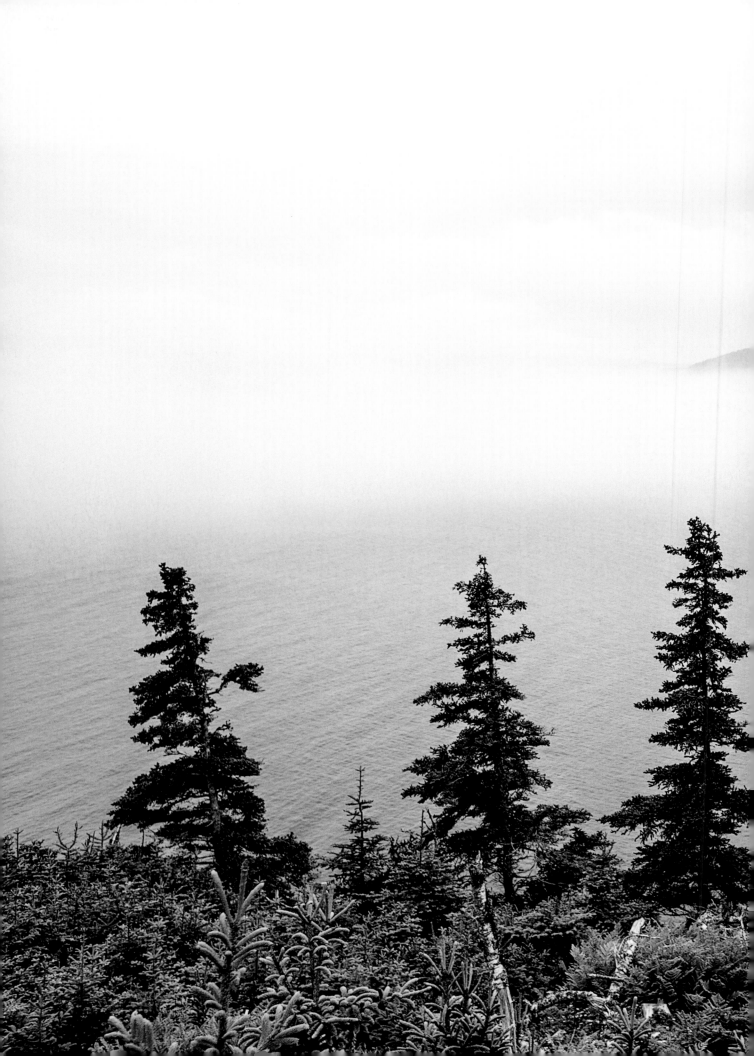

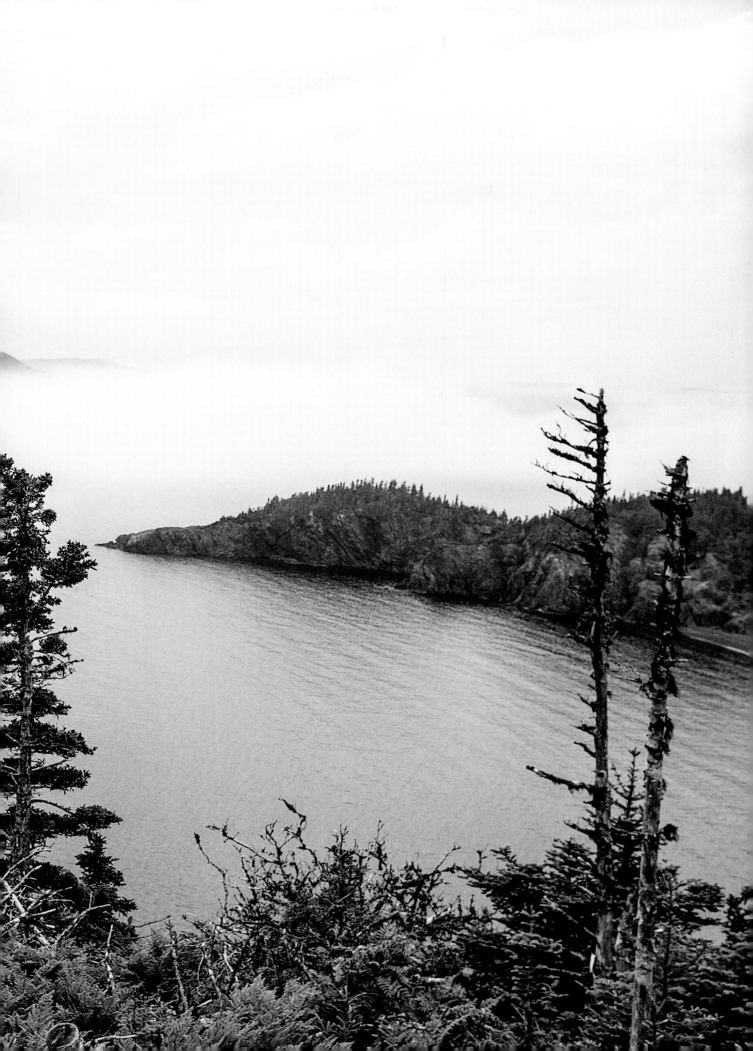

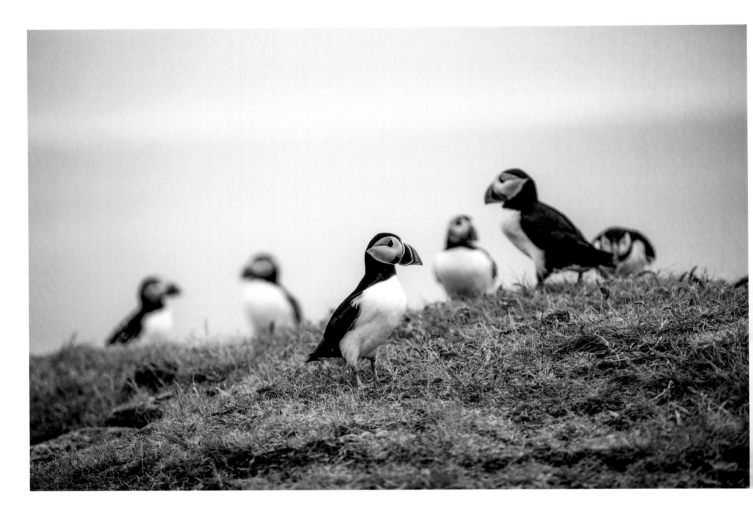

Previous Low clouds and fog near Trinity Harbor both obscure and enhance an ocean view.

Above Puffins at rest on a bluff near Elliston. They nest in ledges in the rocky cliffs.

Opposite A root cellar in Elliston. Vegetable storage in these substantial cellars once helped keep residents going in long, isolating winters.

Following Rocks in the sea off Elliston. The peninsula's rugged beauty is now its greatest economic asset.

concept here in 1992 when she opened Artisan Inn with two rooms in a 19th-century home in nearby Trinity. The inn grew to 15 rooms dispersed among six houses. "The idea is to fit into the landscape," she said. "One building with 20 rooms would stand out."

Thanks to the work of a local historical society, Trinity, a former shipbuilding town first settled in the 1500s, is one of the best preserved villages in Atlantic Canada, a cluster of old wooden houses and steepled churches. Tourists wander its narrow streets, take walking tours, and watch historical dramas at the local theater.

The Skerwink Trail outside Port Rexton is a 3.3-mile footpath that traces the edge of a towering sandstone headland at the entrance of Trinity Harbor, providing access to pine forests draped in a webby green epiphyte

known as Old Man's Beard, stunted fir trees clinging to salt-sprayed cliffs, views of wave-bashed sea stacks, and bogs covered in azalea blooms.

Newfoundland's principal tourist bait is whales, puffins, and the icebergs that cruise by on the Labrador Current on their spring trip south from Greenland. The Bonavista Peninsula has all of those, too. The morning after taking Miller's tour, I went out on a Zodiac boat with Sea of Whales Adventures for a glimpse of the spring whale migration.

The wind chill on this rainy June morning felt like February as my tour group bundled into thermal jump-suits provided by the captain and skipped over the dark water, at times as deep as 1,800 feet. Soon we spied the descending fluke of a diving sperm whale. As we waited

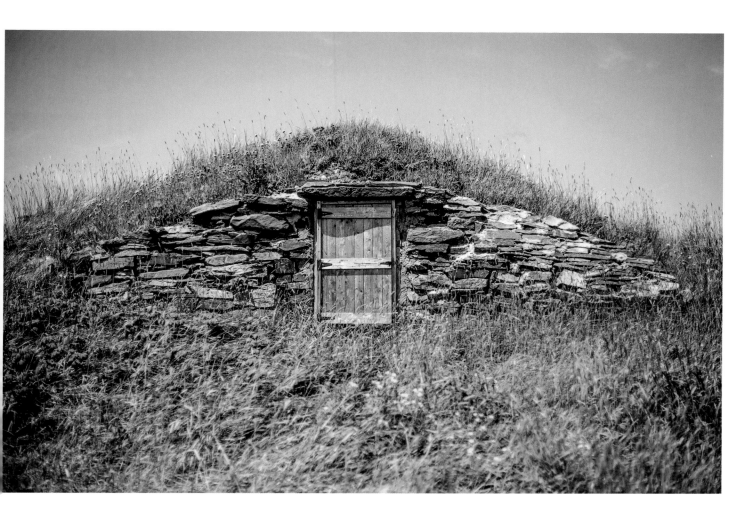

Explorer's Notebook: About a four-hour drive from Port Rexton, a ferry leaves from Fortune, Newfoundland, for France's last toehold in Canada, the tiny nearby islands of St. Pierre and Miquelon. Securely out of English hands since the Treaty of Paris in 1814, they are French down to the continental electrical current, euro currency, and gendarmes' epaulettes.

for it to resurface, a herd of 300 harp seals churned across the bay, slowing as they passed and bobbing their heads higher to get a good look at the boat and its six gaping passengers.

To see the puffins, I drove to tiny Elliston, near the tip of the peninsula, which greeted me with an irony-free sign declaring itself the "Root Cellar Capital of the World." More compelling than the cellar-doored hillsides where vegetables are traditionally stored were a pair of isolated islands just feet from the shorefront cliffs. Here a colony of colorful Atlantic puffins roosted in the ledges, coming and going in acrobatic foraging trips to sea.

The peninsula's farthest point is Cape Bonavista, where visitors climb an 1843 lighthouse for views out to sea and iceberg spotting. Nearby is a statue of the explorer

John Cabot, sent west by England in 1497 to find a route to the East Indies to rival the one Columbus was then still thought to have found. It is said that the cape was the point where he first sighted land, and although the exact location can't be proved, the town here, also called Bonavista, remains proud of its claim.

Miller, who runs the ghost-town tours, grew up in Kerley's Harbour, another of the offshore "outports" that had to be abandoned.

He ended his four-hour tour at his own cabin in the resettled village of British Harbour, a creekside clearing of fallen sheds fronting a white-capped bay ringed in silent forests. Sounding incredulous at his own story of loss and rediscovery, he asked, "Can you imagine leaving here willingly?"

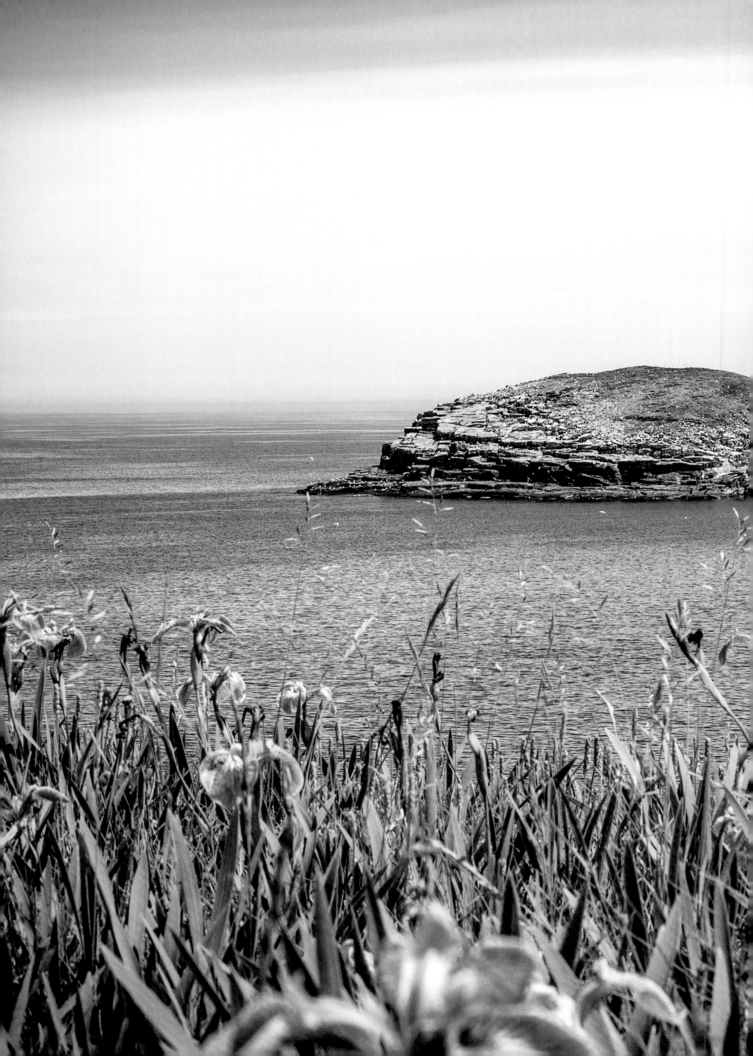

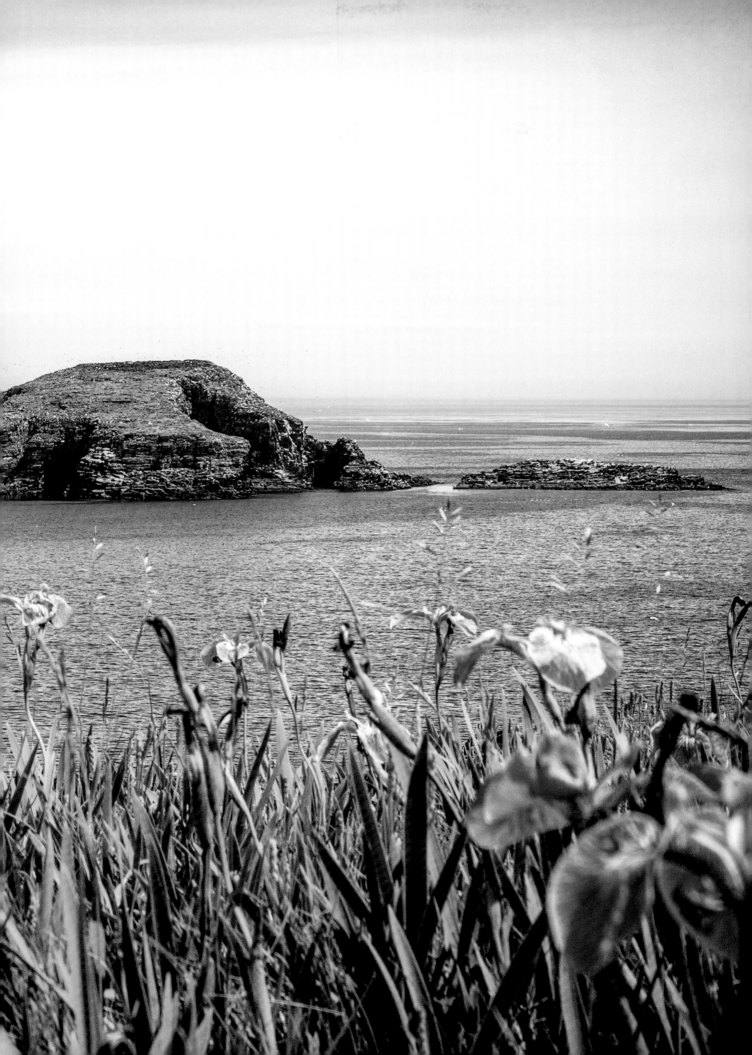

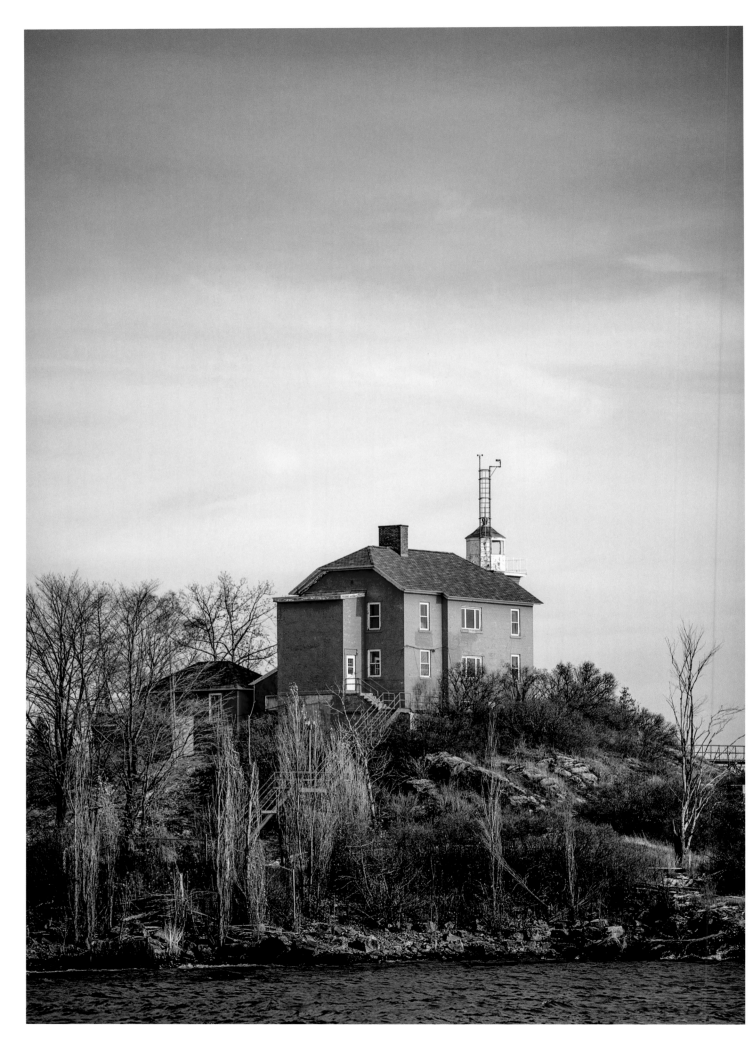

A COPPER GLOW AT THE TOP OF MICHIGAN

Where mighty Lake Superior laps at lonely cliffs and beaches, old mining boomtowns hold fast to their Nordic soul.

TEXT BY STEPHEN REGENOLD
PHOTOGRAPHS BY NARAYAN MAHON AND T. C. WORLEY

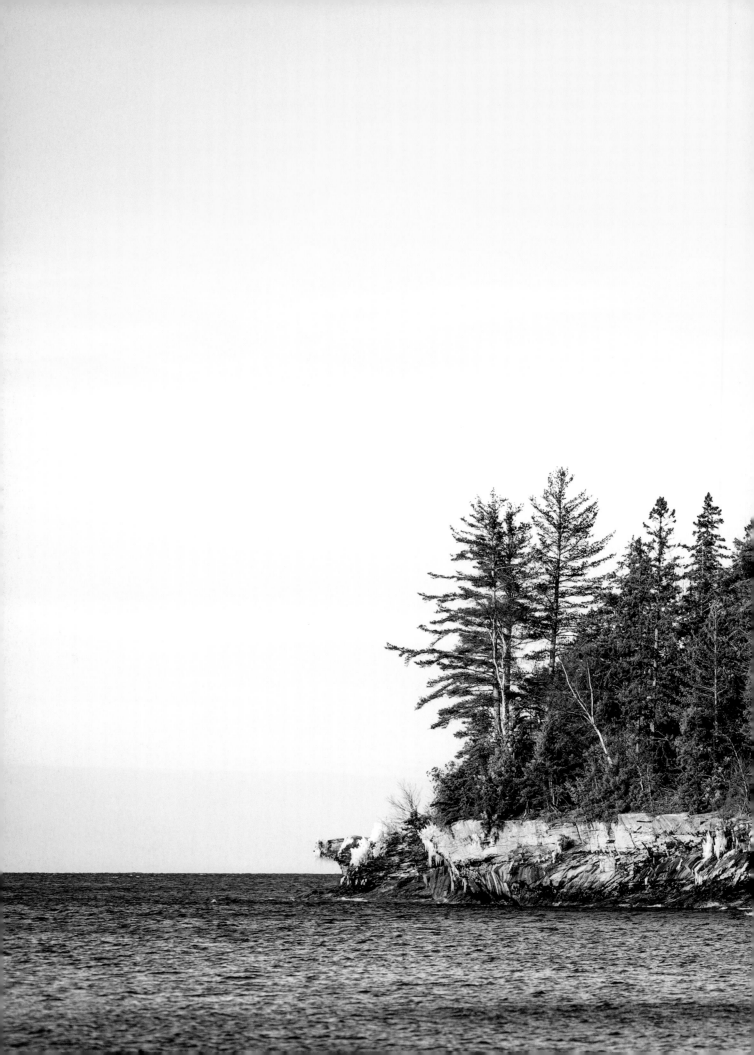

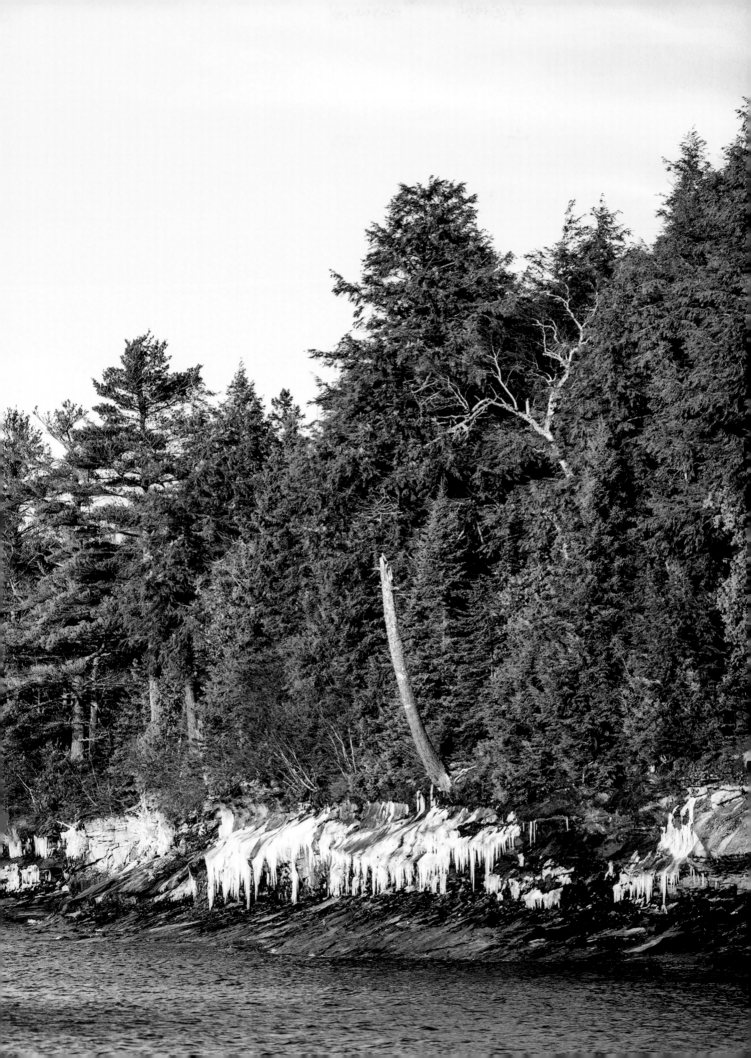

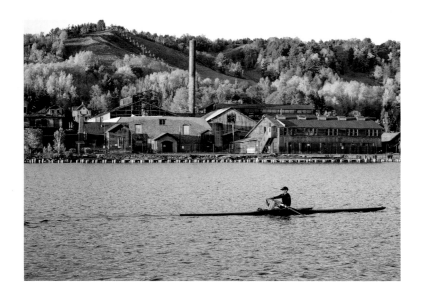

Page 174 Marquette Harbor Light, a lighthouse in Marquette, the largest city in the Upper Peninsula of Michigan.

Previous The shore of Lake Superior near the town of Au Train.

Left A sculler passes the Quincy Smelting Works on a canal once used by the copper industry. A local group gives underground tours of the abandoned Quincy copper mine.

Opposite A sunset over Lake Superior near Grand Marais.

Four hundred feet underground, in a musty, dripping passage, Ed Yarbrough pointed to a dark opening in the wall. "Here's an old explosives bin," he said, tracing a flashlight beam along the rock, "hence the no-smoking sign."

We were in the belly of the long-abandoned Quincy copper mine, a quarter-mile down a tunnel, light leaking faintly from bulbs strung overhead. Water dripped off the ceiling. Cold air seeped from an abysmal black beyond. Then Yarbrough, our guide, turned off the lights. "This is how the old miners worked," he said, lighting a match. He touched off a small candle, and its dim light flickered in the profound darkness. "Now picture swinging a sledgehammer," he said.

It was a Saturday afternoon, cloudy and cool aboveground in Hancock, Michigan, where the Quincy Mine Hoist Association runs tours of this long-shut operation. My wife, Tara, and I were traveling with our daughter in Michigan's Upper Peninsula, a place of forests and marsh, chilly Great Lakes beaches, and old ports and mining towns.

The Upper Peninsula — referred to all over the state as the U.P., is over 300 miles long, its eastern part mostly an arch-shaped land mass separating Lakes Superior and Michigan, and its western part carved out of what looks on the map like it ought to be the top of Wisconsin. There's a bit of Lake Huron shore, too, near the spot where huge cargo ships go through the enormous Soo Locks and an

international bridge connects Sault Ste. Marie, Michigan, to Sault Ste. Marie, Ontario.

Drive west from there, and the uncluttered roads will take you to sleepy towns and lonesome beaches where Lake Superior stretches offshore in deep and endless blue: Whitefish Point, near where the 729-foot freighter *Edmund Fitzgerald* sank in a 1975 storm; the sand and cliffs of Pictured Rocks National Seashore; Marquette, an old Great Lakes port and the U.P.'s largest town, with about 21,000 people.

My family and I were on the Keweenaw Peninsula, which juts 75 miles into Lake Superior and makes up the U.P.'s northernmost point. It's a wilderness of stunted stone mountains, pine and hardwood forest, and sparse settlements born in a mining boom. Dark bubbling streams cut rocky ravines in the woods. The lake is always close by, lapping the land from the east, west, and north.

The Keweenaw, still sometimes called Copper Country, was a promised land for hundreds of thousands of immigrants — German, Italian, Cornish, French-Canadian, and Finnish — who came to pick and drill at operations like the Quincy Mine. For 150 years starting in the 1840s, billions of pounds of ore were pulled from the vast basalt substratum of the Keweenaw, which boasts some of the purest copper ever found. But the mines eventually closed down, and although in the new century some mining

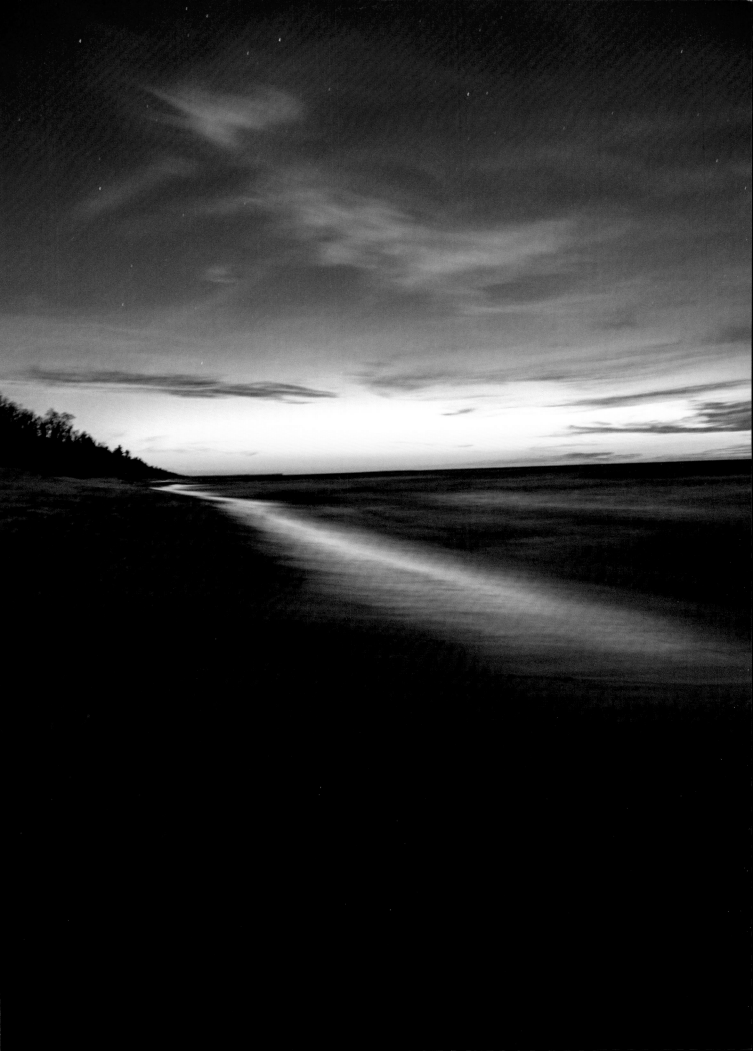

Above The bridge connecting Houghton, a college town, to Hancock, at the base of the Keweenaw Peninsula, the heart of Copper Country.

Below The Lake Superior Brewing Company in Grand Marais.

Opposite Downtown Hancock.

the Bleachers

Sports Bar

THE
~~SALVATION~~

WORSHIP and
COMMUNITY
CENTER

Above Fresh Lake Superior fish at Thill's Fish House in downtown Marquette.

Opposite Tahquamenon Falls near Newberry. Tahquamenon Falls State Park is one of many parks and public recreational sites in the Upper Peninsula.

Following An old barn between Munising and Grand Marais.

companies have showed renewed interest in the U.P.'s store of metallic ores, tourism has supplanted mining as a main industry for the Keweenaw.

Small towns cater to travelers who make the long drive north from Chicago, Minneapolis, Milwaukee, or Detroit. State and national parks, mine tours, inns, gift shops, pubs, and hiking trails occupy summertime visitors.

Beach lovers visit the Keweenaw for its half-moons of sand, where translucent-blue water washes arching shores. Rock hunters pick among water-worn stones for agates, some big as golf balls, glinting in the sun. At McLain State Park, 15 miles west of Hancock, we plunked down on a dune the first night to watch an aptly copper-colored sunset, its dusty light bouncing off Superior's platinum plane. Inland, we hiked mossy trails with the baby in a backpack carrier, rarely seeing another soul.

"It's like Sweden up here," Tara commented at one point, reminded of our trip the summer before. Indeed, the Keweenaw Peninsula is a simulacrum to parts of Scandinavia, boreal and moist, with big stones poking out of piney hills — terrain that keeps you thinking a gnome might skitter by.

Culturally, there are deep Nordic ties. Vowels are stretched and prolonged in speech. Road signs in Hancock offer English and Finnish, Ravine Street doubling as Kurukatu Street in the downtown. Saunas are common.

At the Hanka Homestead Museum, a preserved farm near Keweenaw Bay on the east side of the peninsula, visitors can snoop through a former Finnish settlement. Its granary, barns, sauna, and stable are classic Nordic log construction, preserved to their 1920s appearance. Like many area attractions, the Hanka Homestead is

Explorer's Notebook: At the turn of the 20th century, the vast iron ranges of the Upper Peninsula were producing much of the iron ore for the United States. Most of it arrived in Marquette by rail and was shipped eastward from the city's Lake Superior harbor.

linked to Keweenaw National Historical Park, a preserve of disparate sites established in 1992. Mines, museums, a municipally built opera house, an old 45-room mansion, McLain State Park, and Fort Wilkins, a pre-Civil War-era military base, are operated by or in partner with the National Park Service.

We also explored the main streets of Calumet, Houghton, and Hancock. Our favorite shop, Copper World, on Fifth Street in Calumet, had been selling all things copper since the early 1970s — jewelry, teakettles, clocks, cake pans, ornaments, knickknacks, even postcards pressed with scenes.

Hancock is separated from its sister city, Houghton, by a deep blue canal of Lake Superior that splices off the tip of the Keweenaw. We saw slag piles and smelters on the Hancock side; Houghton had huge rusting boat cleats

along its shore. Seagulls coasted overhead. Michigan Technological University, with 6,500 students, brings Houghton the characteristic advantages of a college town, and there's a nice walk along the canal.

At the end of the trip, we sampled the pasty — a hot meat pie that's become a culinary icon of the Keweenaw — at the Kaleva Cafe in downtown Hancock, below a big slope going up to the Quincy Mine. This pasty is a cousin to the Cornish pasty once carried underground by English miners.

From our table, I pictured the tunnels and shafts hollowing out the hill, deep paths underground following veins of copper thousands of feet down. Glasses and plates clinked inside the cafe. Traffic groaned past outside, travelers heading uphill under trees, disappearing into the heart of Copper Country beyond.

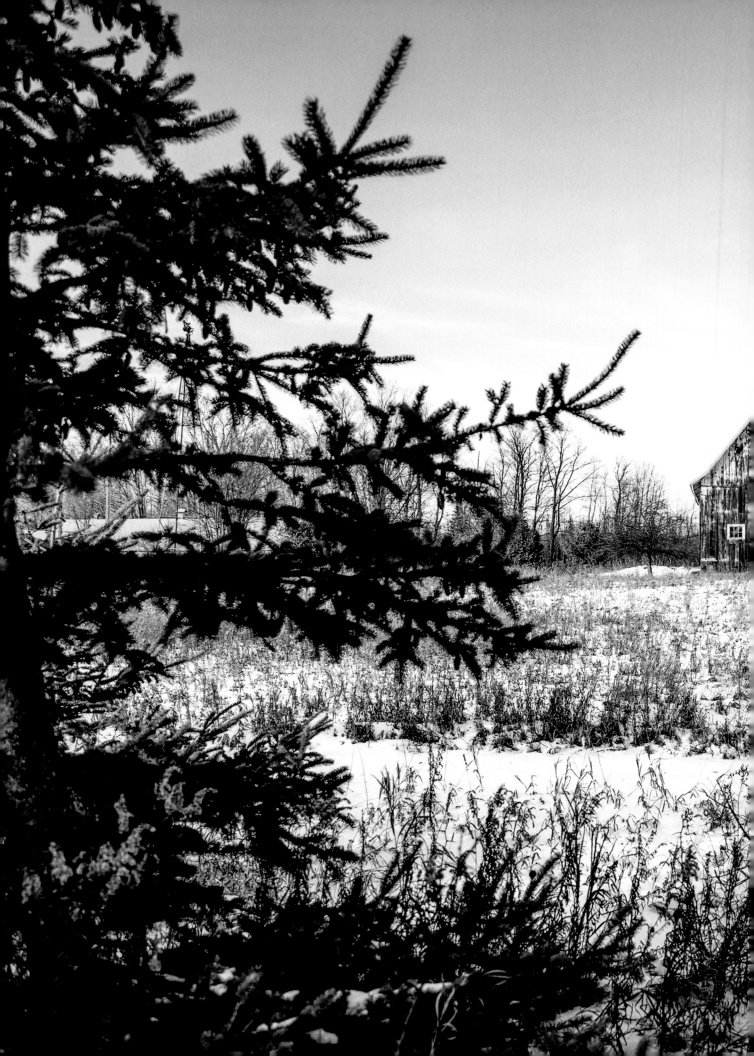

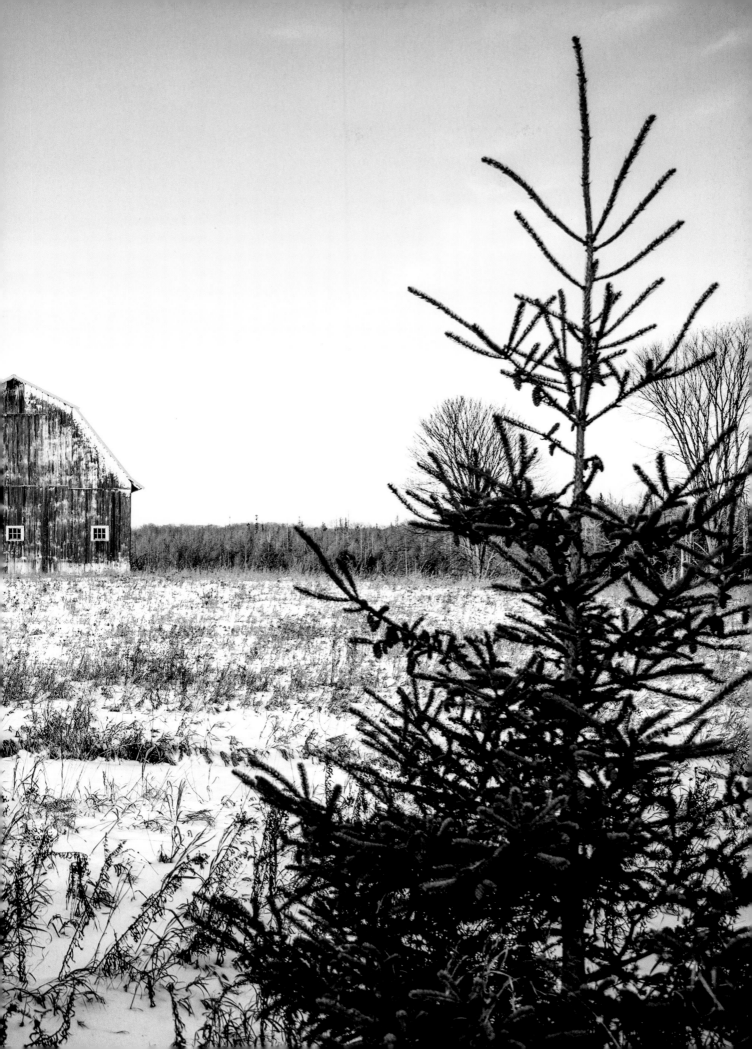

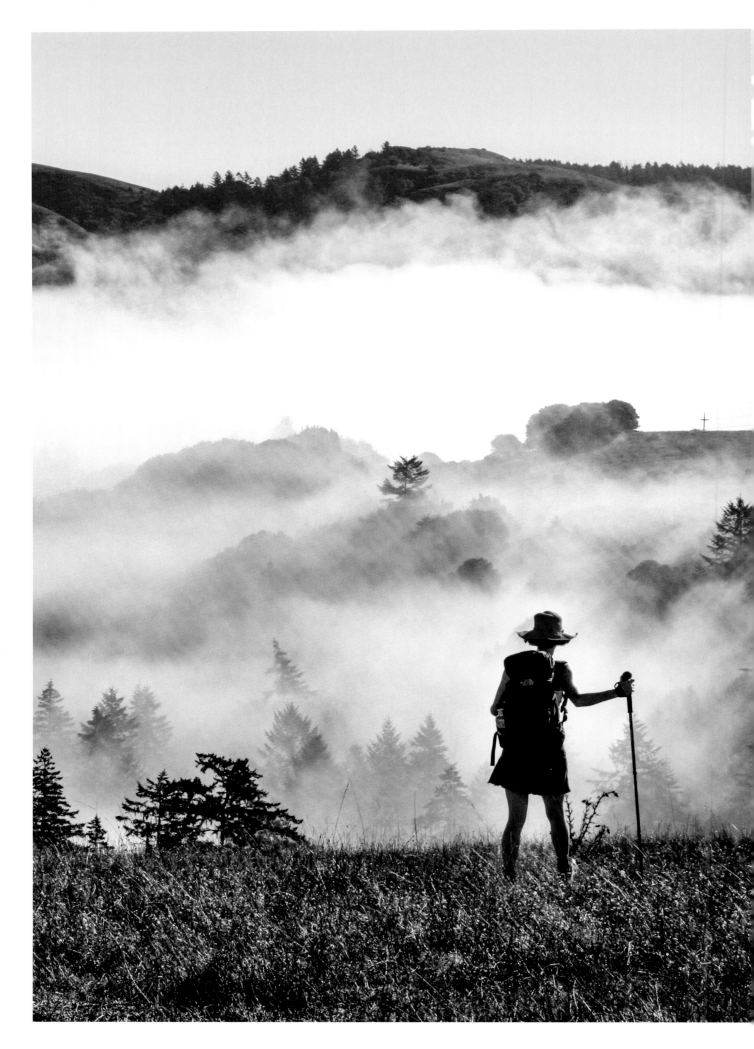

RAMBLING NEAR THE GOLDEN GATE

*For an hour's walk or days of hiking,
trails near San Francisco lead to redwoods,
ridges, and Pacific sunsets.*

TEXT AND PHOTOGRAPHS BY GREGORY DICUM
ADDITIONAL PHOTOGRAPHY
BY THOR SWIFT AND MAX WHITTAKER

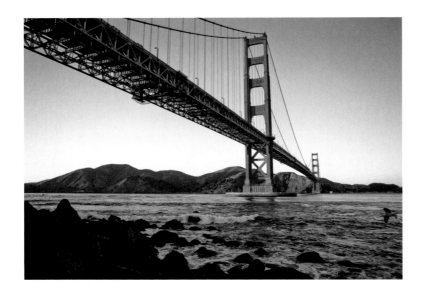

Previous Heading for Bolinas Lagoon and the Pacific Ocean in Mount Tamalpais State Park, north of San Francisco. Marin County has hundreds of acres of preserved space laced with trails.

Left The Marin Headlands are just beyond the Golden Gate Bridge as seen from San Francisco.

Opposite Tree moss along one of Marin County's many hiking trails.

Marin County, just north of San Francisco, cradles wealthy bedroom communities in picturesque bays. Its best-known town is Sausalito, just across San Francisco Bay from the city. But nearly half of Marin's 520 square miles is protected open space, bucolic and wild. Tiny towns are separated by forested mountains. It is the kind of land-scape, with miles of well-maintained trails, that people travel across the globe to traverse — to Wales, say, or the Cinque Terre. But Marin, particularly its western reaches, offers something for anyone spry enough to walk a mile or two, on any budget.

On a Friday afternoon in autumn, my wife, Nina, and I rode a bus across the Golden Gate Bridge out of San Francisco with the hordes of commuters. We planned to spend the next three days hiking before going back home to the city. While our route may have been ambitious — covering as many as 20 miles a day — it's easy to choose shorter routes, or to make connections by car or bus if you want to do it in less time.

We got off in Olema, a crossroads in a long valley formed by the San Andreas Fault. We already felt a world away from the city as we entered the eucalyptus-scented Point Reyes Seashore Lodge, where we had booked a room.

In the morning, we headed out into a dazzling fog, climbing east toward the Bolinas Ridge. Ghostly white deer, descendants of fallow deer imported in the last century,

looked down on us through dripping stalks of fennel. The air smelled like a cool herbal balm, and our boots grew dark with dew. At the ridge, fog was pouring in from a neighboring valley like heavy cream. Tomales Bay, where the fault reaches the sea, shone in the distance. All about us was mad morning chirping and grass bejeweled in the sun.

Heading south along the ridge, we met our first human beings at noon. Pierce and Carmen Morris were on a northward walk markedly better organized than our own: having rambled throughout Europe, they had entrusted a local company to plan their trip. We chatted for a bit and, as we parted, Pierce turned and called back in his sweet Georgia accent, "We're 71 years old, by the way!"

"So," Nina said as we watched them proceed jauntily toward Olema, "thirty more years of this for us?"

Soon we joined the Coastal Trail, which follows the shoreline at a distance, atop a ridge. In the late afternoon, it broke onto rolling, golden hills and our first view of the Pacific. Hawks and vultures romped in the updrafts, swooping close to the shaggy-maned hills, while paraglid-ers sought to imitate them from a promontory up ahead.

We were above the Bolinas Lagoon Preserve, part of the Audubon Canyon Ranch and one of the first places in Marin County to be protected. These hills are not un-spoiled by accident. Freeways and subdivisions planned

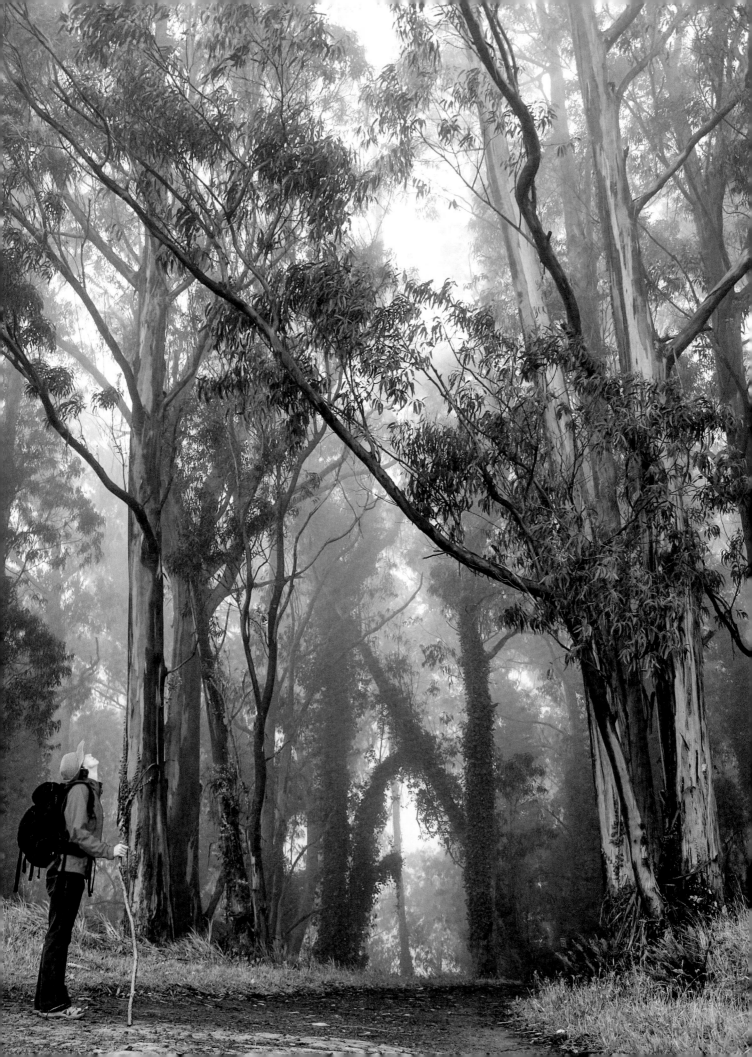

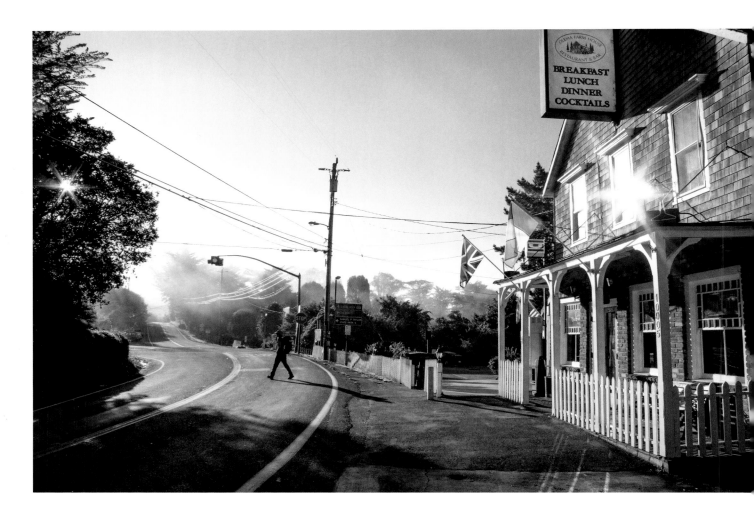

Above Olema, a crossroads town in a long valley formed by the San Andreas Fault.

Opposite Hikers on Marin's trails encounter a variety of terrain, including woods, fields, and shore.

Following The Coastal Trail hugs the shoreline along the Pacific Ocean.

in the 1960s were blocked by local activism. Instead of sprawl on its slopes, West Marin County has salmon in its streams.

As the sun lowered, we turned toward Stinson Beach. The woods soon gave way to streets of bougainvillea and Monterey cypress around '60s-era beach houses with BMWs and surfboards out front. We made the beach just in time to see the perfect ball of evening fire quench itself across Bolinas Bay. The hills we had marked with our footprints seemed improbable pink confections.

"It feels like another country," said Nina, even though we had been on that beach many times before.

We stayed the night at a bed-and-breakfast and then headed off along the Dipsea Trail. We ascended through fantastical, gnarled woods into open, misty heath. Quails,

rabbits, and an elegant buck — in the mist all the same carob color as the trail — granted us room to pass into a dense redwood forest. Higher up, we were in warm sun on the golden flanks of Mount Tamalpais.

Mount Tam is beloved in the Bay Area, and as we approached the Pantoll Ranger Station, the trails became crowded with hikers, bikers, campers, walkers, and runners headed to the peak. A friendly ranger directed us to a trail, Troop 80, that even on a sunny Sunday was quiet and lovely, and we went on our way. For lunch, we took a table on the deck of a restaurant overlooking Mill Valley, and beyond it the bustling Bay Area, while Mount Tam loomed behind us. "This beats sitting on a rock with a PowerBar," Nina observed, sipping a tall glass of iced tea mixed with lemonade.

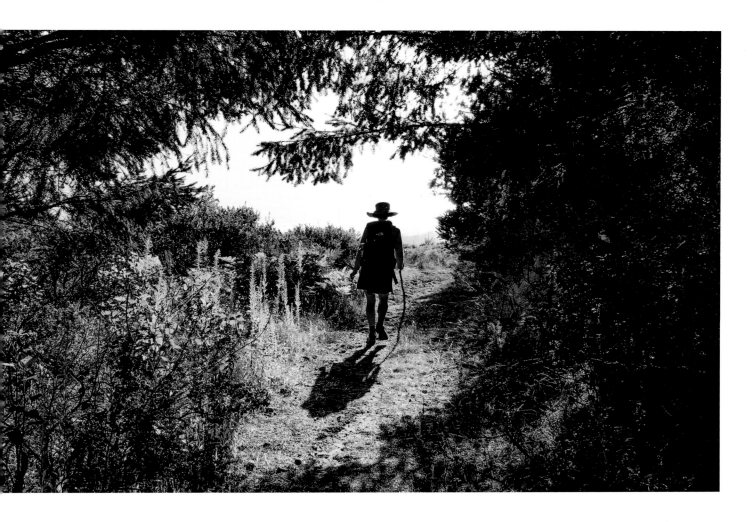

Explorer's Notebook: The small settlement of Bolinas, on Bolinas Bay, is so reclusive that its residents have traditionally torn down highway signs pointing to it. Although GPS has marred its solitude, it perseveres as an enclave of surfers, poets (Robert Creeley and Lawrence Ferlinghetti bought houses nearby), artists, and aging mavericks.

Now that we were more than 30 miles from Olema, people we met found our ramble enchanting: many who knew these trails well had not considered linking them together, and surprisingly few had taken multiday walks there.

A trail as steep as a ski slope deposited us into the Muir Woods National Monument, a grove of truly gigantic redwoods. We walked past tour buses in the parking lot, but with a few more steps we were alone again, hiking through meadows and scented alders along a river. Evening fog gathered in the last mile, restoring the air's coastal quality. Then we smelled wood smoke and came out in front of the Tudor fantasy of that day's destination: the Pelican Inn. We sloughed off our boots, propped our feet by a fire, and toasted the 15 miles we had walked that day.

Part of West Marin's appeal is its diversity of enclaves. The next day we were walking through fields of organic greens at Green Gulch, a Zen retreat and organic farm. Wool-clad Zen students nodded to us as we passed them at work cutting chard. Visitors looking for the deeply contemplative experience of dawn zazen and Japanese tea ceremonies can stay there, but we had just begun our day and were soon climbing out of the valley, and then rambling along a ridge down to the Golden Gate Bridge.

By midday we were on our way to Sausalito and the ferry home.

A BACKCOUNTRY HIKE ON CATALINA ISLAND

*A quick hop from Los Angeles
and inland from familiar beaches,
there's a wilderness to cross.*

TEXT BY ETHAN TODRAS-WHITEHILL
PHOTOGRAPHS BY J. EMILIO FLORES AND ANN JOHANSSON

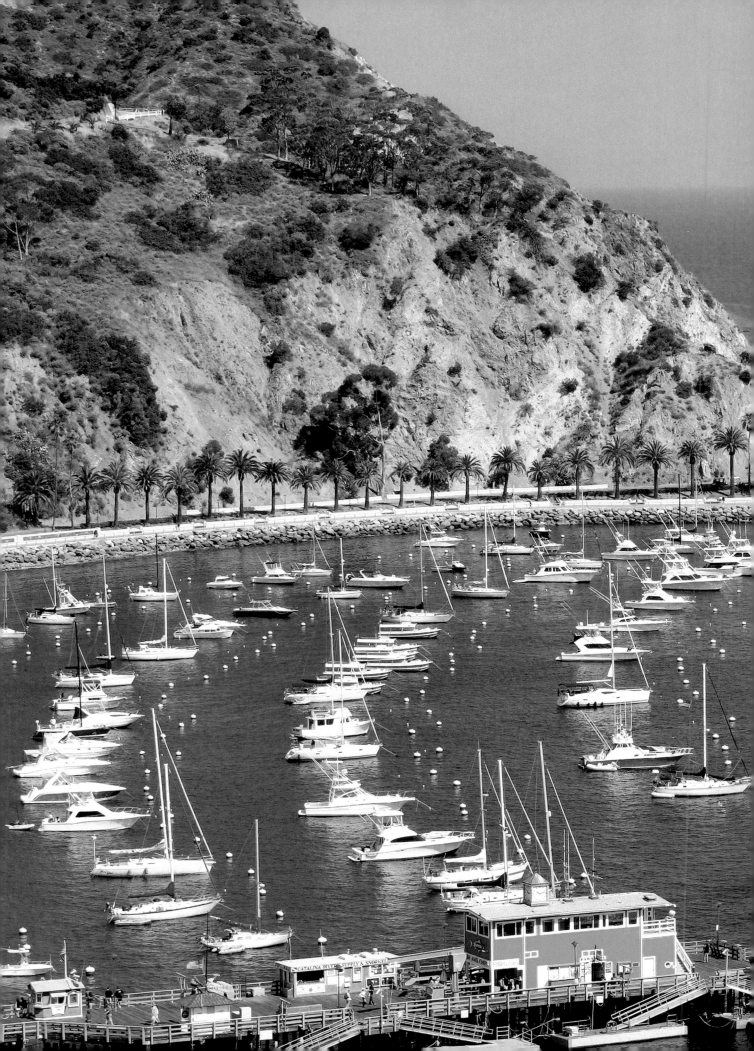

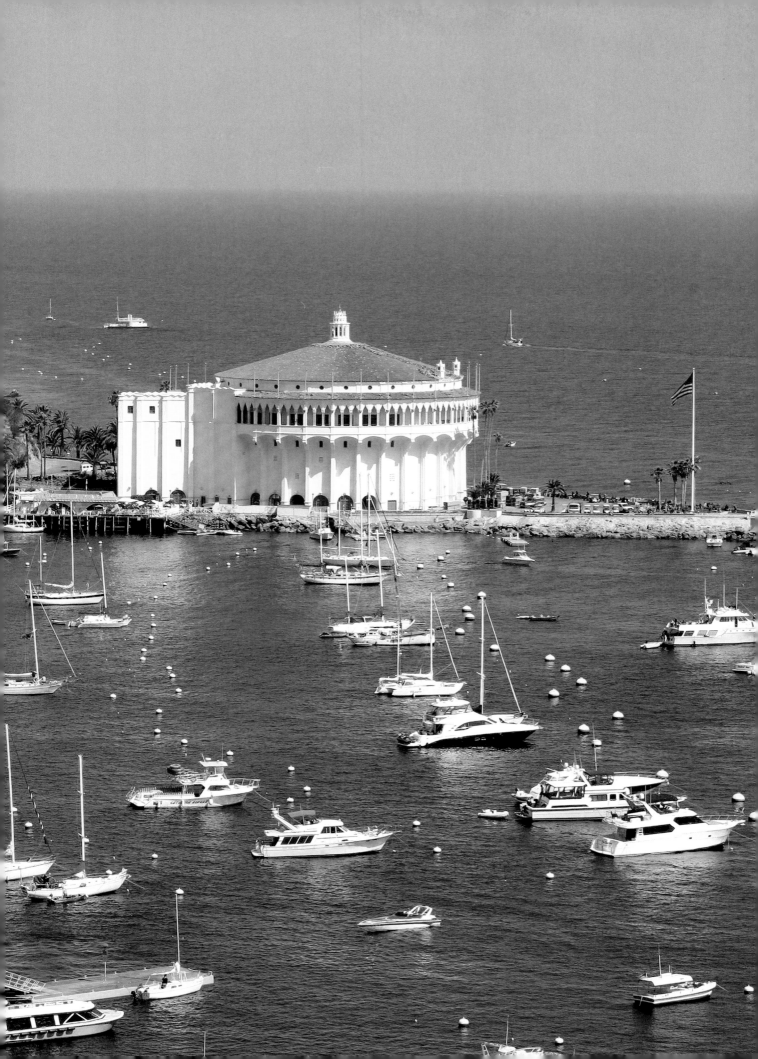

Page 194 Avalon, the main town on Catalina Island and the place where tourists tend to congregate.

Previous Avalon's circular Casino, not a gambling hall but a theater and center for entertainment. The Trans-Catalina Trail begins just outside of town.

Left A Catalina Island fox, endemic to the island. Although it is close to Los Angeles, Catalina is isolated enough to have unique plants and animals.

Opposite A buffalo near the Trans-Catalina Trail. Bison, imported for the filming of a movie in the 1920s, stayed and thrived.

The problem with wilderness is that it is, by definition, so far from where most people live. While many cities have a few nice day hikes, it's a lucky accident of geography and conservation that creates serious, "out there" backcountry hiking opportunities close to a major urban area. One of the lucky cities is Los Angeles, which is only 22 miles, as the crow flies, from the Trans-Catalina Trail, on surprisingly rugged Catalina (full name: Santa Catalina) Island.

Those who hike the full trail take a 37-mile, four-day trek from Pebbly Beach on the east end of the island to Starlight Beach on the west, through cactus-studded canyons, deserted coves, and fields of wildflowers dotted with wild bison. Yes, bison.

On a chilly spring Friday, my friend Miriam and I arrived in Avalon, Catalina's only city and main port, by ferry. Our plan was to walk the trail from Avalon to the small community of Two Harbors, and then walk 11 miles to the end of the island and turn back to take the ferry home from Two Harbors.

Avalon looked more Greek than American. White houses spilled down a green hillside toward a sparkling blue bay where sailboats and yachts, trawlers and speedboats were moored in neat rows. Even the architecture seemed Mediterranean, with the 12-story Art Deco dome of the island's casino (which is not a gambling establishment,

but a public theater, hall, and museum) standing in for a centuries-old basilica. Avalon looked like an appealing destination in its own right, but we had miles to log, so we found the road out of town and began to climb.

The Trans-Catalina Trail began southeast of Avalon, and most of its first few miles were in a broad semicircle on the ridge above Avalon Bay. We climbed about 1,500 feet to the ridgeline on a rutted dirt road lined with eucalyptus trees and prickly pear cactus and then spent a happy few hours taking in ocean views in three directions — sometimes even four. On the mainland, the Santa Ana mountains loomed over Los Angeles, itself invisible beneath the low fog on the coast.

The trail moved inland, separating itself from the road to meander through fields, along the cattail-lined edges of reservoirs, and up and down the folds of eroded green hills. Then, during a rare wooded stretch, I stopped Miriam at the entrance to a small clearing. A bison emerged from the stream below and ambled to the center of the clearing, where it stopped, eyeing us warily. It was a terrifying beast, orders of magnitude larger than any creature you normally expect to encounter on a forested path, its mane and beard matted with burrs and grass and hanging almost to the ground. We took a step toward it; it snorted and took a step toward us, its message unmistakable.

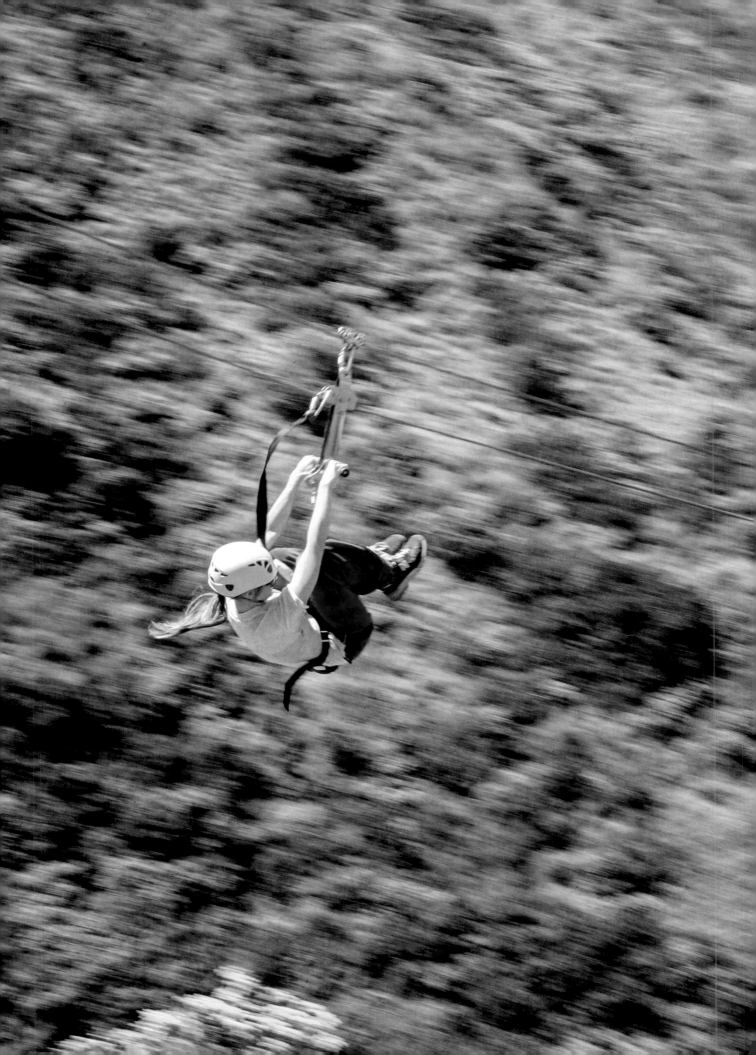

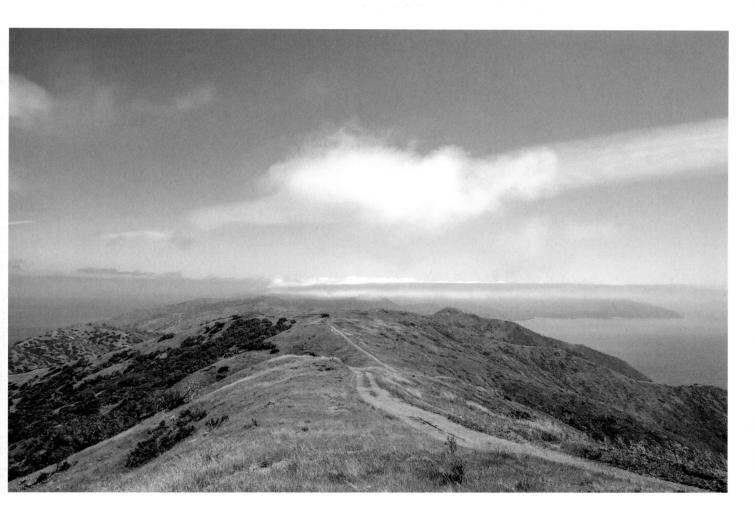

Opposite A zipline on Catalina, not part of the wilderness experience there, but an adventure over the dry hills nonetheless.

Above The Trans-Catalina Trail between Parsons Landing and Two Harbors.

Below The airport in the middle of the island, Catalina's only airport and sometimes an oasis for hikers.

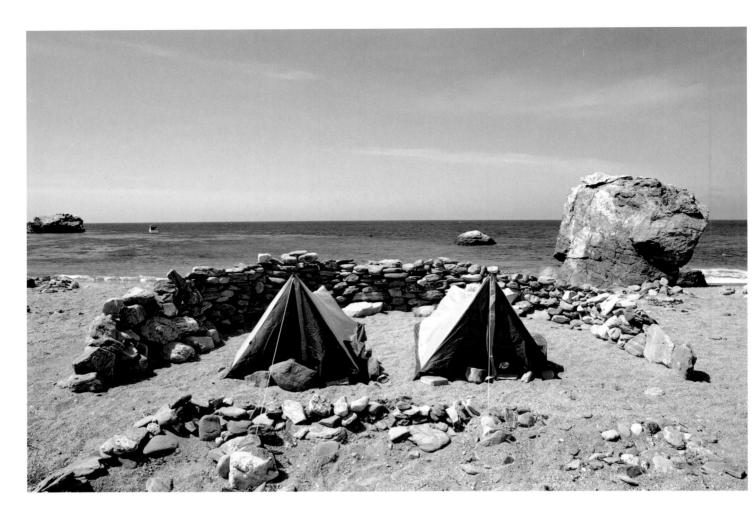

Above Campers' tents in
the Parsons Landing
Campground near the
island's northwestern tip.

Opposite Hikers on the
Trans-Catalina Trail.

Following Walking and
biking are invited on Catalina.
Cars are discouraged.

Bison are not native to Catalina Island. Fourteen were taken there in the 1920s for filming of the silent movie *The Vanishing American*. They were left on the island, where they multiplied happily and their numbers grew into the hundreds. They are largely harmless, but they have injured tourists in cases in which they felt threatened.

"What do we do if he charges?" Miriam asked, terror in her voice. "Dive into the brush," I responded, trying to sound confident, as if a few bushes would somehow deter a charging, 1,600-pound mass of muscle, horns, and hooves. But the bison let us creep by.

Tired and with sore knees, we limped into Blackjack Campground, which was empty but for a family of deer and another, less aggressive bison that soon wandered off. Between two of the island's tallest peaks (both

around 2,000 feet), we boiled water for noodles, chewed on turkey jerky, and made camp. Our original itinerary, we realized, had been too ambitious.

The next morning we were delighted to discover that we weren't nearly as out there as we felt; our cellphones worked. A few calls later, we had a new plan: hike three miles to the airport in the middle of the island and catch a midday shuttle to Two Harbors. After that, we could use the easier coastal road.

Our reward at the airport was a fully stocked cafe. I had a bison burger, enjoying each vengeful mouthful.

Two Harbors turned out to be an odd mix of outpost and resort town, set at a point where the island narrows to about half a mile, leaving a harbor on either side. It had a campsite, cabins, a hotel, a general store, and a

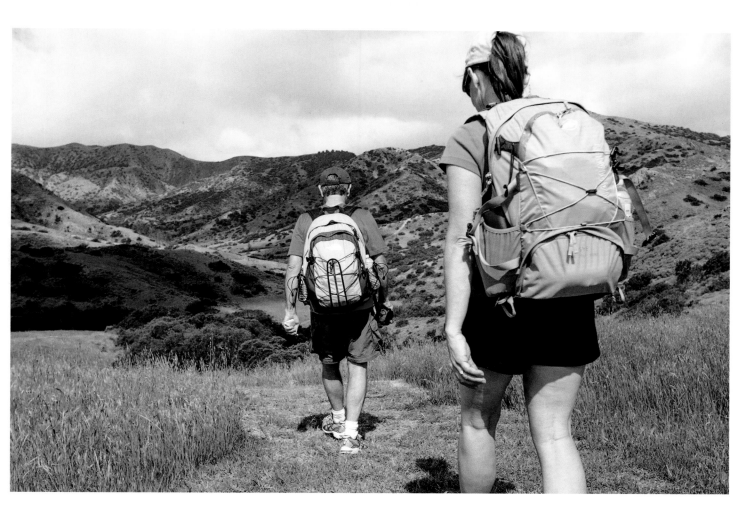

Explorer's Notebook: William Wrigley Jr., owner of the Wrigley chewing gum company of Chicago, once owned most of Catalina Island. The Wrigley family also owned the Chicago Cubs baseball team, and for years the team had its spring training on Catalina.

cafe/restaurant/bar. That evening, we joined members of a local hiking club at their bonfire.

In the morning a ranger drove by and politely suggested we book one of the remaining cabins in town. A storm was coming, and how; gusts would reach over 50 miles per hour.

Walking that day would be not only wet and unpleasant but also potentially deadly, with the powerful winds and a chance of mudslides. And cutting the trip short to go back to the city was not an option. The outbound ferry was canceled that day. We were marooned.

So we embraced it.

In the cafe we met Patrick, a local fish farmer who was dressed like a longshoreman but talked like a scientist. "People are so used to having whatever they want when-

ever they want it," he told us. "But out here, weather still matters."

He drove us up to the Banning House Lodge, an old mansion and hotel. A warming blaze was going in the fireplace there, so Miriam and I picked out a puzzle and spread its thousand pieces over the coffee table. Patrick worked on a correspondence course via laptop, chatting with each and every newcomer, while a Boy Scout troop played Monopoly in the next room. Looking at the view outside the window, as the wind and rain bent the palms, was reminiscent of watching television news coverage of a hurricane.

Only 22 miles from Los Angeles as the crow flies, but no crow in its right mind would be flying this day. We were 22 miles and a world away.

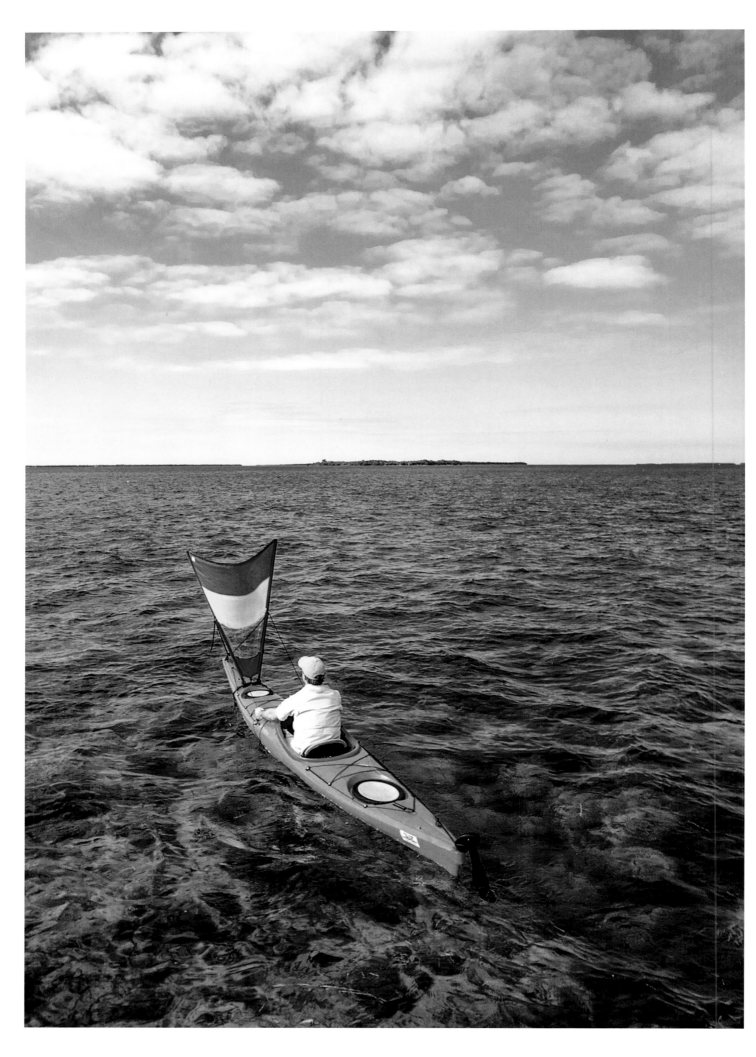

KEY TO KEY IN
A KAYAK

*For paddling it's hard to beat the Florida Keys,
with their clear, shallow water and many landing points.
And that's not even mentioning the weather.*

TEXT BY CHRISTOPHER PERCY COLLIER
PHOTOGRAPHS BY CHRIS LIVINGSTON AND MAGGIE STEBER

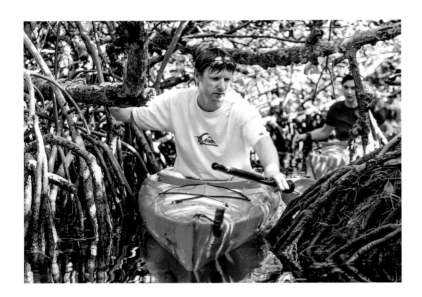

Previous A kayak equipped with a sail near Little Palm Island, off the coast of Big Pine Key. Most visitors zip through the Florida Keys in cars. Kayakers get a closer view of the islands and the clear waters that surround them.

Left Navigating through mangroves off Big Pine Key.

Opposite Paddling under a bridge near the Hawks Cay Resort off the coast of Duck Key.

We were paddling atop an expanse of shin-deep water, and our guide was in the middle of a long recital of facts about the old Seven Mile Bridge, the decaying concrete structure we had just passed beneath. Yes, about seven miles long, he said, replaced by a new bridge with 440 individual spans, featured in the film *True Lies* — and it was right about then that he stopped. The guide, Dave Kaplan — Kayak Dave to his followers — pointed with his paddle to a dark blotch on an otherwise bone-white ocean bottom. It appeared to be moving. "Stingray," he whispered from the perch of his cantaloupe-colored sit-on-top kayak. "Twenty feet away."

Chris Livingston, the photographer I was kayaking with, pulled a camera from a waterproof bag and nimbly inserted it into an underwater casing. Meanwhile, I took a few last paddle strokes to bring our two-person craft in for a closer look. We glided to within a kayak's length of this four-foot-wide, undulating creature as it hovered just centimeters above the sea floor. For about a minute, we watched it coast through the flats at the approximate pace of a waddling land turtle. And then, unexpectedly, this platter-shaped behemoth darted off, leaving a cloud of white sand in its place. "Don't worry," Kaplan said as we paddled onward. "We'll probably see another."

Given our vantage point — midway down the Florida Keys, surrounded by water so clear and so shallow — such

a claim seemed more than just wishful thinking. As it turned out, in this case the prediction was wrong. On our paddle from near the Seven Mile Bridge to Bahia Honda State Park and back on a bright December morning, we saw no more stingrays. But no complaints were lodged. Instead, we paddled past a spiky black sea urchin, a salami-length shark, and at least a half a dozen wading birds. Not bad for a two-hour paddle.

The conventional way to explore the Florida Keys is by car, following U.S. Route 1. But when the landscape being traversed is ultimately a series of islands connected by bridges, it quickly becomes evident that pavement takes an island-hopping traveler only so far. A deeper immersion requires not just looking at the clear, shallow water, but getting onto it. And a kayak may be the best way to do it.

"The Florida Keys is loaded with shallow water," Tom Ashley, a boat captain working for the Little Palm Island Resort & Spa, had said the previous day as he carefully navigated his motorboat through the flats near Little Torch Key. He told us he often took guests and kayaks aboard to shuttle them out to remote shallows. "Out here," he added, "you can see water in five different shades of blue. But often the only way to reach that water is in a kayak."

In the Keys, an archipelago of some 1,700 islands, finding a kayak outfitter has come to be about as difficult

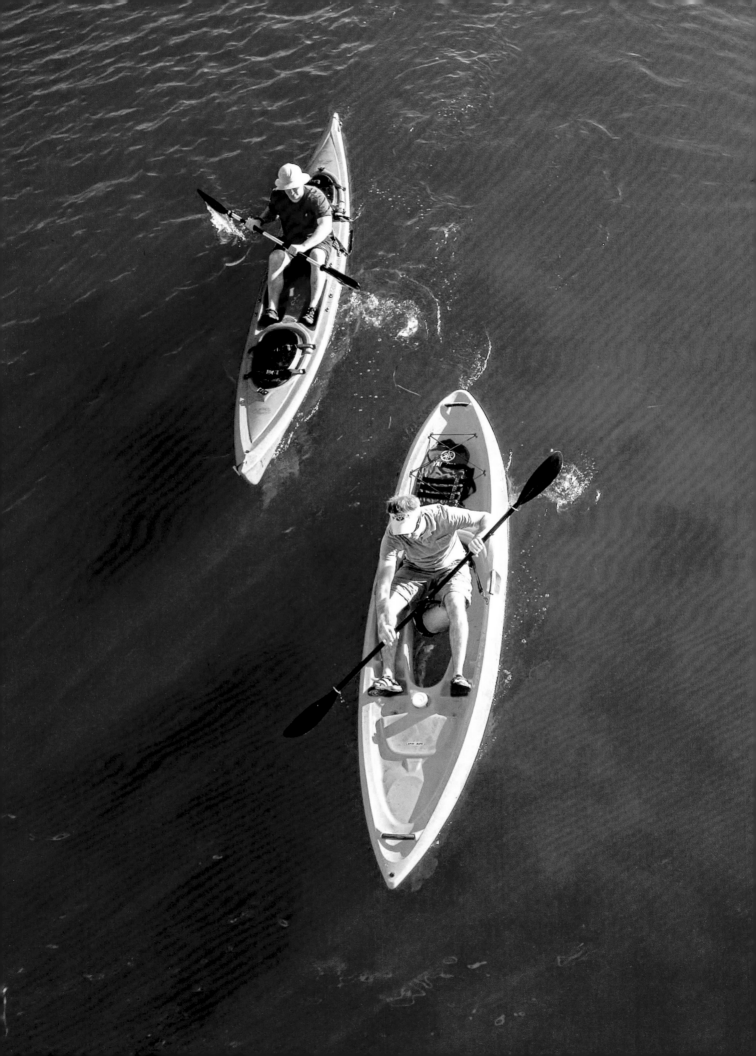

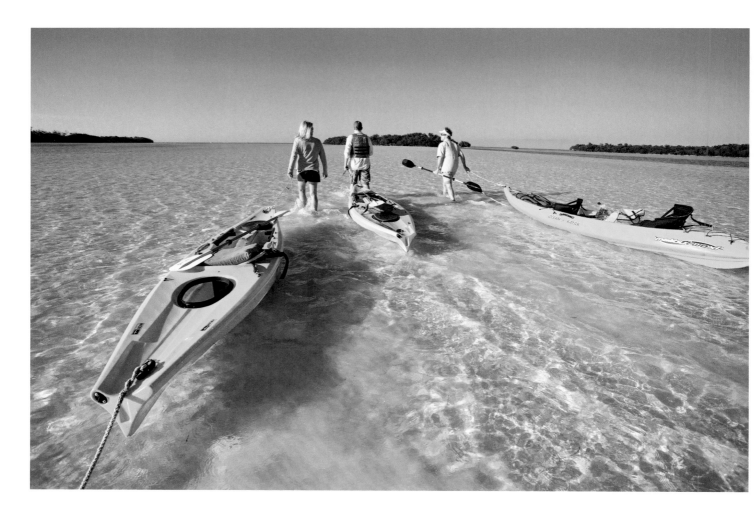

Above Paddlers set out with a kayaking guide to explore some of the uninhabited islands off Sugarloaf Key.

Opposite A young snorkeler at John Pennekamp Coral Reef State Park in Key Largo.

Following Paddler and spectator at Little Palm Island off the coast of Little Torch Key.

as spotting a pelican. It would be hard to find a part of the country that has embraced kayaks more fully or for more purposes than the Keys — or made them more readily available to tourists.

Kayaks are employed in conjunction with snorkeling and spear fishing. They are rigged with sails that can be flipped up in a matter of seconds should the wind blow in an opportune direction. Fishermen go out in them for a cheap form of flats fishing — one that's often exciting because the kayaks are so light that a hooked fish can pull you along while it is trying to escape. "Hook a tarpon, and it could drag you around for half an hour in Florida Bay," said Brandon Jannarone, a guide based in Key Largo.

Beginning kayakers arrive in large numbers from cruise ships docked at Key West. For them, the put-in site may

be within 20 feet of an open-air bar. More experienced paddlers often take longer excursions, even overnight trips from Key Largo to the nearby Everglades.

Regardless of the boat or the style of trip, however, the reward of kayaking in the Keys is often an authentic and unrepeatable brush with the natural world. A great blue heron, after a patient waiting game, nimbly plucked a yellow, pencil-length water snake from otherwise mirror-calm water off Little Palm Island. A non-native iguana peered out from mangroves off Key West near where a couple of red crabs perched on a damp rock. A two-foot nurse shark rippled the water at the National Key Deer Refuge near Big Pine Key.

At the same time, the larger world falls away and time can blur. "People come down here wanting to get away

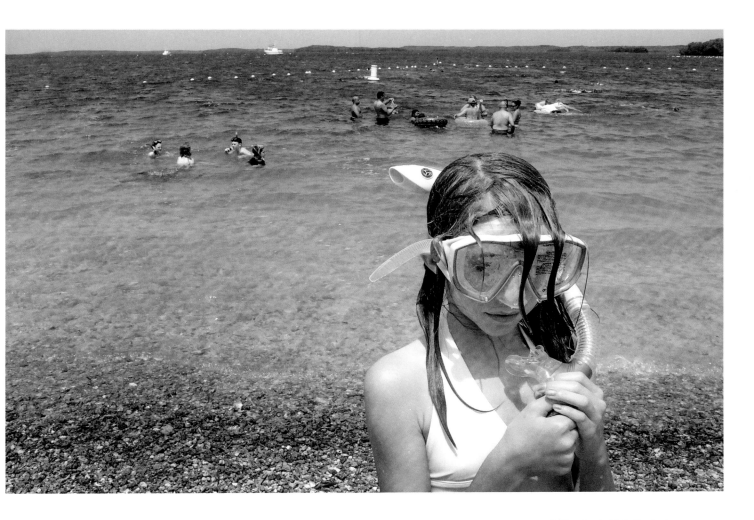

Explorer's Notebook: U.S. Route 1 runs down the East Coast from Maine to Key West. The section that stretches out over the Keys, connecting them with a series of bridges, is one of the best-known scenic drives in the United States.

from the hectic, everyday lives," Jannarone said. "Kayaking fits very neatly into that escapist bracket."

On a trip from Big Pine Key, as the group I was with approached the banks of the oddly named No Name Key, this form of temporary amnesia appeared to be in full effect. Our guide, Bill Keogh, dropped the anchor of his twin-engine motorboat, unfastened four kayaks, then pushed us off into a swath of shallow water thick with sea grass and red coral. It was an easy introduction into this region of the Keys. But now he wanted to take us deeper. "Put your paddle away," he said. "You won't need it for this part of the trip."

Grasping at a series of overhanging branches, he guided his kayak through a narrow, liquid passageway, a natural tunnel of sorts leading into a shadowy tangle of

mangroves, and beckoned us to follow. Baitfish shot about beneath our boats. Flapjack-size jellyfish undulated in small pools. Minuscule crabs scuttled along the muddy banks. Two hundred feet from the entrance, we circled around in an opening about the size of a child's bedroom and came back.

When we were out of the tunnel and resting, I asked Andrew Clarke, a vacationing New Yorker who had been on and in the water around the Keys for several days, what he'd done the day before. "You know," he said while looking quizzically at his travel companion as she paddled over a bed of sea grass. "I can't really remember."

HOT, COLD, AND BLISSFUL ON HAWAII'S BIG ISLAND

You were prepared for spewing lava,
black sand beaches, and lots of Kona coffee.
But did you bring your winter coat?

TEXT BY JEREMY W. PETERS
PHOTOGRAPHS BY MARCO GARCIA

Page 214 Ferns are just the beginning of the flora on the Big Island, with its tropical setting and microclimates.

Previous A wet day on a road near the town of Volcano, outside of Hawaii Volcanoes National Park.

Left Sunset watchers on the beach at the Four Seasons Resort Hualalai on the North Kona Coast of the Big Island.

Opposite An outrigger canoe, photographed from a helicopter.

Frostbite and altitude sickness were not concerns I had in mind when I started planning my Hawaiian vacation. Yet here I was, listening to a safety briefing from Katie, a guide who was about to drive me and a small group of other tourists up to the 13,796-foot summit of Mauna Kea on the island of Hawaii — the Big Island. Our group of satisfactorily athletic 30-somethings should be fine, she said. But if any of us got a little woozy or cold — even with all the extra layers we had brought — she had some spare oxygen and winter coats in her van.

Incongruous as this seemed in the 80-degree weather at sea level, I was not completely unprepared. I had looked into the weather conditions on the mountaintop about a week before this March trip and been floored by what I saw: a blizzard warning. Yes, in Hawaii.

The Big Island is a place of vast geographical diversity, with smoking volcanoes, an alpine desert, and misty tropical forests. It's a place where the hotels have fireplaces for the cold nights and outdoor showers for the hot afternoons; where the sand can be white or black or green; where the landscape is so otherworldly that there are places with nicknames like "Little Mars"; where hilly pastures and cattle ranches seem as if they could be in the American West.

Hilo, where my partner, Brendan, and I picked up our ride for Mauna Kea, is the biggest town, with 43,000

people. Hilo's simplicity set the tone for our trip. There was a low-energy, unpretentious feel that would become pleasantly familiar.

Katie, a guide with Arnott's Lodge in Hilo, drove us and a group of other tourists up the road to Mauna Kea's summit in about an hour and a half, not including a stop at the visitors' center at 9,000 feet for some quick acclimation to the altitude. As we neared the top, the scrubby, spiny bushes and small trees disappeared. There was nothing but rock of a rusty brown color. And then blinding white — an ice-glazed snowpack.

As the wind howled and our faces froze, we watched the sun sink into the horizon just to the west of Maui, which loomed in the distance. I couldn't help but think of the people watching the same sunset from the beach in their sandals and swim trunks.

One inescapable theme on the Big Island as we drove from town to town was nature's apparent intention not to let anyone get too comfortable. I was reminded by the civil defense reports on the radio every day alerting islanders to the latest movements in lava flow. (There are three active volcanoes on the island.) I saw it in the smoldering forests that were slowly being engulfed by the lava's creep, and in a patch of asphalt that was all that remained of a destroyed road in Hawaii Volcanoes National Park. Kilauea, an especially active volcano, is threatening

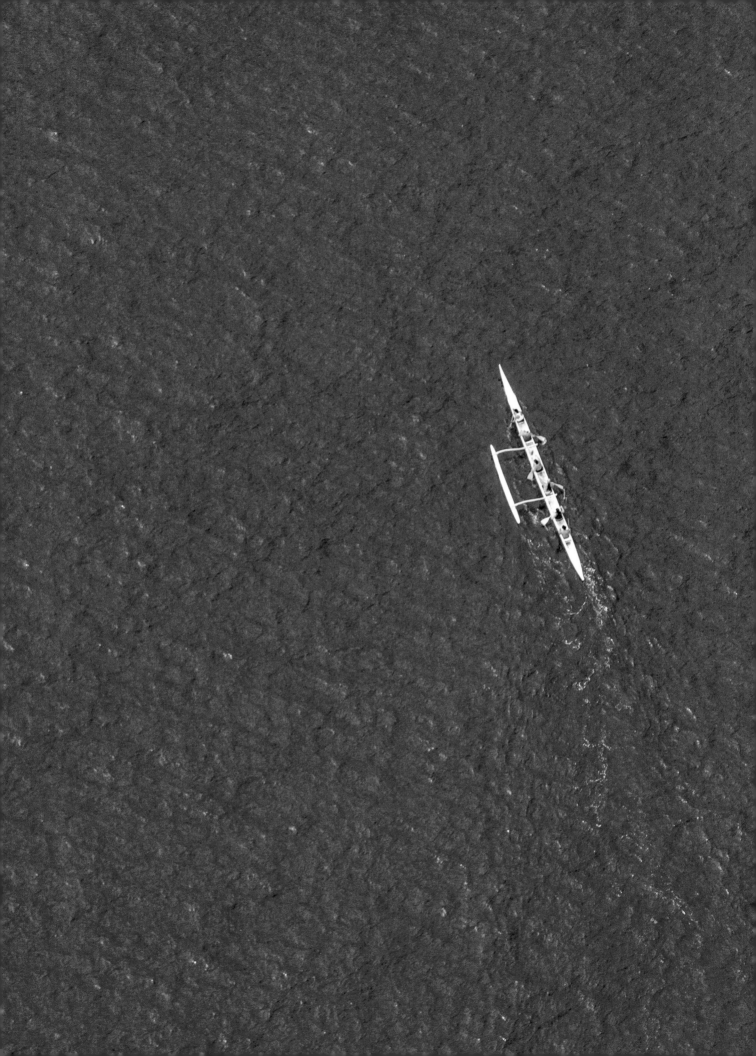

Above A store in Hawi, a town of about 1,000 people near the northern coast.

Opposite The Mauna Kea Observatory at the summit of the Mauna Kea volcano. The snow patches are an indication of the temperatures at this altitude, nearly 14,000 feet.

to overtake the town of Pahoa. There were the constant reminders of tsunamis, too — distinctive disc-shaped sirens along the road in coastal areas and signs pointing the way to the safest evacuation route.

One of the best vantage points from which to absorb the Big Island's continuing destruction and creation is aboard a helicopter. I was initially skeptical. But looking back, I can't imagine taking this trip without seeing what an active volcano looks like from the air. We did the "doors-off" option, which is exactly what it sounds like and probably even more terrifying than you'd think. But looking through a window would have been much less memorable.

To explore the national park, we based ourselves in the village of Volcano, just outside the boundary. At

an elevation just shy of 4,000 feet, Volcano is a good 10 degrees cooler than sea level. It's also in the middle of a rain forest and feels a world away from either the beach below or the snowy summits above.

During the day, we drove all the way down to where the park ends at the ocean. We wound our way through lava fields that looked like the set of an alien movie, barren and brown. At night, Kilauea's glowing crater illuminated the sky in a blaze of orange.

On our last two nights we stayed at the Four Seasons Resort Hualalai on the warmer, drier western coast. Our room was elegantly done and steps from the beach, so that we fell asleep to the sounds of the thumping surf. But extravagances like the Four Seasons are not the reason

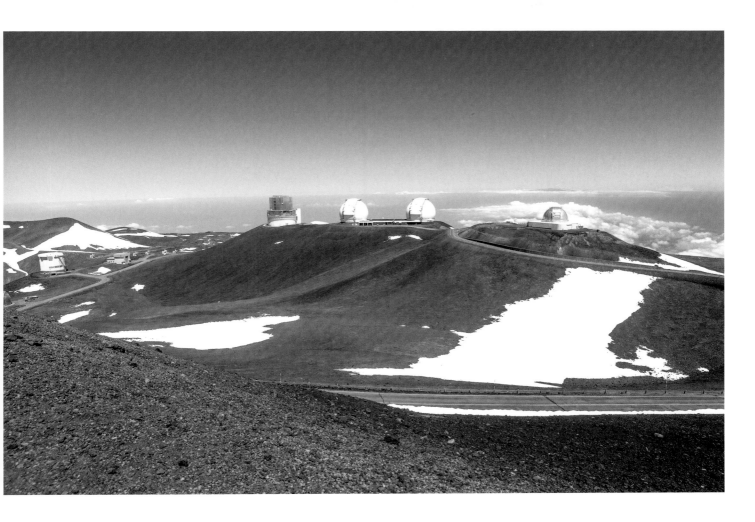

Explorer's Notebook: Geologists say Mauna Kea is actually the tallest mountain on earth. When measured from its base on the sea floor, it is more than 33,000 feet high. At its top, the altitude, lack of man-made light sources, and usually clear weather make it a favorite spot for astronomers.

most people visit the Big Island, as we were reminded when we ventured out to the northern coast. The drive there took us through one little ecosystem after another, from cactus-covered lava fields to brilliant green hilly cattle pastures to pine-forested flatlands.

We had sushi for lunch in the little town of Hawi, which is like many little no-stoplight towns on the Big Island in that its architecture seems, incongruously enough, borrowed from the Old West. The stores and restaurants are built from wood and have big open porticoes looking out onto the street. There was an excellent selection of places to get iced Kona coffee and ice cream, and an impressive collection of crafts and artwork by local artists.

We hiked down into the Polulu Valley, one of several deep chasms on the north end that have been carved out of the shoreline and are ringed with waterfalls and covered in lush vegetation.

There was a black sand beach at the bottom and abundant pine trees. I'd been to palm-lined beaches before, but not a pine-lined one.

As we made the drive back up and over the mountains to return to the Four Seasons, we could see Mauna Kea's 14,000-foot summit sprinkled in snow. Thinking of the people up there wheezing and freezing, we called the hotel and asked them to set aside two chairs in the sun at the Tranquility Pool.

Some immobile bliss seemed in order.

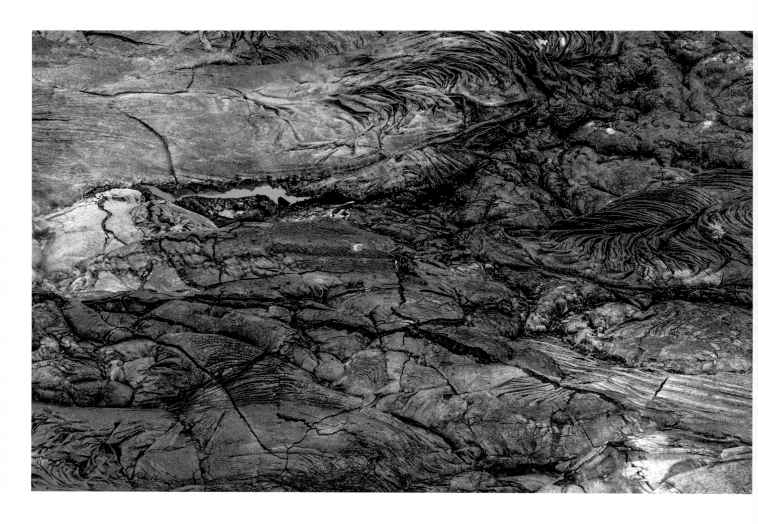

Above A crevasse glows with
lava on the slopes of Kilauea.
This view, from a helicopter, can't
be duplicated on the ground.

Opposite and following A lava
lake, seen in an aerial view, and
hikers' close-up view of lava,
both in the Halemaumau Crater
on the Kilauea volcano.

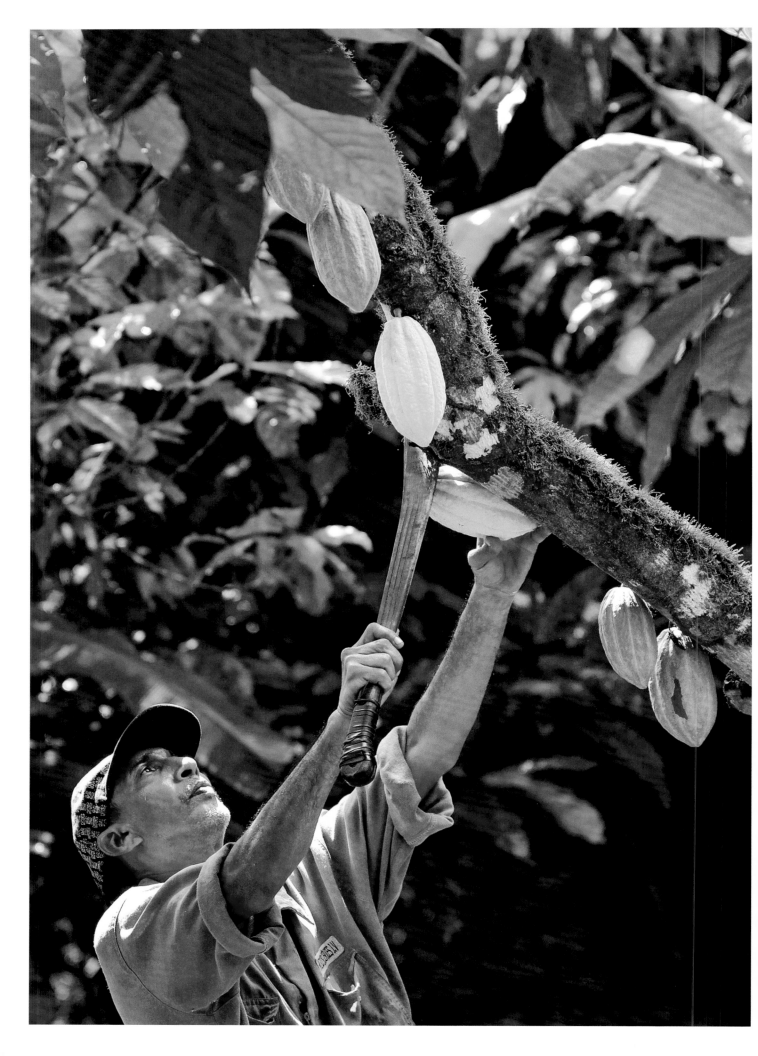

ISLAND HOPPING
FOR A CHOCOLATE BAR

*A Caribbean quest leads to estate tastings,
cacao culture, and cocoa Bellinis,
with time left for sunbathing.*

TEXT BY BAZ DREISINGER
PHOTOGRAPHS BY MERIDITH KOHUT

Previous Harvesting cocoa pods at Delft Cocoa Plantations in the Montserrat Hills of central Trinidad. The chocolate industry is a mainstay on Trinidad, and it is alive and well on other Caribbean islands. Visit several for a chocolate tour.

Left A candy from Cocobel Chocolate on Trinidad.

Opposite A "cacao dance" for tourists at the Fond Doux Estate on St. Lucia.

One morning on St. Lucia, as I was waking from beatific dreams, I discovered that I had turned into a luscious, ripe cocoa pod. Or so I imagined, borrowing freely from Kafka's opening line in *Metamorphosis*. For three decadent days, I had been eating chocolate-stuffed liver pâté, cocoa-encrusted kingfish, and, for breakfast, cocoa-and-cashew granola. At night I drank cocoa Bellinis. I indulged in a cocoa oil massage, hiked through cocoa fields, and created my own chocolate bar. Dawn consistently carried the pungent aroma of cocoa trees, because I was staying on a verdant cocoa estate — and sleeping in a cocoa pod.

Well, sort of: Hotel Chocolat, a boutique property in St. Lucia, features not rooms but "luxe pods," where even the magnificently minimalist décor (rich mahogany floors, ivory-colored bathroom with open-air shower) evokes the essence of chocolate.

Hotel Chocolat's union of tourism and agricultural development, specifically its devotion to all things cocoa, is part of a budding movement across the Caribbean. You might call it choco-tourism. There are options all over the region: in Belize, which celebrates a cocoa-driven local culture in its annual chocolate festival in Toledo; in Dominica, where visitors can stay in the boutique Cocoa Cottage hotel; in Barbados, home of the Agapey Chocolate Factory. The Grenada Chocolate Company on Grenada

pioneered the trend in 1999, offering tours of its factory, farm, and Bon Bon Shop.

For my own chocolate tour, I followed the cocoa trail across four islands and three languages.

I began in Trinidad, where the cocoa industry is such a mainstay that the University of the West Indies there has a Cocoa Research Center. As I drove out beyond the sprawl of Port of Spain, green erupted everywhere: rolling hills, quaint plant shops, iguanas scurrying across the road.

In the Montserrat Hills region, I was greeted by a host of butterflies, thundering squawks from a caged macaw, and the outstretched hand of Lesley-Ann Jurawan, owner of Delft Cocoa Plantations and Violetta Fine Chocolates. She explained that Trinidadians long ago bred their own bean, the trinitario: a hybrid that has become one of three main kinds of cocoa trees grown worldwide. It fuses the prized, complex, and fruit-flavored criollo bean with the hardy forastero, the bulk bean, mostly sourced from West Africa, that accounts for some 70 percent of the chocolate we eat.

I sampled a sliced trinitario pod and tasted a mild flavor, acidic yet sweet. I saw vats of fermenting cocoa pulp and metal drying sheds with retractable roofs. At last Jurawan presented me with one of her own bars. The fruity, spicy sensation made me momentarily understand why

Above Opening the cocoa pod. Inside the white pulp are the cocoa beans, which are naturally dark in color.

Opposite Signature chocolates of the Hotel Chocolat on St. Lucia. The beans are grown on the Rabot Estate, under the same ownership as the hotel.

the Mayans were said to sacrifice humans in exchange for a good cocoa crop. This was to-die-for chocolate.

On another day in Trinidad, Gail's Exclusive Tour Services whisked me away on a drive through the rain-forested Northern Range Mountains. At the visitor center in the village of Brasso Seco, I was handed a cup of the best hot cocoa of my life. Then a guide took me on a hike through acres of criollo trees, laden with red and yellow pods.

Next stop on the trail: Trinidad's resort-driven sister island, Tobago. At the Tobago Cocoa Estate, on the fringes of the Main Ridge Forest Reserve, I pulled into a clearing where a woman with a machete greeted me and explained that not long ago this place was all bush, and that it took five years to clear. Now it's an Edenic 43-acre

estate, home to some 22,000 cocoa trees and the crops that shade them: ginger, cherry, lime, guava, mango, avocado. It's also beside the Argyle Waterfall; a short hike through bamboo forests leads to its cascading pools of chilly mountain water.

I hiked through the estate to a hilltop gazebo and sampled from a pod. At the gift shop, I stocked up on the 70 percent single-estate chocolate. ("Single estate" and "single domain" are the crème de la crème of chocolates, both referring to bean origin.)

A few days later, after some lazy-tourist time on Tobago beaches, I arrived at the Rabot Estate in St. Lucia and checked into Hotel Chocolat.

The Rabot Estate empire includes the hotel, an internationally available chocolate label (Rabot Estate), a

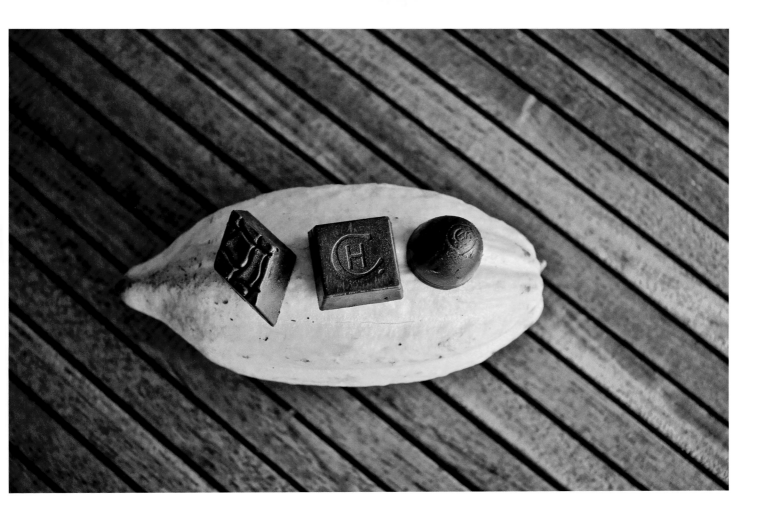

Explorer's Notebook: The Caribbean Sea is a favorite haunt of cruise ships, and one way to pursue chocolate culture is to book a cruise that makes stops on cocoa-producing islands. Some cruises are even chocolate-themed.

restaurant chain (Boucan), chocolate cafes in European cities, and Roast & Conch small-batch chocolate shops.

I devoted a full day to indulgence at the Rabot Estate. There was a hike to its highest point, where I marveled at a 360-degree view of the Caribbean crowned by St. Lucia's magnificent landmark, the Piton Mountains. The Bean to Bar class involved mortar-and-pestle grinding, some cooking-show-style cheating (when it was time to pipe my chocolate into its mold, a ready-made bowl of liquid chocolate appeared), a Tree to Bean tour, and an Engaged Ethics tour.

I remained in this rural part of St. Lucia, with its black-sand beaches, waterfalls, and mineral baths, for four days.

All epicurean adventures should end with rum and chocolate for breakfast. I had mine during a day trip from St. Lucia to neighboring Martinique. The 20-minute flight links radically different worlds; it felt mildly surreal to suddenly be making my way through Martinique's sleek European airport and then cruising down a modern high-way to a Frères Lauzéa, a modish shop that could well be in Paris. Inside, glass cases contained 35 flavors of truffles, from banana and curry basil to guava and coffee.

Two men in black suits ushered in six-year-old Martiniquan rhum vieux and chocolate ganache. I was coached in tasting techniques: sip and swallow the rum; bite the chocolate; sip more rum; swallow together.

The pairings were perfect: single-malt-finish rum and pungent orange chocolate. Litchi truffle with ultra smooth, sweet rum. It could have been nowhere but in the Caribbean.

Above Soufrière, which was the capital of St. Lucia in French colonial days, lies in the shadow of the island's signature twin peaks, the Pitons.

Below Tourists learning about the cocoa business on a "Tree to Bean" tour at Hotel Chocolat.

Opposite The Fond Doux Estate, a heritage tourism site on St. Lucia.

Following A sunset in Soufrière.

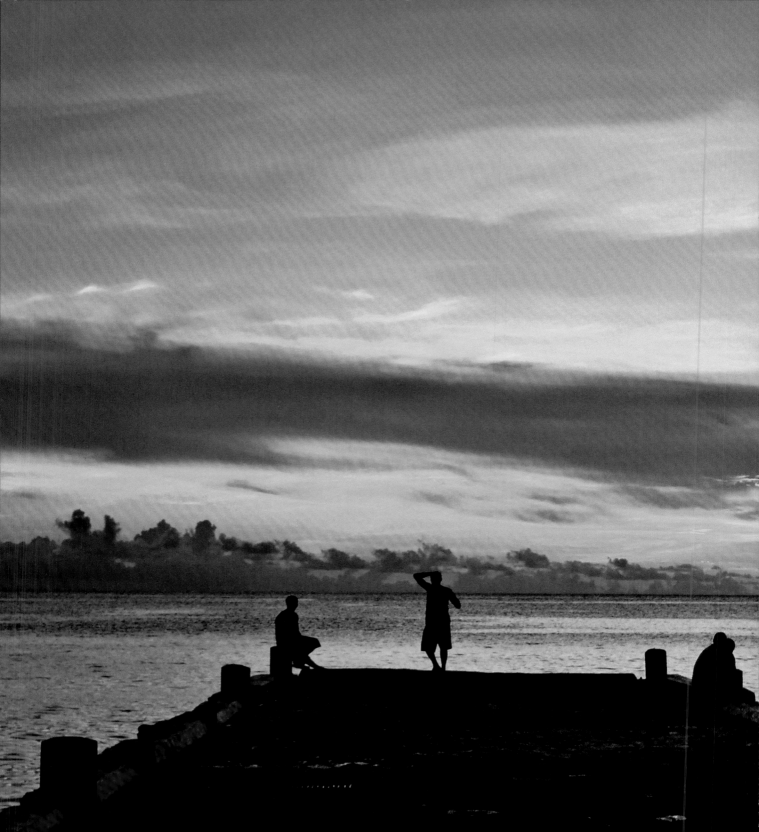

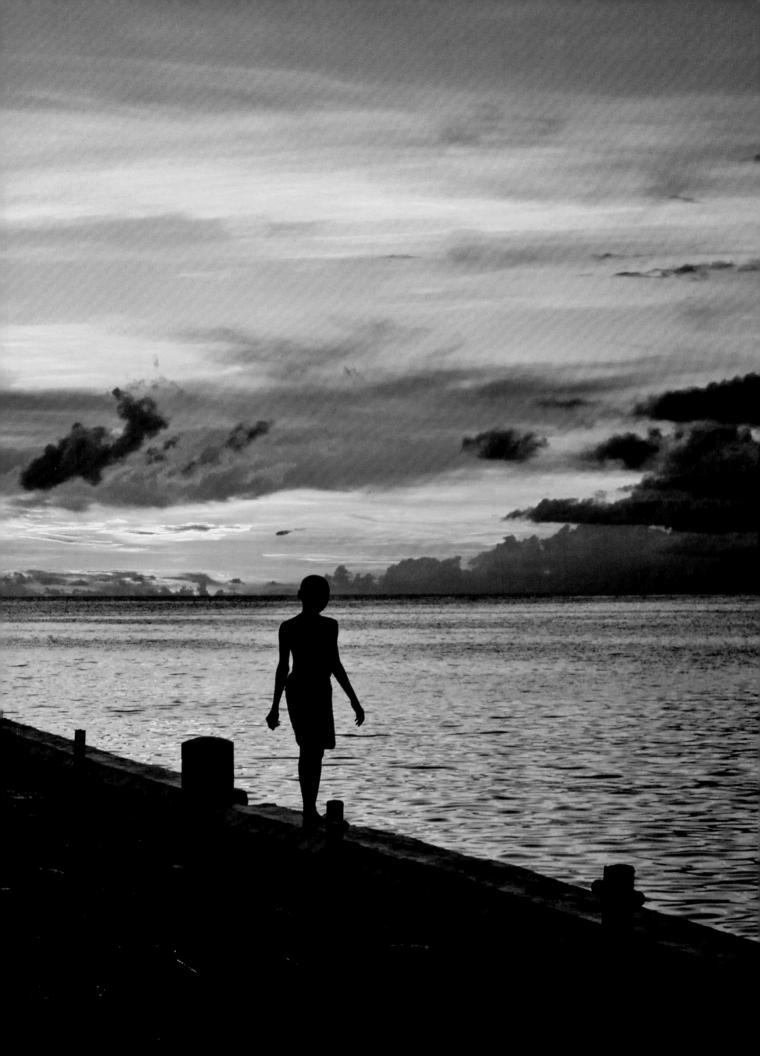

THE TIMELESS REWARDS OF BERMUDA

On an island of pink sands,
bougainvillea, and seersucker, memories
are made on mopeds and jet skis.

TEXT BY ANDREW McCARTHY
PHOTOGRAPHS BY TONY CENICOLA

Previous Oleanders and a sea view, a dime-a-dozen vista in Bermuda, an Atlantic island east of North Carolina.

Left A doorway in St. George's, a Unesco World Heritage Site. Soak up the town's charm and then munch a snapper sandwich at Art Mels Spicy Dicy.

Opposite A scooter rider's view of Bermuda.

Following Once a heavily fortified English naval base, Bermuda is now better known for pink sand beaches, golf, yachting, sport fishing, and wreck diving.

Our scooter zipped past a small sign and I caught a fleeting glimpse. My sleep-deprived brain latched hold of something and went scrolling back through the years. Could this be it?

The trip hadn't started as a treasure hunt. I'd brought my family to Bermuda for a quick, easy holiday — much as my father did when he left my mother at home to enjoy a solitary break and took his three small children (including me, age 9) to Bermuda so many years before.

I hold few specific memories of that early trip, save for an ill-advised attempt at scuba diving and a persistent image of clinging to my father's midsection from the back of one of the thousands of mopeds that raced over the island. Long lost from everyone's memory was the name of the hotel where we stayed.

This time, my wife and I, with our own three children, set up base at the Elbow Beach resort, one of the island's more venerated establishments. Its bungalows were scattered over property that rolled down to a half-mile of buttery sand and warm turquoise water.

Vacationing with an infant brings its own challenges, and its own early morning rewards. Left to my own devices, I would never have been down on the pink sand beach before sunrise, as the sky lost its darkness. Rowan's first exposure to the beach left him confused, then quickly enthralled. "Why hadn't you shown me this before?" his look seemed to suggest. We made it a morning habit.

Images of Bermuda run to pastel-colored cottages with steep roofs, bougainvillea-cluttered hillsides, and grown men wearing brightly colored shorts and high, dark socks, often with an accompanying blazer on top. Seersucker is not uncommon. "Why are the men dressed like that?" asked Willow, my 8-year-old daughter. After stumbling on about tradition and British culture, I found myself hard-pressed to give her a good answer.

While Bermuda still trades on its colonial roots to some degree, much of the stodgy formality I experienced in my youth seemed to have faded. No longer would any of us be required to wear a sport jacket to eat our early bird dinner — we found a relaxed welcome everywhere we went.

It was easy to while away the days alternating between beach and pool, but we dragged ourselves away. We visited the Crystal Caves, dense with stalactites and underground lakes. We took an afternoon ferry to the reinvigorated Royal Naval Dockyard. While cruise ships in port loomed overhead, my children swam with captive dolphins. Delighted during the swim, Willow later wondered, "Do you think they'd be happier if they were free?"

On the other side of the island, in the Unesco-designated town of St. George's, we wandered the narrow

KEEP LEFT

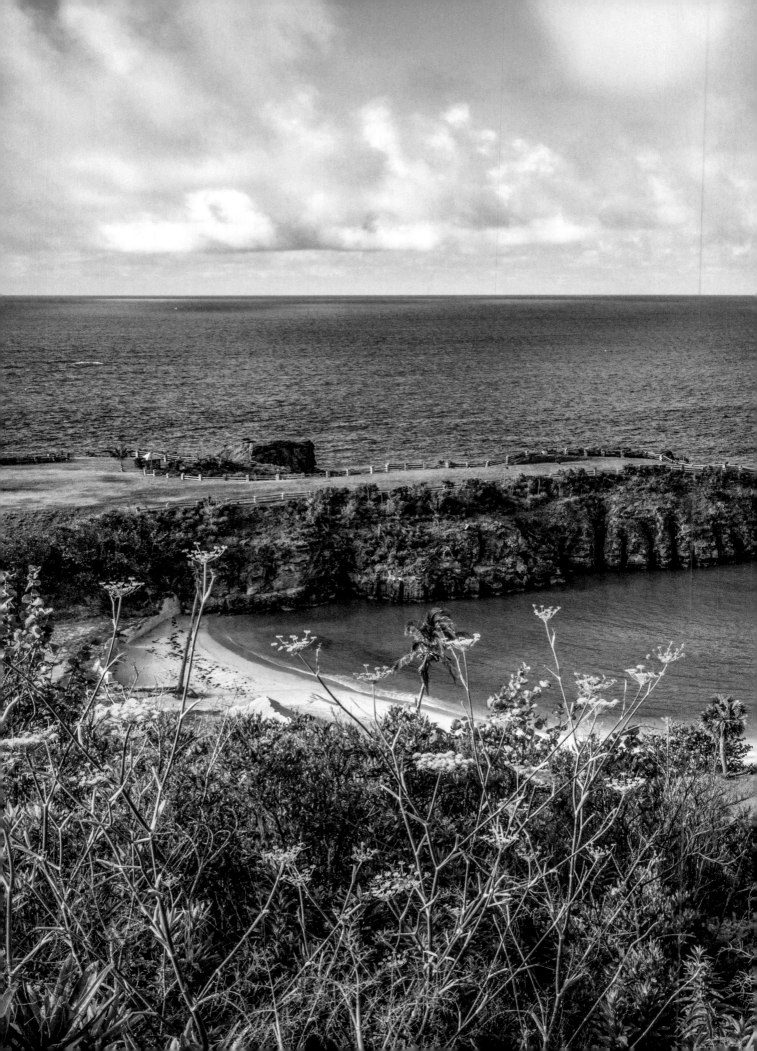

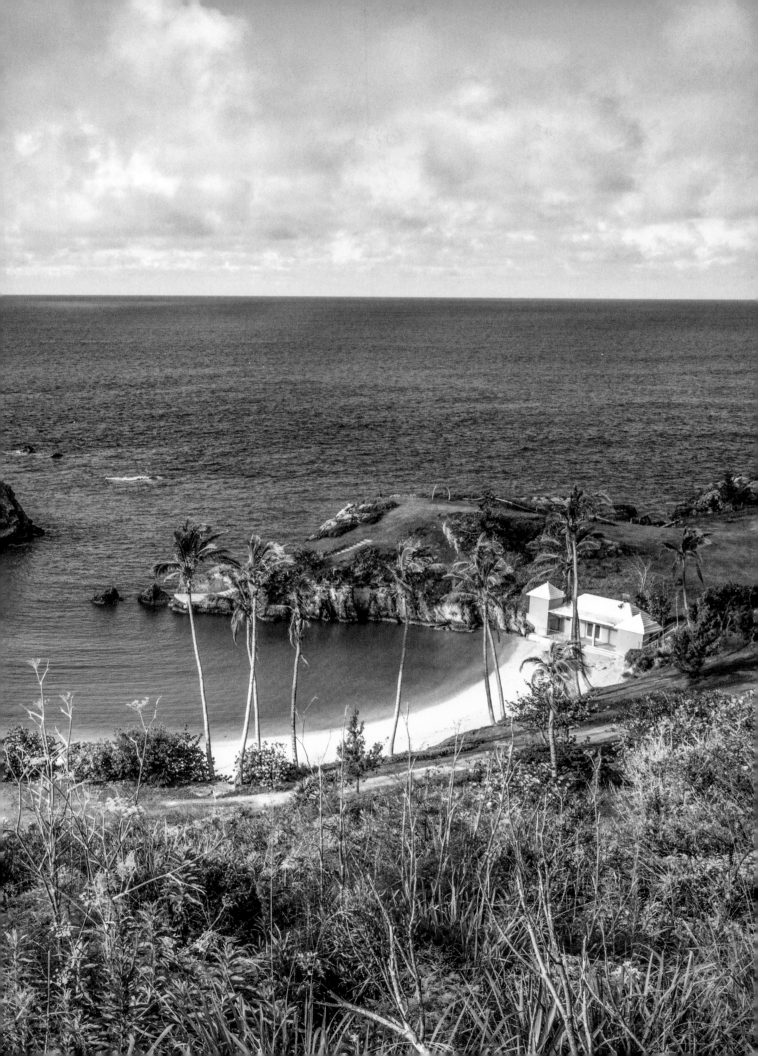

Opposite The Royal Naval Dockyard, where the ships that guarded British interests in the western Atlantic have given way to cruise boats and jet skis.

Right Neptune guards the National Museum of Bermuda at the Royal Naval Dockyard.

Below Period dress at the Royal Naval Dockyard. Look beyond the more commercial tourist lures here, and you will find an interesting history.

Following Crystal Caves, dense with stalactites and underground lakes.

Above Gates Fort, near St. George's, was built around 1612 to guard the harbor.

Opposite Pastel colors are a signature of Bermuda, especially in the island's traditional cottages.

Following A statue of Sir George Somers, founder of the colony of Bermuda, gestures grandly behind a fading fishing boat in the town of St. George's.

lanes eating ice cream under old-fashioned street lamps. Behind the counter at Art Mel's Spicy Dicy we encountered a round, dark-skinned man with a gold tooth and an easy manner. "I'll make yours the way I like mine," Mel, a Bermuda native more formally named Arthur Smith, told me with a wink. He piled high fresh snapper, lettuce, and fried onion, then spread tartar sauce on soft fresh bread. It was without question the best fish sandwich I had ever eaten.

Throughout the island, the food was better than what my childhood memories had captured. At Harbourfront Restaurant in the capital city, Hamilton, we dined on sushi and halfheartedly chided our children as they tossed grains of rice to the habituated fish that swarmed below the overwater deck while the sky faded to purple.

One of the paradoxes of island life, especially on a posh island like Bermuda, is that it's easy to become land-focused. We made an effort to get out on the water, deciding on a jet ski excursion. Daniel Paterson, a lean, young Bermuda native from Sea Venture Watersports, led us out into Riddell's Bay. With my son positioned in front of me, and my daughter clinging on behind, I let it rip. Soon we were bombing across the bay, all of us laughing.

We were less adventurous on the roads. Perhaps it spoke to the overprotectiveness that plagues my generation of parents, or maybe it was just that traffic had gotten worse in the years since I was last on the island, but I found it difficult to comprehend how my father was comfortable careening through traffic with me on the back of his scooter.

Explorer's Notebook: Every two years yachts leave Newport, Rhode Island, and sail 635 miles to Bermuda in the Newport Bermuda Race, one of the sailing world's oldest and most famous competitions. Bermuda is a British overseas territory but has long been a favorite getaway for wealthy families from the American East Coast.

But so as not to appear a lesser man, one evening I put my son on the back of my moped and went for a spin. A few tense minutes later I'd had enough and we turned for home. It was then that I saw that long-forgotten sign in the fading light. Posted low, just a foot or so off the ground, black writing on a fading whitewashed wall reading "White Sands," and an arrow pointing down a poorly paved track. That was it, the hotel name that none of my family could remember for so long. I circled back.

"Where are we going?" my son asked. We climbed over a rise, and then down toward Grape Bay. I avoided most of the potholes. We came upon an old hotel. It looked abandoned, with unfamiliar signs. We circled the rundown building. I squinted through the years and the gloaming.

"What is this place?" my son asked.

"I'm pretty sure I stayed here when I was a little younger than you," I told Sam.

"Really?"

"It was nicer then," I assured him.

A neighbor, who had come out to walk her small black dog, confirmed the hotel's history. It was indeed where I had stayed as a boy. I thought of my father, more than three decades earlier, and how he had struggled with three children without his wife beside him to steady the reins.

My son's voice broke my spell: "Ready, Dad?"

I swung into a wide turn. Luckily, my own wife was waiting with the other kids. I needed to get back and into bed. I had a predawn date on the beach.

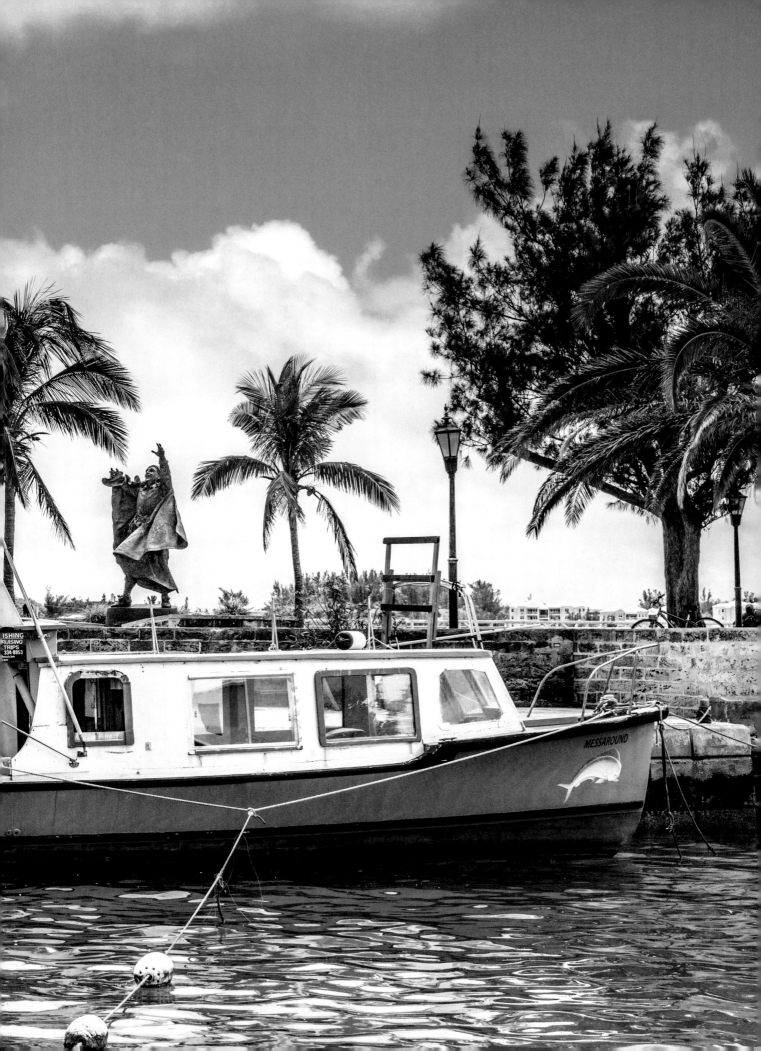

THE WAVES OF BARBADOS

*On the windward side of this
popular Caribbean island, the sea crashes
in a little-known surfer's paradise.*

TEXT BY DANIELLE PERGAMENT
PHOTOGRAPHS BY TODD HEISLER

Previous A surfer at Soup Bowl, a spot on the east coast of Barbados that is considered one of the best surf breaks in the world, yet attracts far less attention than many others.

Left Snake, a surfer who was one of the first to brave the fury of Soup Bowl. The local surfers go by colorful nicknames: Snake, Chicken, Buju, Yellow.

Opposite A beachside ride at Surfer's Point.

It was the kind of scene you'd expect on the north shore of Oahu or the Gold Coast of Australia: three surfers bobbing in the water as a 15-foot swell rolled in. One paddled into it, snapped to his feet, and was suddenly riding it — millions of gallons of the ocean's energy barreling him forward. He turned, speeding left, flipping right, and then crouched down and held the sides of his board, launching himself five feet off the crest. He flew, spinning into the air, drops of water fanning him like white lace, and landed with perfect ease on the wave as it settled back down and lapped toward shore.

But this wasn't Pipe, Indo, or any of the other spots with famous monikers bestowed by the world's nomadic surfing community. This clean, perfect, enormous wave was rolling into the east coast of Barbados. And the only audience this day was an empty, palm-tree-lined beach.

Tucked in the southern corner of the Lesser Antilles, Barbados is the easternmost island in the Caribbean. Its west coast is its famous side: powdery beaches, water as clear as if it were poured from a tap, manicured estates, closely manicured resorts, and even more manicured golf courses. That part of the island is known as the Platinum Coast, so named for the color of its sparkling coastline and its preferred credit cards. That is the Barbados of the travel agencies and guidebooks. But it's only half the story.

The eastern coast of Barbados is another world. Sequestered from the posh resorts by acres of sugarcane fields, thick forests, and troops of wild monkeys in the trees, this is Barbados's rougher side, belonging more to the locals than to the tourists.

The east's main town, Bathsheba, looks as if it had once been the playground of mythical creatures — enormous limestone boulders are casually strewn in the shallows, as though giants were playing catch and paused for a break. The wind barrels in relentlessly off the Atlantic, sweeping the hillside and everything with it. The mountain face is hollowed by the warm blasts; palm trees arch backward, their seaside fronds thinned from the constant howl; waves roll in endlessly from the vast ocean. It is a coastline carved by centuries of wind blowing from thousands of miles away, great gusts of salty air like tempests heaved by the gods.

With isolation, of course, come characters. In Bathsheba, I found myself in a place where people had names like Buju, Yellow, and Chicken. Where you paid deference to Snake, the founding father of Barbados surfing. Where everyone knew to avoid "dropping in" on Smoky's wave if he was having a bad day.

But the real celebrity in town is Soup Bowl, the island's biggest wave. "When Soup Bowl is good, it gives you goose bumps," said Melanie Pitcher, a surfing

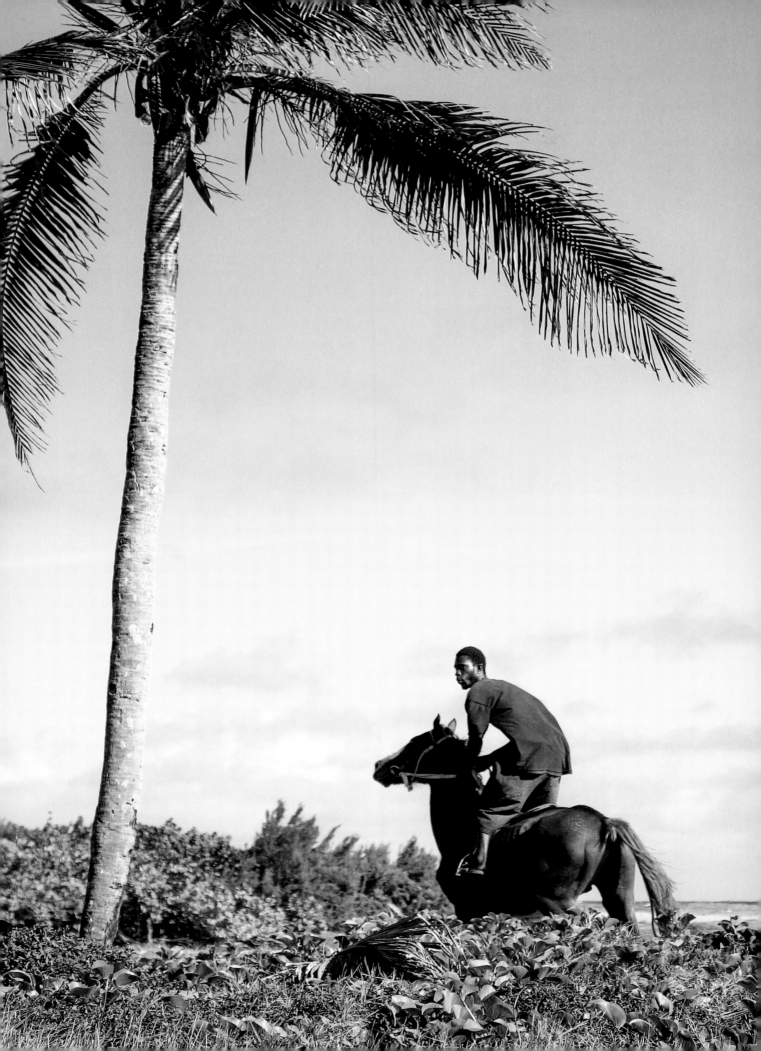

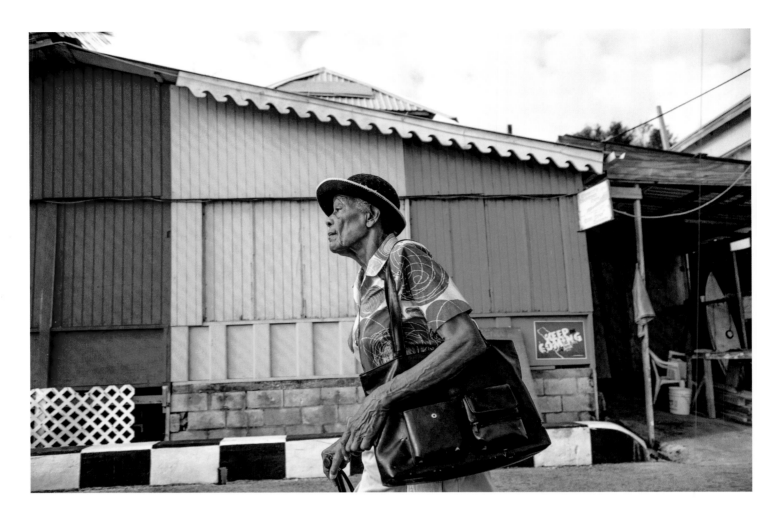

Above A street scene in Bathsheba. While the western side of Barbados is given over to estates, resorts, golf courses, and tourist beaches, the east coast belongs to the local population.

Opposite Surfing experts may choose Soup Bowl, but there are plenty of more forgiving spots, ranging upward from beginner level. At Surfer's Point, an instructor loads boards onto a truck before taking a group out to the waves.

Following Surfers headed to the beach.

instructor and owner of Barbados Surf Trips. We were sitting on the deck of the Sea Side Bar on the main (well, only) road in town, finishing a lunch of fried flying fish with rice and beans, watching the swells curl into massive walls of water. There were no surfers out, but a few people were sitting on the shoreline taking in the show. "When it's breaking clean, people come here after work and stand on the beach to watch," she said. "It's pure magic."

On a map, Barbados looks as if it is drifting into the open Atlantic, which is exactly what makes Soup Bowl ideal. A wave can travel nearly 3,000 miles in the open ocean, undisturbed by sandbars, reefs, or land, before it breaks here, on an unlikely little island shaped like a teardrop, off the radar of all but the most devoted surfers.

Barbados's gifts of wind and waves are, of course, far from undiscovered, though Barbados still trails the world's most famous surfing destinations. The locals are divided about the future, some arguing earnestly that the island needs to promote itself better to people who follow the waves while others dread more development and more competition for the best spots. Much of the eastern and southern coasts already have the trappings of a laidback surfer town — makeshift beer bars, street food vendors selling fried fish, and cheap guesthouses with blue painted walls.

But as the locals will tell you again and again, what makes Barbados unique is that there is a wave for everyone. "Our smaller waves are the most consistent," said Zed Layson, owner of Zed's Surfing Adventures. "You can

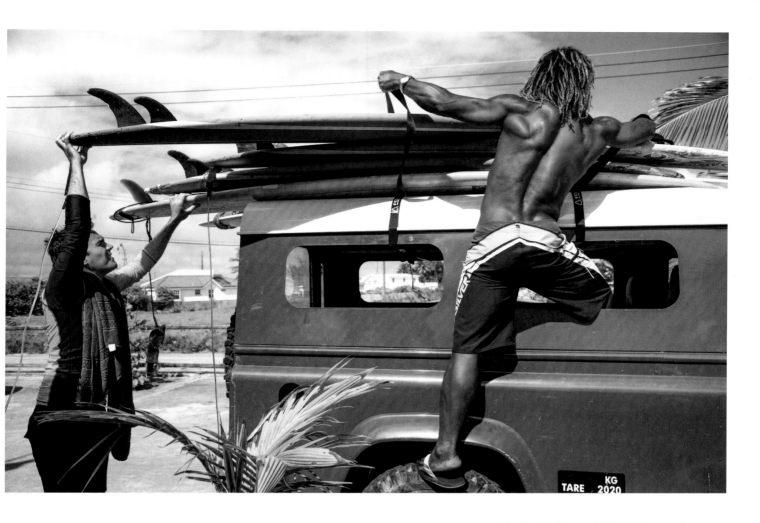

Explorer's Notebook: Barbados gained its independence from Britain in 1966, but the British left their mark on the island. The language is English, the sport is cricket, the driving is on the left, and politics is taken very seriously.

close your eyes and point to the calendar — any day you hit, Barbados will have great beginner and intermediate waves."

Windsurfers find their bliss here, too. At Silver Sands, where the Atlantic Ocean meets the Caribbean Sea on the island's southern tip, the coastline alternates between carved-out bays, sheltered from the wind and perfect for surfing, and the rougher points where the wind can lift a kitesurfer 30 feet off the water.

Before I left Barbados to return to my landlocked life, I went back to Bathsheba one more time. Soup Bowl was even bigger that day. Two surfers stood on the beach, contemplating the break — and, very likely, their chances of surviving it.

"It's going 20 feet today," said the lifeguard, a tall, sinewy man everyone calls Chicken. "I hope those guys

don't go in. Usually I have to rescue tourists who think they know what they're doing."

The surfers looked ready to test their luck — they were fastening the surfboard leashes around their ankles. Chicken snapped his tongue off the roof of his mouth.

"Leashes don't mean anything to Soup Bowl," he said, shaking his head. "If you made a board of pure steel, Soup Bowl could bend it. This swell comes clear across the ocean with nothing stopping it. It can chew you up or it can be sweet and perfect and the most beautiful wave in the world. It's like a woman — it all depends on her mood."

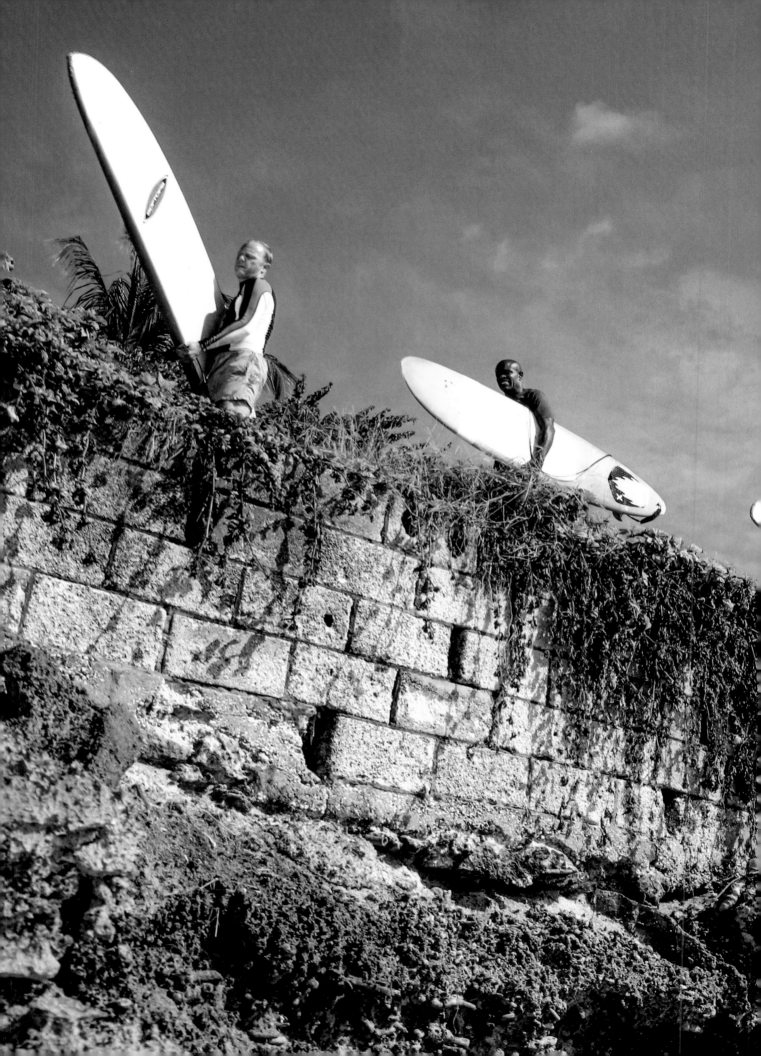

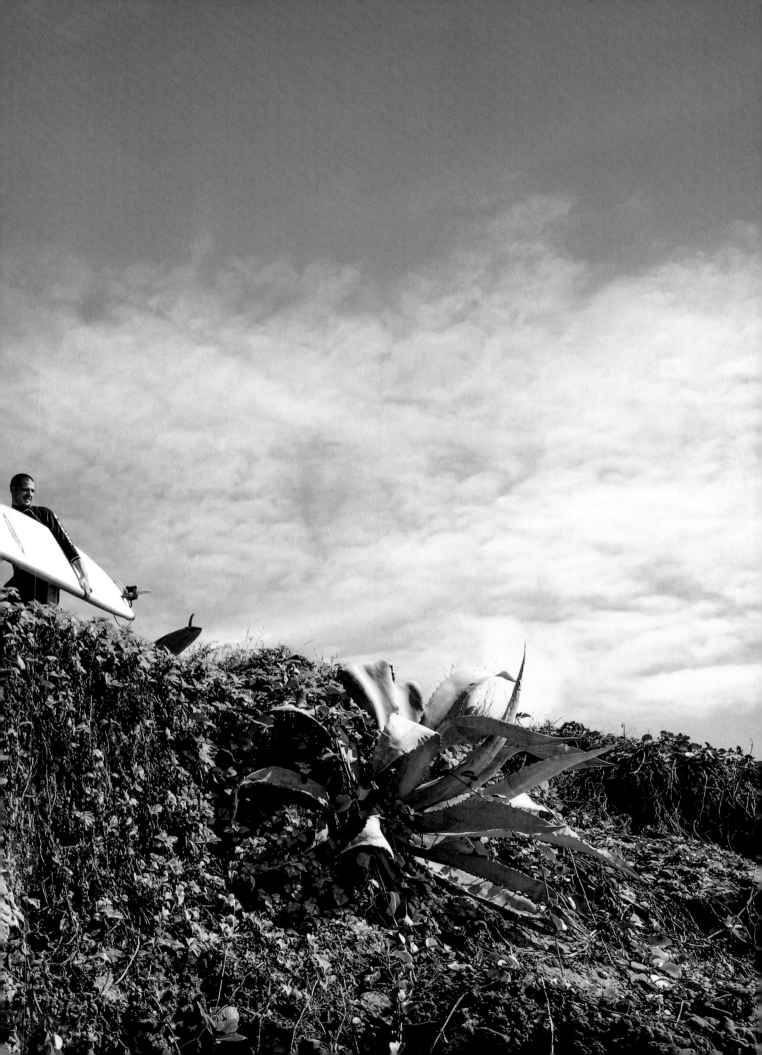

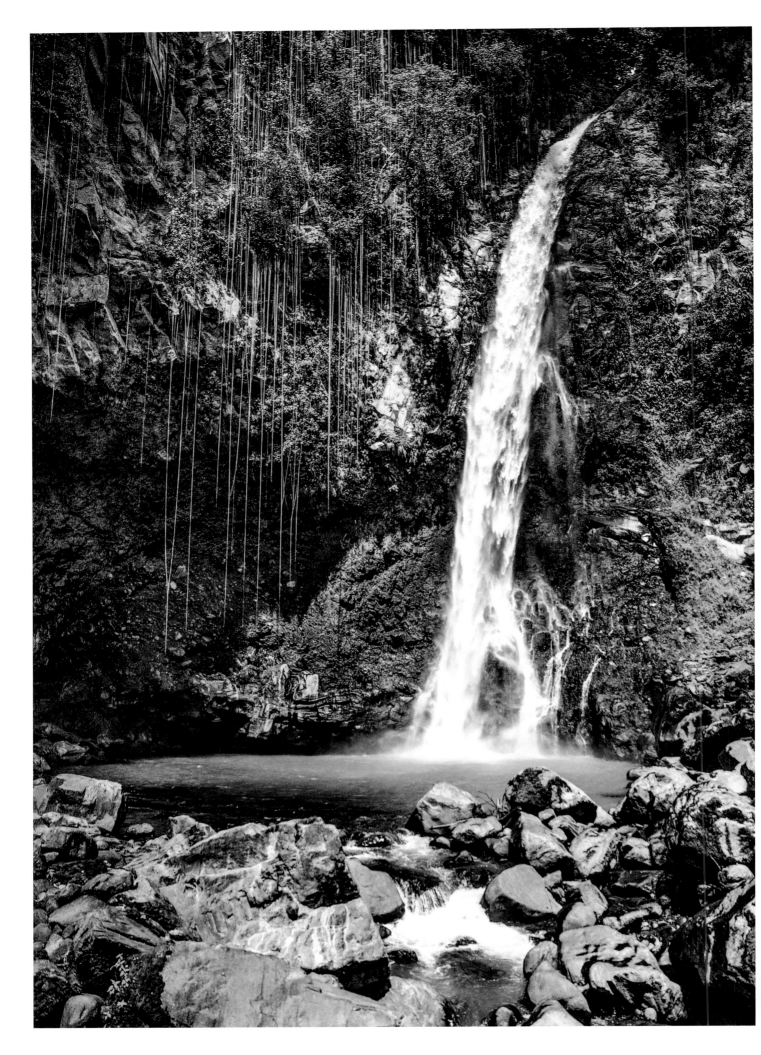

DOMINICA,
THE "NATURE ISLAND"

*A Caribbean island with few beaches
provides a different experience: rivers, waterfalls,
and miles of rain-forest hiking paths.*

TEXT BY JEANNIE RALSTON
PHOTOGRAPHS BY SASHA MASLOV

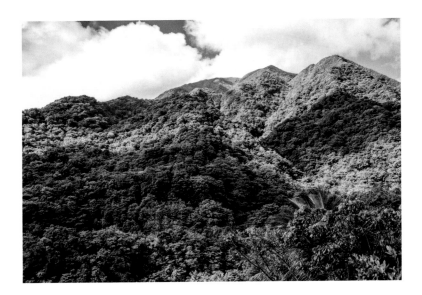

Previous Victoria Falls. On the cliff to the left, roots hang from the trees on the ridge above, dangling like ropes. Dominicans call them "tree beards."

Left A typical interior vista. Two-thirds of the island is rain forest.

Opposite The rugged trail down to the Wavine Cyrique. Three hundred miles of hiking paths cover Dominica, which justly calls itself the "Nature Island."

When I saw that the only way down the 300-foot cliff was a series of ropes and roots for handholds, I gasped. Below, a field of rocks was being battered by the Atlantic. I wistfully thought about earlier Caribbean vacations, when the main activity was sitting on a beach, lifting a pastel drink. But I hadn't come to Dominica for lolling. I grabbed a rope and began the climb down, backward, to reach a place called Wavine Cyrique, which I'd been told was one of the best sights on the island.

It was true. After clinging to the ropes in a rain shower that slickened rocks and brought out the yip-yeeping of frogs, we arrived at a black-sand beach shoved up against a wall of earth. From the top of the cliff, a river poured down 150 feet into the tidal surges of the Atlantic.

My friend Ellesor had been trying to get me to Dominica for more than three years, ever since her niece, Menke, had started serving in the Peace Corps there. But Caribbean islands had begun to feel interchangeable to me, all white fringe and the unvarying S's — sun, sand, sea, SPF. Finally, Ellesor had asked Menke to send me a list of her favorite things to do on the island. Jumping out at me were the words "hiking," "rock climbing," "water-falls," "mountain lakes," and "not like any Caribbean trip you've taken." I was sold.

One of the larger islands in the Lesser Antilles, Dominica is also one of the least known. It's sometimes confused with the more populous Dominican Republic, though the pronunciation is different: Dom-in-EEK-a. A young island, Dominica lacks long white beaches and instead has several active and dormant volcanoes and, as a local man told me, "more mountains than people." What beaches there are usually have black or golden sand, and they're usually just commas between rock cliffs.

But the interior on Dominica, which is billed as "the Nature Island" is filled with wonders, including 365 rivers ("400 when it rains," Menke said) and dozens of waterfalls. Three hundred miles of hiking paths cover the island, one crisscrossing the whole length through the interior; 20 percent of the land is in the national park system. The island feels accessible and authentic. The prominent hotels are eco-resorts, situated quietly in the jungle or near ocean-view cliffs, many making use of solar or wind energy.

Driving around (on the left-hand side), we saw small, hectic towns with an energy as lively as the colors of the houses — lime greens, blazing pinks, deep yellows. Signs like "Iguana Crossing" were often hand-painted. Every town had a series of tiny, ramshackle buildings known as "rum shops," basically sheds with big windows that open up to serve drinks. On the small beaches we passed, the golden sand was populated mainly by multicolored fishing boats parked for a rest, or fishermen building new

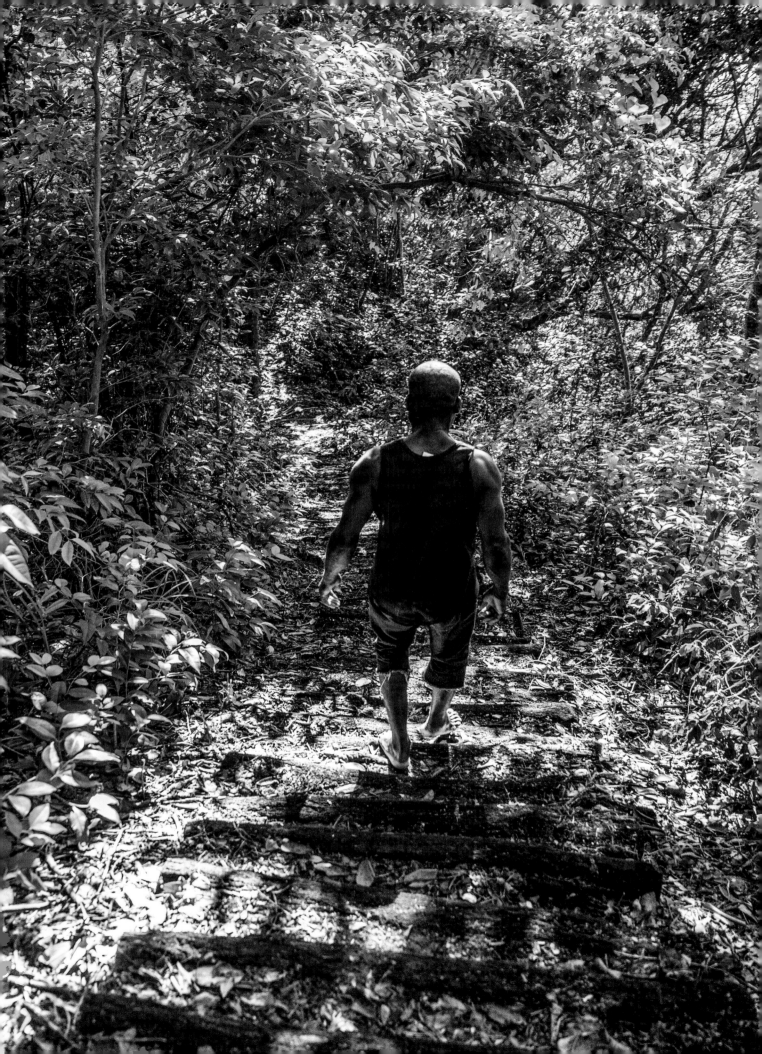

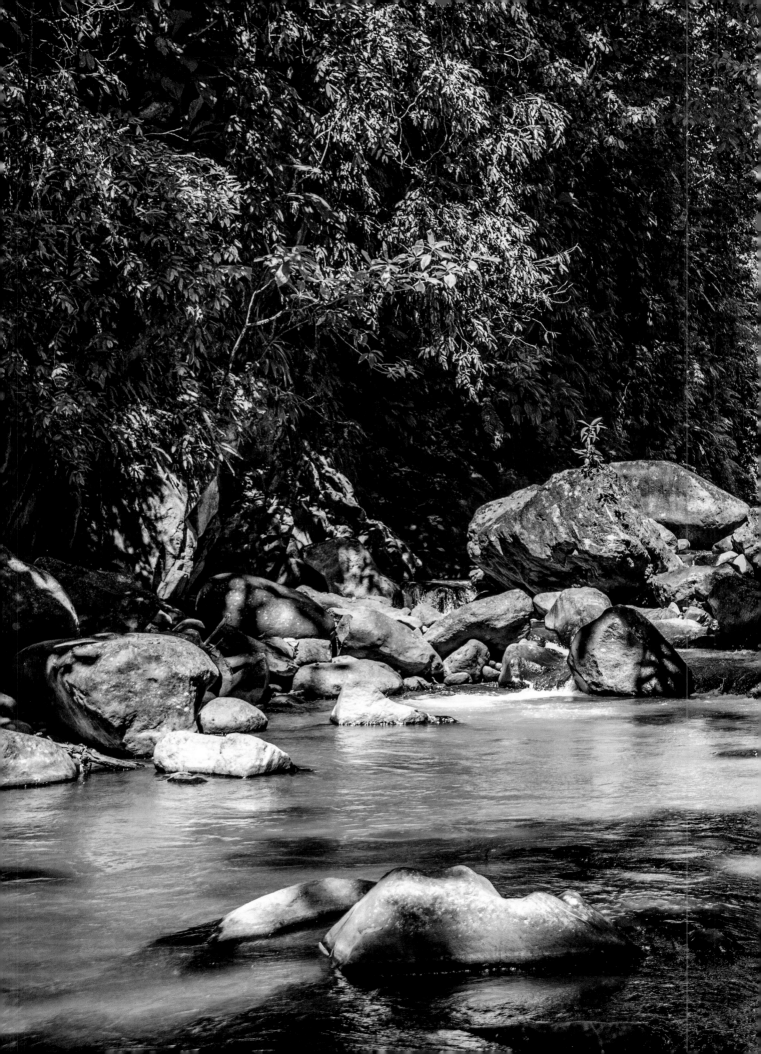

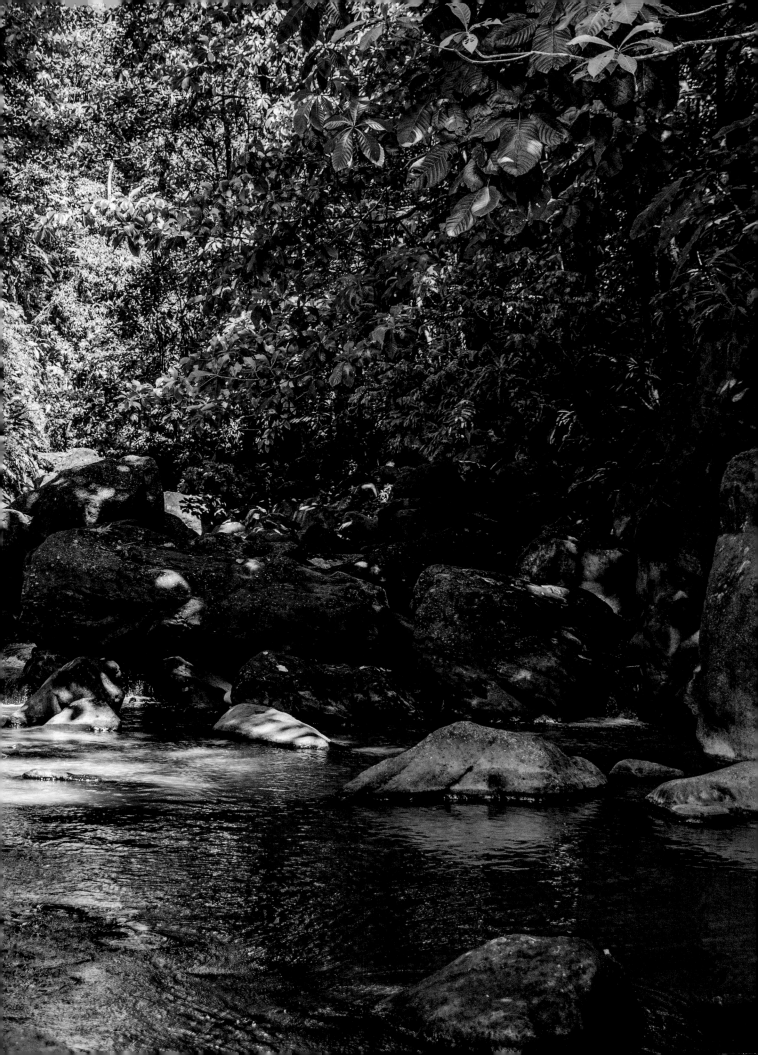

Previous With 365 rivers and a landscape of volcanic mountains, Dominica is laced with untrammeled spots like this hidden pool in the rain forest.

Above Well camouflaged, a freshwater crab hides in plain sight amid fallen leaves in a stream.

Opposite Ingredients for lunch at the Rastarant, a rustic restaurant near Victoria Falls.

boats, or fishermen hacking the day's catch into fillets for customers. In the jungle areas, men were cutting pieces of wood to prop up their yam plants. At Trafalgar Falls, twin waterfalls with cold pools downstream and hot ponds to one side, warmed by hot springs from deep underground, many of the visitors appeared to be locals.

Though I dipped in both the hot and cold water at Trafalgar, I had my eyes on the waterfalls themselves. But a steep boulder field lay between them and me. Menke, Ellesor, and I started scrambling and straining to get up and over the boulders, picking a path, getting stranded twice, but pushing on. Finally, after we got stuck in a flat spot with no way to advance farther upward, a Dominican climbed up to us and led the way to a lovely pool below the 75-foot-tall "Mother Falls" (twin of the "Father") — as

blue as any sea found in this part of the world, but much colder. As I floated in the deep water, gazing happily at my pink toenails, Menke shouted something. But the roar of the falls drowned it out. She paddled closer. "I said, 'Who needs a beach when you've got this?'"

I had the same thought several times over the next few days, for example, when we ventured deep into the jungle at Chaudiere Pool, where we jumped off 15-foot cliffs into 30-foot-deep water and sat down on a rock in the middle of a muscular river and let ourselves be flushed down into the pool. And when we visited another, more violent waterfall on the east coast — Victoria Falls — the force of which generated whitecaps in the pond below and a series of small rainbows. Victoria was even more beautiful than Trafalgar. The cliff beside the frothing

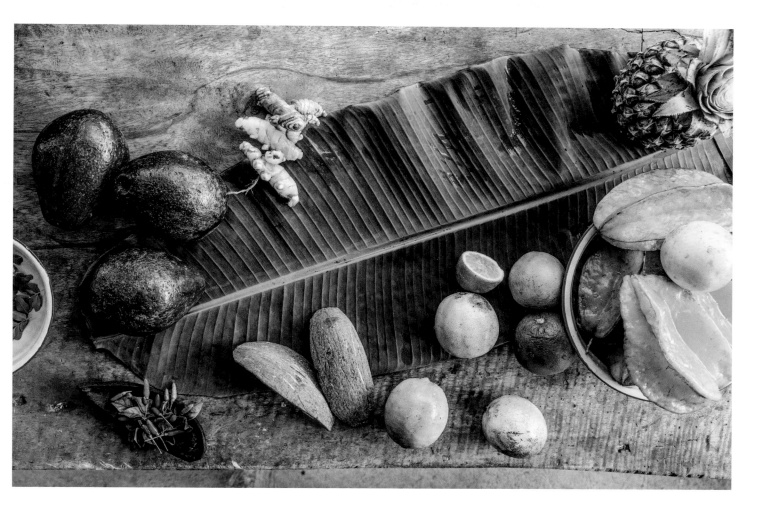

Explorer's Notebook: Dominicans say that their land is the only Caribbean island that Columbus would still recognize. Too mountainous to have been cleared for sugarcane plantations, it is still largely covered by its original forest. Its 75,000 residents include the last of the Carib Indians, whose ancestors welcomed Columbus — a mistake, as later events would prove.

column of water was covered in hanging roots that dangled like tinsel from trees on the ridge above. The locals call these roots "tree beards."

We reached Victoria Falls by a hike along and through a river. Though we came across freshwater crabs snapping their claws and scurrying into crevices, the only other people we saw were the James family, who operate the Victoria Bed and Breakfast at the trailhead. It's a good idea to hire one of the James men as a guide, and an even better idea to place an order for lunch at their "Rastarant" before heading out. The meal will be ready when you return from the falls after your hike. At picnic tables under a tin roof, we ate a Rastafarian stew — homegrown sweet potatoes and green bananas in a rich coconut-cream broth — out of calabash-gourd bowls.

On the day we made our climb to Wavine Cyrique, Nicodemas Lawrence, who maintains the rope-and-root network we would use, warned that we would be sweating. He was right. But, when we reached that river pouring into the sea, our reward was not only seen but felt. We stood under the falls, showered with fresh water while waves swamped our feet. Afterward, as we sat eating passion fruit, I noticed a scrape on my shin and bruises on my companions' legs. When I pointed them out, Menke smiled and shrugged. "If you don't leave Dominica with a few bumps, you're probably not doing it right."

Above The Hangout bar near Calibishie.

Below Opening a cocoa pod found along the trail to Victoria Falls.

Opposite A fish market along the road on the west coast of Dominica.

Following Wavine Cyrique. The hike to get there is rugged, but those who meet the challenge see one of the island's few beaches: a quiet, untouristy escape.

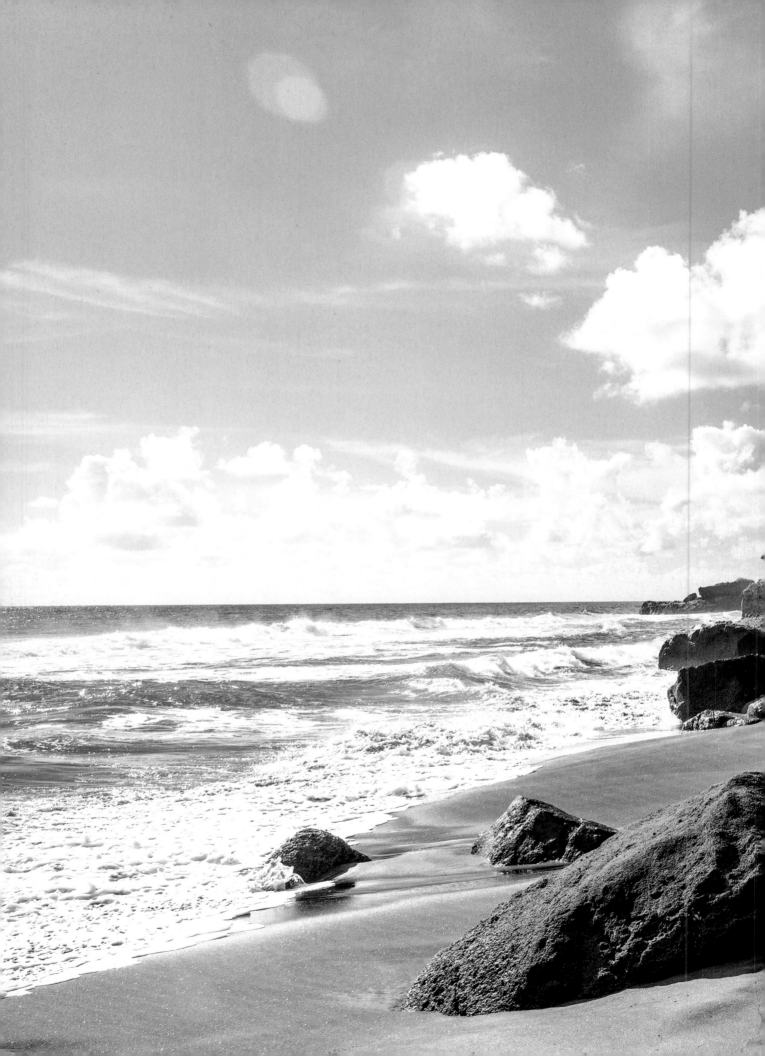

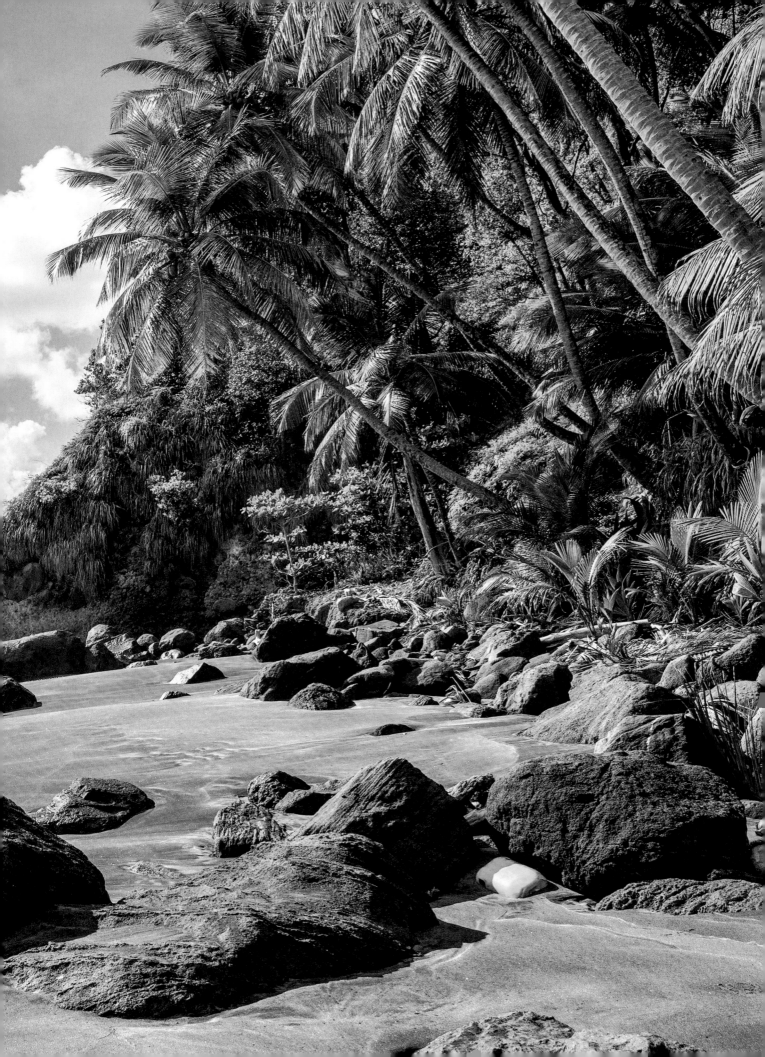

PRACTICALITIES

THE LONG WAY TO NINGALOO

ANOTHER REEF, ANOTHER COAST

Ningaloo Coast, Australia

Exploratory travel is, by definition, individualistic. Adventurous travelers strike out in search of what is new to them, keeping their eyes and ears open as they go and letting their discoveries unfold. Chance and serendipity always play a role.

No reader will exactly replicate any of the experiences described in this book, but the following pages lay out some useful basic information to those who are inspired by its stories and images.

Hotels, outfitters, and restaurants come and go. Sophisticated travelers do their own research; seek the advice of professional travel agents; and once on the road, keep their smartphones and maps and guidebooks in hand.

The guidance offered here is not intended to cover all the specifics and necessities but to focus on some basics and essentials, starting points for the kind of travel that goes beyond the obvious.

Access

- The highway route from Perth up the coast of Western Australia, Australia's largest state, goes through hundreds of miles of thinly populated country. Air conditioning is important for car travelers.
- Even with tires softened by decreased air pressure, drivers should not venture onto the soft-sand track to the end of the Peron Peninsula unless they are sure their vehicles can make it.
- A quicker route to the Ningaloo Reef is by plane from Perth to Exmouth.

The Desert

- The Pinnacles Desert. About 120 miles north of Perth; studded with tombstone-like pillars.
- Kalbarri National Park. Farther up the coast, with rugged rock formations including Nature's Window, a reddish arch that frames a view of the Murchison River Gorge.

Along the Coast

- Shark Bay. Protected marine waters, a beach composed of crushed cockleshells, and expanses of rocky-looking lumps called stromatolites. Wildlife easy to spot in its shallow waters includes dolphins, sea turtles, sharks, and sea snakes. Monkey Mia Wildsights offers tours.
- Peron Peninsula. This long, narrow spit of land is protected in Francois Peron National Park.

At the Reef

- Diving and snorkeling. Multiple opportunities in protected Ningaloo Marine Park.
- Kayaking. At Coral Bay, tours take paddlers to the heart of the reef.

BEYOND THE HORIZON IN THE PHILIPPINES

EAT, SNORKEL, CHILL OUT. REPEAT

Palawan, Philippines

Access
- El Nido, a base town for bangka boating, clings to Bacuit Bay in the north of the long, narrow Philippine island of Palawan.
- Direct flights to El Nido from Manila are available from Island Transvoyager, but are limited and should be reserved well ahead. Information is in the Travel Center in the El Nido Boutique and Artcafé.
- Most visitors fly into Puerto Princesa, the capital of Palawan province, and then take a van or public bus ride of five to seven hours to El Nido. Van companies are waiting at the airport.

Tao Philippines
A five-day sailing expedition organized by Tao Philippines takes 12 to 24 participants between El Nido and Coron, with each day's course set by the winds and currents. Expeditions are open so that anyone can buy a ticket.

El Nido
Many travelers choose to stay in El Nido, a town where towering limestone cliffs fringe a few dusty streets. Big resorts are kept at bay by a scarcity of flights and the town's creaky infrastructure, but there are several places to stay. Visitors swim with parrotfish and picnic in paradisiacal spots with names like Hidden Beach and Secret Lagoon. Day trips to islands for snorkeling and swimming are run by local tour operators.

OUT AT SEA, AN UNSPOILED VIETNAM

THE ISOLATED CON DAO ISLANDS

Con Dao Islands, Vietnam

Access
- Flights to Con Dao on Vietnam Airlines originate in Ho Chi Minh City. The Vietnam-based travel website ivivu.com is a good place to book.
- On the main island, Con Son, scooter rentals are widely available.

Sights and Activities
- Con Dao National Park. Offers the best service and prices for exploring the island and its environs. Park employees lead treks and provide boat trips.
- Rainbow Divers. A big dive operator; runs diving and snorkeling trips from Con Dao.

Stay
- Most inns are Vietnamese-owned and primarily serve Vietnamese travelers, but the islands are increasingly catering to foreigners.
- Six Senses Con Dao. Environment-friendly luxury resort. Villas feature teak carvings, and there are infinity pools and access to activities like kayaking, diving, and turtle watching.

Dine
- The better local restaurants serve a wide range of local, freshly caught seafood. Basic Vietnamese food is also available at family-run restaurants.
- Go early to the daily Con Son Market to pick up produce and a trekker's lunch. Vendors sell snacks like pâté-filled sandwiches and freshly grilled waffle-like biscuits.

THE TWO WORLDS OF THE MALDIVES

A THOUSAND ISLANDS IN THE SUN

Maldives

What and Where

- The Republic of the Maldives, an archipelago of islands and atolls in the Indian Ocean, was once a sultanate and later under British control before becoming independent in the 20th century. The capital, Malé, is on North Malé Atoll. The word "atoll" comes from the native Maldivian language, Dhivehi.
- The Equator slices through the islands, which are known for white sand beaches and coconut palms.

Access

- Many flights from Europe and North America to Malé connect through Dubai. Maldivian Airlines flies to cities in Asia and India as well as between islands in the archipelago.
- The international airport is on an island of its own, Hulhulé, close to Malé. A rank of water taxis floats nearby.

Stay

The Maldives islands are well stocked with luxurious resorts. Those mentioned in this article are:
- Per Aquum. Huvafen Fushi island.
- Naladhu. Part of the Anantara chain that operates in Asia, Africa, and the Middle East.
- Holiday Inn. Kandooma Fushi island.

PEARL IN THE INDIAN OCEAN

MAURITIUS DREAMING

Mauritius

Access

- Air Mauritius and other carriers serve Mauritius.
- Though rusty and slow, local buses offer a view of all levels of local society during travel between villages.
- If you are hiring a taxi, always bargain.

Tour

- Île aux Cerfs. A gemlike island reachable from Grand Baie with the help of local tour companies.
- Blue Penny Museum. Port Louis. Artfully displays the history of Mauritius and two postage stamps said to be the world's rarest.
- Grand Baie. Waterside and open-air bars, as well as some D.J.-fueled dance spaces, make this the island's after-dark nexus.
- Bois Chéri tea plantation. Tours and a lovely hilltop restaurant.
- Saint Aubin. A 19th-century estate with tours and vanilla and rum tastings.
- Town of Blue Bay. Near Mahébourg. A paradise for water sports, snorkeling, and sightseeing.

Stay

- Le Suffren. Port Louis. Elegant hotel with pleasant restaurant and bar.
- Ti Fleur Soleil. Grand Baie. Rum bar, homey spa, and bargain prices.
- Aanari Hotel & Spa. Flic en Flac. Stylish, upscale hotel.
- Luxury resorts and high-end chain hotels offer pricier accommodations.

Dine

Restaurants serve Creole, Indian, and Chinese food, reflective of the main ethnicities among the 1.3 million people of Mauritius. Boats bring in red snapper, octopus, and other fresh seafood.

ONLY IN MADAGASCAR

SPY A LEMUR, MUNCH A BAGUETTE

Madagascar

Access

· Many of the flights to Antananarivo Airport in Madagascar come out of Johannesburg or Nairobi. Check an Air Madagascar timetable before finalizing your itinerary, so you can connect easily between destinations inside the country.
· To save time and bureaucratic complications, get your tourist visa ahead of time, even though Madagascar gives the visas free at the airport.
· Before going to Madagascar, brush up on your French, which is widely spoken there.

Tour

· Plan your trip carefully. Most of Madagascar's goodies are sprinkled hundreds of miles apart. For example, the easiest place to see the dancing lemurs (technically known as Verreaux's sifaka) is at the Berenty Private Reserve at the southern tip of the island; the capital, Antananarivo, is in the middle; the famous tree-lined Avenue of the Baobabs is in the west; the spectacular beaches are in the north.
· Boogie Pilgrim, a Madagascar-based tour operator, will book hotels, arrange for drivers, and handle internal flights.

Stay

· La Varangue. Hilltop boutique hotel in Antananarivo with comfortable rooms and an excellent chef.
· Hôtel Colbert. Also in Antananarivo and with a patisserie that seems straight off the Champs-Élysées.
· Vakona Forest Lodge. Eco-lodge in Andasibe.
· Princesse Bora Lodge & Spa. Beachside hotel on Ste. Marie Island.

CAPE TOWN, TAMED AND WILD

THE WINDSWEPT TIP OF AFRICA

Cape Town, South Africa

Drive

· Chapman's Peak Drive, between Noordhoek and Hout Bay on the Atlantic Coast.
· Cape Winelands.
· Ou Kaapse Weg (Old Cape Road) in the Steenberg Mountains.

Hike and Walk

· Table Mountain National Park. A trail to the top of Table Mountain is a challenging daylong hike. Silvermine and Lion's Head peak are also in the park.
· Kirstenbosch National Botanical Garden. Established in 1913 for protection and study of local flora.

At the Ocean

· Guided horseback rides. Noordhoek Beach.
· Lobster diving. Cape of Good Hope. Rent a wet suit, gloves, and boots from a local dive shop, and buy a fishing permit.

In Town

· Greenmarket Square, in the center of old Cape Town. In densely packed stalls set up along the cobblestones, merchants sell beaded jewelry, masks, and other local crafts.
· Long Street. Young designers have opened boutiques in buildings with wrought-iron balconies reminiscent of New Orleans.

Stay and Dine

· The Constantia. Luxury boutique hotel in the heart of Constantia wine country.
· The Bishop's Court. Bed-and-breakfast in suburban Bishopscourt with views of the verdant east face of Table Mountain.
· The Foodbarn. French-Asian cooking in a converted farm store near one of Cape Town's most beautiful beaches.
· Bizerca Bistro. A hip bistro near Cape Town Harbor, part of central city revival.

A WALK WHERE WALES MEETS THE SEA

THE CRAGGY PEMBROKESHIRE COAST

Pembrokeshire Coast, Wales

Resources
- The Welsh government has a website, walking.visitwales.com, for Wales walkers.
- Specific regional information is available from the Pembrokeshire Coast National Park Authority.
- The British Tourist Authority is also helpful.
- Explorer maps are available from the Ordnance Survey, Britain's official mapping agency.
- *Pembrokeshire Coast Path* by Jim Manthorpe is an excellent guide.

Tour Companies
An Internet search for "walking in Wales" turns up many options for tour companies. Most will organize your route, book lodging, and transfer your luggage while you are out on the trail.
- Celtic Trails. Arranged the tour in this article, and was extremely patient and helpful with email inquiries ahead of time.
- Walkalongway. One of several companies than can transfer your luggage during the day if you prefer to design your own walk and book hotels yourself.

Weather
- The months from June through August are most likely to offer dry walking in sunny weather, although also the most likely time to find many walkers sharing the trail.
- Rains are most likely from October to January; winter brings snow.

BACK IN TIME ON THE ISLES OF SCILLY

EXOTIC GARDENS, WINDSWEPT RUINS

Isles of Scilly, England

What and Where
- The Isles of Scilly, an archipelago of about 150 islands, is reachable by ferry or small plane. Most visitors arrive in Hugh Town, on St. Mary's, where most Scillies residents live. Boats leave from there for the other four inhabited islands: Tresco, Bryher, St. Agnes, and St. Martin's. For help in planning a trip, check visitislesofscilly.com, the Scillies' official tourist website.
- Much of the land on the Scillies is officially in the Duchy of Cornwall, owned by the heir to the British throne, currently Prince Charles.

See and Tour
- Isles of Scilly Museum. Church Street, St. Mary's.
- Halangy Down. Prehistoric site on St. Mary's.
- Star Castle. Fortress on St. Mary's, now a hotel.
- Tresco Abbey Garden. Collection of subtropical plants thriving in the Scillies' relatively mild climate.
- Castle ruins. Tresco.

Stay
Most accommodations are small hotels, bed-and-breakfasts, or tent camping.

LAND OF THE MIDNIGHT TEE TIME

A MIDSUMMER NIGHT'S GREEN

Lofoten, Norway

Access

From Oslo, take a train or a plane 520 miles north to Bodo. From Bodo, get to Svolvaer by a flight on a small plane or a picturesque trip aboard a local ferry. From Svolvaer, it's a 45-minute drive to Hov by taxi or rental car.

Lofoten Golf

· The first stop for anyone interested in the Lofoten Links is its website, which provides basic facts and contact information. Like most people in Norway, staff members at the course speak excellent English.
· There's a full pro shop with clubs for rent, and you can eat and drink at the course's cafe, called, in hoariest golf tradition, Hull 19. (A word of advice: If you have even a single beer, don't drive afterward. Norwegian D.W.I. and speeding laws are very strict.)
· You can also stay at the course in a cabin or an apartment.

Also in Lofoten

· Music. The Lofoten International Chamber Music and Piano Festivals (alternating, with one each year) take place in July. On the strength of the stunning setting, they are promoted as the world's most beautiful music festivals.
· Lofotr Viking Museum. Borg. Has a reconstructed Viking ship and houses, and a Viking Festival in August.

THE FRENCH SIDE OF BASQUE COUNTRY

SPEAKING EUSKARA AND WEARING A BERET

Côte des Basques, France

St.-Jean-De-Luz

· Rue Gambetta. Shopping street with some shops specializing in espadrilles.
· Place Louis XIV. An old square where painters set up their easels under the knobby arms of plane trees.
· Cafe Le Suisse.

Biarritz

· The Grande Plage. Curved stretch of golden sand dotted with brightly colored parasols.
· Hôtel du Palais. At the north end of the Grand Plage. Built as Napoleon III's palace; now a luxury hotel.
· Biarritz Lighthouse. Avenue de l'Impératrice. Provides panoramic views of the coast and the mountains beyond.
· Hôtel de Silhouette. In a residential area just inland from the coast.

Bayonne

· Basque and History of Bayonne Museum. In a 17th-century merchant's house.
· Bayonne market. A scene of plenty with seafood and hanging pheasants and hares.

St.-Jean-Pied-De-Port

· Hôtel des Pyrénées. Classic auberge in St.-Jean-Pied-de-Port.
· The Citadel. Fortifications from the 17th century.

AN UNSPOILED ALGARVE

HILLTOP CITADELS, MOORISH MOTIFS

Algarve, Portugal

Access
- Take a train from Lisbon to Faro and catch a bus to Tavira. A regional train line also serves parts of the Algarve.
- To reach Silves, ride a local bus that departs from Portimão, the small city adjacent to Praia da Rocha.

Tavira
- Tavira Castle. Remains of an ancient fortification.
- Palácio da Galeria. A majestic 16th-century palace that contains the municipal museum.
- Seafood festivals. A staple of the Algarve. One is the annual two-week Festival de Gastronomia do Mar in Tavira. Restaurants offer special menus featuring local tuna, mackerel, octopus, mussels, clams, and other briny bounty.

Silves
- Silves Castle. A medieval Moorish structure with a museum constructed around a deep cistern. Artifacts include painted pottery, finely carved bone, and delicate colored glass.
- Annual medieval fair. Held for several days in midsummer amid a recreated souk, hammam, mosque, and other medieval edifices, ersatz and real. Thousands of locals and visitors in period outfits consume food typical of the time and cheer at elaborate re-enactments of pivotal episodes in the city's history, including crusaders' bloody 15-day siege in 1189.

Pedralva
- Aldeia da Pedralva. Restored rural village with cobbled streets, whitewashed houses, a grocery store, and a traditional restaurant. Activities include hiking, biking, and bird-watching.

SEASIDE IN THE TUSCAN SUN

TUSCANY HAS BEACHES, TOO

Tuscan Coast, Italy

Access
- Pisa, Rome, and Milan are all within reasonable driving distance of northern Tuscany and its coast, and car rentals are available at their airports.

Stay
- Grand Hotel Imperiale. For a hyper-indulgent splurge in the northern coastal resort of Forte dei Marmi, it's hard to beat this place, which has a pool whose bottom appears to be flecked with precious metal, a first-rate spa, and fawning service.
- Hotel Hermitage. On Elba. Pools, a crescent-shaped beach, tennis courts, and a vast breakfast buffet.

Dine
- Many restaurants on the coast adhere to an unimpeachable philosophy, which is that a predinner glass of prosecco or white wine should be accompanied by a predinner nibble, or rather cornucopia of nibbles: peanuts, olives, cubes of mortadella, cubes of Parmesan cheese.
- When it's time to order the entree, the specialty is likely to be fresh fish, and in towns like Porto Santo Stefano, you may be able to eat it soon after watching battered fishing trawlers lumber in with the day's catch.

LITTLE SISTER OF THE ITALIAN LAKES

SUNNY PIAZZAS AND A JEWEL OF BLUE

Lago d'Orta, Italy

Access
- Rent a car at the Milan Malpensa International Airport and drive 28 miles to Orta San Giulio.
- Tourist information is available at the website lakeorta.com.

Walk and Hike
- A pedestrian path loops around the Benedictine monastery on Isola San Giulio. Tanned ferry captains wait by the jetty in Orta San Giulio to take you to the island.
- Sacro Monte di San Francesco. A strenuous climb or, at the top, a meditative stroll.

Stay
- Villa Crespi. A 14-room Moorish confection with a two-Michelin-starred restaurant.
- Hotel San Rocco. Direct lake access and a lovely waterside patio.
- Some short-term apartment rentals are available. One agency is Holiday Homes at Lake Orta.

Dine
- Agriturismo Il Cucchiaio di Legno. Terrific place to sample the region's dishes.
- Al Boeuc. Tiny spot for predinner wines by the glass and platters of bruschette.
- AgriGelateria. Creamy gelato made with organic milk.

OFF SARDINIA, AN ISLAND WITH WILDER SHORES

FAR FROM THE YACHTING CROWD

Sant'Antioco, Italy

Access
- Fly to the airport in Cagliari, Sardinia, and rent a car for the 90-minute drive to Sant'Antioco.

Tour and Play
- Coaquaddus. Beach on the southeast coast of Sant'Antioco. Waves, a boardwalk, and a curving strip of sand.
- Cala della Signora. On the west coast, a contrasting beach experience, with tidal pools and rock formations.
- Sant'Antioco catacombs. Accessed from the main church of Sant'Antioco town. First used by the Phoenicians; centuries later, the burial place of Saint Antiochus, whose bones were removed in 1615.
- Isola di San Pietro. A 45-minute car ferry trip from Calasetta. Spend a day driving around the rugged island, which has spectacular beaches and lagoons surrounded by cliffs.

Stay
- Hotel Del Corso. Small, elegant establishment on Sant'Antioco's main avenue, which turns into a pedestrian promenade after dark.
- The Moderno. Pleasant if slightly downscale alternative, with lower prices.
- Hotel Cala di Seta. Calasetta. A modern house in the center of a fishing port town.
- To rent a private home, or rooms in one, contact an Italian real estate agent or booking service.

Dine
- Corso Vittorio Emanuele, the main shopping street in the town of Sant'Antioco, is lined with good trattorias and pizzerias. Cafes provide sunny seating and cappuccinos, espressos, and gelati.
- Seafood is a restaurant specialty in the port of Calasetta. Local trattoria dishes (alla Calasettana) include bottarga di tonno and casca, Sardinian-style couscous.

NEWFOUNDLAND'S GHOST COAST

THE DRAMATIC BONAVISTA PENINSULA

Bonavista Peninsula, Canada

Drive
- Route 230. Advertised as the Discovery Trail, it runs north up the peninsula to Cape Bonavista, through towns and wilderness.
- Lockston Path Provincial Park. Trails and camping inland in the heart of the peninsula.

Hike and Walk
- Skerwink Trail. Skirts the north and south coasts of Skerwink Head, a rocky peninsula separating the harbors of Trinity and Port Rexton.
- Klondike Trail. Follows an abandoned road near Elliston.

Tour
- Rugged Beauty Tours. Boat tours to ghost towns.
- Sea of Whales Adventures. Whale-watching on a Zodiac boat from Trinity Bay.

Stay
- Artisan Inn. Fifteen rooms in six old houses in Trinity, a well-preserved old town.
- Fishers' Loft. Inn with rooms in saltbox cottages and sea captain's houses in Port Rexton.

Dine
- Bonavista Social Club. Upper Amherst Cove. Menus may include moose burger, lobster pasta, and partridgeberry bread pudding.
- Rising Tide Theatre. Dinner theater at an arts center and playhouse in Trinity.

A COPPER GLOW AT THE TOP OF MICHIGAN

RUGGED BEAUTY WITH A GRITTY PAST

Upper Peninsula, Michigan, United States

Keweenaw Peninsula
- Most tourist sites are along Route 26 or in the cities of Houghton, Hancock, Calumet, and Copper Harbor.
- Quincy Mine. Tours are given by the Quincy Mine Hoist Association, Hancock.
- Keweenaw National Historical Park. This conglomeration of sites provides a brochure with maps.
- McLain State Park. Highway M-203 west of Hancock, with hiking trails and two miles of sand beach.

Lake Superior
- Pictured Rocks National Lakeshore. A 35-mile section of Lake Superior coastline that gets its name from variably colored sandstone cliffs.
- Pictured Rocks Cruises. Leave from the city pier in Munising.
- The Great Lakes Shipwreck Museum. In Whitefish Point, it documents 300 shipwrecks, including the wreck of the *Edmund Fitzgerald*, subject of the famous ballad by Gordon Lightfoot.

Local Fare
- Kaleva Cafe. Hancock. A good place to try the pocket meat pie called the pasty (pronounced to rhyme with "nasty"), a legacy of the Cornish ancestry of many local miners and synonymous with the Keweenaw.
- Italian heritage survives in a thin, tasty sausage known as the cudighi (pronounced COO-duh-ghee). Look for it at restaurants in Marquette.

RAMBLING NEAR THE GOLDEN GATE

GOLDEN HILLS AND FOGGY BEACHES

Marin County, California, United States

Access

- Marin County is an easy drive from San Francisco. Bus service is available from Golden Gate Transit and Marin Transit; the latter's West Marin Stagecoach serves the small towns of West Marin.
- The Golden Gate Ferry connects San Francisco and Sausalito.
- Most trails are well marked, but good maps are indispensable. You may have to piece together maps from several sources, such as the book *Hiking Marin: 141 Great Hikes in Marin County* by Don and Kay Martin and the map "Point Reyes National Seashore and West Marin Parklands" from Wilderness Press.

Along the Way

- Bolinas Lagoon Preserve. Part of the Audubon Canyon Ranch.
- Stinson Beach. Part of the Golden Gate National Recreation Area.
- Mount Tamalpais State Park.
- Muir Woods. Declared a national monument by President Theodore Roosevelt.
- Green Gulch Farm Zen Center. A Buddhist retreat that welcomes visitors by day or overnight.

Stay

Inns fill up fast, so make reservations. Some possibilities:
- Point Reyes Seashore Lodge.
- Redwoods Haus, Stinson Beach.
- Pelican Inn, Muir Beach.

A BACKCOUNTRY HIKE ON CATALINA ISLAND

CLOSE TO LOS ANGELES BUT A WORLD AWAY

Catalina Island, California, United States

Access

- Santa Catalina Island, 21 miles long, is the only island in the Channel Islands archipelago with significant civilian settlement. Its year-round population is less than 4,000.
- Ferries to Catalina make round trips several times a day from Long Beach and other points on the California coast.
- Helicopter flights are also available from Long Beach.
- Cars are allowed only for residents, but sightseers can take buses and trams.

The Trail

The Trans-Catalina Trail is administered by the Catalina Conservancy, which owns 90 percent of the island. Its website has trail maps and information on campsites and services that can carry your gear from site to site.

Off the Trail

- Catch a movie at the Avalon Theater in the Casino, an Art Deco landmark built by William Wrigley Jr., the chewing-gum magnate who once owned most of the island. Big-band greats like Benny Goodman played at the Casino during the 1930s and '40s, and it is still the site of dances, concerts, and film showings.
- Wrigley Memorial and Botanical Garden has 38 acres of plants including eight species that grow only on Catalina.
- Hotels are filled most summer weekends; most require two-night stays, three nights on holiday weekends. Rates drop from October to April.
- The Catalina Island Visitors Bureau provides information on amusements like snorkeling, scuba diving, kayaking, cruise boats, and ziplines.

KEY TO KEY IN A KAYAK

GLIDING ON A SHALLOW SEA

Key West, Florida, United States

Access
- Fly to Miami or Key West, rent a car, and chart a simple course over United States Route 1.

Outfitters
- Most of the scores of kayak outfitters in the Florida Keys are easy to find from United States Route 1, the road that connects the keys and is locally called the Overseas Highway. Do your research in advance. You may want a guide for some trips.
- A short and stable sit-on-top kayak, without an enclosed cockpit, is usually preferred for beginners. Longer boats with storage compartments are used for longer excursions.

Sites and Sights
- Secure a kayak on Geiger Key and paddle a short distance to see translucent turquoise water laced with canary-yellow fish and purple coral.
- Hop on a kayak-filled motorboat for a 15-minute ride to start a half-day paddle around the often-deserted white-sand beaches of the Snipe Keys.
- Take a full-day trip to remote beaches and mangrove islands.
- Join a guided fishing trip in the flats.
- On Key West, take a guided paddle into mangrove creeks.
- For a break from the water, leave the kayak and walk into the city of Key West, an eccentric place where chickens roam the streets along with the tourists. Visit Ernest Hemingway's home, still occupied by dozens of descendants of his pet cats.

HOT, COLD, AND BLISSFUL ON HAWAII'S BIG ISLAND

HAWAII AT ITS MOST SURPRISING

Big Island, Hawaii, United States

Tour
- Several commercial tour operators have permits to conduct tours up Mauna Kea, a dormant volcano.
- In Hawaii Volcanoes National Park, roads and trails take visitors close to an active volcano, Kilauea.
- Paradise Helicopters in Hilo offers one-hour tours that include views over Kilauea.

Stay
- Arnott's Lodge. Hilo. Has apartment-style rooms and leads tours.
- Volcano Rainforest Retreat. A collection of Japanese-style bungalows in a misty forest on the edge of Volcanoes National Park.
- Four Seasons Resort Hualalai. Luxury at its priciest on the Big Island.

Dine
- Farmers market. If it's Wednesday or Saturday, visit the Hilo Farmers Market for local coffee and macadamia nuts. Snack on exotic fruit or buy lunch from the vendors.
- Sushi Rock. On Hawaii's main drag.
- Village Burger. If you're driving near Waimea, this is your stop for lunch. If beef isn't your thing, there are ahi tuna and veggie burgers.

ISLAND HOPPING FOR A CHOCOLATE BAR

THE COCOA BEAN IN THE CARIBBEAN

Lesser Antilles

Touring and Tasting
- Delft Cocoa Plantations and Violetta Fine Chocolates. Tours of the Montserrat Hills cocoa region in Trinidad.
- Gail's Exclusive Tour Services Limited. A range of Trinidad tours, including Brasso Seco visits.
- Rancho Quemado. Trinidad. Part zoo, part nature retreat, part cocoa farm.
- Tobago Cocoa Estate. Tours run for half-days or full days and may include a view of Argyle Waterfall.
- Frères Lauzéa Chocolatiers. Two shops in Martinique; one offers rum-and-chocolate tastings with advance reservation.
- Grenada Chocolate Company. A Caribbean chocolate tourism pioneer.
- Chocolate Festival of Belize. Toledo.

Stay
- The Hyatt Regency Trinidad. Offers an infinity pool with views of the Gulf of Paria and a breakfast buffet of local favorites.
- The Magdalena Grand Beach Resort. In Tobago. Golf course, pool, beach area, and breakfast spread.
- The Hotel Chocolat. Cocoa heaven in St. Lucia, with eco-chic cottages and views of the Pitons.

Dine
- Entre Nous. Feast in Martinique on the porch of a charming Creole home.
- Boucon Restaurant. In the Hotel Chocolat, St. Lucia.
- Beach bars on Tobago are good stops for Carib beer and curried crab and dumplings.

THE TIMELESS REWARDS OF BERMUDA

DADDY, WHY DO THE MEN DRESS THAT WAY?

Bermuda

Access
- Tourists cannot rent cars on Bermuda, so take a taxi from the airport to Hamilton city, where a scooter can be rented. Mopeds are traditional on the island.
- The classic British-influenced male attire of Bermuda shorts, knee socks, and suit jackets remains in evidence, but formality is fading.

See and Do
- Water sports. Bermuda's 34 beaches are popular for swimming, snorkeling, and other water sports.
- Elbow Beach. Expansive stretch of sand on the south shore with a large public beach as well as the private beach of the Elbow Beach resort.
- Crystal Caves. Scenic cavern with crystal pools.
- Royal Naval Dockyard. Longtime base for the British Navy, now a center for shopping and recreation.
- Bermuda Botanical Gardens and Masterworks Museum.
- St. George's. Eastern end town rich in history, with shops and restaurants on narrow lanes.

Dine
- Art Mel's Spicy Dicy. Hamilton and St. George's. Renowned for fish sandwiches.
- Harbourfront Restaurant. Hamilton Harbour.
- Hog Penny Restaurant & Pub and the Lobster Pot. Two favorite spots for Bermuda fish chowder, a spicy seafood-and-vegetable stew.

THE WAVES
OF BARBADOS

UNQUIET SEAS IN THE ANTILLES

East Coast, Barbados

Access

Grantley Adams International Airport is on the south side of Barbados, about a 25-minute drive from the surf beaches near Bathsheba. You'll need a rental car to get around.

Wind and Waves

· Bathsheba Beach. Skilled surfers flock to the Soup Bowl here, but there are plenty of smaller breaks elsewhere on the island for beginners.
· Surf schools. Three prominent ones are Zed's Surfing Adventures, Burkie's Surf School, and Barbados Surf Trips. All offer private lessons and teach all levels.
· Windsurfing. The deAction Beach Shop is famous with windsurfers in Barbados.
· All beaches in Barbados are free to the public.

Dine

· Oistins. This southern fishing town is home to an open-air fish fry where locals and tourists line up for fresh marlin, tuna, and snapper. The fish fry is held every night, but Friday is the time to go, when the music is turned up and the market turns into a raucous street party.
· Sunday brunch. All-you-can-eat Sunday brunch buffets are popular on Barbados. For the one at the Atlantis Hotel in Bathsheba, reserve a table on the porch.
· Rum. The island drink, it is said to have been invented in Barbados and is available almost everywhere, including gas stations. One of the island's attractions is the Mount Gay Rum Tours and Visitor Centre.

DOMINICA,
THE "NATURE ISLAND"

WHO NEEDS A BEACH?

Dominica

Access

· Several Caribbean commercial and charter airlines serve Douglas-Charles Airport.
· The dry season on Dominica is December to June. The other months can be stunningly wet, though temperatures and rainfall often vary widely from place to place on the island.
· The language is English.
· Whether it's the long hike to the Boiling Lake or diving in Scotts Head Bay, there are services available to equip and accompany the visitor. Hotels and inns may offer the services themselves or will recommend an outfitter, a tour company, or a guide.

Stay

Nature-friendly resorts and small inns dominate the tourist trade. Most are eco-conscious, and many are delightful. There are a number of midsize hotels in Roseau, the capital city.

Dine

Most of the island's hotels, even the smaller ones, offer delicious fresh food. Island specialties include tropical fruits; marlin, mahi-mahi, and tuna; hush-puppy-like fish cakes with a fiery dipping sauce; and local rums and fresh juices.

Event

The World Creole Music Festival, held annually, brings in musicians from many countries. They perform in French-Caribbean styles like cadence, zouk, soukous, and Dominican bouyon music, also known as jump up. The island also holds a Jazz 'n Creole Festival, featuring jazz music and Creole culture.

WRITER
BIOGRAPHIES

Dominique Browning (pages 84–87), a former editor in chief of *House & Garden* magazine, works at Environmental Defense Fund, where she founded Moms Clean Air Force. She is the author of *Slow Love, Paths of Desire, The House & Garden Book of Style, The Well-Lived Life, Gardens of Paradise,* and *House of Worship*.

Frank Bruni (pages 132–137) is an opinion columnist for *The New York Times* and a former *Times* restaurant critic, Washington reporter, and Rome bureau chief. His books include *Where You Go Is Not Who You'll Be*, about college admissions; *Ambling Into History*, about George W. Bush's first presidential campaign; and *Born Round*, a memoir.

Christopher Percy Collier (pages 208–211) has written hundreds of stories for newspapers and magazines on subjects ranging from travel and food to health and business. He works as a speechwriter for a Fortune 500 company in Southern California.

Gregory Dicum (pages 188–191) has written for *The New York Times, The Economist, Harper's,* and numerous other publications. He is the author of *Window Seat: Reading the Landscape From the Air* and *The Coffee Book*. dicum.com

Baz Dreisinger (pages 228–231) is a professor at John Jay College of Criminal Justice in New York City and the author of *Incarceration Nations*. Her articles have appeared in *The New York Times, The Wall Street Journal,* and *ForbesLife*. She produces on-air segments for National Public Radio.

Alan Feuer (pages 46–49) is a feature writer for *The New York Times*. He is the author of *Over There*, a memoir of covering the war in Iraq; *Still New York*, a book of essays written with Ric Burns about the paintings of Frederick Brosen; and *I Hope You Find Me*, a book of poems based on the Missed Connection section of Craigslist.

Jeffrey Gettleman (pages 62–69), the East Africa bureau chief for *The New York Times*, was awarded the Pulitzer Prize for International Reporting in 2012. He is based in Nairobi and is the author of a memoir, *Love, Africa*.

Valerie Gladstone (pages 92–97) wrote frequently for *The New York Times* and other publications, most often about dance and the arts. Her books include *A Young Dancer: The Life of an Ailey Student* and *Soile Yli-Mäyry: Forty Years of Painting, Retrospective, 1968–2008*. She died in 2014.

Elaine Glusac (pages 164–171) writes frequently for *The New York Times* and has also written travel articles for *Condé Nast Traveler* and *National Geographic Traveler*. She is the co-author of *Top 10 Chicago*, an Eyewitness guide, and has contributed to Fodor's and *National Geographic* guidebooks. elaineglusac.com

Joshua Hammer (pages 74–79, 154–159), a former *Newsweek* bureau chief in Africa and the Middle East, writes articles for *The New York Times* and many other publications. He is the author of several books, including *The Bad-Ass Librarians of Timbuktu*, about the rescue of precious manuscripts in Mali.

Alex Hutchinson (pages 18–23) is a freelance journalist in Toronto. In addition to adventure travel, he writes about the science of endurance sports for *Runner's World, Outside,* and other publications. He is the author of *Which Comes First, Cardio or Weights?*

Jeff Z. Klein (pages 104–107), a former editor and sportswriter at *The New York Times* and *The Village Voice*, is an author and radio producer who lives in Manhattan and Buffalo.

Dan Levin (pages 28–31) writes about Canada for *The New York Times* and was formerly based in Beijing.

He was previously a reporter for *Newsweek* and *The Daily Beast*, and his work has appeared in other publications including *Fast Company, Forbes*, and *The Los Angeles Times*.

Naomi Lindt (pages 36–41) has traveled throughout Southeast Asia for *The New York Times* and other publications, exploring less-trodden destinations for intrepid travelers.

Andrew McCarthy (pages 238–247) is an editor at large for *National Geographic Traveler*, author of the travel memoir *The Longest Way Home*, and co-editor of *The Best American Travel Writing 2015*. He is also an actor and a television director.

Danielle Pergament (pages 252–255) frequently writes travel articles for *The New York Times*. Her work has appeared in *GQ, Condé Nast Traveler, National Geographic Traveler, Travel + Leisure*, and *New York* magazine. daniellepergament.org

Jeremy W. Peters (pages 218–221), a reporter in the Washington bureau of *The New York Times*, has covered topics including the 2012 and 2016 presidential elections. He contributed to the *Times* reporting that was awarded the 2009 Pulitzer Prize for Breaking News.

Jeannie Ralston (pages 260–265) is editor of the web magazine *NextTribe* and has written articles for *Time, National Geographic, Smithsonian, Condé Nast Traveler*, and *Travel + Leisure* as well as *The New York Times*. She is the author of *The Unlikely Lavender Queen* and *The Mother of All Field Trips*. jeannieralston.com

Stephen Regenold (pages 178–183) is based in Minnesota and has written frequently about hiking, bicycling, and other outdoor sports for publications including *The New York Times* and *Outside*. He is the founder and editor of GearJunkie.com, a website that covers adventures and outdoor gear.

Seth Sherwood (pages 54–57, 124–127) is a travel writer based in New York City and Paris. He writes frequently for *The New York Times* about Europe, North Africa, and the Middle East.

Ethan Todras-Whitehill (pages 198–203) frequently writes travel articles for *The New York Times* and has been published in *Sports Illustrated, Popular Science, AFAR*, and *Marie Claire*. He writes fiction from his home in Massachusetts and is a co-founder of SwingLeft.org.

Bonnie Tsui (pages 142–147) is a frequent contributor to *The New York Times, California Sunday*, and *Pacific Standard*. She is the author of *American Chinatown* and is writing a new book on swimming, which will be published by Algonquin. bonnietsui.com

Christian L. Wright (pages 114–119) is a writer based in New York City. Her work has appeared in publications including *The New York Times, Allure, Condé Nast Traveler, Gourmet, New York, Rolling Stone*, and *The Wall Street Journal*.

PHOTOGRAPHER BIOGRAPHIES

Jes Aznar (pages 2, 26–33, 44–51) is a documentary photographer based in Manila and covering global assignments. He is a regular *New York Times* contributor and a co-founder of @everydayphilippines on Instagram.

Tony Cenicola (pages 236–249) worked for several years as a freelance photographer before joining *The New York Times* staff in 2000. He shoots diverse assignments for *The Times'* Food, Arts, Real Estate, and Science sections, as well as Travel, both in studio and in the field.

Gregory Dicum (pages 186, 189–191), a writer and photographer, has had work published in *The New York Times*, *The Economist*, *Harper's*, and other publications. He is the author of *Window Seat: Reading the Landscape From the Air* and *The Coffee Book*. dicum.com

J. Emilio Flores (pages 194–197, 200, 204–205) is a photojournalist whose work has been published in *The New York Times*, *The Washington Post*, *Le Monde*, *Newsweek*, and *Vanity Fair*. He has received awards from organizations including the National Association of Hispanic Publications. EmilioFlores.com

Marco Garcia (pages 214–225) has been working as a photographer in the Hawaiian Islands for nearly 14 years, having left New York City behind for island life. His work has appeared in *The New York Times* and many other publications. marcogarciaphotography.com

Kevin German (pages 34–43), a photographer and co-founder of the creative agency Luceo, lives in New York and Paris. He is the author of a book about Vietnam, *Color Me Gone*. kevingerman.com

Robin Hammond (pages 13, 60–71), a winner of two World Press Photo awards, is a contributing photographer to *National Geographic* and *Time*. His third book, *My Lagos*, was published in 2016. He is the founder of Witness Change, an organization dedicated to advancing human rights through visual storytelling. robinhammond.co.uk.

Andy Haslam (pages 110–121) is a travel, lifestyle, and architectural photographer based in the United Kingdom. He is a frequent contributor to *The New York Times* Travel section. andyhaslam.com

Todd Heisler (pages 14–15, 250–257) has been a staff photographer at *The New York Times* since 2006. He has received a Pulitzer Prize for Feature Photography and an Emmy for News & Documentary. He lives in Brooklyn.

Alex Hutchinson (pages 16–25), who is based in Toronto, writes and photographs articles on adventure travel. He also writes about the science of endurance sports for *Runner's World*, *Outside*, and other publications. He is the author of *Which Comes First, Cardio or Weights?*

Ann Johansson (pages 198–199, 201–203) is based in Los Angeles and travels the world as a freelance photographer. As part of her commitment to documenting climate change, she is working on a book that will take viewers on a journey along one longitude through all major climate zones. annjohansson.com

Meridith Kohut (pages 226–235), an American photojournalist based in Caracas, has covered Latin America for the foreign press since 2007. A frequent contributor to *The New York Times*, she has covered Hurricane Matthew in Haiti, the drug trade in Bolivia, and gang violence and migration in Central America.

Bénédicte Kurzen (pages 4–5, 52–59, 72–81) is a documentary photographer focusing on conflict and socioeconomic changes in Africa. She holds a master's degree in contemporary history from the Sorbonne. Writing her final essay there, on "the myth of the war photographer," inspired her to become a visual storyteller herself.

Anthony Lanzilote (pages 162–173) is a photojournalist based in Detroit and New York. He is a graduate of the International Center of Photography in New York and the College for Creative Studies in Detroit. Lanzilote.com

Chris Livingston's (pages 206–210, 212–213) photographs appeared in *Sports Illustrated*, *The New York Times*, *The Wall Street Journal*, *USA Today*, and other major publications. He died in 2009.

Narayan Mahon (pages 174–177, 179–185) is an amateur wood chopper, kitty snuggler, and cyclist living in Madison, Wisconsin. He spends his spare time as an advertising and editorial photographer.

João Pedro Marnoto (pages 122–129), based in Porto, Portugal, has been a professional photographer for two decades. His projects reflect on issues of identity and the human condition within an environmental and sociological perspective. jpmarnoto.com

Sasha Maslov (pages 258–269) is a Ukrainian photographer who lives and works in New York. He is a regular contributor to *The New York Times* and other publications and author of the book *Veterans: Faces of World War II*.

John McConnico (pages 100–109), winner of a Pulitzer Prize and a World Press Photo award, has worked in over 90 countries. His clients have included *The New York Times*, Condé Nast, Unicef, the United Nations refugee agency, and the Associated Press. He lives in Brussels. johnmcconnico.com

Samuele Pellecchia (pages 6–7, 140–149) has traveled the world as a photojournalist and video producer. His work has appeared in European exhibitions and in publications including *GQ*, *Vanity Fair*, *The New York Times*, *Newsweek*, and *Russian Reporter*. He founded Prospekt, a photo and video agency based in Milan.

Maggie Steber (page 211), a documentary photographer, has worked in 66 countries. Her honors include the Leica Medal of Excellence, an Alicia Patterson fellowship, and the Ernst Haas grant. She has worked in Haiti for 30 years. In 2013 she was named a Woman of Vision by *National Geographic*. maggiesteber.com

Thor Swift (pages 192–193) is based in San Francisco. Assignments from a variety of editorial and corporate clients have taken him to nearly every continent. thorswiftstudio.com

Andrew Testa (pages 90–99) spent six years in Kosovo covering the Balkans, Eastern Europe, Central Asia, and the Middle East for publications including *The New York Times* and *Newsweek*. He later worked in New York and now lives in London. He has won three World Press Photo awards and was twice named photojournalist of the year by Amnesty International. andrewtesta.co.uk

Hazel Thompson (pages 8–9, 82–89), a British photojournalist and filmmaker, has traveled in 50 countries. Her work has appeared on television news and in publications including *The New York Times*, *Stern*, *The Guardian*, *Vogue*, *Politiken*, and more.

Chris Warde-Jones (pages 150–161) was born in Rome and has spent most of his life there. In a 30-year career in photojournalism, he has traveled all over the world for *The New York Times* and other publications, and his work has often appeared in exhibitions. warde-jones.net.

Max Whittaker (page 188), a photojournalist based in Sacramento, California, focuses on social and environmental issues in the American West. He has contributed work to *The New York Times*, *The Wall Street Journal*, *Harper's*, *Sactown*, and *The San Francisco Chronicle*, and is a founding member of Prime Collective.

INDEX

T. C. Worley (page 178) is a photographer and cinematographer based in Minneapolis and specializing in editorial and active photos. His work has appeared in *The New York Times* and *The Wall Street Journal*. tcworley.com

Dave Yoder (pages 130–139), now based in Milan, was born in Goshen, Indiana, but grew up on the foot of Kilimanjaro in Tanzania. A regular contributor to *National Geographic Traveler*, *The New York Times*, and other publications, he is especially interested in human interest projects. daveyoder.com

We would like to thank everyone at *The New York Times* and at TASCHEN who contributed to the creation of this book.

Special recognition must go to Nina Wiener and Sarah Wrigley, the dedicated editors behind the scenes at TASCHEN; to photo editor Evan Sklar; and to illustrator Ola Niepsuj.

Great thanks must go to all of the writers and photographers whose work appears in the book, both *Times* staffers and freelancers, and to the many *Times* editors who brought these articles to life in the pages of the newspaper and at nytimes.com.

Guiding the transformation of newspaper material to book form at TASCHEN were Anna-Tina Kessler, Andy Disl, Thomas Grell, Kathrin Murr, and Anne Sauvadet, with assistance from Lindsey Dole, Amanda Horn, Annie Marino, and Pimploy Phongsirivech. The Marlena Agency helped make the illustrations possible. Steve Bailey copyedited the manuscript; Anna Skinner and Doug Adrianson proofread the book. Translators for the European-language editions included Claudia Arlinghaus, Daniel Roche, and Michael A. Titz. At *The Times*, Heidi Giovine helped keep production on track at critical moments.

Sincere acknowledgment must go to Benedikt Taschen, whose longtime readership and interest led to the partnership of our two companies that produced this book.

— Barbara Ireland and Alex Ward

Copyright © 2017 *The New York Times*

Editor Barbara Ireland
Project management Alex Ward
Photo editor Evan Sklar
Copy editor Steve Bailey
Illustrations Ola Niepsuj/marlenaagency.com

Editorial coordination Nina Wiener and Sarah Wrigley
Art direction and design Anna-Tina Kessler
Production Thomas Grell

EACH AND EVERY TASCHEN BOOK PLANTS A SEED!
TASCHEN is a carbon neutral publisher. Each year, we offset our annual carbon emissions with carbon credits at the Instituto Terra, a reforestation program in Minas Gerais, Brazil, founded by Lélia and Sebastião Salgado. To find out more about this ecological partnership, please check: www.taschen.com/zerocarbon
Inspiration: unlimited. Carbon footprint: zero.

To stay informed about TASCHEN and our upcoming titles, please subscribe to our free magazine at www.taschen.com/magazine, follow us on Twitter, Instagram, and Facebook, or e-mail your questions to contact@taschen.com.

© 2017 TASCHEN GmbH
Hohenzollernring 53, D-50672 Köln
www.taschen.com

ISBN 978-3-8365-7073-2
Printed in Slovakia

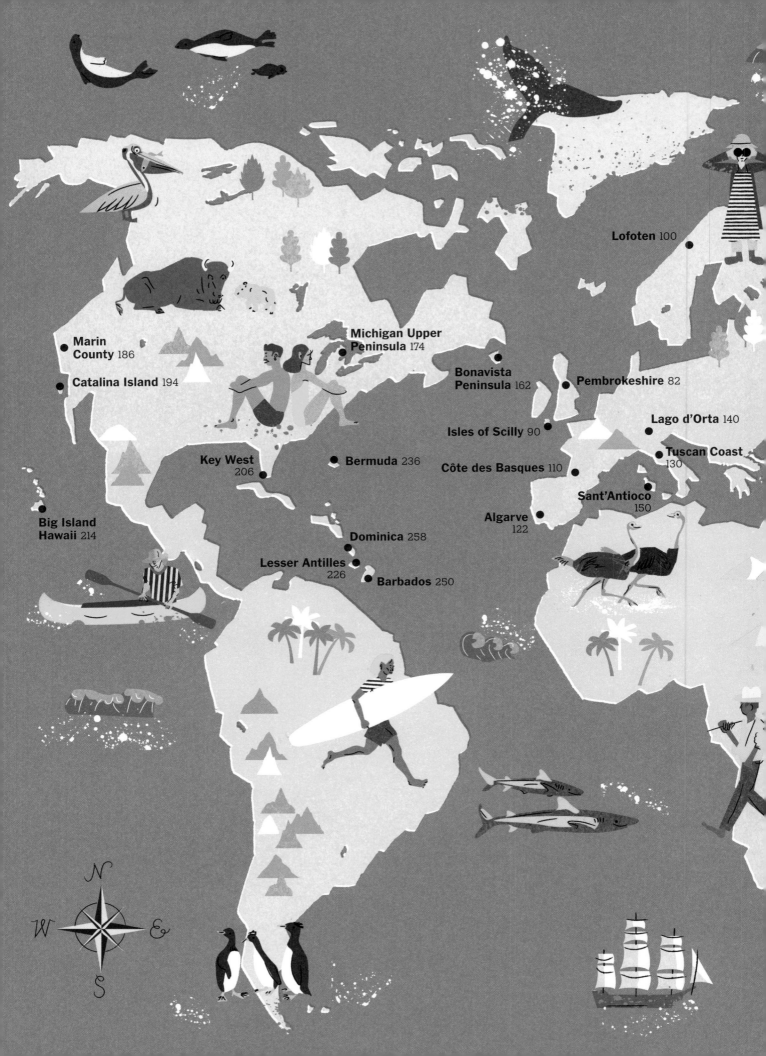

Lofoten 100

Marin County 186

Catalina Island 194

Michigan Upper Peninsula 174

Bonavista Peninsula 162

Pembrokeshire 82

Lago d'Orta 140

Isles of Scilly 90

Tuscan Coast 130

Key West 206

Bermuda 236

Côte des Basques 110

Sant'Antioco 150

Big Island Hawaii 214

Algarve 122

Dominica 258

Lesser Antilles 226

Barbados 250